Super/Heroes

From Hercules to Superman

Library of Congress Control Number: 2006933332
ISBN 978-0-9777908-4-5 paperback (alk. paper)

New Academia Publishing
P.O. Box 27420 - Washington, DC 20038-7420
info@newacademia.com - www.newacademia.com

Contents

List of Illustrations

Do We Need Another Hero?

Angela Ndalianis

One of the most extraordinary cultural phenomena in recent times has been the figure of the superhero. Since the 1930s, superheroes (both male and female) have come to dominate a variety of media formats. The superhero has reached a level of popularity never witnessed before, making a successful and prolific transfer from the comic book and graphic novel (a variation of the comic book that is associated with 'artistry' and the auterism that emerged in the 1980s) into the multi-million dollar blockbuster film. A number of films and their sequels, including the *Spider Man* (2002-), *X-Men* (2000-), *Superman* (1978-) and *Batman* (1989-) series represent only a handful of examples that have attained unprecedented box-office success or cult status in recent years. One aspect of this extraordinary commercial success has been the connection to major contemporary events. The crisis in global identity that followed the devastating events of September 11 2001 is frequently cited in the media as catalyst for the superhero's revived success. Whether valid or not, such assertions reveal an underlying belief in the cultural need and mythic potential inherent in superheroes and their stories. This belief is played out to comic effect in the highly successful animated film *The Incredibles* (2004)–a film whose narrative emphasizes the need to bring back the superhero (from a covert existence in the suburbs) into the mainstream of contemporary life. This appears to be an explicit acknowledgement that the necessity of the hero has become part of the wider cultural consciousness. As we might expect, superhero narratives seem to be inextricably linked to the realities of social and political life.

Beyond the superhero, the non-super-powered everyday hero has infiltrated our media on an even more intensive scale. On television, fantasy, science fiction and adventure series like *Stargate: SG1* (1997-), *Stargate Atlantis* (2004-), *Millennium* (1996-9), and *Star Trek: Next Generation* (1987-94) continue to extend the heroic adventures of the past into the present. Beowulf, Artemis, Cassandra and Thor found their modern articulations in

Jack O'Neill (figure 1), Teyla Emmagan, Frank Black and Worf. Our screens are populated by a breed of professional heroes that are quite particular to our time: detectives (*24*, *Law and Order/:SVU* and *Criminal Intent*), cops (*NYPD Blue*, *Boomtown*), lawyers (*Law and Order*, *Boston Legal*), medical experts (*E.R.*, *House*), talk show hosts (*Dr.Phil*, *Oprah*), Cosa Nostra types (*Sopranos*) and forensic investigators (*CSI /:New York* and *Miami, NCIS*) have all entered the arena that is occupied by the everyday hero. CBS's *CSI* website even provides the audience with an encyclopedia of tools, evidence and procedures that may come in handy when we confront our own real life crime scene–tools that can transform us into highly skilled, crime scene hero investigators (See http://www.cbs.com/primetime/csi/).

Why are audiences–or, more precisely, human beings–so fascinated with heroes? What makes the idea of heroes so necessary in society? In *The Power of Myth* (1988), Joseph Campbell discussed the hero story as being one so ancient that it is found in all of the earliest mythologies, as well as in religious stories of Moses, Christ, the Buddha, and Mohammed. The dominance of superhero narratives in our own world has many parallels with the proliferation and popularity of hero myths and religions of the past. Likewise, when scrutinized closely, many parallels between past and present emerge: the underworld journeys of Batman and Odysseus; the Utopian society of Plato's Atlantis and Aquaman's underwater world; the iconic Savior status of Jesus Christ, Superman and the Silver Surfer. It could be said in the first instance that the superhero's massive presence in our contemporary popular culture–in comic books, television shows and films–has its parallel in mythical narratives about heroes. The hero transcends culture, religion, race, gender, age, and speaks without discretion, to all humanity. Many of the essays in this anthology explore such parallels by focusing on comparative analyses of heroic narratives from diverse cultures, the intention of which is to shed light on the creative process of mythmaking.

This anthology therefore traverses the boundary between hero and superhero. Where does the one end and the other begin? The title, *Super/Heroes*, has deliberately dissected the 'superhero' into two in order to highlight the dual focus on these character types–the hero and the superhero–who have much in common. (In a later essay Peter Coogan sets up a similar distinction but to a slightly different purpose). How are our heroes articulated across a variety of media formats? Studies so far have tended to focus on one of two things: first, in evaluating the nature of the superhero or hero, they have referred briefly to the impact of older heroic prototypes on the contemporary super/hero. And second, while primarily concerned with ancient heroes, they sparingly refer to parallels found in our times. This study, instead, evaluates the social function and formal

characteristics of the super/hero in contemporary, ancient and multiple media contexts, evaluating its continuities, transformations and cultural significance–sometimes across time, and in other instances, within specific temporal contexts. It achieves this by bringing together the expertise of individual researchers with different, but complementary, interests. As such, the anthology's strength lies in its interdisciplinary nature.

The current anthology is the culmination of the "Men in Tights" Superheroes conference, which was held at Melbourne University, Australia between 9th-12th June 2005, and which comprised over 80 speakers (www. ahcca.unimelb.edu.au/Superheroes/). The editors–Haslem, Ndalianis and Mackie–have edited this anthology with a focus on the fundamental belief that there is much to learn from serious scholarly treatment of the hero myth and the way that it manifests itself in diverse cultures and media. Our central aim in this project has been to take the first (in what, it is hoped, will become many) steps towards identifying how heroes and the myths that convey their tales change through time; how they re-emerge in different eras in different media; and how new heroes and myths are created in response to social change or social need. Heroic action usually has a fundamental link to the welfare of the society from which the hero comes. Heroes and superheroes have never operated in a vacuum. They respond in a dynamic way to various challenges and social needs. Whether conscious or unconscious, hero narratives give substance to certain ideological myths about the society they address. Occupying a space outside culture, the super/hero often serves the function of mediator figure that enters a community in crisis with the aim of resolving its conflicts and restoring the *status quo*. As Richard Reynolds has argued "A key ideological myth of the superhero comic is that the normal and everyday enshrines positive values that must be defended through heroic action–and defended over and over again... The superhero has a mission to preserve society not to re-invent it" (1994, 77). Like the epic journeys that mythologized Heracles and Thor, or the Western heroes immortalized by the actor John Wayne, the super/heroes who followed in their wake continue to repeat the same function: these figures often occupy a realm outside the 'norm', yet are integral to it. The super/hero is a concrete manifestation of an abstract concept that speaks of the struggle of civilization to survive and maintain order in a world that threatens to be overcome with chaos.

The significance of mythic formations has been debated since classical times. Plato, for example, understood mythic narratives as a form of therapy that helped resolve conflicts, fears, and desires of the city-state. Since the days of Plato the function of myth as a form of social remedy has become increasingly accepted. Mythographer William Doty has stated that "myth is understood as referring to the fundamental religious

phical beliefs of a culture, expressed through ritual behavior h the graphic or literary arts, and forming a constitutive part ɔ. ̣ ̣ ̣ ̣ ̣ty's worldview" (1986, 13). It is the specific articulations of that worldview that this anthology will explore. Society is constantly in transition, and the development of the super/hero has reflected these transitions throughout time. More importantly, super/hero narratives have peaked in popularity during periods of social crisis. John Girling observes that "the inspirational character of myths is evident in turbulent times. It is this that enables believers to adapt to, and even to shape, the 'reality' of powerful, impersonal forces at work in society. . . Myths, in other words, provide both meaning and identity." (1993, 170). The contributors to this anthology identify and analyze the heroic stories that have continued to voice their presence in cultural memory. They also begin the huge task of articulating how archetypal themes alter and transform across time; and how, in turn, they are presented during specific periods to reflect the changing cultural conditions and ideologies that produce them.

The first part of the anthology "Being a Super/Hero: Myth and Meaning" tackles the issue of definitions. What does it mean to be a hero? Is it different from the meaning of the superhero? The essays in this section embrace the topic from diverse perspectives. Louise Krasniewicz sets the mood by delivering her analysis of Arnold Schwarzenegger in comic book format; here she ingeniously presents him as an action hero politician who was unleashed on the state of California, the U.S.A. and the world at large as a primal force of Western mythic history. Peter Coogan, however, rather than focusing on a mythic archetype as embodied in a single identity, turns his attention to the distinction between heroes like Sherlock Holmes and superheroes like Captain Marvel. He makes the point that whilst heroes may contain 'super' traits, they differ from superheroes in terms of their powers, their identity, and in their generic characteristics. He concludes that conventions of plot, setting, character, iconography and theme are distinctive enough to create a superhero genre. Robert Peaslee narrows in on the superhero's qualities further, using the 2004 blockbusters *Spider-Man 2*, *Hellboy*, and *Catwoman* as case studies. He explores the issue of morality that is integral to the American superheroes, looking particularly at the extent to which these cinematic superheroes test the *status quo* of official society by representing a subversion of dominant, codified law. The social dimension of the superhero is also explored by Gabrielle Murray who investigates the phenomenon of El Santo, the Mexican wrestler and film star of his own film series from the 1950s to 80s. Shifting attention away from Hollywood cinema and the realm of comic books, Murray evaluates the code of heroism ritualized in the figure of the Mexican wrestler (known as a *luchador*) and how El Santo became, for the Mexican people, both saint

and superhero. In the final essay of this section, Erin O'Connell redirects attention to music: as popularized through a wide variety of media–the recording industry, music videos, film, advertising, and print journalism– she argues that the textual and visual hype that accompanies contemporary Gangsta Rap and Political Rap music possesses a sophisticated and complex ethos of idealized masculine behavior that finds its antecedents in mythic heroes such as Achilles, Odysseus, Ajax and Agamemnon.

In Part 2, "Into the Labyrinth: Dark Journeys," the authors explore the more abstract and metaphysical dimensions of the super/hero's mythic journey. Comparing Odysseus with Batman and Achilles with Superman, Chris Mackie discovers iconic and thematic parallels that establish two re- current, heroic prototypes that exist to this day. He argues that Odysseus and Batman, as later 'self-made' heroes (i.e. without heavenly origins), challenge the dominance of 'otherworldly' heroes like Achilles, Heracles and Superman. Raymond Younis develops the dark aspects of the hero's journey along philosophical lines, arguing that the overcoming of nihil- ism is a crucial and integral part of the superhero's journey. Indeed, the superhero is understood as the bringer of a new order whose intention it is to dismantle the current order of oppression. Paul M. Malone shifts at- tention from social to individual despair. Focusing on the popular anime television series *Neon Genesis Evangelion* and, in particular, the protagonist Shinji, he argues that the series reflects a paranoia that remarkably paral- lels the megalomanic fantasies of Daniel Paul Schreber as published in his *Memoirs of My Nervous Illness* (1903)–megalomanic fantasies that are frequently an issue of concern in the superhero story. Behind every super- hero there is the potential for a megalomaniac supervillain. Lucy Wright and Jamie Egolf also follow the path opened by the inner journey. Explor- ing how the shamanic figure has been revisioned in the 2001 film *Final Fantasy,* Wright suggests that the hero Dr Aki Ross is in many ways a mod- ern manifestation of the ancient shaman; as a futuristic, scientific shaman- hero Ross uses both her rational mind and her oneiric intuition to defend life and save the planet. Using such fictional and archetypal scenarios, the Jungian therapist Egolf maps them across the dreams of her patients. The superhero archetypes, she suggests, play an integral role in guiding the individual along their own path to individuality and Selfhood.

The third part, "We Can Be Heroes: Bodies that Hammer," shifts to a range of unique examples of super/heroes taken from a variety of media. Analyzing the superheroic vampire Angel from the popular, self- titled television series, Gwyn Symonds explores a key component of the superhero mythology: the absence or failure of traditional familial structures; for all the battering his soulless body has taken in his successful, heroic quest, Angel failed miserably as the father of his angst-ridden son

Connor. The battered body that Peter Horsfield studies is that of Christ, as depicted in Mel Gibson's *The Passion of the Christ* (2004). Here, Horsfield argues that Gibson, as producer, director and self-confessed Catholic, attempted to renew the cultural relevance of his Jesus by representing him as superhero whose body suffers the intense violence and extreme pain often endured by the body of the superhero. In the next essay, the theme of violence continues, but this time it is the figure of the WWE wrestler who is the recipient. Wendy Haslem explores the ways in which professional wrestling constructs wrestlers as superheroes who continually threaten to destabilize the line that separates fantasy and reality. These superstars are defined by their physical power, transformations and excess – skills that create a superhero theatre that beckons its audience actively to participate in the ritual on display. Joanna Di Mattia transfers the hero dynamic to the Showtime television series *Queer as Folk*. Against the frequent backdrop of the thumping music and vibrating rhythms of dance clubs the show focuses on its group of gay protagonists, in particular, Brian Kinney, who threatens to destabilize and rewrite the traditional association of heroism with the dominant, white, straight ideal of American masculinity. Picking up on previous threads of marginality, nihilism and the destabilization of social norms, Aleks Michalewicz takes the reader on a journey into the Black Metal music genre, arguing that the Black Metal aesthetic elevates performance and participation to a quasi-spiritual state. This transcends the participant to a state of spirituality and allows the performers on stage –through the ritual of performance–to perceive themselves as superbeings.

"Collisions: Gods and Supermen," Part Four, focuses on more explicit comparisons between heroes past and present. Babette Pütz discovers similarities between the stories of Harry Potter and Oedipus. From being raised by foster parents, to oracles that foretell their fate, Pütz outlines numerous events that recur in the lives of both heroes. Ruby Blondell focuses instead on the same hero as depicted across time. Comparing the classical Greek Hercules to the one who appeared in the television show *Hercules: The Legendary Journeys* (1995-9) Blondell explains how "the most unrestrained of Greek heroes" is transformed into a model of "enlightened," non-aggressive, late twentieth-century American masculinity. Following an alternate path, Lisa Beaven investigates the figure of the Guardian Angel, in particular, as it developed in the seventeenth century. She proposes that superheroes of the twentieth century with their supernatural powers, their ability to fly and battle the forces of evil, are directly derived from the concept of the Guardian Angel as it manifested itself during this earlier period of Christianity. Estelle Strazdins continues with the theme of religion, arguing that in the corpus of Hebrew myth, Noah, the Biblical

Flood Hero, is an individual trapped between humanity and divinity who functions beyond society and who, like the modern superhero, saves humanity from destruction. Claire Norton turns to another tradition, that of early seventeenth century Ottoman culture. She explores how the military commander 'Smack-Head Hasan' was re-imagined in manuscripts known as *Gazavat-i Tiryaki Hasan Paþa* as a Turkic superhero who, like his modern western counterparts had special supernatural powers, a sidekick, mysterious origins, and serialized adventures but who differed from modern counterparts by also being licentious, dishonorable, or stupid.

The final part of the anthology, "Media Convergence and Selling Hero Culture" explores various media and commercial dimensions of super/hero culture. Gareth Schott and Andrew Burn's essay investigates the media crossover phenomenon that accompanied the superhero character The Hulk. Focusing especially on the simultaneous release of the blockbuster film and computer game in 2003 Schott evaluates parallels and shifts in audience engagement that occur when this superhero migrates from one medium and inhabits another. Kim Toffoletti returns to a theme that has dominated in the anthology: music. Commencing with a recent crop of "spunky scream-goddess," lycra-clad rockers Peaches, Chicks on Speed, and Karen O from the The Yeah Yeah Yeahs, it is argued that masculinist superheroics are appropriated to problematize the relationships between gender, sexuality, and power in music culture. Craig Norris explores 'girl power' from the perspective of Japanese anime such as *Ghost in the Shell*. The merging of women into machines that, in turn, transform into a type of superhero are considered as indicators the possibility for a new politics of transgressive pleasure and resistance for a Western male audience. Holly Stokes redirects the audience focus to consider the ways promotional media have rearticulated the motivation of the classic superhero; the narrative conventions originally employed to place the hero on a level above the everyday individual have been adapted by advertising to enrich and raise brands like the Coco Pop Monkey and Paddle Pop Lion to this same level of recognition and respect. Consumerism and heroism also collide in Michael G. Robinson's essay, which describes and explores the HeroClix tabletop combat game phenomenon. HeroClix allows players to purchase game packs with assortments of plastic figures based on licensed superhero characters. At the HeroClix tournaments, each player adopts the characteristics of a superhero, or villain (via the plastic figures), and teams of players battle against each other to determine the ultimate winner in this battle of the champions. Interestingly, like many computer games and roleplay events, such new additions to the fantasy arena reflect the way super/hero narratives have been expanding to embrace a great interactive dimension.

As is evident from this brief overview, therefore, heroic types and functions do not remain static through time. Their identities and traits undergo transformations that are the result of the era and culture that consumes them. What are the cultural and mythic ramifications of this? The exciting developments in super/hero narratives, especially since the 1960s, have largely been the product of writers and artists who have come to understand and work around or through the superhero's cultural iconography. Consider, for example, George Lucas' collaborations with Joseph Campbell, and the impact that Campbell's theories had on the *Star Wars* universe (see Decker et.al. 2005). Writers like Lucas have applied the myth of the super/hero to make a statement about the culture that (the Star Wars) myth attempts to comprehend, so that culture may, in turn, comprehend itself. As the anthropologist Claude Levi-Strauss (1969) explained, myths structure and order our thinking of the world around us without our knowing. But how do these myths function once men know? How does this reflexivity alter the more traditional modes in which myth was consumed and the social function that it served? Do myths stop serving their traditional function, or do we need to rethink the critical and theoretical models we use to analyze the new hero types and the mythic structures that contain them? What are the interpretative implications when super/heroic prototypes from various stages of human history merge and coexist with contemporary examples? The exploration of some of these questions will, it is hoped, open up the possibilities of super/hero studies across disciplines. This anthology is, in many respects, a prototype that will open the way to the limitless possibilities inherent in truly interdisciplinary studies.

Figure 1: Jack O'Neill as new science fiction hero in the tv series *Stargate SG-1*. © MGM

A TYPICAL CAMPAIGN SPEECH

THIS IS A "TOTAL RECALL" AND I AM THE "RUNNING MAN"! I AM GOING TO TURN ON SOME "RED HEAT" BECAUSE OF THE "RAW DEAL" GRAY DAVIS IS GIVING THIS STATE. I AM GOING TO BE THE "ERASER" TO HIS "TRUE LIES", AND BRING "THE END OF DAYS" TO HIS "COLLATERAL DAMAGE". I FOUND MY "HERCULES IN NEW YORK", RUDI GIUILJANI, THE FATHER OF THOSE LOST "TWINS". HE WILL HELP ME TERMINATE THE REAL "VILLAIN": BUSINESS AS USUAL IN THE STATE OF KAHLYFOHRNYAH. LISTEN "JUNIOR", THIS ISN'T "THE LONG GOODBYE", IT'S THE SHORT ONE: HASTA LA VISTA, GRAY DAVIS! TAKE IT FROM CONAN THE REPUBLICAN: YOU MUST CRUSH YOUR ENEMIES, SEE THEM DRIVEN BEFORE YOU AND HEAR THE LAMENTATIONS OF THE WOMEN.

WHY DID I MARRY HIM??? HELLO!! HAVE YOU SEEN HIS BODY???

16 WOMEN, MANY ANONYMOUSLY, TOLD THE LOS ANGELES TIMES THAT ARNOLD GROPED AND TOUCHED THEM AGAINST THEIR WILL. ARNOLD WENT ON TO WIN 43% OF ALL WOMEN'S VOTES.

BUT HE'S SO HOT!

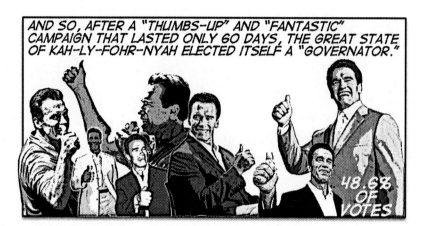

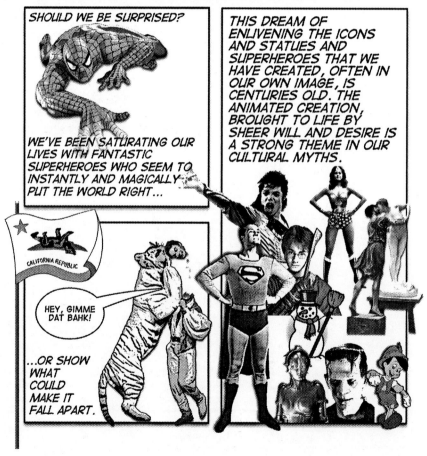

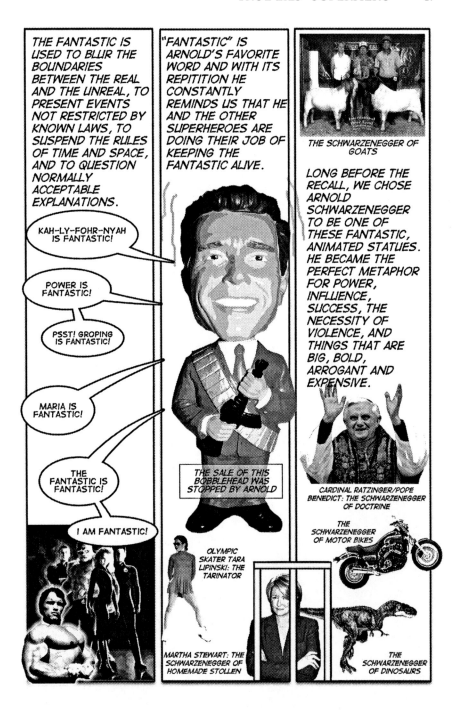

THE FANTASTIC IS USED TO BLUR THE BOUNDARIES BETWEEN THE REAL AND THE UNREAL, TO PRESENT EVENTS NOT RESTRICTED BY KNOWN LAWS, TO SUSPEND THE RULES OF TIME AND SPACE, AND TO QUESTION NORMALLY ACCEPTABLE EXPLANATIONS.

KAH-LY-FOHR-NYAH IS FANTASTIC!

POWER IS FANTASTIC!

PSST! GROPING IS FANTASTIC!

MARIA IS FANTASTIC!

THE FANTASTIC IS FANTASTIC!

I AM FANTASTIC!

"FANTASTIC" IS ARNOLD'S FAVORITE WORD AND WITH ITS REPITITION HE CONSTANTLY REMINDS US THAT HE AND THE OTHER SUPERHEROES ARE DOING THEIR JOB OF KEEPING THE FANTASTIC ALIVE.

THE SALE OF THIS BOBBLEHEAD WAS STOPPED BY ARNOLD

OLYMPIC SKATER TARA LIPINSKI: THE TARINATOR

MARTHA STEWART: THE SCHWARZENEGGER OF HOMEMADE STOLLEN

THE SCHWARZENEGGER OF GOATS

LONG BEFORE THE RECALL, WE CHOSE ARNOLD SCHWARZENEGGER TO BE ONE OF THESE FANTASTIC, ANIMATED STATUES. HE BECAME THE PERFECT METAPHOR FOR POWER, INFLUENCE, SUCCESS, THE NECESSITY OF VIOLENCE, AND THINGS THAT ARE BIG, BOLD, ARROGANT AND EXPENSIVE.

CARDINAL RATZINGER/POPE BENEDICT: THE SCHWARZENEGGER OF DOCTRINE

THE SCHWARZENEGGER OF MOTOR BIKES

THE SCHWARZENEGGER OF DINOSAURS

ARNOLD'S FANTASTIC LIFE IS DECRIBED AS THE FULFILLMENT OF THE AMERICAN DREAM, THE LIFELONG YEARNING FOR POWER, MONEY, SEX AND FAME THAT ONLY HE AMONG ALL AMERICANS HAS EVER ACHIEVED.

ARNOLD GIVES HIS AMERICAN DREAM SPEECH AT THE REPUBLICAN NATIONAL CONVENTION

RECENTLY HONORED WITH A STATUE AT LEGOLAND AMUSEMENT PARK IN CALIFORNIA, ALONGSIDE PRESIDENTS AND ARTISTS, ARNOLD CONTINUES TO DEVELOP HIS POLITICAL AMBITIONS. SOME OF HIS SUPPORTERS ARE TRYING TO CHANGE THE U.S. CONSTITUTION SO HE CAN RUN FOR PRESIDENT OF THE UNITED STATES.

TRUE LIES IS THE INEVITABLE RESULT OF HAVING SUPERHEROES, OR ANY OF OUR DISQUIETING HUMAN SIMULATIONS, COME INTO OUR EVERYDAY LIVES.

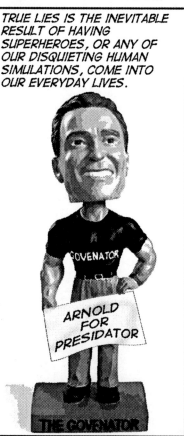

GOVENATOR

ARNOLD FOR PRESIDATOR

THE GOVENATOR

living as a circus strongman); or a super villain (if he pursued his interests at the legal, economic, or moral expense of others, like Dr. Hugo Strange, an early foe of Batman).

But the mission convention is not unique to the genre. Superman's mission is to be a "champion of the oppressed. . . sworn to devote his existence to helping those in need" i.e. to "benefit mankind"(Siegel 1997, 1). This mission is not greatly different from that of the pulp mystery man Doc Savage, whose "purpose was to go here and there, from one end of the world to another, looking for excitement and adventure, striving to help those who needed help, punishing those who deserved it" (Robeson 1964, 4). Nor does Superman's mission differ materially from the missions of adventure heroes of the dime novels, pulps, film serials, or radio programs of the late 19th and early 20th centuries. The superhero's mission does distinguish him from certain hero types, though. Many western and science fiction heroes do not have the generalized mission of the superhero or pulp hero because they are not seeking to do good for the sake of doing good. Instead, many of these heroes reluctantly get drawn into defending a community. Superheroes actively seek to protect their communities by preventing harm to all people and by seeking to right wrongs committed by criminals and other villains.

Superpowers are one of the most identifiable elements of the superhero genre. Hand identifies Superman and Wonder Man as having "miraculous strength and speed" and being "wholly impervious" to harm (*Detective v. Bruns*, 1940). He cites instances when each crushes a gun in his hands, rips open steel doors, stops bullets, and leaps over the buildings of modern cities. He notes that each is designated the "strongest man in the world". These abilities are the heroes' powers—or superpowers, to emphasize the exaggeration inherent in the superhero genre—and they are the first area of real difference between Superman and his pulp and science fiction predecessors. Each of Superman's powers amplifies the abilities of the science-fiction supermen who came before him. Hugo Danner in *The Gladiator* was fairly bullet proof and possessed super-strength and super-speed. In the first issue of *Action Comics*, Superman displays superstrength, super-speed, super-leaping, and invulnerability at only slightly greater levels than Danner does. Over time, though, Superman's powers went far beyond merely exaggerating the strength, speed, and toughness of ordinary human beings as science-fiction supermen had done.

The identity element comprises the codename and the costume, with the secret identity being a customary counterpart to the codename. In his ruling Hand identifies the two elements that make up the identity convention of the superhero when he notes that both *Action Comics* and *Wonder Comics* portray characters with heroic codenames—Superman

and Wonder Man—who conceal "skintight acrobatic costume[s]" beneath "ordinary clothing" (*Detective v. Bruns*, 1940).

The identity convention most clearly marks the superhero as different from his predecessors. Characters like the Scarlet Pimpernel and Zorro established the dual identity convention that was to become the hallmark of the superhero genre. However, the code names of these characters do not firmly externalize either their alter ego's inner character or biography. The Scarlet Pimpernel does not resemble the little roadside flower whose name he takes, except perhaps in remaining unnoticed in his Percy Blakeney identity; Zorro does not resemble the fox whose Spanish name he has taken, except perhaps in his ability to escape his pursuers. These minimal connections between heroic codename and character are not foregrounded in the hero's adventures, but those adventures did serve as models for the creators of superheroes in their portrayals of their heroes' foppish alter egos.

The connection of name to inner character or biography came with pulp mystery men like the Shadow and Doc Savage. The Shadow is a shadowy presence behind events, not directly seen by his enemies or even his agents; thus his name expresses his character. Doc Savage's name combines the twin thrusts of childhood tutelage by scientists—the skill and rationality of a doctor and the strength and fighting ability of a wild savage, thus embodying his biography. The heroic identities of Superman and Batman operate in this fashion. Superman is a super man and represents the best humanity can hope to achieve; his codename expresses his inner character. The Batman identity was inspired by Bruce Wayne's encounter with a bat while he was seeking a disguise able to strike terror into the hearts of criminals; his codename embodies his biography.

The difference between Superman and earlier figures such as the Shadow or Doc Savage lies in the element of identity central to the superhero, the costume. Although Superman was not the first costumed hero, his costume marks a clear and striking departure from those of the pulp heroes. A pulp hero's costume does not emblematize the character's identity. The slouch hat, black cloak, and red scarf of the Shadow or the mask and fangs of the Spider disguise their faces but do not proclaim their identities. Superman's costume does, particularly through his "S" chevron.[2] Similarly, Batman's costume proclaims him a bat man, just as Spider-Man's webbed costume proclaims him a spider man. These costumes are iconic representations of the superhero's identity.

The iconicity of the superhero costume follows Scott McCloud's theory of "amplification through simplification" (McCloud 1993, 30). In *Understanding Comics*, McCloud argues that pictures vary in their levels of abstraction, from completely realistic photographs to nearly abstract

cartoons. Moving from realism to abstraction in pictures is a process of simplification, "focusing on specific details" and "stripping down an image to its essential 'meaning'" (McCloud 1993, 30). This stripping down amplifies meaning by focusing attention on the idea represented by the picture. McCloud explains, "By de-emphasizing the appearance of the physical world in favor of the idea of form, the cartoon places itself in the world of concepts" (McCloud 1993, 41). The superhero costume removes the specific details of a character's ordinary appearance, leaving only a simplified idea that is represented in the colors and design of the costume.

Color plays an important role in the iconicity of the superhero costume. In his chapter on color, McCloud shows the way the bright, primary colors of superhero comics are "less than expressionistic," but therefore more iconic due to their simplicity (McCloud 1993, 188). This simplification makes the superhero costume more abstract and iconic, a more direct statement of the identity of the character. The heroes of pulps, dime novels, and other forms of heroic fiction are not similarly represented as wearing such abstract, iconic costumes.

The chevron especially emphasizes the character's codename and is itself an iconic statement of that identity. Pulp-hero costumes do not similarly simply state the character's identity. The Shadow's face—the most common way the character is identified on pulp covers—while somewhat abstract because of the way the nose and eyes stand out, contains too many specific details to reach the level of the chevron's abstraction. The chevron by itself—Superman's S or Batman's bat—can stand for the superhero, as is evident in chevron-embossed merchandise that flows from the film studios with each new superhero film.

The superhero costume functions within the narrative in a way that the pulp-hero costume does not. Once the genre was established, the costume identifies the superhero's role in a criminal encounter. In *Nightwing: Year One*, Dick Grayson abandons his Robin identity and visits Superman in Metropolis, where the two confront a pair of suicide bombers about to kill the President. Superman stops one bomber, while Dick Grayson goes after the other a block away. Superman's bomber immediately understands who Superman is and why his bomb has failed. Dick Grayson, dressed in jeans and a hooded sweatshirt, confronts his bomber but provokes only puzzlement. Grayson thinks, "Without the mask and company colors I had to explain myself. Obviously there's a slight credibility gap when you're a hero in a hooded sweatshirt and tennies" (Beatty and Dixon 2005, 8, 10). The superhero's costume places his actions in a comprehensible context, much as a police officer's uniform or a surgeon's scrubs would. It announces who the superhero is and explains what he is doing

to the people in his world and the reader as well. Thus the costume is generically functional for both author and audience.

The importance of the costume convention in establishing the superhero genre can be seen in characters who debut with mystery-man costumes but develop regular superhero costumes. Both the Crimson Avenger and the Sandman first appeared between the debut of Superman and that of Batman, before the conventions of the superhero genre had been fully implemented and accepted.[3] The Crimson Avenger begins with a Shadow-inspired costume of a slouch hat, a large domino mask, and a red cloak. In *Detective Comics* #44 (October 1940), his costume changes to red tights with yellow trunks and boots, a smaller domino mask, a hood with a ridge running from his forehead backward, and a chevron of an eclipsed sun. His ward and sidekick Wing acquires an identical costume with a reversed color scheme. They are founding members of the Seven Soldiers of Victory in *Leading Comics* #1 (Winter 1942), a superhero team designed to capitalize on the success of the JSA (Benton 1992, 169). With these new costumes, they formally shift from pulp heroes to superheroes.

The Sandman debuted in a double-breasted green suit, a purple cape, an orange fedora, and a blue-and-yellow gas mask.[4] When Jack Kirby and Joe Simon took over the character in *Adventure Comics* #69 (December 1941), his outfit was changed into a standard yellow and purple superhero suit. That both these characters debuted before the superhero genre had fully been established, that both were tied more to the style of the pulp mystery men (Benton 1992, 23, 27; Goulart 1990, 13, 318), and that both moved into standard-issue superhero garb indicates that DC Comics felt that the characters needed to be in step with their counterparts and that costumes such as these signified superheroism. The missions and powers of both characters remained constant as did their codenames, but their costumes changed in order to assert a genre identification. The costume is the strongest marker of the superhero genre.

Generic Distinction

These three elements—mission, powers, and identity—establish the core of the superhero genre. But it is easy to name specific superheroes who do not fully demonstrate these three elements, and also heroes from other genres who display all three elements to some degree but who should not be regarded as superheroes. This apparent indeterminacy originates in the nature of genre. In his attempt to define the genre of romantic comedy, Brian Henderson quotes Ludwig Wittgenstein's discussion of games

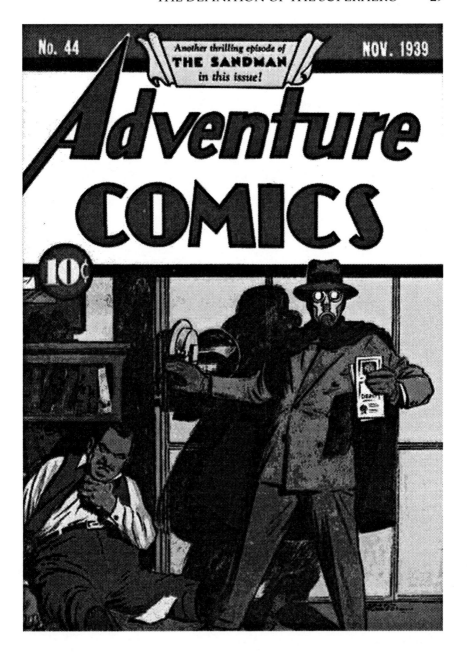

Figure 2: The Sandman on the cover of *Adventure Comics* issue 44, 1939.
© DC Comics

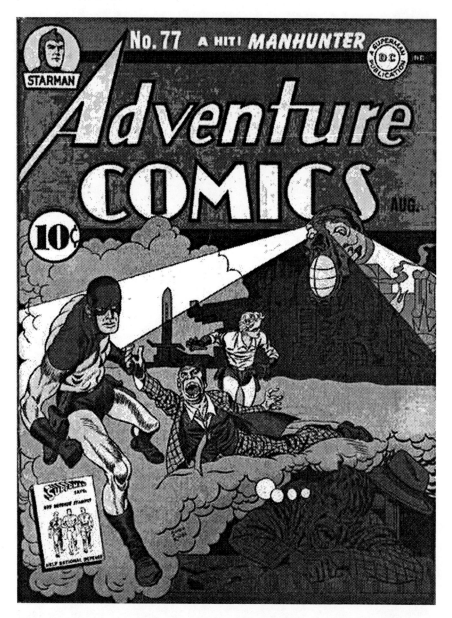

Figure 3: Manhunter on the cover of *Adventure Comics* issue 77, 1942.
© DC Comics

to show that universal similarity is not necessary to define a genre. In *Philosophical Investigations*, Wittgenstein wrote:

> For if you look at [games] you will not see something that is common to *all*, but similarities, relationships, and a whole series of them at that. . . we see a complicated network of similarities overlapping and crisscrossing: sometimes overall similarities, sometimes similarities of detail. . . I can think of no better expression to characterize these similarities than "family resemblances" (ellipses in Henderson 1986, 314).

The similarities between specific genre narratives are semantic, abstract, and thematic, and come from the constellation of conventions that are typically present in a genre offering. Thus, if a character basically fits the mission-powers-identity definition, even with significant qualifications, and cannot be easily placed into another genre because of the preponderance of superhero-genre conventions, the character is a superhero.

For example, the Hulk can be said to be a superhero without a mission. At times he seems absolutely anti-social, and he frequently finds himself in conflict with the U.S. Army, which is not presented as corrupt or maligned, but with the welfare of American citizens as its motivating force. Stan Lee claims the Frankenstein monster as an inspiration for the Hulk, "He never wanted to hurt anyone; he merely groped his tortuous way though a second life trying to defend himself, trying to come to terms with those who sought to destroy him" (Lee 1974, 75). The Hulk was Lee and Kirby's attempt to make a "hero out of a monster" (Lee 1974, 75). The green-skinned goliath's adventures do not arise from his attempts to fight crime or to improve the world. In two early adventures, Bruce Banner moves to stop the Metal Master and the invasion of the Toad Men; but as the Hulk, he offers to join forces with the Metal Master, and once in control of the Toad Men's spaceship he thinks, "With this flying dreadnought under me I can wipe out all mankind" (Lee and Kirby 1977, 42). The Hulk eventually loses his calculating intelligence and wanders the planet seeking solitude while being drawn, or stumbling, into the plans of super villains. The Hulk fights primarily for self-preservation but inadvertently does good. He effectively acts as a superhero but does not have the mission or motivation to do so. His tales, though, are suffused with the conventions of the superhero genre: super villains—the Leader, the Abomination; superhero physics—the transformative power of gamma rays; the antagonistic authorities—General Thunderbolt Ross; an

endangered girlfriend—Betty Ross; a pal—Rick Jones; and so forth. These conventions keep the Hulk within the superhero genre.

Regarding the powers convention, Batman was originally designed as a superhero without superpowers (Kane and Andrae 1989, 99). His mission of vengeance against criminals is clear, and his identity—represented by his codename and iconic costume—marks him as a superhero. While he has no distinctly "super" powers, his highly developed physical strength and mental skills allow him to fight crime alongside his more powerful brethren. As with the Hulk, Batman operates in a world brimming with the conventions of the superhero genre: super villains—the Joker, the Penguin; the helpful authority figure—Police Commissioner Gordon; the sidekick—Robin; the super team—the Justice League; and so forth.

The Fantastic Four illustrate how elements of the identity convention can be absent or weak and yet the characters remain superheroes. In the first issue of *The Fantastic Four*, the powers and mission conventions are clear. After their space ship is exposed to cosmic rays, each of the quartets manifests a superpower. The ship's pilot, Ben Grimm, declares their mission: "We've gotta use [these powers] to help mankind, right?" (Lee 1974, 32). The identity convention first arises shortly after Grimm's statement. The heroes place their hands together and proclaim their codenames: Mr. Fantastic, the Invisible Girl, the Human Torch, and the Thing. These codenames fit with the powers they have received and are expressions of the characters' personalities.

The secret identity and costume elements of the identity convention are absent from the debut of the Fantastic Four. Stan Lee claims that he wanted to do away with these aspects of superheroes:

> I was utterly determined to have a superhero series without any secret identities. I knew for a fact that if I myself possessed a super power I'd never keep it a secret. I'm too much of a show-off. So why should our fictional friends be any different? Accepting this premise, it was also natural to decide to forego the use of costumes. If our heroes were to live in the real world, then let them dress like real people (Lee 1974, 17).

The secret identity is a typical, but not necessary, convention for the genre. It clearly has great importance to the genre as its stable presence in superhero stories shows. Lee and Kirby were trying to be inventive and so chose to disregard aspects of the genre that they felt held them back. But the first issue of *The Fantastic Four* is clearly a superhero comic book, as is evident from the characters' powers and mission, the superhero physics, and the super villainous Mole Man with his plot to "destroy everything

that lives above the surface" (Lee 1974, 42).[5] And it is so without costumes. Significantly, although the Fantastic Four initially wore ordinary clothes, they quickly acquired costumes. The cover of issue three announces, "In this great collectors'-item [sic] issue, you will see, for the first time: The amazing Fantasti-Car, the colorful, new Fantastic Four costumes, and other startling surprises!" According to Stan Lee:

> We received a lot of fan mail. The kids said they loved [the Fantastic Four]. We knew we had a winner, and we were on our way now. But, virtually every letter said, "We think it's the greatest comic book, we'll buy it forever. Turn out more, but if you don't give them colorful costumes, we won't buy the next issue. (qtd. in Gross 1991)[6]

Like the Crimson Avenger and the Sandman, the Fantastic Four were given costumes to assert their superhero-genre identification.

The codename, the other aspect of the identity convention, is nearly omnipresent among superheroes. A rare example of a superhero without a codename is Arn Monroe, Roy Thomas' substitute for Superman in the *Young All Stars*, which came out in the post-Crisis period when Thomas was not allowed to use Superman in the World War Two era. Even Arn gets a superhero moniker of sorts, being referred to as "Iron" Munro and "ironman," an obvious, tongue-in-cheek reference to Marvel's armored Avenger, but he never uses these names as superhero codenames. The lack of a separate codename is a bit more common among sidekicks. Some sidekicks retain their ordinary names, a tradition that probably derives from Tonto and Kato, sidekicks of the Lone Ranger and the Green Hornet respectively. Captain America's partner Bucky, the Crimson Avenger's houseboy Wing, the Human Torch's companion Toro, the Star-Spangled Kid's chauffeur Stripsey, and Magno the Magnetic Man's boy partner Davey all fit this pattern. Ever since the Shadow re-established the single-hero magazine in 1931, mystery men and superheroes have needed codenames for marketing reasons. Sidekicks can keep the same name for both their super and ordinary roles because they are secondary heroes and rarely achieve their own magazines.

Generic distinction is useful in considering the most slippery aspect of defining the superhero genre, the distinction between super heroes (heroes who are super) and superheroes (protagonists of the superhero genre). Generic distinction marks off from the superhero genre those characters from other genres that fall within the larger adventure meta-genre established by John Cawelti (1976, 39).[7] These characters often possess

extraordinary abilities similar to those of superheroes—the strength of Beowulf or the Jedi-senses of Luke Skywalker—or even fulfill elements of the identity convention—the codenames and costumes of The Shadow and the Phantom. These characters are superior to ordinary human beings and ordinary protagonists of more realistic fiction in significant ways. When they are called super heroes, *super* is best understood as an adjective that modifies *hero*; but they are not superheroes, that is they are not the protagonists of superhero-genre narratives.

An excellent way to understand this distinction is through Northrop Frye's theory of modes. Frye sets up a system of classification of fiction "by the hero's power of action, which may be greater than ours, less, or roughly the same" (Frye 1957, 33). According to his scheme, in myth the hero is "superior in *kind* both to other men and to the environment" and is a divine being. In romance, the hero is "superior in *degree* to other men and to his environment" but is identified as a human being, and "moves in a world in which the ordinary laws of nature are slightly suspended" (Frye 1957, 33). The other categories are high mimetic—the hero, a leader, is "superior in degree to other men but not his natural environment"; low mimetic—the hero is "one of us" and "superior to neither men nor to his environment"; and the ironic mode—the hero is "inferior in power or intelligence to ourselves" (Frye 1957, 33, 34). Thought of in this way, heroes who are super—all those characters who are referred to as super heroes but do not fit the generic definition of the superhero presented herein—are romance heroes. Referring to these characters as romance heroes, though, given the contemporary use of *romance*—stories of couples whose love relationship develops to overcome all obstacles—would be confusing; instead it makes sense to refer to them as super heroes.

Besides The Shadow, Buffy the Vampire Slayer is the character most often put forward as a superhero to challenge the definition presented herein. Superficially, Buffy could be seen as qualifying as a superhero. She has a mission—to fight and slay vampires and other demons that threaten humanity. She has superpowers—her training raises her to the level of Batman in fighting ability and her physical strength is greater than the chemically enhanced strength of Riley Finn, an agent of the U.S. military's demon-hunting Initiative, or the supernatural strength of Angel, a vampire. Buffy has an identity as the Slayer. But this identity is not unproblematically a codename like Superman or Batman. This identity is not separate from her ordinary Buffy identity the way Superman is from Clark Kent, whose mild-mannered personality differs greatly from Superman's heroic character. The Slayer is not a public identity in the ordinary superhero sense; even the well-financed and government-sponsored Initiative views the Slayer as a myth, a boogeyman for demons. Buffy does not wear

a costume; and while such a costume is not necessary, it is typical and a significant genre marker.

Finally, and more importantly for the purpose of demonstrating that generic distinction is a crucial element in defining the superhero genre, the Slayer is a hero-type that predates the superhero, fitting firmly within the larger horror genre and specifically within the vampire sub-genre. Literarily, the vampire hunter descends from Dr. Van Helsing in *Dracula*. Historically, the hero-type descends from actual vampire hunters, including the *dhampir*, the supposed male progeny of a vampire who is particularly able to detect and destroy vampires.[8] Thus, though the writers of *Buffy the Vampire Slayer* draw on superhero conventions, the stories are generically distinct from the superhero genre. Therefore, Buffy is a super hero, but not a superhero.

Another way to clarify the issue of genre distinction is to look at supporting-cast characters in superhero narratives who are clearly identified with other genres or who are otherwise excluded from being superheroes. Gotham City police detective Harvey Bullock is a police officer. He is a normal human being and falls into the "loose cannon" stereotype of police officers. If he accompanies Batman on a raid or even tracks down a super villain like the Joker on his own, does he suddenly become a superhero? When Ben Urich, reporter for the *Daily Bugle*, shares information with Daredevil that helps the hero bring down the Kingpin, does that interaction transform him into a superhero? Does the ear-wiggling ability of Willie Lumpkin, the postal carrier whose route includes the Baxter Building, count as a superpower because he is an acquaintance of the Fantastic Four and occasionally sees super villains while delivering mail? Are these interactions as transformative as radioactive spider bites? All these questions can be answered easily with a firm "No." These characters do not fulfill the mission, powers, identity, and generic distinction elements of the definition of the superhero. Neither do strongly genre-identified characters who live in superhero universes, such as Nick Fury (spy/secret agent), Adam Strange (science-fiction hero), Ka-Zar (jungle hero), or John Constantine (occult investigator). These characters may battle villains (mission) and have extraordinary abilities or high technology (powers), but they use their own names instead of codenames and their clothing is genre-specific and functional within each's environment; finally their strong genre identifications make them generically distinct from the superheroes they live among and befriend; they are super heroes (heroes who are super) but not superheroes (protagonists of the superhero genre).[9] These characters merely show that tropes can be borrowed from genre to genre.

Conclusion

In this chapter I have argued for a definition of the superhero comprising mission, powers, identity, and generic distinction. Clearly the superhero has been studied previously without this definition in place, so the question arises, why do we need it? The answer to this question is that we already have it and it is already in use. My definition brings forth the unstated assumptions that generally guide the study of the superhero and the production of superhero comics. As the ruling of Judge Learned Hand shows, a recognition of the mission-powers-identity triumvirate as the necessary elements of a definition of the superhero existed very early in the superhero's history. Generic distinction merely accounts for the "family resemblances" of the other conventions that mark the superhero genre off from the rest of the adventure meta-genre.

Establishing a definition in this way is useful because of the nature of genre study. Genre tales are some of the most important of cultural products because of the way they embody and promulgate cultural mythology (Cawelti 1976, 35-36). All genres have boundaries. Some are narrow, like the superhero, and others are broader, like science fiction. A well-defined genre can be studied for the way the culture industry responds to and shapes popular taste. It can be seen as a way of examining the resolution of cultural conflicts and tensions that audiences regard as legitimate. A poorly constructed definition that fails to distinguish between superheroes and super heroes or fails to account for the metaphoric use of *superhero* renders the term meaningless as tool for genre criticism and analysis.[10]

A sloppy definition of the superhero genre makes it more difficult to examine the way the superhero genre embodies cultural mythology and narratively animates and resolves cultural conflicts and tensions. A tight definition enables scholars to focus specifically on the genre itself, separate it from related genres, and compare it with other genres. Hopefully this chapter provides a basis for the study of superheroes and will help to expand superhero scholarship and our understanding of the meaning of the superhero.

3

Superheroes, "Moral Economy," and the "Iron Cage": Morality, Alienation, and the Super-Individual

Robert M. Peaslee

Introduction

In "The Myth of Superman," Umberto Eco (1972) commented that the prevailing view of Superman (and superheroes generally) as mythical saviors was, by way of myopia, in error; instead, Eco pointed out, analysts should be attuned to the particularly American qualities of Superman, who eschews fighting injustice on the macro or structural level and prefers instead to wage smaller battles of immediate and palpable significance. The effect of this decision, according to Eco, is an implicit acceptance and defense on the hero's part of the tenets of capitalism and bureaucracy, such as property ownership, legality, and due process. In sum, Superman is ideology.

Since the early 1970s, the presence of superheroes (and comic book characters in general) in popular culture becomes increasingly pronounced. In particular, cinematic adaptations abound, largely beginning with *Superman* (1978) and continuing through the 1990s and 2000s with ever-increasing sophistication. If Eco is correct, then, it becomes important to consider the relationship of these characters to the societies in which they operate (both in narrative and in 'real' life); these characters occupy unique positions in relation to power, and how they negotiate this position has much to tell the viewer about the value and legitimacy of the institutions in which such power is situated.

It is the goal of this essay to offer one way of imagining the role of the superhero in contemporary society, a way that recognizes the superhero as an extreme example of the individual in an alienating and diffuse society. The tradition holds, after all, that superhero characters are both Superman and Everyman, alter ego and superego. The character of Aunt May, in an enormously interesting scene in *Spider Man 2* (2004), reminds her reticent super-nephew that "there's a hero in all of us." We are meant to both identify with and distance ourselves from such otherworldly characters,

and, clearly, these films are manifestations of contemporary negotiations between the self and the whole, between desire and responsibility, between chaos and order.

Two theorists offer compelling ways of understanding Hollywood's superhero tradition. E.P. Thompson's (1971) work on the concept of the "moral economy," which analyzes the behavior of 18th century British rural peasantry during that era's occasional bread riots, is of central value to the following analysis. In Thompson's view, the traditional view of riot activity as sporadic, primal responses to physical deprivation (which evokes a rather animalistic view of rioters) is incomplete. What such a summation lacks is an awareness of the reasoned moral argument underpinning such activities, an argument which valued implicit social "goodness" over the doctrine of codified law and an emerging sense of the infallible market economy.

As characters who act variously toward (in tandem with, outside of, in opposition to) explicit expressions of social cohesion (police and government are prevalent examples), superheroes evoke a correspondent implicit goodness, a common-sense approach to doing right that often operates outside the acceptable parameters of bureaucratic authority. It is in consideration of bureaucracy, in fact, that the work of Max Weber becomes vital. According to Weber, the human construction of society, the "technical and economic conditions of machine production which to-day (sic) determine the lives of all the individuals who are born into this mechanism" (Weber 1958, 181) becomes an "iron cage" of constraint; in fact, bureaucracy in full flower comes to act in opposition to the very democracy responsible for its creation. Since superheroes do not reject bureaucracy outright (though they certainly could) but exist to varying degrees within it, the dialectical nature of the human relationship with law and propriety are vividly expressed in their activities.[1] What is of interest is the degree to which Eco's thesis, related above, concerning the ideological nature of superhero characters holds; that is, are viewers discouraged by such characters to think and act outside the established parameters of control and normalcy? This essay aims to add to the discussion of whether or not this is an accurate assessment and raises the possibility that, rather than being ideological, superheroes represent a gap in ideology, what Radway (1986) has called an "ideological seam."

The study will commence with analyses of three films, each of which were released during the U.S. summer blockbuster season of 2004: *Spider-Man 2*, *Hellboy*, and *Catwoman*. The selection of these particular films is not meant to imply any scientific sampling method. Rather, these films were chosen qualitatively based on their roots to comic book culture, their similarities and differences, and the various discourses and institutions

they address. Other films could have been used. In fact, 'superhero' could easily be extended to encompass characters such as Harry Potter and Jesus Christ himself (as portrayed in Mel Gibson's *The Passion of the Christ*, 2004). But that is another paper, and I encourage someone to write it if I do not find the time.

Spider-Man, Hellboy and *Catwoman:* Articulations of Humanity [2]

In this section I would like to make some comments about the role of these three characters (and the texts in which they appear) in articulating the sentiments expressed in the work of Thompson and Weber. In order to make clear the degree to which the trope of the superhero addresses issues of sociality, governance, and alienation, I will make several particular comments about key sequences in each of the films under study. First, however, I would like to make some holistic observations that help couch the finitude of each text in a larger cultural and cinematic discourse.

For example, the setting for each of these narratives is one of extreme urbanity. *Spider Man 2* takes place expressly in New York, while *Hellboy* and *Catwoman* are both implied to unfold in the Big Apple. In all three films, the geography of skyscrapers, subways, sewers, and compartmentalizing spaces such as apartments and cubicles play a constitutive role in not only the mood but also the action of the story. Peter Parker lives in a tiny apartment and is constantly bumped, jostled, and impeded as he moves throughout the city. Only when he is Spider Man is he capable of transcending the maze of urban structure, as he leaps from building to building with the aid of his webs. Patience Phillips, similarly inept as an average citizen, finds liberation from her inhuman pod of a workspace at the moment she quits her design job and embraces her Catwoman chutzpah. Hellboy is perhaps the most confined of the three, as he is essentially jailed under maximum security between episodes with supernatural bad guys. His constant propensity to escape, aided (like his previous two counterparts) by his ability to navigate the rooftops and underground mazes of the city, is a clear expression of a desire for sociality. And yet the city, the apex of sociality, is impossible without the mechanical and bureaucratic structures which act to dehumanize it. Superheroes thus toe the line between integration with and transcendence of the social whole. The urban setting has a fraternal association with the superhero tradition, one that holds its main characters responsible for elevating the plight of humanity, both by their actions and by their very existence, above the calculable and administrative matrix of urban structure and organization.[3]

hero to find a way to arrest its progress and save the innocent citizens inside. This scenario, again, will not be unfamiliar to readers and viewers of superhero lore. All at once, the technological safety and security of a commuter subway train (in terms of reliability, failsafe systems of stoppage and control, etc.) is utterly forgotten, and those on board, hastening toward the end of the line and their certain demise, are without options. Science has failed them–turned against them, even. It is only Spider Man, with a generous application of webs to the passing buildings, who is able to stop the train in time, splayed Christ-like across the front of the train, arms wide, and in physical agony. And should one miss the savior metaphor, his unconscious body is passed back through the train, still in crucifixion pose, where his calm, boyish face is gazed upon by adoring and grateful citizens.

In addition to being reactive to the dangers of technology, Spider Man also spends a great deal of time proactively anticipating the spatial and temporal seams in which the judicial system cannot or does not act. In the opening sequence of the film, where Parker if forced to assume his super-identity to keep his pizza delivery job, Spider Man swoops in to rescue two wayward, ball-chasing children from an oncoming truck. Later, when the hero joins a police chase in progress, only a well-placed web saves a group of innocent bystanders from being crushed by an out of control police car (which, as another example of unchecked technology, is seen as a highly imperfect means of pursuit compared to a nimble webslinger). When Doc Ock robs a bank from which Aunt May is seeking a loan, no vault or security guard is of any use, nor can "the authorities," as they are so often referred to, do anything about the aforementioned calamities with the train and the fusion reactor. Time and again, the tools of security and law enforcement are unable to counter the immediacy or the enormity of the dangers to which their citizens are exposed. In fact, during a key sequence in the film when Parker renounces his heroic identity and ceases his activity as Spider-Man, we see both an alley street fight and a house fire in which members of society are victimized. This is what the normal world looks like. A world without superheroes is one largely without safety, and this fact is presented so clearly to Parker as to compel him ascetically to renounce his personal desires (primarily for a relationship with his love interest) and return to crime fighting. There is little ambivalence here on the effectiveness of law and the agencies entrusted with its enforcement in preventing crime.

Hellboy, Bureaucratic Inadequacy, and Individuality

Despite working as part of a team (the Bureau of Paranormal Research),

Hellboy insists upon undertaking his missions alone. While this tendency is partially and playfully explained by his colleague Abe Sapien as the "whole lonely hero thing," the wisdom of Hellboy's preference becomes clear as the film unfolds. In every altercation which ensues between the Bureau and various forces of evil, human action and technology are of virtually no use. Sammael, the demon whose initial breakout in the museum is the impetus for the first action sequence of the film, disposes of (or, rather, digests) six armed security guards with no effort. Later in the chase, when young Agent Myers tries to assist Hellboy, he finds himself caught in the middle of a busy highway and is saved at the last minute only by the gigantic fist of the hero. Hellboy punches straight down onto the hood of the oncoming vehicle, causing it to flip (in one of the few nifty shots in the film) harmlessly over them. He loses ground, however, on Sammael, and the agent is seen as no more than a bald inconvenience.

It becomes difficult, in fact, to see the Bureau and the agents who comprise it as anything more than a restriction upon the hero. Hellboy is locked into his living space, let out only to foil supernatural wrongdoing. After initially defeating Sammael, Hellboy disappears into the darkness, only to be found a few hours later. Interestingly, when found, Hellboy returns quietly. Much of this quiescence may be attributed to the respect he feels for his father, Broom (who heads the Bureau), but the indication that seems most apt is that Hellboy resents his mission far less than the system in which he must accomplish it.

Later in the film, once the Bureau has learned of Sammael's ability to clone himself, Hellboy and his team search the underground catacombs of the city for the villain's lair. After Abe is able to pinpoint the location of the den on the other side of a wall, the agent's first response is to suggest obtaining a permit to inspect the location. Exasperated, Hellboy uses his concrete fist to obliterate the need for such paperwork. Once the villains are found, Hellboy separates from the team in the ensuing chase. Predictably, all agents concerned (Myers excepted) are killed. Manning, a Justice Department appointee furious at what he sees as an ongoing pattern of damaging, individualistic behavior, lectures Hellboy on the importance of working as a team, to which the hero responds by destroying the room in which they are arguing.

The foregoing sequence is vital at a number of points. First, once again the human forces charged with securing the safety and well being of their citizens are seen as woefully inadequate. Only the superhero can approach evil and succeed. What is more, the agents are lampooned in the sequence as largely impotent bureaucrats in their adherence to law and policy (e.g. the permit). The audience is clearly meant to laugh at the suggestion, all the more so after Hellboy finds a much more direct, though unsanctioned,

means to the end. But what is most interesting is Hellboy's reaction to the admonition by Manning. The righteousness with which Manning approaches the hero is intolerable to him exactly because he has always told everyone concerned that he works alone. Hellboy knows that his human counterparts are no help to him, and yet he is chastised for not working with them properly. There is blame to be handed out in the aftermath of so much death, and the question posed by the dialogue between Hellboy and Manning is, do we blame the individual who left the agents behind or the system who insisted on putting them there?

Shortly after this sequence, Broom, Hellboy's adoptive father, is murdered in his study at the Bureau. The irony here is that the maximum-security installation which has contained the demon hero for sixty years could not protect his father, a fact not lost on the grieving son. His mission to find the reincarnate villain Rasputin is now personal, and his tolerance for Manning–the clearest symbol of bureaucracy in the film–is absolutely zero. Paired together in the final hunt for the Rasputin and his minions, Manning and Hellboy disagree at several points along the way. Hellboy simply dismisses Manning outright, exhibiting rank insubordination at every turn. When Manning later finds himself in mortal danger, it is the action of the hero which saves his life, a fact which leads to a reconciliation of sorts between the two characters. What this reconciliation means, however, is unclear. Has Hellboy returned to the fold, as it were, recognizing that he is needed by his human coworkers? Has Manning come to accept the hero's maverick nature? We are left to speculate. But Hellboy's greatest test is yet to come.

When, in the climactic sequence of the film, Hellboy is given the choice of opening a cosmic lock and unleashing the incarcerated Seven Gods of Chaos upon the world, or refusing and ensuring his love interest's demise, his ultimate refusal to open the lock is played as a reaffirmation of his commitment to his father and, by extension, humanity generally. Once the injured Myers is able to toss Broom's rosary to the hero (who had carried the beads with him since his father's death), Hellboy is then able to resist the temptation to choose poorly. Another interpretation, however, is of interest, and it concerns the degree to which Hellboy does or does not simply fulfill a function. On more than one occasion, Rasputin encourages Hellboy to become that which he was meant to be. What this means is that the hero was conceived as no more than a key brought into the world, along with his giant concrete fist (evil assistant Ilsa asks mockingly, "What did you think it was for?"), simply to be the key which opens the lock and ends the imprisonment of the Seven Gods. In a sense, then, his final decision is very much about the place of an individual in a proscribed system. On the one hand (literally), Hellboy can fulfill his "destiny," perform the

role he was created to perform. On the other, he can choose not to act in the way in which the system assumed he would. He can transcend the role given him and make a choice as a feeling, thinking individual. This is, of course, the path he chooses, presumably to the impassioned delight of most audiences. The interesting question, I would offer, is whether this delight stems from the textual fact of deliverance or the more extra-textual demonstration of individual empowerment.

In the end, the refusal on the hero's part to be no more than a "key" is closely akin to his discomfited role within the Bureau. Hellboy, like many of his super-contemporaries, desperately wants the many components of a "normal" human life: love, friendship, and freedom, to name a few. His workaday sensibility, constantly reinforced by his insistence that his heroic exploits are simply "his job," helps to further place his sensational circumstances on very common ground. His rejection of the bureaucratic apparatus of his employer is thus never a rejection of the mission. It is rather the same rejection given to Rasputin as Hellboy stands before the lock. As the opening lines of the film, and their reprise at the conclusion, attest, what makes a man is not his origins, but the choices he makes. This is a very populist sentiment indeed.

Catwoman, Patriarchy, and Corporate Greed

Catwoman, as a film, seems so obviously engineered as a feminist allegory that pointing it out seems almost redundant.[4] First, there is the bifurcation of our main character: Patience Phillips, whose first name indicates without subtlety her approach to life, and Catwoman, who is powerful, sexy, and independent. Second, there is the ongoing integration of Catwoman's origin story, relayed by Ophelia Powers as a quick lesson on feminist spirituality in which the chosen woman is given "both a blessing and a curse": freedom without hope for personal attachment. Later, there are sporadic but considerable moments of feminine power, such as the sequence in which Catwoman foils a group of male jewelry thieves, keeps the loot for herself, then returns the haul to the police minus a few baubles (including a huge diamond ring which she puts, after some consideration, on her right–rather than the engagement-laden left–hand). Finally, and most significantly, there is the villainous power against which Catwoman must fight.

Hedare Beauty is positioned for much of the film as a company run by a man but making products for women. Their most important commodity is Beauline, a skin cream which reverses the signs of aging in female skin (significantly, no man is ever seen applying the cream), and Laurel Hedare

is portrayed for much of the film as a prisoner of this man, his company, and its addictive produce. When she is cast aside after many years for a new, younger public face (one with whom George Hedare has become romantically involved), Laurel and Catwoman, both in terms of the narrative and in terms of character development, share a certain sympathy. Catwoman, as the reincarnation of a young woman who is killed by the company after discovering the truth about its product (killed, it seems worth noting, by being literally ejaculated out of a waste-drainage pipe) seems to hold a comparable position to the summarily discarded Laurel. Either woman is a threat to the success of the company.

In the end, however, *Catwoman* seems to offer mixed messages regarding feminine empowerment. Most obviously, the true villain in all of this turns out to be Laurel herself, who has been empowered indeed in killing several people in her desire to make the success of Beauline iron clad. The climactic battle of the film is not between Catwoman and some patriarchal oppressor, but between the two strongest female characters in the film. Also of interest is the fact that, if the logic of Beauline as presented in the film is to be trusted, all women who continued to apply Beauline would become, like Laurel, largely indestructible. Such a possibility seems almost Edenic in its feminist implications, yet it is rejected by both Catwoman and the general mood of the film. Finally, and perhaps most banally, there is the matter of Catwoman's costume, a get-up engineered more for a young, male audience than it is for strong women. It is a fair question to ask why Patience's newfound pride and power must be displayed sexually, as though it is only once she can get into that leather, strategically torn cat suit, grab her whip, and strut seductively around the city that she make her mark in the world. It is nearly, if not completely, a caricature.

What is most interesting about this conflicting stance toward female empowerment is that it ultimately plays second fiddle to a more pervasive cautionary tale. This tale recalls the Thompsonian "moral economy" in its critique of unfettered corporate conduct. Initially, Patience's plight stands in contravention to the idea that one's hard work is paid in kind, that the pressures of market profitability will require entrepreneurs to act in accordance with the well-being of the community. Later, Catwoman herself stands as the only safeguard in a system which would have stocked every shelf in the country, if not the world, with a grossly unsafe product overnight. Science, portrayed in the film as tainted by financial desire, is of no assistance whatever in stopping the distribution of Beauline. Judicial systems, barely aware of much of anything in the film, were similarly inadequate. Only the superhero, once again, is capable of meeting this systemic failure to keep the community safe.

Catwoman thus evokes the ethic of Thompson's "moral economy,"

an avenue of escape for its audience, who are predominantly poor work-
ing Mexicans (although in more recent times, the sport has become more
popular with the middle and upper classes). Many of the *luchadors* come
from the same areas and similar backgrounds as their audience so there
is an instant bond of recognition. Often they gain superhero status among
their young audience and become role models for poor, disenfranchised
youth. As an example, it is worth thinking about the practice of *lucha libre*
in Mexico City, where there are two venues, the intimate Arena de Mex-
ico, and the much larger Arena Coliseo, which has 17,000 seats. Both are
shabby, rundown venues in poor neighbourhoods in Centro Histórico, the
old, historical centre of Mexico City. Between them they feature wrestling
three nights a week. A sagging old building, with weeds growing from
its signage and men with shot guns guarding the ticket box, the Arena
Coliseo is situated in what is considered one of the toughest neighbour-
hoods in the city. Yet *lucha libre* is family entertainment, relatively cheap
and therefore possible, an exclusive ringside ticket costing only AU$7,
with children under 10 gaining entrance for AU30 cents.

Tourists are often warned to be careful in these areas but on a night
when *lucha libre* is taking place, the venues erupt in a circus-like, festive
atmosphere. Impromptu stalls appear outside the venues selling publicity
photos of the current, reigning champions and a selection of both adult
and child size masks. Inside the arenas, more vendors wander through
the crowds and orders are taken for food, soft drinks and alcohol, while
cigarette smoke billows through the air. The audiences are made up of
families, from grandmothers through to toddlers, young couples, fathers
and sons, and groups of youths. In the smaller Arena de Mexico, you are
very close to the action, with the *luchadors* entering the ring through the
crowd. Enclosed behind wire on the circular second story of the arena, au-
dience members stand and lean against the wire to gain a bird's eye view
of the action. The *luchadors* stand on the ropes, addressing themselves to
the upper floor and leading them in chants. On leaving the arena, the most
popular ones are mobbed by small children seeking autographs from their
heroes. The action inevitably ends up in the front rows and aisles, with the
audience and *luchadors* in constant interaction: the ring seems too small to
contain these performances.

Masks

This contemporary use of the mask is directly related to its pre-His-
panic function. Traditionally made of wood, masks are now frequently
constructed of *papier-mâché*, clay, wax, leather, latex and nylon. They are

painted and embellished with real teeth, hair, feathers and other adorn-
ments. Sometimes actual, sometimes mythic, masks have historically
depicted deities, anthropomorphic figures and animals such as tigers or
birds. Since the time of the conquistadors and the introduction of Catholi-
cism, they have also depicted the face of Christ, devils and Europeans,
often comically. Masks were and are still worn for magical, transforma-
tive purposes in dances, ceremonies and shamanistic rites. In the confines
of the ritualized performance, the mask-wearer temporarily becomes the
creative being, person or deity whose mask they wear.

The *luchadors* are often outrageously dressed in skin-hugging, day-
glo tights, with the occasional tiny bikini. Historically, most wore full face
masks, whereas now many of the younger men bare their faces. Those of
an older generation, like Santo and his wrestling buddy, the Blue Demon
(Alejandro Cruz), always wore a full face mask with zips or ties at the
back. Although Santo's silver mask is a very simple affair, now many of
the wrestlers' masks are generally brightly colored, with streaming tassels
hanging from the back. Sometimes they take the form of other beings and
animals. Like Santo's, most masks have only small, tear-drop shaped cut-
outs for the eyes, a small hole for the tip of the nose and nostrils, and a slit
for the mouth. These masks completely obscure the *luchadors'* physiog-
nomy,[4] thereby making their appearance anonymous and other worldly.
The mask becomes the symbol of the wrestler who wears it. As Michael
"Bobb" Cotter comments, "To be unmasked [is] the ultimate disgrace and
defeat, and once unmasked, a wrestler [can] never wrestle with a mask
again" (Cotter 2005, 14).

In *Aztecs: An Interpretation*, Inga Clendinnen notes that in Aztec ritu-
als, one of the ways in which the sacred is signified is through "the sudden
darkening and narrowing of vision as the mask slid down over the face"
(Clendinnen 1991, 258). However, the mask not only affects the perception
of the wearer but also the audience's perception of the wearer. What San-
to's and the other *luchadors'* full-faced masks do is they obscure their faces
and therefore their individual humanity. Literally, the mask hides the face
of the wearer and substitutes another face from myth or history. Donald
Cordry notes that Mexican Indian groups associate the face with more
than just an individual's personality: "they directly relate the face with the
soul" (Cordry 1980, 3). To cover the face with a mask is to remove the iden-
tity and soul of the wearer from the everyday: but it is also to substitute it
with a new face, soul or persona. Traditionally, the Mexican Indian used a
mask to cover their soul and transform it by assuming the identity of a god
to afford protection against, and control over, the harshness of their exist-
ence (Cordry 1980). For the *luchadors* and their contemporary Mexican au-
dience, the mask is still one of the elements that enable the alteration from

luchador to superhero or villain. Speaking of this experience, the Mr Niebla says in an article on *lucha libre* (*The Herald Mexico* March 28, 2005): "When I put on the mask and step into the ring, it changes my character and my emotions. I look out and I feel the happiness of all the people, and there's so much adrenaline... and I am somebody different." A profound transformation occurs in which the individual withdraws from the everyday and a new 'super' persona is presented. Understandably for the working poor of Mexico, a desire for protection and control over their existence is still of keen significance. Therefore, in assuming the persona of *luchador*, Santo is transformed into a super persona, an identity who through audience identification offers his audience the heroic possibility of control over their existence.

Wrestling as Ritual Drama

In her essay "Watching Wrestling/Writing Performance", Sharon Mazer provides a summation of wrestling that incorporates the work of Clifford Geertz, Umberto Eco, Victor Turner, Robert Bly, John Preston and Andrea Dworkin. Working with these thinkers' ideas, Mazer says of wrestling:

> The practice and performance of wrestling is more than "the game" — it's a "mechanism to neutralize action" (Eco), represents the "creative power of aroused masculinity" (Geertz), acts as a kind of initiation (Turner) by which men come into a man's world (Bly), and as such carries with it homoerotic implications which are at once celebratory (Preston) and assertive of patriarchal values (Dworkin) (Mazer 2002, 280-1).

These broad foundations also underpin the practice of *lucha libre*; however, there are in its presentation further elements that are specific to Mexican wrestling and its audience, especially in relation to the social and political circumstances of the performance, the wrestlers, and the spectators. The act of wrestling, the costumes, the small rectangular, roped ring, the chanting crowds, the re-enacted stories, the good/bad characters: these are all elements of a ritual performance.[5] In this context it is worth noting that Clifford Geertz has concluded in his discussion of the Balinese cockfight that just as "much of America surfaces in a ball park, on a golf link, at a race track, or around a poker table, much of Bali surfaces in a cock ring" (Geertz 1976, 656). Although more performance than sport, much of Mexico surfaces in *lucha libre*. In Geertz's description of the cockfight, he turns to the concept of "deep play" to explore its symbolic significance.

Geertz takes the notion of "deep play" from Jeremy Bentham: "By it he means play in which the stakes are so high that it is, from his utilitarian standpoint, irrational for men to engage in it at all" (Geertz 1976, 666).[6] But, as Geertz notes, men do engage with passion in these games because what is being explored is something more than material gains; it is the relations that exist between these protagonists and their world.[7] Likewise, the function of the *luchador* is not simply about earnings or winning. In "The World of Wrestling" Roland Barthes calls wrestling a "real Human Comedy." He says: "What the public want is the image of passion, not passion itself. There is no more a problem of truth in wrestling than in the theatre. In both, what is expected is the intelligible representation of moral situations which are usually private" (Barthes 1993, 22). Discussing Barthes' essay, Henry Jenkins further comments on wrestling's function as a morality play:

> Wrestling like conventional melodrama, externalizes emotion, mapping it onto the combatants' bodies and transforming their physical competition into a search for a moral order (Jenkins 1997, 48).

The *luchador's* function consists of the exact realisation of the gestures that the audience expects of the fighter; these excessive gestures are explored until there is an "outburst of their significance," which corresponds with the expression of the tragic tone of the performance (Fernández Reyes 2004, 89-90). *Lucha libre* may be seen as the most important popular theatre of Mexico. Fernández Reyes calls it a melodrama "*lúdico.*" On the surface, it is a game that appears to be about good and evil, involving basic theatrical elements like the mask, the wardrobe, and the characters who act out specifically scripted dramas within montage scenes. As with all wrestling, there is a peculiar relation between the protagonist and antagonist because they are, in actuality, accomplices. This relation is further complicated by the complicity of the audience, who know it is not real, but believe in the tumult of performance. Thus as Reyes argues, just as in the theatre, the public enter an arena and incorporate the conventions of defined rules of communication—rules that can generate a kind of "public frenzy." The public know that they are attending a performance and in this knowledge accept certain conventions. The elements of good and evil function as complementary elements (one does not exist without the other). This ritual performance has certain rules that produce a kind of intensity of feeling or frenzy in those present, while generating participation, projection and identification. The public outburst is later diffused by the function of finding justice for the *rudo* or *técnico* and therefore for

recuperating the order that encodes the "needs and demands of every spectator"(Fernández Reyes, 2004, 90).

A night at the *lucha libre* follows a series of bouts of tag team members and individuals, involving young to middle age men.[8] The action is generally recorded for television broadcast. The well scripted performance of the drama is sometimes comic, sometimes hammy, but often exhilarating. Grown men fly though the air, with an agility and fluidity that seems incongruous to their age, size or physique.[9] The referees tolerate everything except hair-pulling - for that you are slapped down. Yet it is perfectly acceptable to continue to pummel a wrestler when his face wears a "crimson mask" of blood. The final match is always between the best fighters and involves intricate holds and acrobatic stunts. Mazer has noted, for wrestlers, a "relatively large proportion of training time in the gym is spent learning and practicing ways of making openings for spectator participants" (Mazer 2002, 275). The practice of *lucha libre* is renowned for its level of audience participation. This is due to the relation of familiarity, or recognition that exists between the wrestlers and the audience, the neighbourhoods and intimate space in which the fights take place, and also that complicit understanding by the audience that they are a "character" in this exhilarating drama.

More than just a battle between good and evil, what emerges out of the background of identity and identification with the *luchadors* is also an expression of everyday circumstances and authority. As with most ritual performances, *lucha libre* permits an official transgression whereby members of the audience chant and shout what they cannot voice in 'normal' circumstances: they rebel against the repression and hardship they confront daily in their social life. In discussing the *Rocky* films, Valerie Walkerdine argues that the "fantasy of the fighter is the fantasy of a working-class male omnipotence over the forces of humiliating oppression which mutilate and break the body in manual labour" (Walkerdine, quoted in Baker and Boyd, 1997, 55).[10] A similar fantasy exists in the audience's relation to and experience of *lucha* libre. Fernández Reyes claims wives go to shout what they cannot say to their husbands; men shout what they cannot say to their bosses at work; "children yell insults that are not permitted in the house"(Fernández Reyes, 2004, 90). Therefore the wrestling match becomes a form of what Geertz terms, "imaginative realization," whereby the struggles, unresolved difficulties, and ambiguities of everyday life are acted out for the Mexican audience in a way that is exhilarating and meaningful (Geertz 1976, 671). Through identification, these rituals of wrestling empower the audience by offering them access to heroic possibilities, in which they can transform the circumstances of their everyday lives.

It is interesting to note that the passion for *lucha libre* continues and

is spreading and growing. According to the U.S. Census, of the estimated 40 million Hispanics that are in the U.S., about two-thirds of them are of Mexican descent. Just as *telenovelas* have become popular, so has *lucha libre*. Ana M. Lopez comments that U.S. Latinos recognize themselves through television melodrama and cherish "their own, crossover, star system" (Lopez 1995, 267). A similar point of recognition is now occurring with *lucha libre*. In the U.S. the *luchadors* now draw sell-out crowds, appear in commercials, and have inspired the animated children's show "*Mucha Lucha*".

Historically, many of the *luchadors* have often worn a saintly mantle due to their involvement in charity work, social justice, and politics. Super Barrio, champion of the rights of Mexico's poor, went into politics and joined the leftist PRD (Partido de la Revolucíon Democrática, All Party of the Democratic Revolution). A crowd favourite, Mr Niebla is known outside the ring for his charitable work with disabled children. In Mexico, the sport has also inspired a subculture of political activists who advocate their causes dressed in *lucha libre* garb. There is Super Ecologist, fighter for environmental causes; and Super Gay and Super Animal, masked crusaders for gay and animal rights. As a *técnico* Santo brings to the *El Santo* films this same heroic, saintly aura. He is a fighter for good, a masked figure the audience instantly recognizes. He is familiar because he is one of them but somehow he is also different: an invincible, powerful, authority figure. The audience's champion, he conquers evil and enables justice to be carried out. Yet the *El Santo* films do more than just transfer the personae of Santo to the screen, by intercutting real and staged footage of wrestling matches the films attempt to literally reproduce for the audience the ritual functions of *lucha libre*.

The Santo Films

In *Magical Reels: A History of Cinema in Latin America*, John King comments that the state funded Mexican commercial cinema of the 1950s, and continuing through the 1960s, was mainly:

> dedicated to the quick commercialization of *churros* ('quickies' named after the doughy sweetmeat, a breakfast staple)... Myriad middle-class melodramas, increasingly boring comedies from Cantinflas—whose humour had lost its cutting edge many years previously—prurient sex films which lacked the tacky dynamism of earlier 'brothel' films, copies of US adolescent rebellion films, non-rebels with a cause and without an aesthetic, series focus-

ing on masked wrestlers (starring 'El Santo'...), attempts to gloss over the quality by employing colour or costly Cinemascope--all contributed to an industry at the lowest point in its development (King 2000, 130).

Yet if you are a fan, this period is considered the era of the 'golden age' of Mexican B grade movies. Much can be said about these films in relation to the way they display facets of the anxieties, repressions and fears of a particular social and cultural milieu. The main characters are nearly always played by actors who look European, and Santo's string of girlfriends are often blondes. Mestizos and indigenous people generally play *peones*, other worldly creatures, or enact tales from their own pre-hispanic history. There are occurrences of anti-Semitism and racial stereotypes such as the dopey, easily frightened professor in *Santo en "La Venganza de la Momia"* (Santo and "The Vengeance of the Mummy," 1970); or Eric, the treasure-hungry, evil coward, who comes to an unfortunate end in *Santo y Blue Demon contra Dracula y el Hombre Lobo* (Santo and Blue Demon versus Dracula and the Wolf Man, 1972). Yet the above film is interesting in that the Wolf Man, in human form, is played by a blonde-haired, blue-eyed pretty boy. There is also a reoccurring theme of both the celebration and fear of science, modernity and new technology. However, what becomes fascinating about the *Santo* films is the way in which Santo functions as a cipher for both the ritual functions of *lucha libre* and ancient and modern myths. In fact, these films embody what Nelson Hippolyte Ortega calls a "striking example of a very strong Latin American cultural trait: the concomitant use of the old and the new, sometimes at the same time" (Ortega 1998, 80).

The *El Santo* films are similar to Mexican *telenovelas* in that although the films were made as a series, "they always have clear-cut stories with definite endings that permit narrative closure" (Lopez 1995, 256). Like the melodramatic *telenovelas*, they have a notorious "Manichean vision of the world" (Lopez 1995, 261). The films' production values are generally B grade but, as King notes, some employ colour or Cinemascope. They incorporate broad generic elements of crime, horror and fantasy genres. The stories involve classic tales of vampires, zombies, witches and wolf men such as in films like *Santo en "Atacan Las Brujas"* (Santo in "The Witches Attack, 1964), and *Santo y Blue Demon contra Los Monstruos* (Santo and Blue Demon versus The Monsters, 1969). Sometimes they lean more towards science-fiction, such as in *Santo contra La Invasion de Los Marcianos* (Santo versus The Martian Invasion, 1966). In the case of *Santo en "El Tesor De Dracula"* (Santo in "Dracula's Treasure", 1968), a time machine is used. Films like *Santo en El Museo De Cera* (Santo in The Wax Museum, 1963),

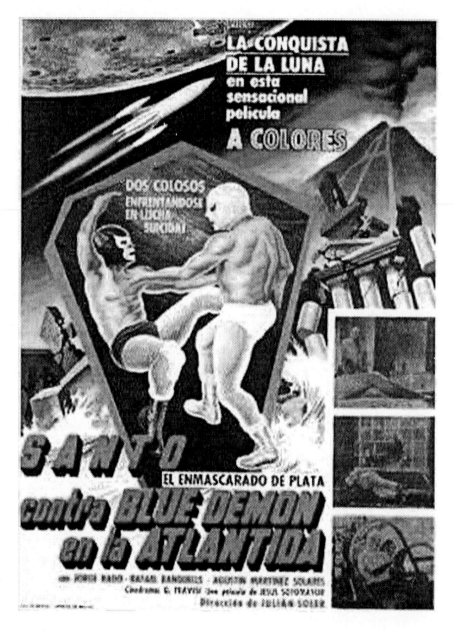

Figure 5: A poster advertising Santo's film *Santo Contra Blue Demon en la Atlantida (Santo versus the Blue Demon in Atlantis)*.

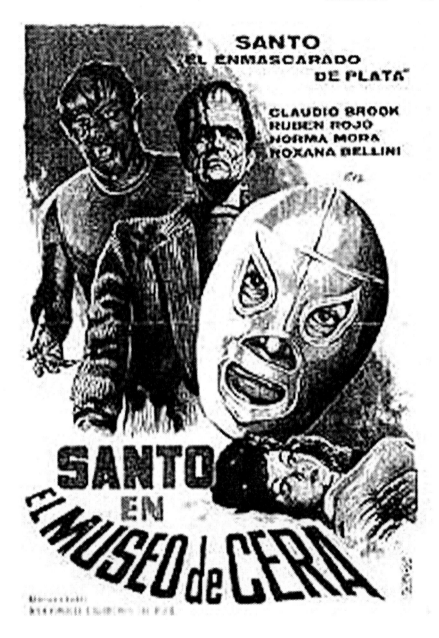

Figure 6: A poster advertising Santo's film *El Museo de Cera (House of Wax)*.

and *Santo Contra La Mafia Del Vicio* (Santo versus The Mafia of Vice, 1970), mix elements of *noir*, crime and fantasy. As well as the fantasy, horror and crime elements, many of the films are loosely based on investigations into past history and civilizations, or myths. The stories are often initiated by a mystery or an anthropological quest, such as in *Santo en "La Venganza de la Momia"* (Santo and "The Vengeance of the Mummy", 1970), in which Santo protects a group of researchers who are looking for the crypt of *"Nanoc, the great Opache Prince"*. When the crypt is found, the researchers are warned that if they disturbed it a curse will be unleashed that will result in their death. The mummy comes back from the dead and begins killing people; Santo remains sceptical until he captures the mummy and reveals that he is one of their own team members. Santo says, "See the dead don't rise. It's the evil of the living that harms our fellow man". So there is an attempt at the demystification of particular beliefs and myths.

As well as Santo being a kind of saintly, moral guide, in this film he also takes it upon himself to become an orphaned young boy's guardian or father figure. While many of the stories are fantastic, some can involve a historical or mythic figure and a familiar place. For example, *Santo en "El Tesoro de Moctezuma"* (Santo in "The Treasure of Moctezuma", 1967), *Santo contra Los Cazadores de Cabezas* (Santo versus The Headhunters, 1969), *Las Momias de Guanajuato* (The Mummies of Guanajuato, 1970), and the various films which invoke *el Día de los Muertes* (The Day of the Dead), such as *Santo en "Los Profanadores de Tumbas"* (Santo in "The Grave Robbers", 1965), and *Santo y Blue Demon en El Mundo de Los Muertos* (Santo and the Blue Demon in the World of the Dead, 1969). Yet none of these films deals with thematic elements of the wrestling genre. They are not interested in the struggles, brutality or rise and fall of Santo, or any other *luchador*. Even through in these films Santo wrestles both in and outside the ring, there is only ever minor discussion of the fact that he is a *luchad*or. The audience brings to the films a prior understanding of Santo, so there is no need for the films to establish his status. What we find is the direct transference of *lucha libre* matches into these hybrid films.

There is no attempt in these films to create an aesthetic integration between the wrestling and other generic elements. Although in real life Santo lost some of his wrestling matches, in the films he might lose a bout but he ultimately always wins. The films literally intercut large sections of recorded and sometimes staged footage of often complete *lucha libre* matches. Generally there are at least two sections of *lucha libre* that can run from seven to fifteen minutes in any of the *El Santo* films, which run between eighty to ninety-five minutes. So the wrestling matches can take approximately fifteen to thirty minutes of the reel time. Sometimes a match will open a film, sometimes conclude it, or a story will be interrupted to

allow Santo to fight. Although the film *Santo contra La Invasion de Los Marcianos* integrates the fantasy story and the wrestling, ultimately concluding with Santo fighting a Martian in the ring; there is rarely any attempt to introduce the wrestling matches or integrate them into the story other than a casual comment from Santo that he needs to retire or leave as he has a fight. The real-live footage is in particularly sharp contrast to the general B grade fantasy and crime aesthetic. It inverts the way the *lucha libre* arena functions, in which we go from the everyday into a frenzied, circus atmosphere. In the films, the wrestling footage works against the fantasy aesthetic to generate something 'real'—a kind of social realist or documentary feel that acts as a point of direct contact with the ritual performance of *lucha libre*. Furthermore, while the action is sometimes heightened by the introduction of the re-enactment of close-ups of certain stunts that the single roving camera used at the *lucha libre* has missed, the audience is often in the background. The distancing of the audience is then compensated for by cut-aways to both real and studio audiences. So the films attempt literally to reanimate the experience of *lucha libre*.

It is worth remembering that Santo continued his wrestling career along with his acting one. He is credited on all the films with his pseudonym and not by his real name. We never see him in public or in his films without his mask. In fact, in some films, we even see him sleeping in it. He is "super" in the eyes of his audience but apart from the traits of a champion wrestler–strength, fitness and agility–he has no magical or science based super-powers. However, because he always wears his mask, he is a transformed persona in the every day life is capable of creating control, yet due to his human skills, he is also an emphatic figure. For his Mexican audience, he is the same figure whether in the strange and fantastic world of the films or in the wrestling ring—a singular persona who lives in dual worlds, and never without his mask. Yet the wrestling skills he brings to the films enables him to dispose of all manner of phantasms, including mummies, zombies, evil doctors, mafia figures, lascivious witches, and even Dracula. Although in the films he is contained but charismatic, he is also an authoritative being who sometimes has the skills of an anthropologist, a politician and a scientist. He reassures the audience in regards to the increasing modernization of their world, by displaying his comfort at dealing with time machines, scientific experiments, and secret tools of communication. In the wrestling ring, he occasionally wears a cape, but in the fantasy world of the films, he generally wears casual clothes along with his ubiquitous mask. Out of the ring, his appearance is disconcerting, casual in dress but with his face hidden by his silver mask, we again have that sense of familiarity but also difference—in fact, a sense of otherworldliness. He is sometimes captured, or takes a beating, but is never really

hurt. It is with human strength that he kills superhuman and monstrous beings. He is not complex in the sense of being emotionally wounded like some superheroes, nor does he ever engage in soul searching, or interior monologues. He is simply a wrestling hero—in fact, a one dimensional figure. And it is this singular façade that enables the films to maintain the continued generation of participation, identification and projection, aroused in the audience in the *lucha libre* arena. Therefore, for the audience, Santo always remains their superhero, the famous *luchador*.

5
Homer and Rap: Epic Iconographies

Erin O'Connell

Remarkably, much of contemporary rap music possesses strong similarities with the Homeric epic poems in poetic form, content and original performance context: not only do the two poetic forms possess striking correspondences in language and image, but also in their validation and critique of the heroic model offered by both Homeric epic and rap music. A comparative analysis reveals that many contemporary rap artists fit readily into the heroic and antiheroic molds of Greek antiquity, and that many of the masculine attributes and existential dilemmas described in rap music echo those first articulated and imagined in the earliest sources for our working definitions of heroes and superheroes: Homer's ancient Greek poems, the *Iliad* and the *Odyssey*.[1] In the several millennia between the legendary stories dictated by Homer and the phenomenon of rap musical culture, the number of narrative tropes that are available for evoking or connoting one's identity has become immense, and contemporary audiences encounter an ever-increasing repository of images that echo an enormous variety of times, places, and contexts. Yet it is clear that the scope of the collective cultural memory in the west inevitably sustains certain narratives and resonant images which comprise our contemporary discursive palette.

The form and content of Homer's eighth century BCE epic poems are the standard resource from which the definition of the genre of epic poetry is constituted. Simply put, an epic poem is a verse narrative that is large in effect, characters, and setting. The epic scale of being is intended to transcend everyday life in every way. Epic poetry is understood to delineate cultural ideals, and most importantly: heroes define themselves in the course of the narrative. The ethos of masculine greatness is elaborated and modeled in the context of great struggle and eventual victory, a particular sort of victory defined by the warrior context of the heroic paradigm. Epic poetry is the earliest literary genre depicting masculine iden-

tity, especially young male identity. Surely it is no coincidence that epic poetry is also the primary literary genre of emergent nations. The social experience of the stereotypical rapper (i.e., young black male) is in step with both of these narrative arcs: we find a similar sort of struggle and victory articulated again in the lyrics of the 20th and 21st century genre of 'Gangsta' and 'Message' rap songs, as well as in the large-scale marketing of this contemporary art form. The central importance of masculine image in the epic context reappears in rap culture: how a man appears and what he possesses defines who he is; his reputation is based on other people's perceptions of his abilities and accomplishments. The words used to describe him and the stories people use to define him are all-important and worth killing and dying for.

When observing the cultural phenomenon of rap music from the erudite perspective of literary high culture, the contemporary rapper may at first seem comical with his single name, his studied fashion and costume, and his parasitical reliance upon various heroic and antiheroic poses. The shuffling between stereotypical caricatures of masculine power is protean—from Head Thug in an inner city street gang, to Mobster, Revolutionary Guerilla, Warrior, King, Philosopher, Business Mogul, Don Juan, and Dandy. But this multiple, hybrid quality, combined with the non-stop self-promotion, regular doses of incisive (if familiar) social commentary, and arresting lyrical verbosity is one of the defining features of the contemporary rap artist and rap culture.

One of the essential and more salient differences between Homeric heroes and rappers is the fact that rap artists are actual, contemporary human beings; they are not merely characters in a heroic narrative, nor can their individuality be effaced by the epic simplification that attempts to define the general identity of large populations. Rappers are living (and dead) poets, historical artists whose art includes modeling themselves (wittingly or unwittingly) on archetypal characters that hail as far back as the Homer's Bronze Age Achilles, Odysseus, Paris, Hector, or Diomedes.

In the discussion that follows we begin to trace the points of similarity between epic and rap. A brief review of the original performance, poetic form, and the narrative content of Homeric epic demonstrates clear correspondences with rap music, including the dual role of warrior and poet, the delight with self-promotion and visible displays of one's own wealth and power, and the clear ambivalence about the heroic code in the critical portrayal of experiencing the limits and constraints of the system.

Just a few of the formal conventions of Homeric epic poetry which also appear in rap are as follows: Homeric epic poetry was composed orally by poets called *aoidoi* (literally 'singers'), and was not written down and read, but memorized and sung. Homeric epic is intended to be recited

aloud. This is generally true of rap: memory and improvisation are key components of the rap artist's skill. The Homeric epic was performed not in its entirety but in long sections typically by a rhapsode, a name that literally describes the performer as 'stitcher of songs'. The rhapsode sang Homeric poetry in a kind of chant, like a rapper. The rhapsode relied only on a staff ('rhabdos') as accompaniment to beat out a simple rhythm with a big stick. Rap too is essentially a kind of music without melody, built instead around rhythm, (this is especially clear in the early years of rapping, ca. 1950s-1980s). Instead of a proper melody, as we understand it, the ancient Greek language had a special feature of its own, a fixed pitch accent on all important words. According to this fixed accentuation the rhapsode's voice had to glide upward or downward within a gamut of approximately three and a half musical tones at the most, which is the same kind of limited range one hears in everyday speech.

Similarly, the rap artist sings or speaks with a limited range of pitch intervals in straight stressed rhymed verse. Drums and other sounds provide the backbeat, a rhythm typically in a 4-beat measure. In its earliest incarnations, rap music used no actual musical instruments, but only other recorded sounds, pirated musical or percussive phrases or chord medleys called 'samples'. Homeric epic is also written with a consistent beat: its rhythm is in dactylic hexameter verse, according to which the vowel sounds are arranged in a pattern of long-short-short. This is a simple musical beat, and it is a beat you can tap out in almost every rap song.

In both poetic genres, although the poem is sung, the emphasis is on the lyric content, the quality and success of which is determined by the audience. An additional formal similarity between epic and rap is that Homeric poetry was recited at festivals to large audiences. Rhapsodes were in competition with each other, and won prizes for being the best. The "best" was determined by popular appeal, based on dramatic and lyrical ability, the most effective balance of the traditional prefabricated elements and personal style. Their performance was a blend of tradition and something fresh. The modern rapper too is in overt competition with other rappers, and describes himself as verbally and emotionally bashing his opponent with the poetic lyrics of his rap song. This contemporary performance genre represents a modern version of the ritual emasculation that has long been central to establishing identity and preeminence in the West. Rap artists routinely challenge each other to public face-offs, pay-per-view verbal battles, to let their audience determine who is best. Not only do the poetic performances enact a battle of words and wit, but also the content of the songs concerns battle. As we shall explore more fully in the discussion on content below, the atmosphere of battle suffuses the form and content of both epic and rap, and is essential to their dynamic energy.

Another formal aspect of Homeric epic poetry is the reliance upon frequent repetition of formulas, such as stock phrases and descriptive epithets (such as: "Swift-footed Achilles," "Zeus of the Wide Brows," "the wine-dark sea," and stock phrases such as: "he fell thunderously and his armor clattered upon him"). Scholars of oral poetry have determined that that in addition to the economical usefulness (in terms of the rhapsode's memory), the regular occurrence of these epithets and stock phrases is due to their metrical function: they form a metrical unit that fits the rhythmic requirements of the hexameter verse. While the epithets give grandeur and identity to the greatest warriors, and the stock phrases provide a pleasing familiarity of pattern and context, the desirability of having such metrically useful phrases is related in large part to the fact that this sort of verse was memorized and performed orally: the rhapsode had a selection of phrases with which to transition or finish out the metrical count of a poetic line. It is similar to the use of refrains and choruses in song.

Rappers too have their own descriptive epithets, for example: Grandmaster Flash, LL Cool J ('Ladies Love Cool James'), Intelligent Hoodlum, Notorious B.I.G., the Grand Verbalizer, Anybody Killa, and so on. It is standard procedure for rap artists to take on a stage name, and go by this chosen name in every aspect of their professional life, with their given names typically only mentioned parenthetically in journalistic contexts. As with the epithets which often accompany the names of the Homeric warriors, the rappers' chosen names typically define features of their appearance or powers. For the rappers, with the stage name comes a persona that is characterized and defined by their lyrics that are always self-composed.

Another formal corollary of rap to the Homeric formulas and stock phrases are the 'samples' of musical phrases and drum beats that are pirated from other, often well-known songs to satisfy the rhythmic expectations set up by the song. Historically, much of Rap music has relied on the repeated samples not only to satisfy the metrical conditions of the song, but also to add to the substance of its sound and meaning. Typical rap audiences easily recognize these samples of sound, music, and beats as part of their cultural tradition. These too, like the stock phrases in Homer, provide a pleasing familiarity of pattern and context. In rap samples, the familiarity of riffs and rhythms from funk and soul music functions as a kind of code, and carries with it the power of black collective memory (Rose 1994, 138). In the *political* rap genre, such sampling often takes the form of parts of speeches from Martin Luther King, Malcolm X, the sound of police sirens, voices of policemen, gunfire, and other cultural touchstones and riffs. Clearly, such formulas are not only useful to the rapper in the rapid composition of his tale, inasmuch as they tie his composition

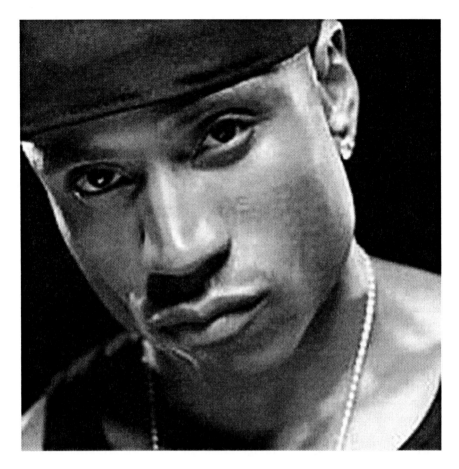

Figure 7: James Todd Smith, the American hip hop artist better known as LL Cool J (Ladies Love Cool James).

together, but they also function just as importantly as resonant elements of the song's content.

We discover yet another extension of a sort of sampling in the massive body of photographs and illustrations that accompany the marketing of rap and its rappers. On album covers and in advertising images, the power and threat of aggressive violence is portrayed by reference to other familiar contexts. Rappers present themselves not only as inner city gang members or military warriors with guns, bullet proof vests and other fighting gear, but they also model themselves in word and image after the Mafia, the Roman gladiator, comic book Superheroes, royalty—anything denoting

power, importance, and often, conspicuous wealth. A heavy reliance upon portraiture and caricature floods the marketing and media coverage of rap culture with images of the faces and bodies of the rappers, almost always looking serious, if not exceedingly hostile. A type of portrait frequently encountered on album covers and in magazines devoted to covering and advertising rap music shows the rappers with a thuggish sneer, or an angry brooding expression. The very successful rapper Tupac Shakur was often 'giving the finger' (i.e., the middle finger) in photographs, revealing the large 'Thug Life' tattoo on his chest, or giving other gangsta hand signs which indicated hostile intent, (e.g. the hand sign for 'war').

This kind of iconography relates to another formal element of both genres: the narrative convention of starting *in medias res* 'in the middle of things'. Both the rhapsode and the rapper assume that the audience already knows the story, that it is a familiar story, and the retelling of it makes no unexpected changes. Beginning in the middle of things is not confusing because the audience is familiar with the setting, and has a pretty good idea of how the story will end, as well. As with many a Gangsta or Message rap song, if one is not familiar with the particular social and cultural scope of references, some of which can be quite obscure, the lyrical content can be confusing, but when one knows the context, the poetry is more engaging and meaningful. This pertains as well to the photographs and other illustrations, which make up part of the discursive world of rap culture.

This very brief summary suffices to make clear that in terms of form and performance, whether we are examining the *Iliad,* the *Odyssey,* Gangsta or Message rap, we have before us a well-attended public festival in which a performer stands before the crowd. With nothing but a strong back beat this performer entertains the crowd by rhythmically reciting a familiar tale of righteously vengeful warriors struggling for supremacy in battle. Mixed in with this nearly relentless verbal dueling and description of bloody violence is the possibility of triumph, the acquisition of heaps of material wealth, desirable women, and most importantly, undying fame, all this vividly described in a sonically impressive, lyrically memorable oral performance.

Just as striking is the similarity between the two genres in terms of thematic subject and content, especially given the vast span of historical time between them, and the considerably different socio-cultural contexts from which they arise. The *Iliad* tells the story of the Trojan War, a war between the Greeks and their neighbors across the sea, the Trojans. The *Iliad* uses the story of the hero Achilles as a means of structuring and focusing its portrait of the war. Additionally, one of the aims of the poem is to portray the sheer number of people whose lives are decisively affected by the

war. The first lines of the poem set up the subject and world of the song, especially the notion of rage:

> Sing, Goddess, Achilles' rage,
> Black and numerous, that cost the Greeks
> Incalculable pain, pitched countless souls
> Of heroes into Hades' dark,
> And left their bodies to rot as feasts
> For dogs and birds, as Zeus' will was done.
> (*Iliad,* Book 1, l.1-10, tr. Lombardo, 1)

We detect a similar theme in the lines from a contemporary rap song (itself an adaptation of someone else's earlier song of the same title):

> This here's a ballad for all the fallen soldiers
> I'm about to show you how a hustler's life
> (this is life, man) and a soldier's life parallel.
> And the one thing they got in common is pain.
>
> Picture split screen:
> On one side we got a hustler getting ready for the block (human beings);
> Other side you got the soldier getting ready for boot camp (soldiers) -
> They're both at war (this is life).
> Stay with us....
> ("A Ballad for the Fallen Soldier," *The Blueprint 2: The Gift and the Curse,* Rap Artist: Jay-Z)

Both Homeric epic and Gangsta or Message rap artists represent existence as a constant struggle: beat or be beaten. In the *Iliad,* the subject is war and the experience of the warriors (literally called 'heroes' in Homer's Greek), and the subject is also the question of agency, blame, and inevitability concerning this painful destruction. Although the poem treats the subject of the conflict between the two sides, its primary plot focuses on the internecine conflict between two Greek warriors: the half divine Achilles is outraged by the dishonor he has received from Agamemnon, the leader of the Greek forces, who has rescinded his war prize, a young woman who has been given to Achilles as his portion of honor, granted to him by vote of the troops. Although arguments are made that Agamemnon must be obeyed, due to his preeminent rank, the poem clearly characterizes Agamemnon's behavior as an outrageous betrayal of the shared

expectations and values of right behavior, and as lacking the proper com-
munal spirit of a leader. The critical response of the Greek warriors to
Agamemnon's decision makes the community's sense of his guilt emphat-
ically clear, and legitimizes Achilles' wrath. Indeed, the first word of the
poem is *mênis,* meaning 'anger' or 'wrath'. The opening of the poem makes
it clear that the central thematic subject of the poem will be the particu-
lar anger of Achilles. His wrath will steer the plot structure by which the
heroic paradigm is illuminated. The epic scope of the poem implies that
despite his uniqueness, the experience of Achilles is universally relevant
to an understanding of male human beings and the patriarchal cultures in
which they live.

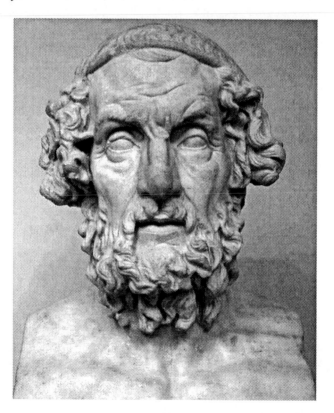

Figure 8: A marble portrait bust of Homer. Roman, 1st-2nd century AD
from Baiae, Italy.

In Homeric literature heroes define themselves both by their actions and by their words. The poem makes clear that the ideal hero is not only supreme in battle, but also effective in speech at the very least in order to illustrate his own excellence and superiority over others. Verbal duels are honorable substitutes for physical battle, both are competitive, both have a winner and a loser. In fact, nearly half of the *Iliad* is composed of direct speech; the greatest heroes perform the greatest speeches, and the most speeches. The speeches are characterized by their dual function of defining the speaker and attacking the opponent. In the case of Achilles, it is his anger that causes him to go to enormous lengths in order to confirm his own identity and to make sure his point of view is understood. His first speeches express his anger in the form of diatribes against Agamemnon: he verbally attacks and belittles him with derogatory terms. The unspoken fact of his superior fighting prowess adds mightily to the threat.

> "You bloated drunk,
> With a dog's eyes and a rabbit's heart!
> You've never had the guts to buckle on armor in battle
> Or come out with the best fighting Greeks
> On any campaign! Afraid to look Death in the eye,
> Agamemnon? It's far more profitable
> To hang back in the army's rear isn't it?
> Confiscating prizes from any Greek who talks back
> And bleeding your people dry.
> (*Iliad*, Book 1, l. 236)

When Achilles withdraws his support for the war his absence not only means a lengthier and more deadly battle for the Greek warriors, it also signals a radical rejection and subversion of the central heroic values of his culture by the very individual who is most capable of performing them. In the *Iliad*, the Homeric cultural ideals are articulated in the face of their disruption. Achilles' rejection of the heroic code is seen most clearly when he articulates the futility of the heroic values and the current violence in his response to his mentor and peers who are pleading with him to return to the war against the Trojans:

> So this is how I see it.
>
> It doesn't matter if you stay in camp or fight —
> In the end, everybody comes out the same.
> Coward and hero get the same reward;
> You die whether you slack off or work.

And what do I have for all my suffering?
Constantly putting my life on the line?
....
Why do the Greeks have to fight the Trojans?
Why did Agamemnon lead the army to Troy
If not for the sake of fair-haired Helen?
Do you have to be descended from Atreus
To love your mate?
(*Iliad,* Book 9, l. 319-329; 345-349; 168)

Along with the focus on self-definition we find in both Homer and rap a distinct and emphatic desire for a witness to conflict and masculine aggression. Just as the word "I" is central to the discourses of Achilles, so too is it a powerful word in the vocabulary of the African-American male. A powerful autobiographical impulse characterizes the most important African-American male narratives of the 20th century; there is clearly an enormous effort and pleasure in getting others to see things through his eyes. For example we hear the words: "I, me, mine" occurring several hundred times in *Straight Outta Compton,* a very successful rap album by a group called N.W.A. (an acronym for "Niggaz With Attitude"). More generally, the equivalent of verbal battle, or cutting someone down is a major feature of the rap tradition and goes by various names. In rap we hear a boasting type of speech rife with bravado and self-promotion as it tells tales which are limited to a handful of themes also found in the Homeric frame of reference: the superior status and skills of the rapper, the lameness of his opponents in both physical and verbal battle, how troublesome women are, how good it is to be 'paid'—both in the form of money and fame—for rapping instead of stealing or dealing drugs. For the contemporary rapper, sex and violence and material wealth represent perfectly the drive for modern American glory. But it also becomes evident that the lyrics and media images of much Gangsta rap music also echo the Homeric desire for legendary fame, a glorious reputation, and plunder—which includes the possession of women as physical evidence of your excellence. Political, or Message Rap typically diminishes the machismo and overt sexism and focuses on an explicit critique of the American society that makes it so difficult for African-Americans, or the poor, to achieve these things. In both epic and rap arrogant male pride is an attitude and a weapon. In neither context is pride or the public display of masculinity perceived as a bad thing. Rather, it is essential to survival and success in hostile territory.

Because the heroes of epic live and act within a fighting ethos, their activity is highly competitive and personal. A warrior is either glorious or

shameful. As in rap music, the driving force for the hero is 'honor,' and an intense preoccupation with his status, or reputation, in the eyes of other people. In the *Iliad*, dying courageously in battle at the height of manhood endows the warrior with the kind of qualities and honors for which the élite compete throughout their lives. A glorious, or beautiful death guarantees fame to a man who has given his life and refused to be dishonored in battle, or to be shamed as a coward. For all time to come, a courageous death raises the dead warrior to a state of glory, and the reputation that surrounds his name is the ultimate reward that represents his greatest accomplishment. Excellence is attained all at once and forever after in the very deed that puts an end to the hero's life. Hector's behavior in Book 6 demonstrates the Homeric ethic that there is no complete manhood without war. After his wife Andromache has spoken of how she fears that she is sure to be left a widow, and their child an orphan due to Hector's certain death in battle, Hector's reply to her reveals the egotistical and patriarchal nature of his values.

> "Yes, Andromache, I worry about all this myself,
> But my shame before the Trojans and their wives,
> With their long robes trailing, would be too terrible
> If I hung back from battle like a coward.
> And my heart won't let me. I have learned to be
> One of the best, to fight in Troy's first ranks,
> Defending my father's honor and my own.
> ….
> And someone, seeing your crying, will say
> 'That is the wife of Hector, the best of all
> The Trojans when they fought around Ilion."
> (*Iliad*, Book 6, l.463-9, 483-5; 125)

Hector is thought to be a most excellent and heroic warrior when he willingly faces his executioner - yet his death is also tragic because, as the poem makes clear, he fails to protect his family and kingdom. Hector is caught between two absolute but absolutely irreconcilable duties as warrior and as family man. Rap artist LL Cool J echoes these words of Hector and includes himself in the ranks of great mythic heroes when he said in an interview:

> I'm working real hard, striving to be a legend. You know what I want? I want the media, MTV, radio stations, everybody to give me a clear lane so that I can do this. I guarantee you that in five years I will have accomplished an incredible feat. I'll make sure

the kids get a positive message; I'll never promote anything that's negative. I want to show people what I'm capable of and what this music is capable of. I want my music to cultivate and stimulate some sort of spirituality. I just want my airtime. To show the world who I am: ...the seed of David. A person who's the rightful heir to Solomon's knowledge.... The world will never see such a display of power after my career is over. I'm gonna sandblast the universe. I've wanted to rap since I was nine years old. Since I was a little boy, running around in my Superman pajamas with a towel hanging out the back of my shirt." (LL Cool J, 1991)

One of the most compelling similarities between the two genres is that in the *Iliad* as well as Gangsta and Message rap the delight in the warrior life and the critique of the warrior life go hand in hand. The ambivalence is clear, if often subtle, and it is unresolved. The choice to privilege the terms demanded by the heroic code has, of course, its price, and Homer and many rappers consistently make a point of this. On the one hand, for example, Hector is an admirable and sympathetic hero. He has many great moments of excellence throughout the long battle. And yet on the other hand, on several occasions, Homer undercuts the greatness of his prowess, as well as the price of the warrior life in general. This note of critique and ambivalence can be heard throughout the *Iliad,* most emphatically in the story of Achilles, a particularly apt model for the stereotypical rapper who is part thug and part political rebel. As is the case with the critical reception of many rappers, the immense size of the indignant rage of Achilles may seem more egotistical than divine and absurdly out of proportion to its cause, and the poem raises the question of whether Achilles is too mad for too long. A considerable portion of rap audiences and rappers has also questioned the legitimacy of the violence valorized in gangsta rap. For example, the lyrics of DMX (a.k.a. Earl Simmons, the 'crew leader' of the Ruff Ryders) reveal the desperate conflict and moral quandary he feels in being a hardcore thug. In a series of songs from his 2000 album " ... And Then There Was X" he wavers within a number of songs between sadistic celebration of his thuggery and remorse about it. His remorse is sometimes overt, and sometimes merely the self-evident implication of his exhaustion at the unfortunate results of his trade, such as when he tells the tale of killing a protégé who has betrayed him ("Here We Go Again").

There is also a subgenre of rap songs that are wholly focused on mourning the inevitable death of many 'gangstas'. One standard in this genre is Ice Cube's "Dead Homiez" a pure lament that critiques the results of gang violence and exhorts his audience to more thoughtfulness about the problem. The song echoes several moments from the *Iliad* (e.g., funeral

rituals, mothers, fathers and comrades mourning the dead young man, the wisdom of self-restraint, preference for life over possessions), and also resonates with ancient Greek mourning rituals in its description of pouring a libation in honor of the dead.

> Up early in the morning dressed in black
> Don't ask why 'cause I'm down in a suit and tie.
> They killed a homey that I went to school with,
> I tell you life ain't shit to fool with.
> I still hear the screams from his mother
> While my nigger lays dead in the gutter.
>
> He got a lot of flowers and a big wreath,
> What good is that when you're six feet deep?
> I look at this shit, and gotta think to myself,
> I thank God for my health,
> Because nobody really ever knows
> When it's gonna be their family on the front row.
> So I take everything slow, go with the flow,
> Shut my motherfucking mouth when I don't know.
> 'Cause that's what Pops told me
> But I wish he could have said it to my dead homey.
> I remember we painted our names on the wall for fun,
> Now it's Rest In Peace after every one
> Except me....
> It seems I'm viewing a body every other month.
> Plus I knew him when he was yay big,
> Poured beer on the curb, before I'd take a swig.
> ...
> They say be strong and you're trying,
> How strong can you be when you see your pop's crying?
> But that's why Ice Cube's dressed up
> Because the city is so fucking messed up.
> And everybody's so phony, take a little time
> To think about your dead homey.
> ("Dead Homiez," Ice Cube, *Kill at Will*, 1990)

While there are numerous examples of lyrics that deromanticize violence and express regret, they are regularly interspersed with the joyful valorization of hardcore violence. A third element that helps explain the uneasy coexistence of these two discursive threads are the lyrics that expose and rationalize thuggish behavior and gang violence as a response to

specific oppressive social conditions. The brutal realities of the inner city gang life with its drug dealing, pimping and murderous violence has its origins in the socio-economic conditions of racism, police brutality, unemployment, poverty and the introduction of cheap and potent drugs (especially crack cocaine).

In the Homeric context, the *Iliad* makes clear that because Achilles is fated to an early death, every insult to his social honor is equally intolerable and unforgivable. He has no use for apologies and gifts, because there is no possible compensation. He can never be "paid in full." In his eyes, an insult to Achilles can only be repaid with the complete and utter humiliation of the guilty party. As with the rhetorical (and often actual) position of the gangsta rapper, the refusal of Achilles to obey the cultural codes stems in part from what is perceived as an irredeemable injury to his honor.

Clearly the mix of valorization and critique is characteristic of both genres, and in both the critique exposes the high costs of the heroic paradigm. The *Iliad* as a whole magnifies the great loss of life, the lost potential of young warriors, and the deep sorrow and mourning brought about by the demands of the heroic code. Yet in both Homeric epic and rap the real sorrow and regret about the cost of living the heroic paradigm is undercut by a certain fetishization of the dead and the threat of inevitable death. Clearly there is some sort of pleasure in vicariously experiencing the violent killing and dying of warrior after warrior in epic and rap poetry. The poetic care and craft in the repeated descriptions of such scenes is persuasive evidence for this. Numerous portrayals of rappers show them in the pose of the dead or the sacrificial.

In conclusion, we note the ways in which popular culture's rap lyrics allow us to see how human beings of all stripes continue to discover for themselves the limits of the dominant social paradigms. The old trope that 'those who ignore history are doomed to repeat it' is again found true. Many of those who live the model, whether on the winning side or losing side, inevitably stumble across the sort of perceptive insight that exposes the weak points, the costs and losses required by the system, which has the critical effect of throwing the dominant model into question. These insights typically focus on the complex problem of justice and injustice, the uneven distribution of power, and the inequalities that result in the pursuit of dominance.

Monitoring this trend of exemplary and ambiguous portrayals of the heroic paradigm in the context of rap culture shows an old familiar pattern: 'heroes' die young by violence or hubris, or they simply disappear from the horizon by no longer participating in the heroic ethos. The audience loses interest when this latter plot development occurs. What does it mean that the rapper Paris no longer raps but now spends his days working

the stock market? Has LL Cool J lost his edge because he preaches fiscal responsibility? Why are there no canonical stories about the post-war years of Menelaos, or the post-wandering years of Odysseus? Whither Diomedes?

In terms of the evolution of the hero's narrative arc, it becomes clear that a sort of creative inertia sets in when the violence fades. What would movement towards a more viable heroic model look like? Could it achieve a happy marriage with the demands of narrative interest? We can only wait and watch, or participate in the creative artistic output of artists to see how the classic tropes of heroic masculinity repeat and revise.

6
Men of Darkness

C.J. Mackie

This chapter is concerned with four different heroes: two from antiquity, whom we usually think of as 'Homeric' heroes (even if the ancient sources for them are quite diverse), and two contemporary superheroes. As far as antiquity is concerned, our main focus of attention will be Achilles, the hero of Homer's *Iliad*, and Odysseus, who gives his name to the *Odyssey*, the other epic attributed to Homer. These two individuals are our earliest extant Greek epic heroes (ie. with actual surviving poems devoted to them), although the Greeks told narratives about a whole range of other heroes who perform a wide variety of individual feats. There were almost certainly pre-Homeric epics about some of these other heroes, like Heracles and Jason, but these poems have not survived (Kullmann 1956, 25-35; and Meuli, 1974). As far as contemporary superheroes are concerned, our focus of attention will be Superman and Batman, who can also be thought of as the first and pre-eminent superheroes to emerge in the new 1930s comic book genre. The four individuals, therefore, on whom we will be focusing, ancient and modern, are central to the commencement of a literary and cultural tradition, which they then proceed to dominate.

Our first task in this chapter is to explore some of the fundamentals of Greek hero myths, and some of the parallels and resemblances between the ancient and the modern, be they conscious or unconscious responses to antiquity. There is no particular case made in the following pages that Superman and Batman are created with Achilles and Odysseus consciously in mind. The influences on the creation of the earliest superheroes are diverse, and they resist the simple equation with specific Greek heroes (indeed Superman's creation has been seen as a conscious response to the rise of Nazi Germany, Boichel 1991, 4ff.). Rather, the central argument in this chapter is that we can identify a similar 'rivalry' between the two contemporary superheroes that we also find in the ancient epic context. A comparable pattern seems to exist in which (super)heroism moves from the transcendental to the human, from the almost invulnerable, otherworldly

kind of figure, to the very human man of darkness and courage. Odysseus in the *Odyssey* seems to respond to Achilles in the *Iliad*, just as Batman's particular brand of heroism throws out a new and direct challenge to the already established figure of Superman.

Before we take up this argument it is worth being clear about some of the fundamentals that link the four together. Most scholars tend to think of the *Iliad* as pre-dating the *Odyssey* by a generation or so, although the dates of the two poems, and the manner of their composition, are far from certain. Indeed the authorship and emergence of the *Iliad* and *Odyssey* (the 'Homeric question') are as contentious now as they have ever been (on this subject, Turner 1997). The *Iliad* certainly has a very 'archaic' character to it, and is eastward-focused, whereas the *Odyssey* seems to reveal a more 'modern' social context that is focused towards the western Mediterranean. The probable order of the two poems in antiquity has its parallel in the emergence of the two comic-book superheroes in the late 1930s, first Superman in 1938, and then Batman in 1939. The period of a generation or so in the case of the Homeric poems (twenty or thirty years?) is obviously a lot longer than the one year between Superman and Batman; but it is worth making the point that comic-book conventions in contemporary mass culture become familiar and are stabilized much faster than the likely processes of epic dissemination in archaic Greece (for an overview of the superhero genre, see Peter Coogan's chapter in this volume).

It is also significant that the 'earlier' heroes in the two couplets, Achilles and Superman, have otherworldly origins through important parenting and birth narratives, whereas the latter two are both 'ordinary' men. A fundamental aspect of the myth of Achilles throughout antiquity is the divinity of his mother Thetis. She is a Nereid, a sea-nymph, who is pushed by Zeus into a marriage with Peleus, a local (mortal) Thessalian king. The product of the marriage is an only child, Achilles, who is brought up by the Centaur Chiron after the separation of Peleus and Thetis. In Homer's *Iliad*, Achilles is a doomed mortal who must go to Hades after his death like everybody else (9.410ff.,18.98-126, etc.). Having a goddess for a mother brings him some benefit on the field of battle (such as his immortal armor and his immortal horses), but it will not save him from ending up in the Underworld (which is where he resides in the *Odyssey*, 11.465ff.). So a fundamental distinction between mother and son is emphasized: the immortal goddess has a doomed son, and she faces the prospect of mourning his death forever. This explains the fact that in the *Iliad* Thetis and Achilles have not really undergone the usual rites of passage separation of mother and son. Their separation will take place at his death, rather than on his transition into manhood. It is little wonder that later post-Homeric versions of Thetis and Achilles describe her many attempts to stave off his

death, and his descent into Hades, such as her dipping of his body in the river Styx (on which see Mackie 1998).

The *Odyssey* is much less interested in such notions of birth, fate, and the different conditions of existence of the mother and her son. Odysseus is a child of two mortal parents, Laertes and Anticleia, who are both important background figures in the poem. Laertes is a kind of long-suffering survivor of his son's twenty-year absence from Ithaca. In the wake of the invasion of the royal palace of Odysseus by 108 greedy suitors of Penelope, Laertes lives on an isolated farmstead away from all the trouble. Anticleia however, has succumbed to the grief and anxiety brought about by her son's long absence. She dies while he is away, and, much to his horror, Odysseus sees her shade in Hades when he pays a visit there on his journey home (11.150ff.). Thus both Homeric poems emphasize the longevity of the fathers of the two heroes, whereas the fates of the two long-suffering mothers are very different. The *Iliad*'s Thetis will live forever, albeit bereaved of her short-lived son, whereas in the *Odyssey* it is Anticleia's death and transition to Hades that is emphasized. There is an implicit sense in the *Odyssey* that Odysseus and his mother can be re-united in death, but that will not be the case with Achilles and Thetis.

As it turns out, immortality is offered to Odysseus (in a very un-Iliadic way), by the beautiful goddess Calypso (5.135ff. etc.), but Odysseus thrives in a world where people get old and die. Despite all the attractions of Calypso and her island, Odysseus opts for the mortal world: home, family, old age and death. The point is that in our two Homeric epics much is made of the different ontological status of the mothers of the two heroes, and this has its impact on the type of heroism that they evince. The superhuman background and power of Achilles allow him to dominate and even transform the heroic landscape in the bright light of day on the battlefield at Troy (*Iliad* Books 20-22). In the *Odyssey* however Odysseus performs his most brilliant heroic acts in the shadows and in the darkness. He seems to have a kind of 'light within' which allows him special sight and special powers in the dark confines of enclosed spaces in situations of utter terror. By day he is politically astute, and depends for his power and his survival on his capacity to say the right thing at the right time. But in the darkness he is a brilliant and ruthless agent of destruction who outsmarts and out dares his many adversaries.

A similar kind of dichotomy operates in the case of the two superheroes. Superman's extraordinary powers, like those of Achilles, are fundamentally connected to his otherworldly birth and background. His original name is Kal-El, which is given to him when he is born on the planet Krypton (for an overview, Reynolds 1992, 60-66). His father Jor-El sends him to earth just before Krypton explodes. The rocket carrying him lands

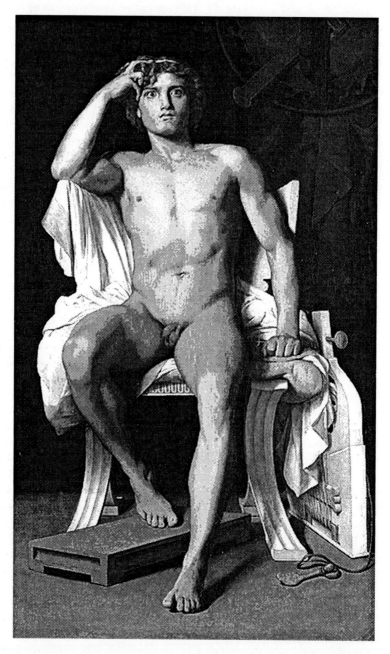

Figure 9: Achilles in the The Wrath of Achilles, by François-Léon Benouville (1821-1859) © Musée Fabre.

near Smallville where he is now called Clark Kent by his adopted parents, Jonathan and Martha Kent. The notion of the crucial role of the foster-parent in the upbringing of the child (Chiron/the Kents) is a significant part of the narratives of Achilles and Superman. Likewise they both grow up in fairly rural or remote parts of their respective countries. Achilles grows up in comparative obscurity in Thessaly in north-central Greece. He is really an outsider in the Greek army at Troy, which (in terms of wealth, numbers and power) is dominated by the southern Mycenaean princes like Agamemnon, Diomedes and Idomeneus. There is a sense in the *Iliad* that Achilles' very different temperament from the other Greek princes at Troy is partly explained by his 'northern' origins. In the early DC Superman comics Smallville was just a fictional town that was quite distinct in its size from Metropolis where he leads his working life; but it later acquires a more recognizable obscurity in rural Kansas or Maryland.

In the cases of both Achilles and Superman therefore an otherworldly family background, and a rather rustic, earthly, upbringing provide the basis for their renown in an entirely different kind of world. Achilles comes to dominate - in a spectacular way - the battlefield at Troy, which is populated by gods and men (see, for instance, Book 20.1ff.). In the *Iliad* the whole world seems to be focused on the war at Troy; and so Achilles is pre-eminent in a struggle between two countries in which the Olympian gods, and other great heroes, have an active involvement. Superman's special powers enable him to overcome all of the threats and dangers to the city of Metropolis in which he lives and works. In contrast to both of these individuals, with their special powers of transcendence, Odysseus and Batman must rely on more intuitive abilities to outwit their enemies. Neither can rely on special powers conferred on them at birth. Batman is a child of well-to-do pillars of the society of Gotham city. There is nothing otherworldly or immortal about his mother and father. In fact, as we shall see, the deaths of his parents lead ultimately to the 'birth' of Batman. By day Batman is Bruce Wayne, a rich and respectable member of the society of Gotham City but at night he offers us a very different persona. As a human bat he belongs to, and virtually 'owns', the night. This is when he operates, and this is what gives him the upper hand. The villains that he encounters fear him more in the dark. He therefore gives his enemies a taste of what they dish out to the good citizens of Gotham City.

In view of the importance of darkness in the many comic and cinematic narratives of Batman, I begin with a few words about darkness and night in Greek myth. The notion of immersion in darkness is a kind of initiatory rites of passage motif that finds its way into many different heroic narratives (Van Gennep 1977). In these kinds of narratives it is typical for the young man (he usually is young, and it usually is a man) to be separated from the

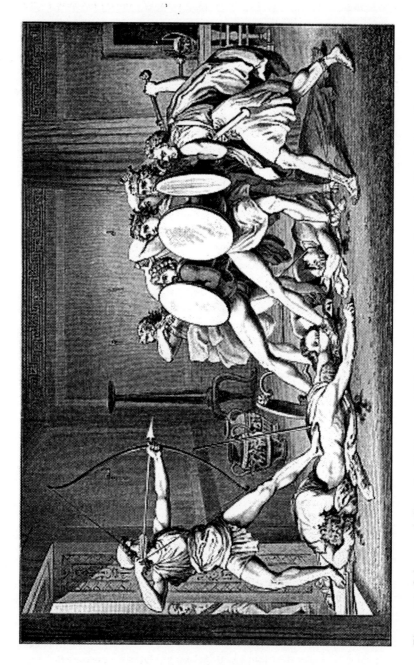

Figure 10: Odysseus killing the Suitors, published in Gustav Schwab, *Sagen des Klassischen Altertums* (1882).

world in a confined and total darkness. In many of these encounters the hero is enveloped in a kind of primordial blackness, not just night (Eliade, 1965). There are no lights and stars and fires to show the way, none of the familiar sights and sounds. Immersion in a kind of total blackness is really a living encounter with death. The classic narrative in the Greek tradition is Theseus' descent into the Labyrinth to confront the Minotaur – half-man half-bull; but there are many variants of this narrative. One account in the *Iliad* is the old king Priam's descent to Achilles in Book 24 to plead for the body of his son Hector. This particular narrative has much in common with other Greek quest narratives: Heracles' descent to the Underworld to bring back Cerberus; Jason's descent into a monster's belly to cut out its tongue; and Perseus' quest to the lair of the gorgon Medusa in the dark west—the setting of the sun—to chop off her head.

All of these individuals, including Priam, belong to the earlier generations of heroes – the generations before the warriors who fight in the Trojan War itself (like Achilles and Ajax and Hector). It may be said that confronting monsters, or confronting the darkness of the unknown where the monsters often reside, is a defining quality of narratives of the earlier pre-Trojan War generations of heroes. It is significant in this context that one later generation individual who really thrives in darkness in a rather similar way is Homer's figure of Odysseus in the *Odyssey*. And this appears to involve a direct rivalry with Achilles. As we have seen, the best evidence suggests that the *Iliad* was composed a bit before the *Odyssey*, although how long before, and what form this took, is far from certain (for an introduction to many of the issues, Powell 2004). Early Greek epic poetry seems to have been very competitive or 'agonistic'. That is, the poems themselves, and the heroes in them, seem to have been offered up as rivals to earlier poems and other heroic traditions. Richard Martin argues that the *Iliad*, and its hero Achilles, compete with earlier Heraclean epic poetry (1989, 228-30). Such competition may simply be an early manifestation of the Greek penchant for poetic rivalry, one that finds a more formal context later in the dramatic festivals of classical Athens. Or it may be driven by numerous changes in social attitudes through time, and the need for new epic poets to acquire renown by competing with earlier poets and their work. If Martin is right, Homer's Achilles is a kind of un-Heraclean rival to a flourishing epic tradition which had Heracles as the central figure. In the case of the two Homeric poems, it is quite feasible that Odysseus, and the *Odyssey* itself, mount a challenge to Achilles and the *Iliad* (a subject well discussed by Nagy 1979). This does not mean that the two poems are necessarily by different poets, although they may be (the authorship of the *Iliad* and *Odyssey* is a major scholarly question). An artistic challenge can be made by one poem to another, even if they are by the same poet.

Odysseus of course is not 'created' for the *Odyssey* in the same sort of way that Batman is 'created' at a clearly defined time in a new comic title. For instance, Odysseus appears earlier in the *Iliad*, and he presumably goes right back into pre-Homeric epic verse, perhaps centuries before our first extant texts. What we can say is that Odysseus' character and temperament *in the Odyssey itself* are inevitably shaped and constructed with that particular text in mind (and any other texts with which it 'competes'). The nature of the response of the *Odyssey* to the *Iliad* seems to be a kind of ancient parallel to the way that Batman's first appearance is a conscious response to Superman, who first appeared the year before. After the successful creation of Superman by Jerry Siegel and Joe Shuster in June 1938, Bob Kane and Bill Finger were under pressure from their editor at DC Comics to come up with a suitable response (on the creation of Batman, see Boichel 1991, 4ff.). The response was the creation of Batman - a distinct move away from a figure who had an otherworldly parentage and an extra-terrestrial background (Uricchio and Pearson 1991, 182-213). Batman is, or was, a new kind of hero in 1939, just as Odysseus in the *Odyssey* seems to offer up a challenge to the domination of superhuman heroic activity (especially Achilles and Heracles).

In contrast to Odysseus, the Achilles figure of the *Iliad*, might be described as a kind of dark and brooding creature. He is a figure of demonic and fundamental violence, one who is associated in Homer's text with monsters, and with gods of the Underworld like Hades and the Furies. Because he is a hero who is doomed to an early death - and he knows it - darkness is a kind of way of life for Homer's Achilles. But, despite this, he is almost unique among early epic heroes in that he does not fight a monster, and he does not go to the Underworld as a living man. It is really quite significant that his heroic exploits, like most of Superman's (especially when compared with Batman), are performed solely in the bright light of day on the battlefield. Being seen is very important to Achilles. He desires the kind of immortality that comes from being talked about (the Greek *kleos aphthiton*, 'immortal renown'), and so the more visibly heroic he is to everyone around him, the better. Heroic conduct where no one can see him is scarcely worth the effort. Homer's Achilles is fundamentally associated with Olympian fire; and at one point in the *Iliad* he is completely immersed in the blazing fire of the river Scamander at Troy sent by the blacksmith god Hephaestus (21.324ff.). Achilles is such a bright and terrifying figure in the full glare of his Olympian armour that his main Trojan opponent Hector turns and bolts at the very sight of him (22.131ff.).

Just as Achilles is the outsider, the doomed man of transcendent strength and power, who shines in the bright light of day, so Superman's fundamental powers entirely transcend the ordinary human existence.

And it is this aspect that so emphatically distinguishes him from Batman. Magical flight is obviously not available to Batman because he is not born with such a capacity. Superman can fly to the scene of the crime in an instant, and every time he does so the nature of his existence is reiterated in an important way. He has no wings; but he has no need of any. And so the iconography of him is not bird-like, or bound up in signifiers of flight (apart perhaps from his cloak which tends to give some emphasis to his flight). But Batman has to use other means to win the day. He is a bat who cannot fly (not usually in the early comics anyway). His appearance as a human bat suggests the capacity to fly, but the reality is quite different. He depends on intellect and ingenuity to fly by other means. In the earliest comics, and indeed in many later manifestations, he is suspended from the landscape in which he operates by the skilful use of the baterang or the batgyro or the batplane and batropes (eg. *Batman versus the Vampire* DC Comics #31 and 32, 1939). Death can come to him at any time from the great heights at which he fights. It is important that Batman's confrontation with death is often played out at the highest levels of the tallest skyscrapers of Gotham City. His vulnerability to death is central to his heroism.

It is worth noting in this context that magical flight of the sort associated with Superman is also witnessed in narratives of earlier Greek heroes, like Perseus and Bellerophon, in their confrontations with monsters; but this capacity tends to disappear as the mythological generations unfold. Flight in Greek myth is almost always the preserve of gods, who occasionally offer this capacity to worthy heroes to conduct their quests. So Perseus is able to fly to the Gorgons' lair by means of the winged sandals that Hermes gives him. We should recognize therefore that Superman's fundamental ability to fly *whenever he likes* is a fairly radical idea in a Greek context. Even Heracles scarcely ever flies; and he has Zeus for a father. The later generation of heroes, those associated with the Trojan war in the Homeric poems, like Odysseus, definitely cannot fly, and the gods never invite them to do so; and this is the case even with Achilles with his divine parentage. Achilles and his horses are both very swift of foot (and, in Homer, special horses are described as 'flying', the Greek *petomai*); but this is as far as it goes. Magical flight in Greek myth is often associated with an unwelcome transcendence of the basic human condition of existence; and the hero who flies often comes to a sticky end. Bellerophon, Icarus and Phaethon, all meet with death in a fall from the sky; and the Greek poets and mythmakers use them to teach some moral lessons. The message is that humans should live in a human way, within human bounds.

Thus the capacity of Superman (not to mention Wonderwoman, Captain Marvel, et al) to fly whenever he likes makes him more like Greek *gods* in this regard, than Greek heroes. Batman however has a much more

human orientation, one that is more bound up in raw ingenuity and courage. Intellect is one of his main weapons. He is a kind of gadgets man who uses technology to enhance his prospects of victory: the batmobile, the baterang, the batcave, potions and chemical mixes. Batman is a kind of superhero trickster who overcomes adversity by outsmarting his enemies, both in his use of special weapons and in his skill in disguise. And the parallel with Odysseus in both of these aspects is quite significant.

Indeed cunning intelligence (the Greek *mêtis*) is Odysseus' defining quality. The most renowned examples of his *mêtis* are his invention of the wooden horse to take the city of Troy (*Od.* 4.271ff.; 8.492ff.; 11.523ff.), and his skilful ploy to get himself out of Polyphemus's cave (*Od.* Book 9). The idea of the wooden horse, and the ultimate success of the trick, help to signify that Odysseus is really the main destroyer of Troy. Achilles is a great horseman with immortal horses; and the combination of these two characteristics helps to signify his dominance of the battlefield at Troy. But in the saga of Troy it is a horse carved from wood, not living horses, that brings defeat to the city. Odysseus is marked out from the rest of the Greeks (and Trojans) by virtue of the fact that his inventions are entirely out of left field. He is a trickster figure - a human parallel to the divine figures of Prometheus and Hermes. All the other Greeks at Troy use standard weaponry to try to take the city - the spear, the bow, the rock, the ambush, and so forth- and when these fail in the main task they just keep on trying with the same sorts of weapons. But Odysseus can think outside the square. He can come up with an entirely different kind of weapon, the wooden horse. And so it is Greek cunning and invention that defeat the naïve and superstitious Trojans. Troy really falls to an idea. Likewise in the huge cave of Polyphemus Odysseus' intellect comes to the fore when he uses wine to get his enemy drunk and a burning stake to plunge into his eye (9.345ff.). Polyphemus must be defeated, not killed, so that they can get out from the cave, because a huge rock blocks their exit.

Moreover the notion of a transformed identity through disguise plays a fundamental part in what is going on in these narratives. When Odysseus is in the cave of Polyphemus he calls himself 'Nobody' (9.364ff.); but when he gets out, he calls himself 'Odysseus' again (9.502ff.). There are other narratives of him in disguise, creeping into the city of Troy (*Od.* 4.240ff.), and into the camp of enemy soldiers wearing unusual garb (*Iliad* 10, the 'Doloneia'). Likewise the culmination of the *Odyssey* is his defeat of all the suitors of his wife in the house. This is a victory which depends heavily on his disguise (13.429ff. etc.) as an old beggar (that is, he is entirely transformed in his general appearance - his age, his voice and his class). Greek heroes are often informed in a significant way by what they wear - Heracles in his lion skin, Achilles in his immortal armour, Perseus

with his special garb, given to him by the gods. Odysseus is a master in transforming his identity, and this is one of his most significant weapons. In the same way Batman uses different personas to gain access into the various sections of society - the world of the wealthy and the world of the gangsters. His daytime profile is the urbane figure of Bruce Wayne, but at night he has other personas. Batman is his principal night-time identity, but it is not his only choice of disguise to fight crime. He sometimes needs to infiltrate gangs and gain information. To this end a major alter ego is 'Matches' Malone, a figure whose voice and appearance are fundamentally different from either Bruce Wayne or Batman (Malone wears a moustache, a red suit, and dark glasses in the gangster mould).

As Batman is completely at home in the dark landscape of Gotham City where his particular skills seem to come to the fore, so Odysseus seems to have an innate capacity to shine in the darkness, even without a god by his side. In early Greek thought night is the 'divine time'. In Homer it is a time when human movement usually ceases, unless a god is showing the way. In the *Iliad* Priam can go and retrieve the body of his son Hector from Achilles only because he has a god Hermes to show him the way (24.349ff.). And in the *Odyssey*, Odysseus's son Telemachus can embark on a night sea-journey by virtue of the fact that the goddess Athena is his guide (2.393ff.). But Odysseus seems to have the innate capacity to operate in the darkness using his own intellect as a guide, be it in an enemy camp, or in Troy, in the cave of the Cyclops, or in the wooden horse. This attribute suggests that whilst Odysseus may have no superhuman powers *per se*, he does have a kind of divinity about him.

The *Odyssey* is often described as a particularly moral work in so far as Odysseus ultimately overcomes the evil doings of the suitors who are vying to marry his wife while he is away. Odysseus has a very personal kind of morality. He manages to lose all his men on the journey home from Troy to Ithaca, and so he can scarcely be held up as a kind of model of altruistic virtue. In fact when he finally gets home he finds himself at war with his own community, many of whom have turned against him in his absence. But the generally moral nature of the *Odyssey* does have its parallel with Batman (and indeed with the superhero genre in a more general sense). Much of Batman's sense of altruism for the community, and indeed his decision to become Batman in the first place, spring from terrible wrongs done to him as a child. When he is only eight years old he witnesses the murder of both his parents, Thomas and Martha Wayne, by a criminal called Joe Chill (*The Origin of Batman* DC Comics #47, 1948; Reynolds 1992, 66ff.). As a consequence the young Bruce swears an oath to rid the city of the evil of crime. Like Odysseus in the *Odyssey*, he is a kind of avenger of evil, driven by a quest to find the people who committed the crime. And so

Batman directs his energies against the social underclass who perpetrate evil deeds on the good and innocent people of Gotham City. Both Batman and Odysseus (in the tradition of Heracles' labors and the adventures of Jason) are repeatedly challenged by a weird wonderland of strange and diabolical individuals. Batman has to deal with the Joker, the Riddler, the Penguin, Scarecrow, Catwoman, and so forth; and Odysseus has to deal with drugs (Lotus-eaters), alluring women, cannibals, and terrible monsters in his grand quest to get home. The worlds that they operate in are full of tricksters who have no moral basis for their actions. Things are not always what they seem at first glance for either Batman or Odysseus, but their determination, intellect and courage usually prevails over their enemies.

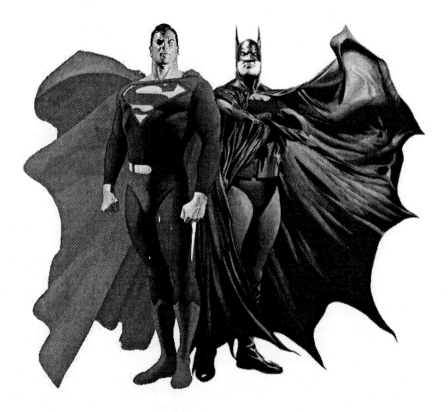

Figure 11: Alex Ross poster art depiction of Superman and Batman.
© DC Comics and Alex Ross

So, to conclude. We can take the two Homeric heroes - Achilles and Odysseus - and the two most dominant 20th century superheroes - Superman and Batman - and identify particular parallels and contrasts between them. Achilles and Superman are entirely dominant within their social and heroic contexts, and this dominance usually manifests itself through raw power and strength of an otherworldly kind. Despite their backgrounds, neither of them is invulnerable, for Superman has Kryptonite to deal with, and Achilles has his own imperfect invulnerability (the Achilles' heel story). But they are fundamentally figures who transcend the ordinary conditions of a human existence, especially when they have dressed themselves in their appropriate outfits for combat (Achilles' immortal armour / Superman's cloak, tights etc.). As we have seen, Odysseus and Batman by contrast, have a parentage that offers none of the same elemental power and dominance, but they make up for this by an innate ingenuity and flair and courage. Their similar kind of heroism is really founded on their human origins and their greater vulnerability to the attacks of their enemies.

So the two traditions - in the case of these four different individuals - reveal a corresponding movement from the otherworldly kind of hero to the more 'human' one. And in many ways it is the later, the more human figure, who comes to dominate the heroic rivalry between them. Despite his special destiny and his divine background, and the brilliance of his Olympian fire, Achilles is killed before the fall of Troy. His great heroic 'moment' is his killing of Hector with his special spear, but he never sees the fall of Troy itself. The death of Hector is Achilles' 'sack of Troy'. It is Odysseus who can claim to be the real destroyer of the city. He is a new man for a new age, and with a new value system; and Achilles sometimes looks archaic, even a little bit old-fashioned, in comparison with him. The *Odyssey* may not surpass the *Iliad* as an epic poem, but there is at least a sense in which Odysseus surpasses Achilles in the saga as a whole. Likewise the response of Bob Kane and Bill Finger to Siegel and Shuster's Superman was to create a hero whose vulnerability to death corresponds more to our own. The notion of the superhuman hero is always that little bit more distant and remote from our own time and place, and from the nature of our experience. In this sense Batman, like Odysseus, is the more 'modern' of the two superheroes, and probably the more dominant of the two in contemporary popular culture. And like Odysseus he is a man of darkness, someone who comes into his own in the dark confines of the underworld of crime and evil.

7
Restlessly, Violently, Headlong, like a River that Wants to Reach Its End: Nihilism, Reconstruction and the Hero's Journey

Raymond Aaron Younis

> I praise, I do not reproach, [nihilism's] arrival. I believe it is one of the greatest crises, a moment of the deepest self-reflection of humanity. (Nietzsche)

Nietzsche, writing almost at the end of the nineteenth century, proclaimed the twentieth century as the time of the advent of nihilism. In *The Will to Power* he wrote:

> What I relate is the history of the next two centuries. I describe what is coming, what can no longer come differently: the advent of nihilism… For some time now our whole European culture has been moving as toward a catastrophe, with a tortured tension that is growing from decade to decade: restlessly, violently, headlong, like a river that wants to reach the end... (Preface, section 2)

Similarly, Martin Heidegger, writing in 1927 (in *The Question of Being)*, foreshadowed a time in which nihilism would be humanity's normal state. In a sense, they were right. One can find some evidence for these claims in much popular culture now, especially in terms of the recurrent interest in forces and figures of nihilism and negation in superhero films. But there is little or no research on the links between nihilism and the superheroes of popular culture particularly in the context of the work of Nietzsche and Heidegger; Nietzsche's idea of the overcoming (Nietzsche's term is important here: *Überwindung*) of nihilism is a crucial and integral part of the superhero's journey and ultimately of the superhero's project –as it is of the hero's journey. One might think of Neo in the Matrix trilogy or the heroes of the Starship Enterprise (for example in conflict with the Borg in *Star Trek: First Contact)*, the Jedi knights, and so on. The essay will close with some reflections on the superhero as the figurative and messianic bearer

of a new mythos and a new logos aimed at an overtly reconstructionist discursive and ideological thrust directed against the advent of an age characterized by amorality, disorder, estrangement, chaos, negation, meaninglessness and nihilism.

'Nihilism' has many definitions and connotations. Alan Pratt describes it in these terms: "all values are baseless and ...nothing can be known or communicated" (2006, n.p.). He goes on to link it to pessimism and existentialism, and most recently, anti-foundationalism (which he seems to associate with postmodernism). Donald Crosby's work (1988), quoted by Pratt, links nihilism to a "process of questioning [that] could come to but one end, the erosion of conviction and certitude and collapse into despair" Crosby qtd in Pratt 2006, n.p.). Michael Novak, also discussed by Pratt, draws connections between nihilism and the existentialist experience of nothingness or nausea; Richard Rorty understands nihilism, as Pratt points out, in terms of the "ability to recognize contingency and pain"; and others link nihilism to banality, or "banalization" and stress the everydayness of the experience or awareness of nihilism (2006, n.p.). Other ways of understanding nihilism highlight revolutions which privilege violence and a rejection of sources of authority as well as systems which provide a contrast to postmodernism understood as something that "finds strength and reason for celebration in the varied and unique human relationships it explores" (Wikipedia 2006, n.p.); Palmieri (2003) understands it in terms of individuals or groups who accept "no doctrine, however widespread, that is not supported by proof", whereas George di Giovanni (2005) argues that Jacobi was "responsible for forging the concept of 'nihilism' —a condition of which he accused the philosophers..." (di Giovanni 2005, n.p.). Nihilism has also been linked to the philosophical pessimism of Schopenhauer (CNNS 2005), to the work of Steven Weinberg, and by implication to a certain strand of modern physics, in one sense (the "more the universe seems comprehensible, the more it also seems pointless..."); or more surprisingly, to the philosophy of Kierkegaard: existentialism is seen as a "negation of the ruling Hegelian philosophy" (Freydis 2005, n.p.). L. A. Schiereck argues that nihilism in the work of Max Stirner should be understood in relation to egoism (1996); Daniel Berthold-Bond (1993) argues that Hegel saw nihilism as a product of skepticism. And one of the few book-length systematic studies of nihilism and popular culture, that of Hibbs looks at nihilism in terms of "no fundamental meaning or ultimate point in human life" (2005, n.p.), before applying it to popular culture, but his focus is not on films about superheroes.

Two ways of understanding nihilism, however, stand out, principally because they are generally influential and for the most part, innovative and brilliantly articulated: Nietzsche's understanding of nihilism as

devaluation', and Heidegger's understanding of nihilism as an ontological forgetting and devaluing of Being. Nietzsche's writings on nihilism are complex and at times provocative, and they have been the subject of many studies. Nietzsche is sometimes called a nihilist because he affirmed the death of God. He may have meant not just that God is a subject of incredulity now, but that monotheism is in a state of eclipse, or in a state of crisis, and that the twentieth century represents a radically different paradigm. Notwithstanding the generalized and somewhat monolithic nature of this conception of an age, it must be said that there is some evidence to support this version, and popular culture is a pertinent sphere to turn to. In any case it is problematic to describe Nietzsche as a 'nihilist'. It is important to observe a distinction between someone who recognizes nihilism as a symptom of an age or as a defining part of the zeitgeist, on the one hand, and someone who actually promotes, practices and sustains nihilism.

Nietzsche actually asked and answered the question: *"What does nihilism mean? That the highest values devaluate themselves. The aim is lacking; — why? — finds no answer"* (*Will to Power*, 2 Nietzsche's italics). What is striking about the question is that it emphasizes his awareness of the importance of nihilism as a cultural phenomenon but also as a psychological or experiential ('existential', one might say) state of being. What is remarkable about the answer is the understanding of nihilism not so much as an intellectual position, a political ideology or a metaphysical realization, but as an inescapable problematic within modern ethics. Nihilism is not about facts here, but about *values*. And it is about values which are not devaluated necessarily, but which, very much in the manner, presumably, in which systems deconstruct from within- 'de-valuate' from within. The impetus seems to be a lack of any teleological, or final, ultimate (one might say, higher') purpose. The deepest questioning finds no adequate answer.

What Nietzsche meant is that all "great things bring about their own destruction through an act of self-overcoming....we stand on the threshold of this event. After Christian truthfulness has drawn one inference after another, it must end by drawing its most striking inference, its inference against itself..." (*Will to Power*, 2). In an astonishing passage, which might be considered by some as the writing of a nihilist, of someone who has seen into the heart of the experience of nihilism, Nietzsche asks: are "we not perpetually falling?... Are we not straying as through an infinite nothing?... God is dead. God remains dead. And we have killed him. How shall we, the murderers of all murderers, console ourselves?" (*Gay Science*, section 125). It seems that Nietzsche is affirming a kind of nihilism himself. But he also asks in the same passage: "Must we not ourselves become gods simply to seem worthy of it?" (*Gay Science*, section 125). Nihilism

"as a psychological state" as he put it, is manifest in the disenchantment of the seeker who seeks meaning and cannot find it; in a rejection of forms of access to life after death and false gods–one "cannot endure this world though one does not want to deny it..." (*Gay Science*, section 125) But Nietzsche cannot be described as a nihilist. He wrote, quite explicitly in *The Will to Power*, that the valuelessness or meaninglessness that is often associated with nihilism is only a transitional phase that will be followed by meaning-making, a 'yea-saying' in the face of existence.

Martin Heidegger wrote in *Being and Time* of the sorts of things that may have led to the emergence of nihilism as a ruling paradigm within modernity and postmodernity. He wrote of the trivialization of the question of Being; of the forgetting of being in modern ontology and metaphysics; of the emergence of dogmas, which sanctioned the utter neglect of the question; and he wrote of the need–an urgent one–for the *destruktion* of ontology. He took great care to distance *destruktion* from negation or negative operations (which are significantly associated with many forms of nihilism). Just as Nietzsche stressed the affirmative project of revaluation–and this is surely not co-incidental given Heidegger's meticulous and extremely detailed studies and readings of Nietzsche–Heidegger stressed the positive potentiality of his ontological project. What is required according to Heidegger is a fundamental reorientation with regard to the ontological question, that of Being.

He wrote about nihilism in many works: in *Nietzsche*, he wrote of the frenzy of modern existence, of the privileging of feeling, the misunderstanding of redemptive forces, and the affirmation, misguided in his view, of personal experience and concreteness. He wrote, in *Poetry, Language, Thought*, of a clearing which gives light to all existing things, an opening through which humanity has access to its own ontological essence, a 'lighting' in which human 'beings' apprehend what they are, and which is obscured or forgotten or neglected by an age under the influence of nihilist ontologies. This clearing is described as an openness in which being attains and maintains a kind of constancy (one assumes in the face of the sanctioned neglect of the question of being itself). He believed that poetry for example, takes us close to this openness, to that clearing, where being itself remains close, and is 'heard' constantly. Being 'opens' the poet; "truth setting itself to work" (61-62) against nihilism. Truth 'shines forth' not as simple being, not as something that is simply a being; truth grounds itself in sacrifice (an important point in relation to the superhero); it is sustained, maintained, constant, in thinking as questioning.

According to Heidegger, the prevalence of technology as technocracy means that the world becomes an object that serves the purposes of calculation; it is de-sacralised and accorded value because it can be used

for the purpose of technological advance. The question of being becomes forgotten, trivialized. So in *The Question Concerning Technology*, he argued that beings are assailed, driven, focused on technologies of communication at the expense of traditions and roots, the very sources of their being in modern cultures. We have become seduced he argues to such a degree calculative thinking will become the dominant paradigm of thinking (Heidegger1977, 56). Objects as well as subjects are at hand, until utilized technologically- yet another example of how the question of being has been neglected and superseded by the question of technology.

In *The End of Philosophy* (an important text in relation to superhero films such as *The Matrix, Star Trek: First Contact,* and the *Star Wars* films), he connects such technocratic developments and desolation: technology, as a carrier of nihilism, "lay[ing] waste our nature" (Heidegger 1973, 54). In *The Question Concerning Technology,* he argued that such technologies distance us from "the full breadth of the space proper" to "our essence" and "man" "must first and above all find his way back into the full breadth of the space proper to his essence" (Heidegger 1977, 39), a space where being opens up, lights up, revealing the most fundamental and urgent question of ontology, and where "the clearing belonging to the essence of being suddenly clears itself and lights up" (Heidegger 1977, 44) and where beings remain grounded in being as a mystery. This is another point that needs to be remembered when the figure of the superhero is discussed. In *The Question Concerning Technology,* he insisted on a kind of heroic renunciation: "when man, in the disclosing coming-to-pass of the insight by which he himself is beheld ... renounces human self-will ... man [he], as the mortal, looks out toward the divine" (Heidegger 1977, 47), a passage that recalls his famous quote in *Der Spiegel:* "only a god can save us now" (18), which suggests that the forces of nihilism within modernity had become far too developed to the extent that Europe's spiritual energy emanating from the ground of being were in a state of eclipse. This point is also affirmed in *Poetry, Language, Thought,* where he wrote explicitly of the "default of god" (Heidegger 1971, 91), that is, the failure of the god to arrive within a technocratic age.

Such analyses of nihilism have significant implications in terms of understanding superheroes. Nietzschean and Heideggerian themes recur in superhero films, especially in relation to the superhero's journey. Joseph Campbell famously explicated the hero's journey in terms of successive stages in *The Hero with a Thousand Faces,* among other works, in terms of trials, thresholds, and the return. It is not difficult to find examples of these in superhero narratives or evidence for the claim that many superhero narratives feature a struggle between the goodness or virtue or wisdom embodied in the superhero and the nihilistic tendencies embodied in their enemies.

One might think of *Star Wars: Attack of the Clones* (2002), *Star Trek: First Contact* (1996), or more recently, *The Matrix: Revolutions* (2003). What is particularly striking is the conjunction between nihilism and a kind of amoral, technologically mediated, neo-imperial megalomania in films like *Attack of the Clones* and *First Contact;* and perhaps most notably, a negation of many things that make human life meaningful or valuable in *Revolutions.*

In *Attack of the Clones,* the superhero must battle an adversary who gathers an army of clones which will threaten the existing order. Technology becomes a means to gain more power; it is a way, not of preserving and maintaining a pre-existing relation with the ground of being, which might be something like the 'force'–but rather as a way of overcoming the presence of this 'force' within the Jedi order and their masters. The fact that this order is associated with peace, stability, goodness hardly seems to matter; the nihilist is interested in power not wisdom or virtue, in values that negate precisely those things which the superhero embodies, such as compassion, enlightenment and wisdom. The values of these villains are defined implicitly in terms of the negation of the superhero's values, so the conflict between the two not only becomes inevitable but also necessary.

But the superhero must also deal with a threat that is closer to home; Kenobi's pupil, Anakin, is ambitious, talented, opportunistic, proud and disobedient. The narrative positions the apprentice as a potential apostate. He refuses the relation of master and student in several crucial senses, and in so doing, is positioned, particularly because of his lack of experience, maturity, and a surfeit of pride, by the narrative as a potentially negative force in relation to his teacher. It becomes clear in this narrative why he will fall in later films. Nihilism is invoked in two forms and the superhero must inevitably contend with both: a biotechnologically-mediated, hyper-destructive desire for power regardless of the human cost and a form that is tied to hubris and will eventually, though not in this particular narrative, lead to a kind of Luciferian fall from grace into nihilism. Indeed, it is notable how the Star Wars films mimic in many ways the biblical mythology of the fall from grace.

In *First Contact,* the heroes, broadly the crew of the Starship Enterprise, must confront and defeat an enemy that represents an aggressive, invasive, expansionist culture, that of the Borg, who are guided by an overtly assimilationist ideology and a neo-imperial hegemonic aspiration. In this way, once again the narrative positions the villains in opposition to the heroes; two incommensurable sets of values are played out, and the conclusion is typical of the genre in general. The crew of the Enterprise represent cultural diversity at its functional ideal, the Borg represent assimilationism and by extension, the destruction of cultures that are not like their

own, and that cannot be assimilated completely into their own; the former represent the forces of intergalactic peace and harmony, the latter are invaders and will not hesitate to colonize and destroy. And so on; the values are clearly antithetical. Of course, the narrative cleverly complicates the issue by reminding the viewer that Picard, the leader of the superheroes himself, is tainted by traces of the Borg (which are, in a sense, still inside him and threaten to obscure his judgment, and therefore leadership, in the battle to come). But this strategy, on one level, simply reminds the viewer that extraordinary levels of heroism are required of him–he must fight the enemy outside and the traces of the enemy within. His heroism, and his courage and resourcefulness, and virtue, are doubly threatened and therefore also, ultimately, doubly realized. He is, in a sense, doubly a hero, for his values prevail in the face of not one but two profound challenges and trials; he crosses two thresholds, and in so doing overcomes the demons within himself and the demonic forces, forces of negation, which threaten the earth and the cosmic order.

The most noteworthy example is *The Matrix* trilogy. In the final confrontation between Neo, the superhero, and Smith, the super villain, the shadow of nihilism is perhaps most vividly and astonishingly configured. There can be little doubt that Neo is the messianic figure (he has links to the Oracle, he is identified as 'the One', he is a liberator and therefore a kind of redeemer whose coming had been foretold in prophecy, and so on) and as such must overcome, inevitably, the forces of nihilism in the world, demonic or Luciferian forces, which are the embodiments of negation or nihilation of life, of its meaningfulness, of its purposefulness (within the context of oracular, prophetic or messianic narratives). Neo saves, like any superhero; he is enlightened, courageous, loving, forgiving and compassionate, like most superheroes (and not surprisingly like Christ, the Buddha and Moses). Smith on the other hand is arguably the most vivid and uncompromising figure of nihilism in popular film. In the course of their final confrontation he questions almost everything that Neo holds sacred, loves and believes in, and he does this often in a mocking way. Indeed he questions, mockingly, the figure of the sacred, something which situates him in the broad domain of the apostate. He is a rogue program certainly, but he is virulent in his apostasy; he is preoccupied with self-replication, itself a figure of his own megalomania and his own amoral egotism; indeed in him, nihilism is linked to egomania lifted to the degree of the infinite. He wishes to replicate himself endlessly, regardless of the cost to human life or liberty, a point which puts him in one sense in the same class as the Borg. He represents an amoral, hegemonic nihilating force that must be exorcised from the system in order to prevent its destabilization and destruction.

Figure 12: Neo's final battle with Mr. Smith, from *The Matrix: Revolutions* (dir. Wachowski Brothers). © 2003 Warner Bros.

So, it is not surprising to hear him question and mock Neo (as Christ is mocked in the desert and as the Buddha is tempted in the wilderness). Their confrontation is clearly framed in messianic/apostatic terms: Smith acknowledges the return of the messianic figure ("welcome back"); Neo responds with an eschatological (not foreign to messianic figures generally) reply "it ends tonight." The cosmic context of this battle is also clear—the battle takes place on the earth and in the sky against a background of thunder and lightning and portentous choral music on the soundtrack. It seems that the cosmic order is at stake. Smith proclaims one of the nihilist's credos: "the purpose of life is to end." They battle as countless Smith clones look on (a reminder of the moral bankruptcy that characterizes Smith's brand of nihilism–bio-technologically mediated, every subject a "standing-reserve," in Heidegger's terms, raw material to feed his virulent ego- and megalo-mania). Smith asks Neo why he persists in fighting, why he bothers to get up again; he asks mockingly if Neo knows what he is fighting for, if Neo actually believes that he is fighting for freedom, truth, love, peace. Of course these are precisely the things that give meaning and purpose to Neo's life; these are, in Nietzsche's terms the very foundations of Neo's understanding of being as meaningful, valuable and purposeful (as indeed they are with almost every superhero or redeemer).

Crucially Smith, nihilism-incarnate, sees these values as "temporary constructs," "vagaries of perception," the work of a "feeble human intellect trying to justify an existence without meaning and purpose." Nietzsche's analysis of nihilism and Heidegger's attempted re-orientation become crucial: Smith's nihilism, which in itself comprises questions which find no answer (other than the repetition and replication of ego-megalomania, the prison house of the virulent, self made practicable by amorally applied, proliferating bio-technologies), is decisively counteracted and, ultimately, overcome by Neo's messianism, which in itself comprises questions which find decisive, ethically grounded, answers–namely, the value of human freedom, the desirability of heroism, the necessary work of redemption and the laudable (high modernist) project of universal emancipation (read: secular salvation). Moreover, Smith does nothing to reorient himself towards the essence of his own ground of being, and to see himself for what he is, for what he might become, in that comportment, in the light of the clearing that Neo discovers. Herein lies the main reason, one presumes, why Smith transforms every encounter with the other (bar one at the end) into an encounter with another version of himself and in so doing provides a graphic postmodern (in the sense of hyper-simulated presence) inscription of a hegemonic, neo-imperial figure, which repeats itself in a sort of absurd hyper logic of the same.

Neo on the other hand, is originally a hacker but reorients himself towards his ground (which causes a kind of fear and trembling that is familiar in messianic narratives, not just hero narratives), and towards the essence of his own being, which he reflects upon and opens himself to–in Heideggerian terms, his project is an authentic one because he reorients himself in relation to the mystery of his origin and it is in that clearing, through that openness, in his comportment to that mystery (not imperiled or transcended by technology) that he learns of his beginning and his end. He meditates on his ground, on the question of his being and its essence, its truth, and discovers his mission, its meaning and his purpose (which is presumably why he dies in a messianic, Christ like fashion, evident in the cruciform explosion of light through the site of conflict at the moment of Neo's destruction of Smith–itself an act of self-sacrifice–and the cruciform position Neo occupies before the god of the machines). Indeed, after the messianic project is completed by Neo and the new world order is realized, after Neo's destruction of the apostatic figure of the nihilist, the god of the machines parodies the words of God the symbolic father, uttered at the site of the crucifixion of the messianic son: "It is done".

The mythos (in the sense of a story or narrative with sacred or transcendent dimensions within an imagined or real community) of the superhero is recognizable from these examples. It is situated in the fictive spaces of the Hollywood (fantastical) imaginary, and in this sense, it is dissimilar to the supernatural spatial and temporal dimensions for example, of monotheism. What the mythos, evident in *The Matrix* trilogy, *Star Trek: First Contact,* and other such films, shares with the mythos of Christianity or Judaism or Hinduism is a language of symbols and metaphors and analogies to convey a sense of transcendence, but it is a sense that does not culminate in some otherworldly, purificatory telos. The symbolic order is restored in *Matrix Revolutions,* but it seems provisional and temporary (in the final scene the Oracle raises the possibility of Neo's return, a virtual resurrection one might say). The work of redemption, with regard to Zion, is at a certain stage, that of peace, but the threat has not been eliminated. The symbolic order is restored in *Star Trek: First Contact,* but the crew of the Starship Enterprise will have other challenges to face, other enemies to conquer; and in a very important sense, some of these threats will not come from outside (as stated earlier, the traces of the enemy are already inside the fabric of Picard's being).

The mythos of these superhero narratives parodies in some ways the mythos of protoapocalyptic texts (for example the Book of Isaiah) in the sense that the battle between the superhero and the villain has a cosmic dimension; the moral fabric of the world, indeed, the world as a whole stands to gain or to lose from this encounter; it is the symbolic world order

that is at stake (very much as, in a sense, the conflict between Lucifer's legions and God's archangels is symbolic of the conflict between good and evil on an existential level within the world order, or on a psychodynamic level, within the hero's consciousness). Often, order is restored, harmony seems to reign, graciousness, forgiveness, compassion are actually and symbolically reinstated, often in a ritualistic or metaphorical way. Often the values and the ideology of the superhero are clearly nationalistic as in the mythos of some post apocalyptic exilic and post-exilic texts, for example, in the Old Testament. But in the examples discussed the mythos is rooted in a sort of Hollywood assertion of an American imaginary with central values such as democratic values, freedom, self-realization and a kind of inviolable sovereignty.

Often the superhero, like the savior of apocalyptic and post apocalyptic, postexilic texts, has supernatural powers, brings cosmic healing into effect and is seemingly indestructible. All of this belongs quite recognizably to a mythic world order and a mythic-symbolic language (captured for example in the costumes that the superheroes wear–these almost invariably distinguish them from their polar opposites or from their foes–and in the distinctive symbols that sometimes appear on these costumes).

It is also important to note the mythos of the messianic figure, which the symbolic order of superheroes mimics. The messianic figure in the Old and New Testaments is almost always a leader, sometimes a king (as in the case of the Davidic line), often a symbolic moral and spiritual redeemer- often a redemptive figure whom the world requires in order to be saved from terrors and catastrophes. These figures are often regarded as 'chosen' as Neo for example, is regarded as the chosen one by Trinity and Morpheus, or they are seen as mysterious figures; indeed the mask of the superhero, literally and metaphorically, is a graphic representation of the essential mystery that surrounds them and in a sense, sustains their power and privilege). This mythos is connected to nationalism, in this case almost invariably American, just as in the Old and New Testaments, it is connected to Zion; and the mythos is, as it is in Judaism and Christianity, connected to a humanist aspiration towards political, cultural and social harmony; a kind of harbinger of a new post-nihilist world order (for example, in a post exilic sense in Judaism and in a post-apocalyptic sense in Christianity).

The logos embodied in the figure of the superhero is in stark contrast to the evil that is embodied in their foes. The Johannine and apocalyptic logos is linked with God's creative (supernatural), activity, with life, and with the image of the warrior (1 *John* 1.1 and *Revelation* 19.13), an important image in the context of the iconography and ontology of superhero films. The logos also represent a cosmic order (for example in the metaphysics

of Heraclitus and the Greek stoics; it is wise these thinkers believed, to live in harmony or in accord with the logos which governs the order of the cosmos). So it is important to consider the significance of the logos that is embodied in the superhero both in terms of familiar monotheistic mythological and apocalyptic contexts but also in the context of classical Greek metaphysics and physics. It is the warrior image of the apocalyptic tradition that is most apt here and the idea that the logos represent a symbolic or actual cosmic order. In many superhero narratives, the central figure is often inscribed as a warrior, or if they are not, they assume certain recognizable warrior values such as courage, wisdom, strategic thinking, resilience, refined combat techniques, extreme efficiency, toughness and so on. It is not surprising to see Neo master Jiu Jitsu, Morpheus master the art of the samurai, Daredevil master the art of pugilism or the knights of the Jedi master the art of swordsmanship and martial arts combat techniques. All of this is in accord with a certain kind of logos-discourse that revolves around the symbolic figure of the cosmic warrior.

Moreover, it is also not surprising to find such superheroes embodying a principle or principles of an actual or immanent or impending new world order. The symbolic order which Neo inaugurates through a kind of apocalyptic self-sacrifice is one which it would be foolish to challenge, given that it is predicated on a universal condition of peace and co-existence (an interesting metaphor, perhaps a sublimation, if one considers the ongoing hostilities, and the escalating complexity in some senses of the American presence, in Iraq). It would indeed be wise, one assumes, for the citizens of Zion and indeed the world of the machines, to exist in accord with the logos of the new world order. Similarly, the Starship Enterprise bears with it the metonymic inscription of a cosmic order that is overtly nationalistic (it is an American ship, after all, especially in the original series) and yet culturally diverse; it is a figure in which cultural diversity is valorized as an integral part of the new world order in relation to heroism and alterity, and for example, in *First Contact,* in contradistinction to the assimilationist strategies which characterize imperial and post-imperial, invasive cultures (such as the culture of the Borg).

Eliade's (1959) distinction between sacred and profane space is also noteworthy. He argued that all religious experience can be described in these terms (this is not the place to consider the claims of his numerous critics). *Homo religiosus,* according to Eliade, lives close (in space) to holy things, such as consecrated objects; it is striking to say the least, that Neo is guided for much of his life by characters with names like Trinity, the Oracle and Seraph; it is also striking that Jedi function on so many levels like guardian angels and are close to the 'force' (or the 'light' side). Eliade also insisted on the relation of otherness between the sacred and the

profane and this is a distinction that many superhero films mimic; Neo is wholly other when compared to the sentinels; the Jedi are wholly other (eventually) to Vader and the forces of darkness. But Eliade's emphasis on the sacred as something that belongs to a wholly other order, that is, an order that does not belong to this world is more problematic. It is in this sense that many superhero films represent not so much a transcendent mythos and logos but a secularized or chthonic mythos and logos. They do not occupy a wholly other fictive sacred space; they are figures in the world order who valorize moral, humanist and nationalist, sometimes sacred, aspects of that order (as the figure of Neo valorizes an anti-imperial ethic, a humanist affirmation of independence, a nationalist aspiration– concerning the Zionites–and Judaic-Christian apocalyptic, eschatological and soteriological motifs such as burnished night vision, crucifixion and resurrection symbolism).

It is in this sense that one might speak of the superhero as an extension of the Eliadean *hierophany*; the space of the 'sacred', reflected in the symbolic form of the redemptive capacity embodied in the figure of the superhero, makes itself manifest in the hero's world and to the viewer of the superhero narrative. The space of the scared opens up, irrupts, within the symbolic order valorized by the actions of the superhero (cosmic peace, a kind of covenant, the space of a new covenant, emerge through Neo's redemptive, Christ-like end; through Spiderman's challenge to the monstrously transformed Doc Ock; through the knights of the Jedi who are not just crusaders of but also bearers of the 'force' within the cosmic order). This is why these superheroes represent a point of balance, or order, or harmony, a kind of ontological centering or ethical anchoring in a world that would otherwise drift towards perdition, apostasy, chaos, disorder, catastrophe, meaninglessness, purposelessness, 'standing reserve' (in Heidegger's sense) or devaluation (in Nietzsche's sense). The space of the sacred is a space within and a space around the superhero in contexts such as these. This is the space of the imaginary where nihilism cannot stand, where it is itself nihilated in the irruption of the power, grace and affirmative values of the superhero, which themselves constitute a kind of immanent or secularized hierophany that valorizes the work of emancipation and redemption and a consequent, (often) nationalistic-humanist, (almost always) ethically symbolic, new world order.

8
My Own Private Apocalypse: Shinji Ikari as Schreberian Paranoid Superhero in Hideaki Anno's Neon Genesis Evangelion

Paul M. Malone

> I borrowed from everywhere. Even names that have no bearing on anything actually came from the countless rules that govern these things. It might be fun if someone with free time could research them (Anno 1998, 170).

At the climax of the 1995-96 Japanese animated series *Shinseiki Evangerion* (*Neon Genesis Evangelion*), directed by Hideaki Anno, two titanic figures called Evangelions, or "EVAs," prepare to battle deep beneath the earth's surface, controlled by two teenage boys. One of these, Shinji Ikari, riding inside one of the giants in a tube of oxygenated liquid, screams: "You betrayed me! Just like my father!" The other, Kaoru Nagisa, hovers bizarrely beside his EVA. In reality Kaoru is the Angel Tabris, last in a series of seventeen supernatural invaders. Far above them, Earth's embattled defenders helplessly await the struggle's outcome. Tabris's champion has only to hold off Shinji's EVA long enough for the Angel to pass one final barrier; if Tabris makes contact with the massive entity crucified beyond, the world will end.

On one level, *Evangelion* is an entry in the popular "giant robot" or *mecha* genre of *manga* (comics) and *anime* (animated films), exemplified by Mitsuteru Yokoyama's classic *Tetsujin 28-Go* (*Gigantor*: manga, 1956; anime, 1963) and *Jianto Robo* (*Giant Robo*: manga, 1967; live-action series, 1968; anime, 1992) (Drazen 2002, 247-8). *Mecha* is typified by the presence of a young hero who controls—usually from within—a gigantic humanoid weapon that "clearly plays to a wish-fulfilling fantasy of power, authority, and technological competence" (Napier 2005, 86). Fusion with the massive machine both permits the protagonist to perform superheroic feats of speed and strength and creates a dramatic tension "between the vulnerable, emotionally complex and often youthful human being inside the ominously faceless body armor or power suit and the awesome power he/she wields vicariously" (Napier 2005, 87).

Figure 13: *Neon Genesis Evangelion* (1995-6) © GAINAX/Project EVA.

Evangelion is the story of Shinji Ikari, summoned by his estranged father Gendo to help save the world. Gendo commands the shadowy organization NERV, an arm of the even more obscure SEELE. It is 2014, fifteen years since Second Impact, allegedly a meteor strike in the Antarctic, shifted the earth's axis, killing half its population. This cataclysm was in fact set off by SEELE's discovery of Adam, a gigantic being called an "Angel" in English (Japanese *ashito*, 'apostle'). Now other Angels are attacking Earth; each is differently shaped and armed, and learns from its predecessors' mistakes. Should an Angel reach Adam, crucified deep below NERV headquarters, the final catastrophe will occur: Third Impact. To prevent this, from Adam's DNA NERV has constructed the Evangelions, giant cyborgs that can only be piloted by teenagers; as commander, Gendo orders his son to pilot Evangelion Unit 01. This summons at such a crucial juncture implies that Shinji—who has been raised apart, cared for by his uncle and aunt since his mother Yui's death years before—will be a kind of secret weapon. Indeed, despite lacking both training and enthusiasm, Shinji proves easily able to "synchronize" with his EVA unit and manages to vanquish the invading Angel, raising the expectation that, with proper instruction, he will fulfil the heroic destiny described in the series' opening theme (Napier 2005, 97).

Evangelion is also a critique of the *mecha* genre, however, and of the social crisis of 1990s Japanese society, in which "the post-80s advancement of high-technology and the dismemberment of family structure still come short of the deconstruction of traditional ideology" (Kotani 1997, 99-100). Unlike the saintly inventor/fathers of iconic *mecha* (Drazen 2002, 250), Gendo Ikari is a sinister figure whose obsession with constructing the EVAs cost his wife Yui her life when she vanished inside Unit 01 while testing it. Gendo now uses NERV's mysterious Human Instrumentality Project as a means to reunite with Yui; this objective puts him increasingly at odds with his SEELE bosses, who see the same project as the next step in collective human evolution. Moreover, in a typical giant robot *anime* the protagonist would enthusiastically pilot his father's creation out of filial piety and hunger for justice; but Shinji is a vacillating introvert, horrified by the EVAs but desperate to feel useful and earn Gendo's respect.

Despite Shinji's revulsion, however, he is a successful enough pilot that Evangelion Units 00 and 02 quickly become subsidiary to his Unit 01, which hides a dark secret: it still contains Yui Ikari's soul, partially explaining the ease with which Shinji often seems to control his EVA compared to his better-trained colleagues. The other pilots have their own psychological problems: blue-haired and impassive Rei Ayanami turns out to be a clone of Shinji's mother; while the redheaded Asuka Soryu Langley is brilliant but competitive, abrasive, and jealous of Shinji's apparent "luck" as an EVA pilot. A certain amount of adolescent erotic tension arises between Shinji and Asuka; Shinji and Rei; and even between Shinji and the slightly older Misato Katsuragi, his immediate superior and surrogate mother.

None of this melodrama is unusual for *anime* plotlines. The last third of the series diverges markedly from the science-fiction/action paradigm, however, eventually deconstructing its own narrative. Rei dies in battle and is replaced by another, even more aloof, clone. Asuka suffers a breakdown and loses the ability to pilot her unit. Shinji seems to be singled out as the last hope, likely to come through in a final climactic set-piece battle. The last Angel attacks in human form, as already described: Kaoru Nagisa, a new EVA pilot, is the first person to show Shinji respect and tenderness. After making homoerotic advances to Shinji, he hijacks an EVA and attempts to contact Adam. It is Kaoru, not Shinji, who actually wins the battle, but the macho paradigm of *mecha* is overturned even in the bowels of the earth: the gigantic figure transfixed on the cross deep underground is not Adam at all. Rather, it is his female counterpart Lilith, mother of humankind. Upon realizing this, Kaoru asks Shinji to kill him. Shinji's heroism is thus doubly undercut: first by his initial failure, and then by the fact that the enemy is destroyed at his own behest. With Earth

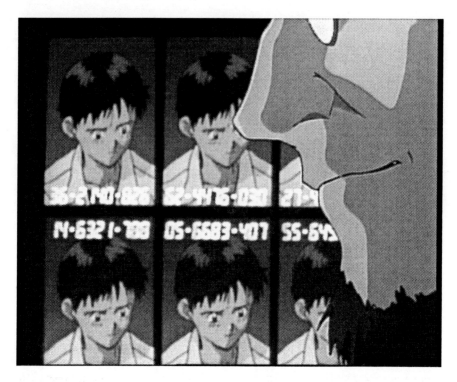

Figure 14: *Neon Genesis Evangelion* (1995-6) © GAINAX/Project EVA.

apparently saved, and the hero having done his duty, even inadvertently and at terrible emotional cost, this is where most action-oriented *anime* series would end.

Evangelion is particularly unusual, however, in that the story not only continues beyond this point, but also ultimately comes to *two* endings: in the series' original broadcast ending, the last two episodes contain no action. Instead, Shinji is questioned by disembodied intertitles about his identity and sense of self-worth. A combination of flashbacks and abstract animation leads Shinji to be able to imagine himself as a whole and integrated member of a world no longer under threat, even while it also formally reveals and deconstructs him as a fictional creation and animated drawing. The series concludes with a joyous Shinji congratulated by the other characters, including his resurrected mother, in a reconstituted world.

This unconventional ending was so unpopular, however—Anno received death threats—that a completely new version, presented as the "real" final two episodes, was released as a theatrical feature, *Shenseiki*

Evangelion Gekijo-ban: Air/Magokoro o, kimi ni (The End of Evangelion, 1997). In this revised conclusion, after Kaoru's defeat an impatient SEELE sends troops to destroy NERV and slaughter its personnel. SEELE then triggers the end of the world using Shinji's EVA—with him inside—as catalyst: the Kabbalistic *sefiroth* or Tree of Life forms in the sky, Rei and Lilith fuse into a huge angelic being, and all human souls are released from their bodies. Meanwhile, on another plane Shinji has an epiphany, with his mother, Rei and Kaoru as "spirit guides"; he chooses to regain corporeal form rather than enjoy spiritual communion, and is told that anyone else who wishes can do the same. Shinji awakens on a deserted earth beside a bandaged Asuka, whom he tries, but fails, to strangle as the film ends. As Susan Napier points out, *End of Evangelion* "more than makes up for the minimalism of the final series episodes by presenting an over-the-top apocalypse so full of awesome catastrophe and bizarre revelations as to seem almost a parody of the apocalyptic genre" (Napier 2002, 427).

It is striking that two of *Evangelion's* most important elements are given the German names NERV and SEELE. Indeed, because in the first ending the conflict between Gendo Ikari and his masters seems to be resolved in Gendo's favour, while in the second SEELE intervenes violently to pursue its own programme, we might call these two conclusions the "NERV-ending" and the "SEELE-ending" respectively. But why, in a Japanese program, are two such important entities given German names, and why these particular names? (NERV's precursor, the organization that actually began work on the EVAs, also bears such a name: GEHIRN.)

Both *Evangelion* fan websites and academic studies agree that *Gehirn* means 'brain,' *Nerv* 'nerve,' and *Seele* 'soul' (Napier 2005, 268). In fact, however, *Seele* can be translated not only as 'soul' but also as 'mind,' 'heart,' 'spirit' and, most importantly, 'psyche,' having maintained much the same broad meaning as the original Greek word ψυχη. Given the density of Judeo-Christian imagery and terminology in *Evangelion*, translating *Seele* merely as 'soul' assimilates the term to this discourse misleadingly; for the broader meaning of *Seele* is directly relevant to interpreting the series as a reflection of Shinji's own psychology.

Such an interpretation is nothing new. Susan Napier has argued that from the first episode, *Evangelion* is "already an exploration of inner psychological worlds":

> Shinji and Misato's descent into the seemingly bottomless depths of NERV headquarters can be read... as a descent into the unconscious.... It is surely no coincidence that, in the first episode, Misato and Shinji enter NERV only to become hopelessly lost, a situation that recurs symbolically and concretely throughout the

series until the final episode explicitly displays Shinji as "lost" in his own subconscious (Napier 2002, 428).

Napier elsewhere describes the series' ending as "an almost classically psychoanalytic exploration of the personal identities of Shinji and his friends/colleagues at NERV, who, the viewer has by now discovered, are all deeply psychologically damaged" (Napier 2005, 101; see also Drazen 2002, 308). Likewise, one *Evangelion* fan guidebook interprets the feature film's climax as a Freudian conflict between Shinji's libido and death wish (Fujie and Foster 2004, 155-9; see also Napier 2005, 269-70). Both endings, while very different, have clear psychological overtones. At the same time, the very existence of two endings opens the possibility that neither version represents a reality external to Shinji's psyche, and that the entire action of the series may have taken place within his mind.

The wider interpretation of *Seele* obviously substantiates a psychological reading of *Evangelion*; if, however, we see Shinji's descent underground as a journey both into his psyche and into his brain—since the NERV installation was constructed by GEHIRN—is there a more general relevance of *Nerv* to such an interpretation? What is it, exactly, that we are seeing inside Shinji's mind? Or, from another angle, is there another textual locus where we are likely to find the German terms *Seele* and *Nerv* in close conjunction? It happens that there is in fact a text of major significance and relevance that revolves around exactly these two concepts.

Napier has observed of *Neon Genesis Evangelion*:

> These apocalyptic visions ... are not limited to the destruction of the material world. Rather, viewers and readers are confronted with stories whose narrative impetus appears to be a growing sense of hopelessness in relation to overwhelming forces that are both exterior and interior. Not surprisingly, an atmosphere of claustrophobia and paranoia pervades these works, ultimately leading to memorable visions not simply of cultural crisis but also of cultural despair (Napier 2002, 423).

No study, however, has yet observed *Evangelion*'s remarkable similarities to the paranoid fantasies of Daniel Paul Schreber (1842-1911). Schreber, who had lost his post in Leipzig as Presiding Judge of the Supreme Court of Saxony due to a breakdown in his early fifties, published his *Denkwürdigkeiten eines Nervenkranken* (translated as *Memoirs of My Nervous Illness*) in 1903, in an attempt to demonstrate his sanity; instead, he offered a detailed case history of what was then known as *dementia praecox*, which would be examined not only by Freud, but also by Jung, Alfred Adler, and

Jacques Lacan, among others.

Outwardly, Schreber seemed simply demented: bellowing nonsense or snatches of poetry, banging away on pianos, losing control of his bowels. Inwardly, however, Schreber's paranoid megalomania led him to believe that he was turning into a woman through the manipulation of his soul, which he thought contiguous with his nervous system: "The human soul [Seele] is contained in the nerves [Nerven] of the body" (Schreber 2000, 19). Schreber's nerves were being manipulated by rays that were themselves the nerves of God—or rather, the dual "anterior" and "posterior" gods, whom Schreber calls Ormuzd and Ariman—in order to repopulate the world, which Schreber believed already destroyed and peopled with "fleeting-improvised men," from Schreber's newly formed womb. The villain in this scenario was initially Schreber's therapist, the eminent neuroanatomist Paul Emil Flechsig; gradually, however, God Himself took on this role. Though God's normal function was to keep distant from His creation—Schreber's cosmology was essentially deist—Schreber's excited nervous state had supposedly attracted the divine nerves so powerfully that God now felt forced to drive Schreber insane in order to extricate Himself (Schreber 2000, 250). The Memoirs are a product of Schreber's superheroic resistance to this strategy—though the word "superhero" was unknown to Schreber, he informs the reader that his travails "have probably never before had to be borne by a human being" (Schreber 2000, 128), but that God's machinations against him, the "greatest seer of spirits of all millennia" (Schreber 2000, 81), are doomed to failure (Schreber 2000, 67; 235; 254); and for his pains, Schreber claims, he has been compensated with the superhuman powers of invulnerability and immortality (Schreber 2000, 255-6).

It was C. G. Jung who first discovered Schreber's book and recommended it in 1910 to Sigmund Freud. The Memoirs offered Freud the opportunity to argue that paranoid schizophrenia stemmed from "an attempt to master an unconsciously reinforced current of homosexuality" (Freud 1958, 59). The central thesis of Freud's famous 1911 essay on Schreber is that the paranoid, repressing unwelcome homosexual desire, completely withdraws his libidinal cathexis—his erotic interest—from the external world:

> The end of the world is the projection of this internal catastrophe; his subjective world has come to an end since his withdrawal of love from it…. And the paranoic builds it again, not more splendid, it is true, but at least so that he can once more live in it. He builds it up by the work of his delusions. *The delusional formation, which we take to be the pathological product, is in reality an attempt at*

recovery, a process of reconstruction. Such a reconstruction after the catastrophe is successful to a greater or lesser extent, but never wholly so; in Schreber's words, there has been a "profound internal change" in the world. (Freud 1958, 70-1; emphasis in the original)

For several years, Freud embraced Jung as a kindred spirit, and the two men bonded over Schreber, larding their correspondence with catchphrases from Schreber's writings. The sexual interpretation of the libido underpinning Freud's reading of Schreber, however, was soon disavowed by Jung in favour of a broader interpretation as a form of emotional, not necessarily sexual, interest in the external world (Adams 2004, 86-9). By 1914 Jung and Freud had severed all ties, and Jung could describe Freud's analysis of Schreber as "very ingenious" but ultimately unsatisfying (Jung 1968, 179-80). Jung saw schizophrenia as closely tied to introversion; because Freud was himself an "extravert," he could not but have great difficulty understanding schizophrenics (Jung 1968, 190-1). Despite these differences, Jung's interpretation of Schreber's delusions still has much in common with that of Freud—though Jung's conclusion is perhaps less optimistic:

Closer study of Schreber's or any similar case will show that these patients are consumed by a desire to create a new world-system, or what we call a *Weltanschauung*, often of the most bizarre kind. Their aim is obviously to create a system that will enable them to assimilate unknown psychic phenomena and so adapt themselves to their own world. This is a purely subjective adaptation at first, but it is a necessary transition stage on the way to adapting the personality to the world in general. Only, the patient remains stuck in this stage and substitutes his subjective formulation for the real world—which is precisely why he remains ill (Jung 1968, 189).

Although Jung never produced a detailed analysis of Schreber to counter Freud's, Schreber remained a touchstone in the works of both men and their followers (Adams 2004, 89-92).

Moreover, Schreber's text is not only located at the intersection of Freudian and Jungian thought, but also at the historical moment when the rise of neurology in the late nineteenth century had "raised the 'nervous' patient to a status that demanded and received dignified recognition" (Bromberg 1959, 151). Unfortunately, however, a generation of neuroanatomical psychiatrists like Schreber's Dr. Flechsig, believing

that "mental disorders are brain disorders," now subjected patients to humiliating regimens of drugs, restraints, isolation, surgery, and electrotherapy exacerbated by the added threat of abuse from warders and fellow inmates (Dinnage 2000, xiv-xv; Bromberg 1959, 154-6).

The development of psychoanalysis created a strong and often critical counter-movement to the neuroanatomical approach. In 1912, for example, Jung averred, in words that could have referred precisely to Flechsig's handling of Schreber:

> If he wants to help his patient, the doctor, and above all the "specialist for nervous diseases" [Nervenarzt], must have psychological knowledge; for nervous disorders and all that is embraced by the terms "nervousness," hysteria, etc. are of psychic origin [seelischer Herkunft] and therefore logically require psychic treatment [seelische Behandlung]. Cold water, light, fresh air, electricity, and so forth have at best a transitory effect and sometimes none at all. ... Here the doctor must also be a psychologist, which means that he must have knowledge of the human psyche [der menschlichen Seele]. (Jung 1966, 246; Jung 1974, 271)

Given the materialist nature of his treatment, it is understandable that Schreber internalized this frame of reference within his delusions. As Janet Lucas has pointed out, "Of all the aspects of this text, what I find most striking is its literalness... Schreber understands nervousness (here he means nervous illness, as in the title of his work...) in terms of physical nerves" (Lucas 2005). This literalization is in fact common among schizophrenics, who generally "have no capacity for metaphorical understanding" (Adams 2004, 81-2). At the same time, however, Schreber has similarly literalized Seele. The year that Schreber was admitted to Flechsig's sanatorium, the psychiatrist published Gehirn und Seele (1894; enlarged second edition, 1896), also usually translated as "Brain and Soul" (Keegan 2003, 56; Santner 1997, 71). In fact, the book treats "the age-old problem of the relationship between mind and brain" (Keegan 2003, 58); a rendering more in keeping with Flechsig's materialist viewpoint would be "Brain and Psyche." Schreber, however, literalizes his therapist's terminology by focussing exclusively on the metaphysical connotation of Seele. Thus the opening sentence of his memoir, "The human soul is contained in the nerves of the body," is a delusionally transfigured restatement of Flechsig's thesis: "Diseases of the association centers are the foremost cause of mental illness; they form the proper object of psychiatry" (Santner 1997, 71; see also Lucas 2005). Schreber did not invent the cardinal concepts of this discourse; he took them from his therapists and transmuted them. Remarkably, a

century after Schreber's incarceration these same two concepts are further appropriated and re-literalized in *Neon Genesis Evangelion*.

Hideaki Anno claimed to have suffered a breakdown himself during the production of *Evangelion* (Anno 1998, 170); he entered Jungian analysis—the Jungian approach being prevalent among clinical psychologists in Japan (Kirsch 2000, 218)—and began reading up on psychology "to explore 'what the human mind is all about inside'" (Eng 1997). The use of psychological terms in the earlier stages of *Evangelion* indicates that Anno was deepening his acquaintance with psychology rather than starting from scratch; from this point, however, psychological themes already present in the series began to take over.

Whatever Anno was reading, both Freud and Jung, who frequently refer to Schreber, have been available in Japanese for at least thirty years. Other writers on psychology, too, have mentioned "the most studied text ever written by a psychiatric patient" (Miller 2001, 1943); and the *Memoirs* themselves have been available since at least 1991, under the title *Shureba kaisu roku: Aru shinkeibyokanja no shuki*. One would think it unlikely that Anno did not come across some mention of Schreber, which might in turn have led him to read the source itself—though it need not have, given the detailed account in Freud's analysis, for instance.

In any case, however, *Evangelion* clearly is not based directly upon Schreber's memoirs; rather, the two texts exhibit a surprising degree of intertextuality, which allows us to read *Evangelion* as a detailed fictionalized representation of paranoid delusion that further deconstructs the protagonist's already problematic "heroism". In this context, it is interesting that the Schreber depicted in the *Memoirs* displays several traits comparable to those of Shinji Ikari.

Interpreters have noted, for instance, that a key feature of Schreber's fantasies is a sense of personal mechanization:

> Plugged into madness, rendered into a machine, strapped into restraints, probed by devices, subjected to the psycho- and electromechanical theories of the time, Schreber was naturally both intensely aware of the fact that he had become a machine and horrified that he was one (Roberts 1996, 37).

This sense is thought to have been initiated in Schreber's childhood: his delusions conflate both Flechsig and God with Schreber's father Dr. Daniel Gottlob Moritz Schreber, a well-known child-rearing expert whose disciplinary methods included the use of mechanical contrivances such as orthopedic straps to enforce not only proper posture but also blind obedience. Moreover, Schreber's father seems to have used his own children as guinea pigs: "The physical sensations of these restraints and

the intolerable pressure caused by the devices were augmented by the detailed, omnipresent observation of [Schreber's] body and his behavior by his father" (Bregman 1977, 125). Schreber senior's authority within the home was buttressed by social pressure outside, as both he "and many of his contemporaries saw his system as working toward saving mankind" (Schatzman 1973, 29). No wonder that Schreber junior found his own consciousness "both rent and joined by an inner panopticism" (Sass 1992, 253), a common feature of paranoia that Sass arrestingly illustrates with a reproduction of a 1924 painting by the schizophrenic artist Adolph Wölfli, marked by a giant pair of stylized, staring eyes (Sass 1992, 259). No wonder also that the younger Schreber found his own way to save the world, in his case from a God who refused to stay in his proper sphere and was now inextricably entangled with Schreber's own prodigiously tormented nerves.

Shinji Ikari, too, unlike a typical *mecha* protagonist, regards his missions in the EVA as a physical and emotional torment (Napier 2002, 424-5). Moreover, though Gendo Ikari is as physically remote from his son as he is emotionally distant, he often observes Shinji from his office high above the EVAs or electronically. Here also, Gendo's paternal authority and critical supervision are underpinned by his patriarchal position as supreme commander of an organization literally charged with saving the world (Kotani 1997, 99). This surveillance is echoed in the organic forms of many of the Angels, marked by striking or destructive eyes, eye-shaped markings, or even shaped like eyes themselves. Their constant reappearance from the skies mocks NERV's motto, "God's in his heaven, all's right with the world" (taken from Robert Browning, but a perfect summary of the "state of affairs in accordance with the Order of the World" marked by God's distance from his creation in Schreber's cosmology; Schreber 2000, 23).

For relief from the constant surveillance and bodily interference that he felt himself subjected to, Schreber had recourse to bellowing, reciting memorized ballads and dramas by Schiller and Goethe—though obscene doggerel worked just as well (Schreber 2000, 203)—and by preference, music. An accomplished pianist, Schreber found that the voices in his head could be stilled by playing (Schreber 2000, 157-8). Recurring classical music plays an important role in *Evangelion*, but it is equally important that Shinji himself is musical: the EVA pilots form a string quartet in which Shinji plays cello. However, for day-to-day refuge from the pressures of his often terrifying life, Shinji resorts to curling up with a digital tape Walkman; one of the most unsettling images of the feature film is of Shinji still huddled with his Walkman, with its display in closeup showing that the battery is finally dead.

Perhaps the most notable characteristic of Schreber's dementia is gen-

der confusion; Freud asserted that this stemmed from suppressed homo-
sexuality, though any real evidence of this is lacking (Adams 2004, 79).
As an alternative, it has been claimed that Schreber's overbearing father
isolated him from his mother:

> ...which was, in turn, defended against by an all-out identifica-
> tion with the father.... Beneath this compulsive masculine iden-
> tification Schreber remained secretly an infant who wished to be
> the sole possessor of the mother—possession possible only by
> magical, primitive identification with her—a symbolic, magical
> merging with her (White 1961, 62-3).

A Jungian analyst elaborates: "Schreber's predominant identification
was with an idealised maternal self-object, a merger of divine and mytho-
logical great mother figure, and that of the divine child, with the helpless
infant in himself" (Edwards 1978, 245).

Susan Napier has described Shinji's situation in *Evangelion* in similar
terms, particularly given that the identity of Shinji's EVA with his mother
Yui becomes increasingly clear:

> With its image of a small human encapsulated within a large
> liquid cylinder, Shinji's immersion (perhaps a more appropriate
> word than "fusion") in the EVA strongly suggests a birth scene....
> Thus the EVA has both aspects of the maternal—Shinji is inside its
> protective capsule—and the self—Shinji is "synchronizing" with
> it, fusing with it to make it act under his volition. In fact, the critic
> Kotani Mari points out the increasing feminization of Shinji in lat-
> er episodes, hinting at the affect [sic] that the EVA has on Shinji's
> personality (Napier 2005, 99; Kotani 1997, 101-2).

The "feminization" described by Kotani and Napier was in fact
planned at an early stage, with designer Yoshiyuki Sadamoto being asked
to create a protagonist whose appearance signalled his break with the tra-
dition of the macho *mecha* hero:

> So finally I tried for a look where you could see the forehead
> through the bangs, shorter hair—the look of a boyish young girl....
> Especially in the past one or two years, this type of refractive, fem-
> inine character has not been seen (Sadamoto 1998, 164-5).

The role of Shinji, moreover, was cast with a female voice actor, Megumi Ogata; not an unusual choice for boys' roles in animation, but here further contributing to an impression of androgyny. These elements are much more important to Shinji's characterization throughout the series than the relatively late homoerotic advances of Kaoru.

Schreber's famous "unmanning," of course, began internally, with "the idea that it really must be rather pleasant to be a woman succumbing to intercourse" (Schreber 2000, 46), but he soon perceived outward manifestations, in the form of smoother skin, female buttocks, and the beginnings of a bust, as well as an overall sense of increased 'voluptuousness' (Schreber 2000, 53; 163-5; 248). These changes were signs that Schreber was being prepared to fulfil the role of the so-called "Eternal Jew," whose fate it was also to be unmanned and to become the single human being spared in the destruction of the world (Schreber 2000, 60-1). As with Schreber's unmanning, Shinji's feminization too is accompanied by supposed outward physical signs of femininity and foreshadows his eventual position as sole surviving human being and catalyst for the repopulation of the world. The combination of feminization and messianic delusion induces Schreber to liken himself not only to Christ (Schreber 2000, 80) but also, and even more explicitly, to the "Immaculate Virgin" (Schreber 2000, 17-8); likewise, Mari Kotani sees the combination of Shinji/Evangelion as a "female saviour" (Kotani 1997, 102-4) and titles her study of the series *Seibo Evangerion* ("*Evangelion* as Immaculate Virgin"). At the same time, in both cases, this feminization also points up the artificiality of masculinity and patriarchy in the respective contemporary societies, as what Kotani calls "a cult of meta-masquerade" (Kotani 1997, 103) and Santner an "insupportable habitus" (Santner 1997, 178).

Janet Lucas further points out that Schreber uses scientific terminology as a substitute for religious faith (representing "the symbolic legacy of his father"). When, however, science fails to cure his "nervousness," the dichotomy between science and religion collapses, God is revealed as "thoroughly inept," and Schreber constructs a hybrid discourse of science and religion with himself as the central "master signifier" (Lucas 2003)—a bizarre combination of machine and messiah, of physical *Nerv* and metaphysical *Seele*. A similar conflation of science and religion permeates *Evangelion*; despite the scientific trappings of DNA and supercomputers, both NERV and SEELE depend upon prophecies from the Dead Sea Scrolls, while recurring Kabbalistic imagery marks the EVAs not only as 21st-century cyborgs but also as descendants of the medieval Golem.

Patrick Drazen has observed that the creators of *Evangelion* turned to Western religious ideas because:

Judeo-Christianity ... lends itself to apocalyptic visions. It thus serves the Japanese the way Islam or voodoo serves the pop culture of the West: as a fantasyland onto which we can project our fears and suspicions, claiming that this arcane and alien faith is capable of almost anything. (Drazen 2002, 307)

Similarly, the Westerner Schreber, whose interest in comparative religion is an important element in the construction of his delusions, projects his own fears partly onto the "arcane and alien faith" of the old Persians who "were pre-eminently the 'chosen people of God,'" as evidenced by the retention of the Persian names Ormuzd and Ariman for his two gods (Schreber 2000, 31).

Schreber's conflation of science and religion, of course, is closely bound up with his own apocalyptic "preoccupation with themes of death and rebirth" (Bregman 1977, 127), another common feature of schizophrenia (Adams 2004, 80-1). Here, however, "the ultimate creation is ... the 'new birth' of Schreber himself, whose entire personality structure must be recreated out of the ruins of his previous identity" (Bregman 1977, 127). As we have seen, both endings of *Evangelion* depict what Drazen calls "the reconstitution of Shinji's psyche" (Drazen 2002, 308). The feature film, in fact, ends in a vision of "rapturous" apocalypse in perfect concert with Freud's interpretation of Schreber, which according to Santner,

culminates in a remarkable claim that gives the psychic mechanisms of paranoia a nearly kabbalistic cast ... as if Schreber had recreated, in debased form, the Lurian "procedure" of *tikkun*, the recollection of divine sparks scattered into earthly exile through the cosmic trauma of the "breaking of the vessels." (Santner 1997, 57)

The Kabbalistic concept of *tikkun olam* (Hebrew for 'repairing the world') is a fitting description for SEELE's version of the Human Instrumentality Project in *Evangelion*; hence it is appropriate that the procedure begins with the all-important Tree of Life forming around Shinji's EVA. (The NERV-ending too, of course, ends with the world repaired, though by less violent means).

Finally, this common atmosphere of apocalypse and rebirth reflects both works' similar historical positions in a context of social crisis. Eric Santner explicates Schreber's delusions as products of their German historical context, arguing that "the series of crises precipitating Schreber's breakdown, which he attempted to master within the delusional medium of what I call his 'own private Germany,' were largely the same crises of

modernity for which the Nazis would elaborate their own series of radical and ostensibly 'final' solutions" (Santner 1997, xi). Against a background of comparative economic prosperity and nationalist pride, these crises included increasing political conflict among the classes and between Germany and its neighbours; ongoing secularization, industrialization, and urbanization; and a sense of increasing pressure on Schreber's own middle classes (Santner 1997, 6-9). For Santner, it is Schreber's engagement, however unwilling, with these crises of modernity that makes him a quintessentially modern author.

Cindy Hendershot, moreover, has further argued that Schreber's paranoid discourse bears a crucial similarity to the themes and language of modern science fiction, particularly in American films of the 1950s, during the beginning of the nuclear arms race. She claims:

> Schreber's ... belief in "fleeting-improvised men" peopling the world after its destruction and his survival of the destruction can be related to science-fiction discourse prevalent in the late nineteenth century and throughout the twentieth century. Schreber's "miraculously created puppets"... relate to the nineteenth-century popularity of the golem, which has become transformed into the robot... (Hendershot 1999, 13).

Thus, where Santner, through Freud, sees quasi-Kabbalistic eschatological mysticism in Schreber's text, Hendershot sees robots and technological apocalypse. These two strands meet and intertwine again in *Evangelion*.

Patrick Drazen, in similar terms, has described the social context of *Evangelion* as follows:

> The beginning of the last decade of the twentieth century saw the Japanese economic bubble burst: real estate, which had been ridiculously overvalued, plummeted in price, and everything else went with it; the acquisitions of the affluent '80s had to be sold off at a loss; and Japan lost its perceived spot as undisputed leader of the Pacific Rim. In the year 1995, when *Evangelion* premiered, Japan suffered perhaps its worst year since the surrender [of World War II], capped by the Aum Shinrikyo cult gassing of the Tokyo subway in March and the Kobe earthquake in September. (Drazen 2002, 309)

Anno, even before the series had begun airing, said: "This is a worldview drenched in a vision of pessimism... But... But it's only natural that

we should synchronize ourselves with the world within the production"
(Anno 1998, 170-1).

In *Evangelion*, the "atmosphere of claustrophobia and paranoia" de-
scribed by Napier (2002, 423) thus not only reflects a *fin-de-siècle* Japanese
social crisis analogous to that in Germany a century previously, but in-
deed also appropriates the very same German psychological terminology
that Schreber had appropriated in his turn, conflating these terms with
religious concepts in a manner typical of paranoid discourse in general
and Schreber's case in particular. The degree to which Shinji's experiences
carry the traits of mental illness, however, signifies not his psychic insta-
bility, but rather the ferocity of Hideaki Anno's social critique: *Shinseiki
Evangerion* is literally 'New Century Gospel,' and *Neon Genesis Evangelion*
depicts a future dysfunctional Japan in which Shinji Ikari comes to a cri-
sis of identity that destroys his very world and forces him to reconstruct
it and himself, in a process that can be seen in two completely different
ways. One version shows the world around him apparently surviving re-
newed; in the other, the world is destroyed and its renewal left in abey-
ance. In both cases, however, Shinji's changed relationship to the world is
really a "profound internal change": in *Evangelion* as in Schreber's delu-
sions, NERV and SEELE are two sides of the same coin, and the superhe-
roic feat is a battle not against supernatural invaders, but rather against
the demons within.

9
Shamans vs (Super)heroes

Lucy Wright

Super-muscles and super-punches will only get you so far. When the en-emy takes an inexplicably numinous form, you must turn inwards–to the mind, to dreams, to the spirit world–in order to find a solution. Adept with spiritual visions and altered states, the shamans were possibly the earli-est heroic figures to 'save the day' by protecting their communities from the hostile forces of chaos that surrounded them. In this paper, I argue that the modern superhero is a contemporary manifestation of the ancient shamanic role. Where one is a superhero, the other is a supernatural hero. I will analyze how the shaman has been reconfigured in popular culture and trace the expressions of the shaman from rock art, Greek mythology and contemporary science fiction films. Examining superhero characters such as Superman and Batman, and also sci-fi characters such as Dr Aki Ross in *Final Fantasy: The Spirits Within* (Sakaguchi, 2001), this chapter of-fers an investigation into the similarities and differences between Shaman and superheroes.

Shamanism: Origins and Features

Shamanism has been a key feature of nomadic cultures all over the world, from regions as diverse as the Arctic Circle and the Amazons, to Australia and Africa. Shamanism dates back at least to the Stone Age, with shamanic imagery such as birds, shamans in trance states, and animal spirits found in the earliest cave art of the Paleolithic era (Ripinsky-Naxon 1993, 191). Religious historian Mircea Eliade was one of the first scholars to undertake a comparative study of the shaman, and to elucidate the characteristics of this enigmatic figure. Eliade identified how the shaman performed many different roles in society, including that of magician, healer, psychopomp, priest, mystic and poet (Eliade 1964, 4). But above all, Eliade argued that the shaman is a "great master of ecstasy":

> Healer and psychopomp, the shaman is these because he com-
> mands the techniques of ecstasy–that is, because his soul can
> safely abandon his body and roam at vast distances, can penetrate
> the underworld and rise to the sky. Through his own ecstatic ex-
> perience he knows the roads of the extraterrestrial regions... The
> danger of losing his way in these forbidden regions is still great;
> but sanctified by his initiation and furnished with his guardian
> spirits, the shaman is the only human being able to challenge the
> danger and venture into mystical geography. (Eliade 1964, 182)

Eliade noted that the shaman was an expert at achieving ecstatic
trance states which enabled him or her to perform supernatural feats, such
as communicating with the spirit world, magical flight, telepathy, trans-
mogrification, and mastery of fire. Indeed, the root of the word 'shaman'
can be traced to the Tungusic *saman*, which means "one who is excited,
moved, raised" or "to know in an ecstatic manner" (Grim 1983, 15). To at-
tain a receptive state for enacting their supernatural power, shamans used
certain techniques such as taking preparations of hallucinogenic plants;
by hyperactivity such as beating a drum or dancing; through deprivation
and fasting; or through dreams. Often a shaman symbolically 'died' in
order to leave his or her body to make this journey.

Inherent in the practice of shamanism is the perception of a stratified
cosmos, where the world is divided into different realms, both spatial (the
underworld, the spirit world, the heavens, etc) and temporal (past, present
and future). By traveling through the various realms and communicating
with spirits and deities, the shaman searches for the root of the evil (that
which has upset the balance in the community, e.g. illness or misfortune)
and seeks to redress it. This apotropaic quest often requires battling errant
or malevolent spirits, or returning lost souls to their rightful place. One
of the key roles of the shaman was that of mediator between the human
realm and the animal/spirit world, and healer of illnesses, both physical
and spiritual. In shamanism there is a belief in the spiritual lifeforce in
all things–whether human, animal, inanimate or elemental–and that these
spirits are capable of affecting and interacting with the real world (Eliade
1964). Edward Tylor called this mode of being-in-the-world 'animism' and
identified it as a key feature in 'primitive cultures'. Tylor noted in animis-
tic beliefs there was a distinction drawn between the human soul and the
external, ghostly spirit (1871, 194-195). Where the soul is strictly human
and is strongly connected to the living body, spirits are autonomous and
often wicked, or at least mischievous. Shamanic practices are largely fo-
cused on dealing with the soul and spirit.

Figure 15: Image of a Shaman. © Rock Art Research Institute, University of the Witwatersrand. Used by permission.

In his study of shamanism as a religious metaphor, Michael Ripinsky-Naxon hypothesized that the origin of shamanism can be traced to early humans' awareness of the death/rebirth cycles of life. Ripinsky-Naxon argued that this "*Ur*-religion" was the first stirrings of mankind's attempt to articulate and control his environment. (1993, 9). Like Tylor, Ripinsky-Naxon theorized that the original source of animistic and totemic (the sense of kinship with animals and plants) beliefs arose from the visitations of dreams, or visions experienced during trance. That is, that trance states had a neurological basis. Ripinsky-Naxon noted that it was the "shaman's task to organize and impart coherence to the inveterate journey of existential quest, thus affording ideological purpose and ecological possibilities to the human condition" (1993, 10). In short, the key role of the shaman is that of mediator between the human realm and the animal/spirit world, and healer of illnesses, both physical and spiritual.

The vocation of shaman was not for the faint-hearted. There were two ways in which young shamans were recruited: the role was either inherited, or the shaman was 'called'. Not all who *can* become shamans *do*. While shamanic talents can be lineal, it is more common to be called in dreams, or in an encounter with a totem animal. Waldemar Bogoras, a Russian revolutionary who was exiled to Siberia where he lived with the Chukchee people, poetically described this second method as being "doomed to inspiration" (1904, 53). Initiation ceremonies are ordeals of pain and suffering. Some initiates starve themselves under supervision, others wear collars of stinging ants, or wander in the wilderness for many days and nights without water or food, and often ablutions and bodily purifications are an important part of this process. The purpose of these hardships is to undergo a symbolic death. After the ties of corporeality are broken, the shaman is free to travel in the spirit world and seek knowledge. The survival of the test results in enhanced powers of perception, and often the winning of an animal spirit protector of some kind (Narby & Huxley 2001, 1).

Eliade concluded that, while the practices of shamans varied significantly over time and place, shamans played "an essential role in the defence of the psychic integrity of the community" (508-9). Eliade argued that shamans defended "life, health, fertility, the world of 'light' against death, diseases, sterility, disaster, and the world of 'darkness'" (1964, 508-9). (What is this if not the essence of the superheroic saga?) Robin Wright, in her study of the Baniwa shamans of Colombia, goes so far as to propose that in their magico-religious role, shamans are literally "guardians of the cosmos":

One of the legacies of cosmogony… is that the world in which humans live is permanently flawed by evil, sickness and misfortune. Like a sick person, this world is in constant need of healing. In the process of his apprenticeship, the shaman acquires the power to heal and remake the world through his complete identification with the spiritualised being of the cosmos. In this sense, shamans are the guardians of the cosmos. (1992, 126)

Mythical and Folkloric (Shamanic) Heroes

The prevalence of shamanism in humanity's early cultural development resulted in the widespread appearance of shamanic metaphor and lore in many myths and legend. For instance, early epic narratives are most likely derivative of, and certainly contain vestiges of, shamanic themes and ideology. Classics scholar Gerald K. Gresseth suggested that the *Gilgamesh Epic* and the heroic epic genre itself "was not a fortuitous artistic discovery but the result of a new idea, that of the human hero as contrasted with an older, more divine or 'shamanistic' type of hero" (1975, 1-18). Likewise Greek historian Walter Burkert argued that the shamanic quest of traveling to a supernatural realm to bring back knowledge or to perform a deed–often to parlay with a supernatural owner of animals, such as the Master of Animals or the Old Woman–provided the underpinning structure for a number of Greek myths, particularly those of Heracles (1979, 88-89). Eliade also identified the similarities between shamanic practices and the metaphors used in Greek myths, and found many parallels between shamans, and classical heroes. He cites Orpheus as a shamanic hero, able to heal illness, to charm animals, and of course his descent to Hades to recover his wife Eurydice's soul (Eliade 1964, 387-394).

To offer a few more examples, Achilles was tutored in healing and warcraft by the centaur Chiron (another example of a hero seeking knowledge from the supernatural animal world), while Jason (also taught by Chiron) sought the golden fleece in order to avert the disaster foretold by the Oracle if his cousin Phrixus' soul was not laid to rest. The name Jason literally means 'healer', and he acts to restore his community by rescuing a lost soul. There is also Prometheus, who stole fire from the gods to give to humanity; and Priam's night journey in *Iliad* Book 24 through the battlefield at Troy to Achilles to bring home the body of his son Hector for a proper burial. This description also has a 'shamanic' pattern to it. Another example is the *shamanin* of India, female shamans whose initiation process bears a striking similarity to the Greek myth of Persephone. British anthropologist Verrier Elwin analyzed how the young

shamanin are generally 'called' to their profession by the appearance, in a dream, of a 'suitor from the Under World'. If the girl refuses this divine lover, as usually occurs, she become ill and loses interest in the world. Only when she confesses to her parents, and they finally bless the union and arrange the 'marriage', does the girl recover. The young initiate then takes up her role as healer and her ghostly partner assists her in her work (Elwin 1955, 115). In the Greek myth, Persephone was snatched by Hades, the god of the Underworld and taken down to his realm against her will. While there, she eats the seeds of a pomegranate, which means that she must stay in the Underworld. At the mourning and grief of her mother Demeter, Zeus steps in to settle the matter. It was agreed that Persephone will spend part of the year with her mother and part with Hades (in the *Homeric Hymn to Demeter*).

Shamanic imagery lives on in the folklore of other regions as well. Many shamanic initiation rituals involve shamans' visualizing the removal of their own flesh until only the skeleton remains. Another shamanistic ritual is the visualization of the dismemberment of the body piece by piece –both of which symbolize the freeing of the soul from attachment to the body. This is usually followed by a mystical rebirth. This is a common trope in Asian and Baltic heroic tales, where the hero is cut into pieces, then restored by a woman, usually a girl relation, who arranges the bones in the correct order (Stutley 2003, 18).

The Superhero as Shaman?

The pillaging by superhero comic writers of mythology, folklore, and biblical and classical literature for stories is well documented (Reynolds 1993, 53). But it is rarely recognized that superheroes also act in ways that allow comparison with the figure of the shaman. In his key text on the genre *Superheroes: A Modern Mythology*, Richard Reynolds looked to Superman to deduct the key characteristics of this relatively recent phenomenon, which include: 'lost' parents; a 'man-god' origin story; a commitment to justice; a secret identity; and a clear distinction between "the normal and the superpowered" (Reynolds 1993, 12-14). Of course, not all superheroes have all of these features. Neither do many shamans possess all of them. However there are at least two important features of a superhero that are shared with the shaman: Both have unusual powers, which they employ in a purifying and healing role in their communities (often at great cost to themselves); and both use science or magic (which are usually conflated).

Firstly, superhero comics and films are concerned with the ongoing battle between chaos (represented by villains) and the social order ('normal'

people whose way of life is to be protected at all costs) (Reynolds 1993, 24). The superhero and the shaman both signify the ability to cross over between worlds where different rules apply, where the fantastic is possible. That is, superheroes and shamans are able to mediate and move between different orders of reality, between chaos and normality. This transitional and mediatory role is often manifest in metaphoric terms. While superhero stories do not necessarily involve literal geographic shifts (although these are possible by using the metaphor of flight), narrative tricks may symbolize the Underworld by using tormented dreams, or the dangerous laboratory, or a dark alleyway; and angry spirits may be translated to a supervillain who disturbs the social order in some way. In this liminal role, both act altruistically. Superheroes and shamans essentially do what they do for the good of mankind, or at least their immediate community or metropolis (Richardson 2004, 694). They risk their lives in a never-ending battle against the forces of darkness and chaos. A common motif is that superheroes 'pay' for their special powers and the price is often an emotional distance from the communities they protect. A shaman is also necessarily an isolated figure. As the Inuit shaman Igjugarjuk noted, "solitude and suffering open the human mind, and therefore a shaman must seek his wisdom there" (Narby & Huxley 2001, 82).

The other crucial aspect of 'superhero-ness', is related to the nature of the world in which the superhero exists–where science and magic are conflated. Reynolds argued that "science is treated as a special form of magic, capable of both good and evil" (Reynolds 1993, 16). The superhero is very much a product of the industrial age and employs scientific terminology. Superman was born in 1938, and as with the other heroes of the 'Golden Age' of comics he manifested many utopian ideals about technology, modernity and masculinity (Bukatman 2003, 185). It was later in the 'Silver Age' that superheroes became more complex characters, often struggling with difficult choices and feelings of ambivalence towards technology. The vast pantheon of superheroes who followed Superman owe many of their super-abilities to science and/or technology (for example Spiderman was bitten by a radioactive spider; the X-Men's Wolverine is a product of genetic mutation and a secret military project; and Batman's abilities are amplified by the technological support that his fortune [as Bruce Wayne] can afford him). However, explanations of how these 'scientific' powers actually work are at best vague and symbolic. Superhero stories simply draw on scientific terminology of the times to lend their characters a sense of authenticity, and to 'futurize' them.

Claude Levi-Strauss emphatically argued that 'primitive' approaches to knowledge were scientific in the sense that it was the result of long observation of natural phenomena, experiments and deductions. He called

this kind of knowledge 'the science of the concrete' (Levi-Strauss 1966, 1-33). Ripinsky-Naxon agrees that shamans must necessarily be scientific in their approach to knowledge to fulfill their important role:

> Equipped with an impressive corpus of empirical knowledge (eth-noscience) and a profound grasp of human behaviour, the sha-man fulfils the vital role of a psychocultural adaptive mechanism, not merely as healer of diseases, but as a harmoniser of social and natural dysfunctions and imbalance. (Ripinsky-Naxon 1993, 9)

In superhero stories, the science and technology are not important in and of themselves, but as signifiers of a type of knowledge. Reynolds points to the 'alliance of knowledge and social order' as the way in which nor-mality is established and promoted. In shamanic cultures, the shamans likewise have access to a particular type of knowledge which is the source of their power (Reynolds 1993, 25). In addition, the shaman is responsible for maintaining the group's mythological knowledge (Stutley 2003, 6). Whereas shamans *protect* knowledge, superheroes *embody* knowledge; it is inscribed on their physical form.

The costume and mask is a particularly interesting point of compari-son between the superhero and the shaman. Reynolds pointed out that the costume was "a crucial sign of super-heroism" (Reynolds 1993, 26) and ar-gued that wearing the costume instigates a series of associations, or what anthropologists would call sympathetic magic. It literally transforms and transports the hero from normality, to super-ness. The shaman's donning of ceremonial animal skins or wearing antlers and horns, also transforms and augments the shaman's powers. Ripinsky-Naxon suggested that it was through this act that the shaman was able to draw on the power of the animal world:

> A total transformation requires also the transference of the spirit or soul, so the mask, becoming a metaphor, allowed the wearer, through *mimesis*, to take over the *animus*, as well as the *persona*, of the creature or being it represented. (Ripinsky-Naxon 1993, 42)

Many superheroes find their vocation in a similar way to shamans, undergoing sometimes painful initiations to adjust to their new powers. The Hulk inherited his superpowers from his father's genetic experiments and periodically endured a physical transformation which strains the lim-its of human musculature. Batman was in a sense 'called' when he wit-nessed the brutal murder of his parents, and a bat revealed his destiny to fight crime in Gotham City. Catwoman would still be timid as a mouse if

Figure 16: The spirits unleashed in *Final Fantasy: the Spirits Within (dir.* Hironobu Sakaguchi). © 2001 Square Enix/Columbia Pictures. All Rights Reserved.

not for her encounter with an Egyptian cat deity. And one of the few bla-
tantly ecological superheroes, Poison Ivy's powers come from plants after
a biological accident (although in *Batman & Robin* she is villainously intent
on turning Earth into a greenhouse).

Looking to science fiction, which is intimately bound up with many
of the same concerns as the superhero genre, there are a number of he-
roic figures which are both 'superheroic' and 'shamanic'. Neo in *The Ma-
trix* trilogy (Wachowski, 1999, 2003) is a particularly shamanic superhero.
Using the metaphor of the world as a complex virtual reality network,
Neo finds his destiny by following a white rabbit. He was born with this
knowledge and learns how to use it after he encounters the 'programs' or
malevolent spirits of the machines. As his powers develop he is eventu-
ally able to alter the fabric of both the reality of the matrix as well as that
of the 'real' world. He can fly, fight with superhuman strength and speed,
and stop time. His true moment of initiation occurs when he is shot by
the agents, and learns how to live past the symbolic (that is, in the matrix)
death of his body.

Finally, Dr Aki Ross in *Final Fantasy: The Spirits Within* is an example
of a normal person being 'called' into a shamanic role after a spiritual en-
counter. Aki is a scientist in a future where all life on Earth has been wiped
out by aliens that cannot be killed. She is 'called' into service to save her
world because she has been physically infected by alien ectoplasm. *Final
Fantasy* follows shamanic pathology and visualizes two causes of death or
illness: the loss of soul (when a blue soul is ripped out of the living body it
inhabits), and possession, which is when a living human is infected by red
alien ectoplasm, as happens to Aki.

Working both in the laboratory and communicating with the aliens in
her dreams, Aki symbolizes the shamanic state of standing in both worlds.
The dream-state that Aki enters is akin to the shaman's quest to discover
the source of 'evil', and to deduce the cure. She comes to understand the
nature of the aliens–they are *ghosts*, spiritual energy. Also, through the
technology of her time–based on 'bio-etheric' energy which her mentor Dr
Sid has developed as a result of the alien invasion–Aki also comes to un-
derstand the 'scientific' basis of the alien's existence. In a shamanic initia-
tion sequence, Aki journeys to their destroyed homeworld and witnesses
their story. She learns how to lay the ghosts to rest using a machine to
collect eight spirits, and thereby save her world. *Final Fantasy* offers both a
shamanistic (magical) and scientific worldview syncretically working to-
gether. Aki is a combination of these epistemologies which challenges and
problematizes the dichotomy between the rational and the non-rational,
the technological and the animistic, the superhero and the supernatural
hero.

In conclusion, this chapter has argued that shamans are archaic examples of heroic figures who cross over to a fantastical realm in order to save their community, as many later superheroes have done. I have analyzed the similarities between both superheroes and shamans, identifying both as isolated characters, separated from the very people they protect. Both have unusual powers, which they employ in a purifying and healing role. Where superheroes and shamans differ most is in their temporal and ideological locus of action: shamans are products of the natural world, while superheroes and science fiction heroes are modern adaptions after the introduction of technology and new modes of scientific thought. It is clear that certain elements and motifs of the shaman appear in popular culture in various forms and that superheroes continue the special heroic tradition begun by shamans.

10
Dreaming Superman: Exploring the Action of the Superhero(ine) in Dreams, Myth, and Culture

Jamie Egolf

Introduction

This chapter reviews the archetypal image of the Superhero(ine) in dreams, in mythology, and in culture. It explores the action of the Superhero myth and its meaning in the individual and in culture from a Jungian perspective. Jungian analysts and mythologists, including Joseph Campbell, have written about the hero myth in such figures as Odysseus in Greece, Parzival in medieval British Isles, and Superman in America. Comic book analysts have written about the creation of Superman, which to some represented the force in immigrants and orphans who arrived in America, often with few resources, and had to somehow survive and fulfill their destiny. Their progress was nothing less than superheroic. Individuation, the goal of Jungian work, involves heroic activity as well. Drawing on my experience a Jungian-trained psychotherapist who has worked with hundreds of individuals during my 36 year practice, I explore the superhero archetype in the dreams of ordinary men and women in case studies from my practice. This chapter also explores heroism as it relates to the individual in culture and as it compares to the hero in mythology.

Superman came on the comic book scene in June of 1938, created by two seventeen year olds, writer Jerry Siegel and artist Joe Shuster, shortly before World War II began in 1939. For several years there had been considerable economic and political unrest in Europe and the Far East. Germany and Poland were at war over a disputed territory as were Japan and China. Hitler had appointed himself War Minister in Germany and published *Mein Kampf* also in 1939. Against the backdrop of a US stock market in decline, the United States had adopted a stance of neutrality, and President Roosevelt had urged European nations to settle their disputes amicably. And taking his cue from the world of fiction, Orson Welles produced the radio program "War of the Worlds," creating widespread panic when fiction was misinterpreted as fact (Grun 1991, 512-516). This worldwide

unrest was the context that fuelled the birth of the mythic image and a savior figure–Superman. By 1941 "*Superman* was being advertised as 'The World's Greatest Adventure Strip Character' and was appearing in a half dozen comic books and on the radio" according to the *World Encyclopedia of Comics*.

Comic book analyst Gary Engle comments on another force in the culture that influenced Superman's immediate success in 1938:

> It is impossible to imagine Superman being as popular as he is and speaking as deeply to the American culture were he not an immigrant and an orphan. Immigration... is the overwhelming fact in American history. Except for the [American] Indians, all Americans have an immediate sense of their origins elsewhere. Like the peoples of the nation whose values he defends, Superman is an alien [and] an immigrant. From the nation's beginnings, Americans have looked for ways of coming to terms with the immigrant experience. The American identity is ordered around the psychological experience of forsaking or losing the past for the opportunity of reinventing oneself in the future. This makes the orphan a potent symbol of the American character. Superman raises the American immigrant experience to the level of religious myth. (Dooley and Engle 1987, 86)

Coming from Krypton, Superman was an alien himself, and it was natural that he became a champion for orphans and immigrants in America. Many immigrants brought to their new country the burden of oppression they had experienced in their countries of origin. There were also thousands of children orphaned after WWI, and many of them had made their way to America. Writing before this time, Carl Jung taught and wrote that no one knows him/herself better than the orphan. In my practice as a Jungian-trained psychotherapist, the orphan archetype comes up often in the dreams of people who were never, in fact, orphaned, simply because the psyche of a person who has experienced abandonment functions like the psyche of an orphan. The Superman archetype not only serves to compensate for the feelings of powerlessness, helplessness, and victimization of the 'orphan', but it also facilitates healing from our corporate wounding as American 'orphans' and creates the energy one must have to realize the potential for selfhood.

In 1883 Friedrich Nietzsche wrote *Thus Spoke Zarathustra*. Zarathustra was a prophet based on a figure Nietzsche said had appeared to him in a dream as a boy, and his moral teaching was in part about the cosmic struggle between the powers of light and darkness–good and evil (Jung

1988 1:4). Zarathustra's message was also that the idea of the Overman (Übermensch, Superman) is the new goal for human beings. To be just a human being is to be a laughing stock (Higgins 81, 2). In these terms, "only rare, superior individuals–the noble ones… can achieve a heroic life of truly human worth" (Kemmerling 2005). It seems that as a result of political changes in Europe, there was a radical shift in personal identity. Nietzsche may have played a part in this identity shift, as he was (and is) widely read; the Übermensch would become a serious phenomenon in culture and in individuals. In both Europe and America, there was fertile ground for the genesis of the Superman phenomenon in the unique style of each continent.

In my practice, I became curious about the frequency of Super(wo)man dreams. I researched comic book analysts to get a fresh perspective on this archetypal image. That research began and continued to inform the present essay. In this essay, I explore the Mythic image of the Superhero(ine); Superman's relationships; and the Death of Superman. I use dreams, examples of the Superman archetypal image, and material from case studies. Jungians use such dreams and myths to understand and explain the inner processes of their clients.

Mythic Image of the Superhero(ine)

Becoming aware of the force and magnitude of the Super(wo)man archetype allowed me to instruct my clients about the positive and negative ramifications of it. It is important to become conscious of the dangers of identification with any archetype, such as a love goddess like Venus, a water nymph like Syrix, or like Superman. That knowledge allows clients to accept their humanity and their uniqueness. For those with significant wounds, it is difficult to accept their ordinary and vulnerable selves. The Self is not fully present when the psyche has been deeply wounded. The hero and superhero archetypes are images that represent what is known as the transcendent function, a process that operates as a bridge between the opposites, therefore providing unification in the psyche, restoring energy and promoting healing. One of the aims of Jungian work is to reconcile such opposites as good and evil, the ordinary and the extraordinary, weakness and power. The Superman archetype can spring up either in individuals or in cultures to compensate for fear¬Super(wo)man will protect us! An example is a client who is a middle aged woman and a second generation European immigrant, for whom Super-heroine dreams were a compensation for her feelings of powerless and unworthiness.

She often dreamt she was Superwoman, she could fly, and she actually believed that she could accomplish anything she chose, either in dreams or in waking life. She had a wall lined with plaques from organizations showing their appreciation to her for what she had accomplished for them as a donor or a volunteer. But her inner feeling was that she was weak and ineffectual. In actuality she is the president of a realty company that produces millions of dollars worth of business annually. She had been raised by talented parents who were university professors, but who were indifferent to their children. The father was alcoholic and abusive, and the mother was complicit in his treatment of the children. These circumstances contributed to her "orphaned" psychology because of the emotional and physical abandonment she experienced. She was gradually able to change her identification with Superwoman and still allow the energy this archetypal image represents to facilitate her movement toward Selfhood.

Superman and his alter ego Clark Kent together form a mythic, archetypal image. This and all other archetypes reside in the collective unconscious, a psychic territory that is shared by all of us. Archetypes are the seeds for, or patterns of our behavior as individuals and in cultures. In a given situation, such as the immigration and orphaning mentioned before, an archetype may arise to explain and motivate our instinctual response to the situation. The image or symbol attached to the archetype populates our dreams, our fantasies, and our creative expression of the event that stimulated the activation of the archetype, and our response to it. Leonardo's Mona Lisa is an example of his archetypal expression of woman, painted by a man orphaned at birth. Mythologist Joseph Campbell elaborates further: myth is the "secret opening through which the inexhaustible energies of the cosmos pour into human cultural manifestation–religion, philosophy, arts, social forces, discoveries in science and technology, and the very dreams that blister sleep boil up from the basic, magic ring of myth" (Campbell 1973, 3).

The hero myth also explains the process of becoming one's whole Self. Hero and superhero have overlapping symbols and images. The hero in a fairy tale, for example, achieves a "microcosmic triumph, and the hero of myth a world-historical macrocosmic event." The fairy-tale hero achieves a personal success, while for the mythological hero, success is a means for the "regeneration of his society as a whole" (Campbell 1973, 38). Superman is an example of the mythological hero. His birth and the story of his origins are miraculous. The "hero is not born like an ordinary mortal because his birth is a rebirth from the mother-wife. That is why the hero so

often has two mothers. The hero is frequently… reared by foster parents" (Jung 1976, 5:321). Buddha and Moses, for instance, were brought up by foster mothers. The mother is sometimes an animal, like the she-wolf of Romulus and Remus. The dual mother may be replaced by the motif of dual birth such as Christ's death and resurrection.

> In Christianity… baptism represents a rebirth. Man is not merely born in the commonplace sense, but is born again in a mysterious manner, and so partakes of divinity. Anyone who is reborn in this way becomes a hero, a semi-divine being. Christ's redemptive death on the cross was understood as a baptism… a rebirth through the second mother symbolized by the tree of death. (Jung 1976, 5:321)

Superman possesses this duality of birth and rebirth as well. In *The Superman Story*, he describes his origins while attached to the "mind prober ray" which he invented as a boy to retrieve long-buried memories from his unconscious. Because of repeated exposure to kryptonite over the years, there are gaps in his memory. He recalls his mother, Lara, and his father, Jor-El, and the situation that propelled him as Kal-El from his planet–the ground quake which destroyed Krypton. His parents, being unable to escape themselves, placed Kal-El into a rocket ship that penetrated the earth's atmosphere and exploded, expelling the boy, whose cries were heard by his foster parents-to-be, Jonathan and Martha Kent. Soon they recognized his "superpowers–super speed, flying power, heat vision, and telescopic vision." In their wisdom, the Kents decide to keep their son's superpowers a secret during his growing up–they were determined that he would have a normal childhood. At a certain point in Clark's development, he was ready to use his powers to help people. Knowing that he needed to have a recognizable uniform, he unraveled his indestructible body suit, and his mother Martha fashioned his new uniform from it. His father Jonathan helped too, designing an insignia, a stylized S to stand for his professional name. Clark himself stitched up his boots using material taken from the rocket ship with a needle made from a sliver of metal from the ship. Its seat belt became the belt of his costume (Azzarello 1979). Mythologically, this scenario is reminiscent of the Parzival legend in the Grail stories. Parzival at the beginning of the tale is dressed in the homemade clothing which was fashioned by his mother; he is drinking up the spring sunshine and throwing javelins (Von Eschenbach 1991, 70). As he leaves the family home to begin his journey, he is, in a sense, a fool. To the Jungian therapist, the fool state represents a psyche which is in a state of flux, or unindifferentiation. As Parzival continues on his journey

toward knighthood, he exchanges his homemade suit for the costume of a knight. The changing of the clothing represents Parzival's move further away from his boyhood and his fool or undifferentiated status and toward his hero status. Like Parzival, Superman has traded his homemade garment in for his new man-of-steel *persona*.

An example from case material of the movement from this state of flux or 'undifferentiation' occurs in a man who dreams that *he is stacking blocks, moving them from one place to another; he's sweating and working hard. The blocks are colored like a child's building blocks, and he makes piles and then structures from them.* It is difficult for this client to move out of his boyhood and into adulthood. In a similar way, Superman recounts the last days of his youth in Smallville as the happiest days of his life. "But they're gone now," he tells Lana, "and not just in the way that childhood is over when you grow up either" (*Superman* #210, 2004).

Superman and Relationship: *Anima* and *Animus* Development

The inner feminine image in a man is called the *anima,* or soul image, and the progression from one female image to another is called an *anima progression.* This soul image becomes transferred to a real person who becomes the object of intense love or equally intense hate or fear. Man is an incomplete being without this *anima* development. To illustrate this from case material, a man dreamt of:

> a beautiful woman in a long gown with a crown of oak leaves, who was caught within some thorny bushes, that he couldn't penetrate to reach her. He thought she was like a goddess from Druid mythology. Sadly, he was unable to feel the support of the innerfeminine because "she" was out of reach—until he did a little bushwhacking into the thorns so as to retrieve her. He couldn't actualize a marriage to a woman in waking life until he retrieved this illusive anima figure and until the inner marriage was successfully completed.

Superman's *anima development* takes a circuitous route until it is complete: after building his 'fortress' of solitude in the Arctic Circle, he built a special headquarters for his new super-powered associate, his cousin Kara, the daughter of his father's brother Zor-El. She's a Superheroine in her own right and an *anima* figure. Superman's love life progresses from Lana Lang, an early sweetheart from whom he eventually grew apart, to Lori LeMaris, a mermaid from the sunken continent of Atlantis, and then

finally to Lois Lane, whom he believes he can not marry without subjecting her to the dangers inflicted by his enemies. The images of Parzival's love object, Venus and the endless knot, were etched upon his shield; other knights often had the Virgin Mary or the Queen of the castle to whom they were beholden emblazoned onto their shields. Another knightly relationship parallel is Superman to Lois and King Arthur to Guenivere. Both men were removed, committed to higher purposes, and basically unavailable to their love objects emotionally. In the earlier Superman comics, it was really Clark Kent who loved Lois "in hopeless frustration, and Superman could not return Lois' love because to do so would be to reveal that he was in reality Clark" (Dooley and Engle 1987, 140). The medieval triangle between King Arthur/ Guenivere/ Lancelot was never resolved. In the tale, Arthur ends up in Avalon, Guenivere in a convent, and Lancelot in a monastery. But the Superman/Clark Kent/Lois triangle is resolved both when the dual images of Clark and Superman are conjoined and when Superman finally accepts his humanity (as well as his *anima*) and Lois accepts his humanity as well.

In a woman, the unconscious image of the opposite sex is referred to as the *animus*. The development of the inner masculine is equally important for women to become whole, and the *animus* progression looks a lot like *anima* progression does for the man, namely, movement from the youthful, playful adolescent to a fully-developed male, and often, movement from a negative image to a positive image of masculinity. A college student I worked with dreamt that:

> although she was engaged to one man, she was actually in love with Superman, whom she thought of as Christopher Reeve, "an awesome guy–determined and strong to go past paralysis and to advocate for stem cell research". In the dream, she and Superman were trying to save a girl–herself, from her burning apartment. She had to face the hard choice of which animus figure she would choose her fiancé or Superman/Christopher Reeve. Later she dreamt that she was also able to fly.

Her flight shows us that she was able to transcend the force from each of the opposing male figures and hold the tension between both. Another woman whose family migrated from Eastern Europe dreamt that:

> an army was coming, like medieval knights of the Round Table, carrying torches. She wasn't afraid because it was an army whose intention was good, to overthrow the King, who had kept the people poor and oppressed.

Figure 17: Superman and Lois Lane's wedding from the cover of the special "Wedding Album" issue of *Superman*, issue 47, 1996. © DC Comics

The knights of the Round Table are animus figures and here they are a healing symbol as well as a symbol of the liberation of her oppression. Their torches represent escape from the darkness she lived in.

Superman-comic-book writers fluctuated in their perception of Superman after he decided to marry Lois–he lost his powers, he regained his powers. In *Superman: The Movie II*: "Superman flies Lois to his Fortress of Solitude where his… mother Lara tells him, "If you intend to live your life with a mortal, you must live as a mortal. You must become one of them. You will become an ordinary man. You will feel like an ordinary man. You can hurt like an ordinary man. All your great powers on earth will disappear forever." But "the more recent DC Comics and TV episodes have figured out a way for him to have both his powers and Lois" (Kamm 1998, 52-53). For both Superman and Parzival, the hero journey continues and is deepened by their entry into a relationship with the *anima* and also, of course, with an actual woman, namely Superman with Lois, and Parzival with Blanchfleur.

The Death of Superman

Sadly, as I wrote this section of the paper, I received news of the death of Christopher Reeve. The event that was as strong a catalyst for me to write about the Superman story as the dreams of my clients was Superman's death. On the first page of *The Death of Superman* (Jurgens, et al 1993) the captions read "Somewhere else" and "Doomsday is coming." An enormous fist with claws hammers away at an iron door until it is cracked. Monsters steal electricity from Metropolis. A boy is orphaned because they have taken his "momma." The monster rampages, overturning semi trucks and destroying bridges and forests. But the Justice League is on their trail with Superheroine Maxima and Booster in tow. Using her psychic powers to tap into the monster's mind, Maxima tunes into the creature, only to find that "he is hate… death and bloodlust personified! Nothing more." The Lexoil refinery is on fire, and Superman has been alerted. The other Super- heroes have been compromised, and one is dead. The creature Doomsday destroys everything in his path. Superman realizes that he has to take on Doomsday alone. The battle ensues and eventually Superman perishes, and so does *Doomsday*. A crypt is constructed for Superman, and a funeral and funeral march are held in the city. Superman's body is placed inside the crypt, and Doomsday's body is disposed of in space. In *The Death and Life of Superman: a Novel*, Roger Stern elaborates on the incredible situation which occurred after Superman's death in a conversation between Dubbilex and Guardian:

Dubbilex: "The Man of Steel's wounds were still open and oozing blood, I could sense nothing of his spirit."

Guardian: "I see what you mean. Then to the best of your knowledge, Superman was already dead, yet his wounds still closed."

Dubbilex: "Not merely closed. They apparently healed." "Do you have any idea how? Or why?" (Stern 1993, 230).

Later the headlines of the Daily Planet state, "BACK FROM THE DEAD? SUPERMAN'S BODY MISSING" (Stern 1993, 275).

And later: "Lois and her friend Jenny are convinced that he is alive. They exit a diner together and are nearly knocked over by a stream of people running down the street. One man was sharing that Judgment Day had arrived. [He] the bearded man took one look at them and brought his palms together as if in prayer. 'Make your peace! The hour is at hand!' Lois gently touched the man on the arm. 'Do you know what's going on down the street?' 'The great Superman is risen and walks among us!'" (Stern 1993, 333). Superman, as we saw from his dual birth, and now from his equally miraculous death and resurrection, is incarnated with divinity–he is godlike. When I read about Superman's death, I was reminded of another of Nietzsche's concepts–"God is Dead. God is no longer a living force in the world (Higgins 1987, 8). In Jung's lectures on *Nietzsche's Zarathustra*, delivered as seminars in Zürich, between 1934 and 1939, he wrote about this concept: "Then God appears in the place where one would expect him the least, and that is in the Shadow." And further, "if the god is dead and so appears in the shadow, then the negative qualities of the shadow become the armor of a new and terrible god" (Jung 1988, 1:128). Before Superman reappears, Mongul and Cyborg, supermen playing god, wipe out Coast City, California and its eight million people leaving a sickening black hole. They have become the representation of the terrible shadow god. Superman's regeneration, 'resurrection,' and stronger connection with Clark Kent moves him toward the fulfillment of his personal destiny. Becoming the Self is beyond heroic–it is superheroic. It is in the relationship to our ordinariness and also in the awareness of our dark shadow that brings wholeness and helps us understand our Self. There is also the possibility for a new kind of relationship with God (Kamm 1998, 64).

Identification with the Superman or Superwoman archetype causes an inflation, which Jung wrote about extensively. This identification and inflation can be seen in the following two stories: The first is about Ukrainian Olympic champion figure skater Oksana Baiyul. In a television interview, Oksana (who was in fact an orphan), stated that through her skating and her championship, she had *"become Superwoman"* (Baiyul, 2004).

This remark shows that she suffered from inflation. Tragically, she and her career soon crashed, as frequently happens with an inflation, and she fell into alcoholism, weight gain, and poor performances. In another case, a college professor made a very positive transformation after he almost crashed and found himself nearly bankrupt. He was paying little attention to his spending habits which were based on having 'the finest things in life' until he had the following simple and cryptic dream:

> 'But you're a mathematician', a voice said, meaning that he was like some famous mathematicians he knew. This man understood the meaning of this dream in a very powerful way. He had thought that his skills in mathematics were somewhat limited, although his talents really were considerable. Years ago he had made a decision to identify with Nietzsche's Superman. He had searched for truth and a system by which he could make moral judgments. After he read Nietzsche's Zarathustra during the time of his search, he came to believe that the superior man could make finer judgments than any set of rules or social norms could proscribe. At the same time, he began to feel suicidal because of his inflated state. His dream at this time humbled him and brought him out of his inflation, and he had to face the earlier depression he had tried to run from. After working through it, he was able to accept himself and others as ordinary people with rich inner lives. He could no longer consider himself and the famous mathematicians to be Supermen. His work to resolve his depression and accept himself as an ordinary being, has taken on superheroic proportions.

I have seen clients become ill when they try to be *Supermen* and *Superwomen*, seemingly because of the stress and pressure of their goals and expectations of themselves as super beings. They wear out their bodies, and their illnesses then force them to accept their limitations. In his seminar on Zarathustra in 1935 Jung, stated:

> You see, identifying with the Superman means that he is no longer a fly in the marketplace. If he could only realize that he is just one of those ordinary people, he would be aware that it was quite natural that he should participate in that moment, and then it would not be dangerous. So the danger Nietzsche describes here [of infection by poisonous flies in the marketplace] is only valid inasmuch as he has an inflation: he identifies with the Superman and leaves the ordinary man behind. Such infections only happen when one is not humble enough, when one immodestly and

immoderately identifies with one's ideals or the ideals of the Superman: then naturally one has no basis, but is suspended in the air, only to come down and wake up, perhaps having fallen into a deep, black hole (Jung 1988 1:607-8).

We can understand from history the dangers that being "possessed" in the Superman archetype cause when its wrong use manifests horribly in such groups as the Nazis and their "urge to purify the world through the annihilation of some category of human beings imagined as agents of corruption and incarnations of evil" (Cohn 1975, xvi).

Conclusion: The Return From The Hero Journey

Joseph Campbell states:

> When the hero-quest has been accomplished, thorough penetration to the source, or through the grace of some male or female, human or animal personification, the adventurer still must return with his life-transmuting trophy. The full round, the norm of the monomyth, requires that the hero shall now begin the labor of bringing the runes of wisdom, the Golden Fleece, or his sleeping princess, back into the kingdom of humanity, where the boon may redound to the renewing of the community, the nation, or the ten thousand worlds (Campbell 1973, 193).

A superheroine who fostered her community is a woman in her mid sixties who had been sexually molested more than once as a very young child. While in treatment, she dreamed of:

> 'eyes, the vitreous humor falling out of them'. This brief dream fragment reminded her of the book The Kite Runner in which a boy who was an orphan was sexually molested by a man. He was able to face his abuser with help from an adult. He picked up a slingshot, and shot the molester in the eye. Both the boy and his rescuer escaped. The woman saw her own story more clearly in the book and realized that she had hidden her true identity, including her femininity, which she had considered to be dangerous and vulnerable. She identified with the boy's escape and was able to escape her victimhood and her orphan psychology. She has claimed for herself a completely new life, a new identity, and even a new kind of marriage to her husband of over forty years. She was recently honored in the nation's capitol for her heroic work as

an environmental and animal activist and was actually referred to as a "Wildlife Heroine." Her heroism has indeed enriched her community through the protection of animals although her conscious motive was not to become a heroine.

Comic-book-hero Superman has made his world a better place to live. He has gone toe to toe with his enemy and has overcome. He has used his power for good purposes. To his role as a carrier of a god imago, he has added his newly accepted mortality, and he has faced the terrible shadow god. In doing so, he has tapped into the life force and into his humanity in a profound way. He shed his skin as a formless soul in flux, carried his newfound transformation into the world, and transformed it as well: in the December 2004 issue of *Superman Comics*, Superman has a conversation with Batman:

> Superman: "I admire you–through sheer determined will, you've made yourself the BEST you can be. You're my friend… But I don't like you."
> Batman: "I guess you do have something to get off your chest…"
> Superman, once again called Kal-El: "My life is motivated by what I believe is LOVE while yours … There's a DARKNESS in you that's ugly. VERY UGLY… and it will kill you."
> Batman: "Nothing can kill me. Anything that tries makes me STRONGER."
> Kal-El: "You're less connected to humanity than I am."
> Batman: "You here to SAVE ME?
> Kal-El: I can't do that. You're the BEST, but I need you to be BETTER. I need to know that you'll try to find PEACE.
> Batman: I will. When my WAR is OVER.

This recent Superman comic-book dialogue is quite different from the early dialogues in the Superman comics. Before, Superman was an isolated, otherworldly superpower, battling his enemies. By now, Superman, like Parzival, has liberated the "Grail Castle" and has won the "sleeping princess" to whom he is now married. This union makes his power so different, so much more human. We see in the Superman/ Batman dialogue that the two superheroes are very different. Batman is still operating in a war zone with vengeance and aggression. Superman, by contrast, is living in another reality, more affected by his positive feminine (*anima*) growth. Through his love and his compassion, through his humanity, through eros, the hero has redeemed himself and his culture (*Superman* 210, 2004).

We Can Be Heroes: Bodies That Hammer

11

The Superhero Versus the Troubled Teen: Parenting Connor, and the Fragility of 'Family' in *Angel*

Gwyn Symonds

> You have to kill your father. You have to. Now, before anything
> else goes wrong. (Cordelia to Connor in *Orpheus*, 4:15)[1]

The term 'superhero' defined as 'extraordinary heroism' by its prefix, generally involves amazing strength worthy of great moral and physical tasks. There is not much time or place in such a scenario for domestic family concerns. Superheroes are not commonly thought of as family-focused, at least not beyond their origin stories.[2] The television series *Angel* (1999-2004), unusually for the superhero genre, gives a place to its superhero's struggles on the home front trying to parent his rebellious, adolescent son, Connor, while carrying out his mission to help the helpless as a vampire with a soul. The superhero tries to become Mr. Dad after Connor is introduced as a teenager into the storyline when he dramatically reappears (after being kidnapped as an infant only episodes earlier) through a magically created tear in the dimensional fabric separating Los Angeles from the hell dimension Quortoth, in *A New World*. He has spent a traumatic childhood in that hell, raised by the vampire hunter Holtz, who has taken him to avenge the death of his own family at the hands of Angel (when in his evil incarnation as Angelus).[3] Connor greets Angel with a sardonically grinning "Hi, Dad" (*A New World*, 3:20), raises a lethal crossbow in a gun-like shape and fires two sharp wooden stakes at his father. Thus, the series signals the introduction to the hostilities marking the parent/adolescent familial relationship. Angel deflects the first of many lethal barbs, both verbal and literal, that Connor will rain down upon him in the following storyline, reacting in startled shock to the return of his son and scrambling to get out of the firing line. Immediately, we know that being a superhero is not going to be of much help to Angel in dealing with his parenting problems.

While Angel is always a target in his fight against evil, this is the first time he has been attacked by his son, who stands ready to kill him with all the hate and anger that 16 years in a hell dimension being raised by

Angel's bitter enemy, can instill in him. That rebellion takes place in a supernatural Los Angeles where violence and threat underlines the fragility of the family unit. In a world defined by the battle between good and evil, familial ties are inevitably subject to collateral damage. That fragility is highlighted in the relationship Angel has with Connor, which is literally and metaphorically a battleground where violence, hate and misunderstandings prevent family unity. The battle to save the relationship, to reestablish his violently truncated fatherhood, is complicated by his super heroism. His commitment to the superhero's mission against evil gets in the way because Connor rejects its values. It is also the root cause of his rift with his son because the evil Holtz is the nemesis against whom Angel, the superhero, must defend himself and others, despite his son's strong emotional attachment to Holtz as the father who has raised him.

In the role of the patriarchal father, Angel's collision with his son has all the hallmarks of the generation gap but there are generic twists to its rendition. The hybridization in *Angel's* mix of horror, film noir, superhero and supernatural-horror elements places the concept of family in a television space that encourages the viewer to see it as culturally and psychologically complex. The image of relationships under threat in opposition to the ideal has long been a thematic interest of generic horror with "its engagement of repressed fears and desires and its reenactment of the residual conflicts surrounding those feelings" (Clover 2000, 130). "Horror has escaped from its Gothic castle" (Maltby 2003, 354) and, as Vivian Sobchack details (in her analysis covering decades of generic horror cinema set in the urban cityscape, small towns and suburbia), has peeled back the repression in the familial, revealing the explosive emotions beneath reactionary nostalgia (Sobchack 1987). Connor's story arc begins with the vampire Darla falling pregnant to Angel and leads to Connor's own mating with his father's love interest Cordelia who has become evil[4] and the subsequent birth–as a fully formed adult–of their daughter Jasmine. It ends with Jasmine's death and the replacement of Connor's horrendous family history by one of conventional family normality, after Connor goes into a nihilistic, homicidal meltdown. In an act of parental self-sacrifice to save Connor from himself, Angel agrees to become the CEO of the Los Angeles branch of the evil law firm Wolfram & Hart, in return for his son getting an ideal family life with a human family. The ideal is made possible by a mind wipe that removes all memory from Connor of his painful and dysfunctional past, inclusive of his memory of Angel. The normality Connor is given papers over the truth of his origins and the fraught nature of his family history. It is a magically forced happy ending in which Connor joins a family far away from a Los Angeles where happy families seem unable to survive for long.

The show's generic use of the vampire horror metaphor allows it to explore what happens to familial relationships at the point where crisis and dysfunction strain the bonds that hold the family unit together and reveal "the glaring contradictions that exist between the mythology of family relations and their actual social practice" (Sobchack 1987, 179). Normality is an ideological space and patriarchal repression is threatened by the monstrous in the horror genre with the happy ending a reactionary return to repression (Wood 1984). Thus, Angel's decision to paper over his son's identity and history through magical manipulation retains an aura of emotional and moral dubiousness and nostalgic futility. In the horror genre the monstrous can invade home and hearth or emerge from within the family construct itself but, in *Angel*, there is no hearth in the strictest sense. The space provided by the cavernous Hyperion hotel, where team Angel have their offices and Angel resides before he moves to Wolfram & Hart, and the urban decay on the streets of Los Angeles, suggest a space not conducive to relationship intimacy because of a lack of stability that precludes putting down family roots. As a detective trying to help the helpless in the alleys of a city where the demon underbelly has emerged to become nightclub cool and corporate, Angel also operates in a generic space which sits in the shadowed, destabilized and shifting world of film noir—a stylistic ambience described by Paul Schrader as affecting the moral authority of all characters: "no character can speak authoritatively from a space that is being continually cut into ribbons of light" (Schrader 2003, 235). It is also an ambience that shares aesthetic space with the darkness of vampire horror: "One always has the suspicion that if the lights were all suddenly flipped on, the characters would shriek and shrink from the scene like Count Dracula at sunrise" (Schrader 2003, 235). The effect of the noir aesthetic on the morality of Angel's superhero status is to link him more with Batman as the Dark Knight than the heroic clarity embodied in the traditional Superman ethos. As the super heroic head of Angel Investigations, he is trying to force justice and order on urban chaos and decay. The show embodies aspects of the revisionism of the myths of the superhero described by Aeon J. Skoble in his analysis of the *Watchmen* and *Batman: the Dark Knight Returns*, which views the superhero as also a force for repression (Skoble 2005). Angel engages in the self-appointed vigilante justice that Geoff Klock notes revisionary versions of the superhero foreground, with the hero sharing some of the darker character traits of the villains they oppose (Klock 2002). Angel has no problem, for example, mind-wiping his friends of their knowledge of the events related to Connor to ensure the security of his son's happiness. When he tries to carry out his mission while also acting as the CEO of Wolfram & Hart and servicing its evil clientele, he inevitably finds himself morally compromised.[5]

The generation gap becomes an ideological clash when Connor supports his adult daughter Jasmine's global reform agenda. Connor's support for this political agenda, which promises world peace while hiding the price—cannibalizing a percentage of humans to feed Jasmine's existence—misguided though it may be, is as much a philosophical difference with Angel as it is a product of family angst. Angel's victory over Jasmine at the cost of ongoing war and suffering in the world is ironic and Connor's desire to believe in something of his own, rather than his father's patriarchal super heroic agenda, arouses sympathy. In *Peace Out*, Connor poignantly confesses to a comatose Cordelia his anguish at his inability to find something worth believing in:

> It's started, Cordy. The new beginning… And it is better. Not harsh and cruel—the way that Angel likes it so he has a reason to fight. 'Cause you know that's what he's about, him and the others. Finding reasons to fight. Like that's what gives their lives any meaning. The only damn thing! (punches the lectern, smashing it) I'm not like them. I just… I want to stop. Stop fighting. I just want to rest. God, I want to rest. But I can't. It's not working, Cordy. I tried. I tried to believe. I wanted it. Went along with the… the flow. Jasmine, she's…she's bringing peace to everyone, purging all of their hate and anger. But not me. Not me! I know she's a lie. Jasmine. My whole life's been built on them. I just… I guess I thought this one was better than the others (*Peace Out*, 4:21).

Connor's deep emotional pain is couched in youthful disillusionment with the adult world around him that Angel represents to him. The activism that galvanizes him to fight for the change Jasmine promises is not unquestioning support of any alternative truth but, as he perceptively recognizes, of a more palatable lie. The trauma of his childhood has not left him capable of youthful optimism and his attempt to separate himself off from his violent heritage has only reaffirmed it, as his smashing of the lectern as he asserts his rejection of violence shows. Connor's idealism has left him deeply alienated and he cannot find hope, peace or inspiration in Angel's superhero creed. World weary, he is tired beyond his years: "I just want to rest." Angel has earlier articulated a credo of the superhero to Connor describing the Champion as a moral exemplar in a world that struggles to live up to that perspective:

> Nothing in the world is the way it ought to be. It's harsh, and cruel. But that's why there's us. Champions. It doesn't matter where we come from, what we've done or suffered, or even if we

make a difference. We live as though the world were as it should be, to show it what it can be. You're not a part of that yet. I hope you will be. I love you, Connor. Now get out of my house. (*Deep Down*, 4:1)

Minimalist in its aims, and somewhat joyless, forged from living in a world offering no certainty that you can make a difference, this is an adult version of the mission that is not likely to inspire Connor's youthful idealism. Connor cannot see that it is a world in need of the special brand of brooding vampire super heroism Angel embodies knowledgably rooted as it is in the demonic violence and social decay he is fighting. However, his rebellion is a running critique of Angel's brand of super heroism which *is* devoid of what youth seeks, hope and optimism.[6]

Angel is a sole parent and typical of the show's exploration of concepts of family in non-traditional forms. The family formed by Wesley, Lorne, Gunn, Fred, Cordelia and Angel, making up the team at Angel Investigations, forged out of friendship and a shared mission, is non-biological and non-traditional. Gunn points out the superficiality of conventional definitions of the family after being trapped in a façade of suburban family life that was a cover for a hell dimension:

Do you know what the worst part of that place was? Wasn't the basement. At least there, you knew where you stood. Demon was gonna cut your heart out and show it to you. Nah. It was the fake life they gave you upstairs. The wife, kids, all the icing on the family cake. But somewhere underneath it, there was the nagging certainty that it was all lies, that all the smiles and the birthday candles and the homework were just there to hide the horror. Is that all we're doing here, just hiding the horror? (*Timebomb*, 5:19)

This is a generic horror and dissident view of conventional concepts of family. The superficialities of perceived normality, "the icing on the family cake" can be fakery and lies, "hiding the horror" with a decorative cover on top of emotional emptiness and pain. Gunn's question, "Is that all we're doing here, just hiding the horror?", is at the core of the show's exploration of what a real sense of family might mean in a world of repressed threat and moral darkness.

Gunn's question hangs over Angel's super heroic mission to restore order and his striving to maintain his own idealistic sense of family—asking whether he is merely trying to repress what cannot be contained in order to maintain his patriarchal parental role. In the episode *Dad*, prior to Connor's return, Angel's role is that of protective nurturer to a baby

whom he cradles in his arms and who was totally accepting of him as a father. Lorne is right when he quips: "I'm sensin' a serious Mama Bear vibe" (*Dad*, 3:10). Angel has to deal with external threats aimed directly at Connor. "Hey, he's not even a day old and he's got an enemies list." Creepily, cooing at a surveillance screen showing a crying baby Connor, Linwood, a partner at Wolfram & Hart, raises the additional possibility that malevolent danger directed at Connor's existence may not only come from outside the family:

> That's a cute little baby. Yes, you are. And your daddy is a vampire with a soul. And sometimes he reverts to a creature of pure, malevolent evil, who could rip your tiny throat out. Yes, he does. (Chuckles) I like kids. (*Dad*, 3:10)

Linwood raises the possibility of whether Angel/Angelus can ever truly be a safe person to raise his son. The false prophecy that "The Father Will Kill the Son" persuades Wesley to believe Angel is a threat and he leaves with baby Connor, setting in motion the events which allow Holtz to kidnap him. Yet, infant Connor gives Angel unquestioning acceptance, touchingly conveyed in the scene in which Angel's switching to his vampire face amuses and quietens a restless and crying Connor, after every other tactic of parental nurturing—food, diapering, singing—has failed. Not only is his vampire identity revealed to his son in that scene, it is a part of his successful nurturing role as a parent. Since time works differently in the hell dimension, Connor returns after having lived 16 years during a matter of weeks in Los Angeles. As a parent, Angel can literally say it seemed like only yesterday that his son was such a sweet child. In common with all parents who see childhood acceptance of them morph into teenage rebellion, Angel is caught unawares. Ironically, Angel is faced with adolescent anger and rejection of him at the very moment of the restoration of the family ties Holtz tore apart.

In *A New World* Connor wants all the family secrets out in the open; he wants to see Angel's vampire face: "You have a second face. A face for killing. Show it to me. I wanna see it" (*A New World*, 3:20). When Angel complies and morphs into that face, the superhero is given a very different reception from the one he received from the infant Connor. He is venomously rejected.

> Angel: It's part of what I am. (Morphs back into his human face) A
> part I hope you will be able to accept one day.
> Connor: You'd have to kill me first.

For the adolescent, separation from his patriarchal origins is a battle to the death. Richard Reynolds lists the superhero's desire to mask his identity from everyone as a core tenet of the genre and its revelation as a taboo (Reynolds 1992). However, Angel's real fear is not of revealing himself as a vampire to others but only to his son. He hopes for acceptance[7] but he has got his son back at the point in Connor's growth cycle when there must be a separation from the parent and the beginning of the death of many aspects of the parent/child relationship. Despite the fact that Connor's return is complicated by being in a hell dimension under Holtz's influence, it could be said that on his first day back in Los Angeles Connor is exactly where he would have been if he had never left and had grown up with Angel. He is engaged in the adolescent struggle to become independent, while Angel wants an acceptance and closeness that this struggle often precludes.

Connor's raging and violent emotions are a threat to the social fabric held in place by Angel and his team. His authentically portrayed, raging, destructive teenage obnoxiousness makes him as difficult for the audience to like as it is for other characters in the story.[8] In Connor's defense, it has to be said, it is not easy being the mythical human son of two vampires. When team Angel finds out that Darla is pregnant in *Offspring*, the uncertainty of his potential for evil because of his vampire heritage is laid out:

> Lorne: It could be anything. A child born to two vampires...
> Gunn: Maybe it's some kind of 'uber'-vamp.
> …
> Lorne: Born out of darkness to bring darkness.
> Angel: Great. So, we're saying that my child is the scourge of mankind? (*Offspring*, 3:7)

He is variously described as "the boy wonder"(by a sarcastic Lilah in *Benediction*), "the Destroyer" (by slug-possessed, ominous Fred in *The Price*), "Angel's hell-spawn" (by Lorne in *Supersymmetry*, 4:5), "Angel's raging psychopathic son" (by Hamilton in *Origin*, 5:18), "Kid Vicious" (by Lorne in *Inside Out*, 4:17), "evil love child" and "my little parasite"(by Cordelia and Darla, respectively, in *Quickening*, 3:8), "that patricidal pup"(by Lorne in *Deep Down)* and "the bastard son of two demons"(by Holtz in *Benediction*). It is no wonder he lives down to these perceptions of those around him. However, it is as much his problematic nature as a human adolescent, as it is his mythic origins, that makes Connor difficult for Angel and his heroic team to deal with. As Lorne comically puts it: "This is beyond my ken, and all my action figures" (*Offspring*, 3:7).

Connor is trying to deal with the perennial adolescent problem of coming to terms with his origins when he realizes that he has not been dealt the ideal family. The problem is succinctly posed when Connor spits an insult at the demon Lorne, who has had a nurturing role in his infant life:

> Connor: Filthy demon.
> Lorne: Actually, that's *uncle* filthy demon to you. It wasn't that long ago–like a week–I was changing your diapers, you little... (*Benediction*, 3:21).

Uncle and demon, vampire and Dad, that is Connor's familial heritage whether he likes it or not. While Holtz may have neglected to mention to Connor all the good Angel has done, he has not exaggerated the evil. Connor's desire to mark himself as separate from that is understandable and speaks to the idealism of his youth. Connor expresses his real fear about his origins to Angel–when the latter reverts to Angelus–that the evil Angelus, not the superhero Angel, might be his real genetic heritage: "The truth is, Angel's just something that you're forced to wear. You're my real father" (*Soulless*, 4:11). Sorting out who, amongst the three alternatives of Angel, Angelus or Holtz, is his 'real father' is the source of Connor's conflicted adolescent. With all the directness of his youth, Connor wants to simplify matters and pick one of the three as a prelude to defining his own identity. In reality, they have all fathered him *and* failed him and his desire to choose is not easily acted upon.

Against Angel's problematic relationship with his son, the show juxtaposes Angel's idealized image of the family unit for which he yearns. In *Deep Down*, Angel is entombed in a box at the bottom of the ocean, having been put there by Connor, who wrongly believes his father has murdered Holtz. Against that backdrop, the episode segues into an idyllic family Thanksgiving meal, shared by Angel with his mission family, Wesley, Gunn, Lorne, Fred and Cordelia, and Connor. They sit around a table sharing a meal and warm banter as Angel smiles happily and basks in the glow he feels, remarking to Cordelia, sitting beside him: "I wanna freeze this moment, you, Connor, all of us, safe and happy and together" (*Deep Down*, 4:1). Wesley responds by raising his glass and they all echo his toast: "To family". Cordelia's reassurance to Angel that "Things are back to the way they should be and nothing is going to break us apart again" signals the illusion of that perfect Kodak moment, hanging as it does on that contingent "should be". Angel's desire for family unity is deeply parental but it is a desire that is unrealistic, given that the family pictured has not only been destroyed by external forces but also from within. Wesley is exiled

from the group because his actions led to Connor's kidnapping, Cordelia has chosen to leave for a higher dimension due to a spiritual promotion, and Connor's anger at his father knows no moral bounds and has stopped just short of patricide, though not by much.

Angel's fantasy begins to fall apart as the dishes are passed back and forth across the table to everyone seated there, but not to him. He becomes increasingly agitated that he is being ignored, is excluded from the family circle and the conviviality of sharing the food. He grabs a serving dish, only to have the food turn into seawater. Startled, he knocks over his glass as it, and the illusion, is completely shattered. He looks down to find water lapping his chair. The warm, candlelit colors of the family scene change to a darkened, cold blue/gray as the camera pulls back from Angel's horrified face to reveal an empty table with only a malevolent Connor sitting there. "Freeze the moment, Dad. It'll last forever" he says. A remark that chillingly contrasts for the audience the idealized image of family with the reality of Connor's hate for a father he has imprisoned in a watery grave. The camera pulls back again from a close up of Angel's face to reveal him in the box at the bottom of the ocean. Far from having the loving son of the dinner party, Angel comes out of his fantasy to the reality that the son he loves hates him so deeply that he wants him to suffer for eternity.

The dinner scene proposes that what holds a family together is unstable and difficult to grasp for long. Even Angel's hallucinatory fantasy can only be momentary, just long enough to freeze it in that Kodak moment, before all hell breaks loose in family conflict. The hallucinatory moment is one of those "worlds that lie between the spaces" of this world that the horror and superhero generic director Sam Raimi so eloquently describes as the option opened up by the horror genre (Wiater 1992, 146). I would argue that nowhere else in the series is its sense of family as an enduring entity portrayed as more fragile than here, when it is at its most idealized and hopelessly lost. The fact that the illusion begins to come apart when Angel sees the food is not passed to him, metaphorically highlights the literal impossibility of him having the conviviality of breaking bread with family and friends, at least in essential details. As a vampire, he does not need or desire to eat, he lives by drinking pig's blood. His vampire nature denies him the basic human traits on which inclusion depends. When she sees he is not eating, Cordelia says "You're not hungry?" He replies "I'm starving" and in a sense, he is. He is as hungry for the ideal of belonging and family that is out of his reach as he is for the blood his body craves for sustenance. As a vampire, involuntarily cursed with a soul that has brought him to a brooding remorsefulness for the murderous evil he has committed, he really is, as Cordelia comically puts it elsewhere, "loser-pining guy" (*Bachelor Party*, 1:7). He is detached by guilt and his murderous past from

a shared humanity and sense of belonging and his fantasies reveal it is a fulfillment that he deeply craves.

When Justine, Holtz's accomplice, asks in *Deep Down* whether finding Angel at the bottom of the sea will change anything, Wesley's reply that "Everything changes," captures the fatalism of the Los Angeles noir world. As Justine herself has learnt from the killing of her sister by vampires and the loss of her own dysfunctional tie to Holtz as a family pair, evil or not, the family unit is not immune from the fatalism and effects of change. Prior to Connor's birth, through his friends and their shared mission, Angel had managed to find an unconventional sense of family that was hard won. However, as he lies in his ocean coffin, that fragile family unit has fallen apart. Even the laid back Lorne, has "lost the mission" and gone to Vegas. The season three finale ends with Fred and Gunn standing in an empty Hyperion hotel, asking: "Where did everybody go?" (*Tomorrow*, 3:22). Their band-of-brothers form of heroism has not proved sustainable in the face of the demands of the mission. Wesley, following false prophecy has found that by not trusting in Angel's love for his son he has contributed to the destruction of both Angel's familial bond with Connor and their heroic family group. The sense of loss in *Deep Down* is paralyzing, as Gunn realizes when he and Fred try to make a plan to find Angel: "This is it Fred. No Angel, no Cordy, we can't find Holtz, his psycho girlfriend's gone. We got nothin'." While Gunn is talking about the logistics of their problems, the subtext is clear, without family, traditional or otherwise, you "got nothin'".

Angel's second fantasy in *Deep Down* is of the thwarted meeting on the bluff by the sea that he and Cordelia had scheduled as a date to declare their love, a meeting waylaid by her ascendance to a higher dimension and the attack on him by Connor. In responding to Cordelia's comment on the beauty of the scene, but referring to her beauty as well as the scenery, Angel echoes the idealism of his earlier fantasy, describing it too as "Just the way it should be". However, this time he is not entirely capable of maintaining the completeness of the fantasy and recognizes the illusion: "But it's not, this isn't how it happened." Cordelia's answer: "I know. I like this version better," including as it does her declaration of love and their embrace, is interrupted abruptly with Angel turning into his vampire face and biting her before he wakes in the coffin screaming out against his actions. It is not just the reality of his entombed situation that intrudes on his fantasy but his self-doubt. Even in his fantasy he cannot be sure he can control his bloodlust, the Angelus of who he is. The third fantasy Angel has at the bottom of the ocean is an exchange with Connor where they joke over hugging, and it ends with the Angelus part of him snapping Connor's neck. Angel's incapacity to form a close relationship with

his son is a part of larger difficulties he has in his other relationships. As Cordelia aptly puts it: "Mr. Distance has intimacy issues"(*Eternity*, 1:17). Jean Lorrah, discussing the final image in the credits of the show of Angel walking alone down a dark alley at night, describes it as an image of isolation: "In Angel's world, people don't come together in a crisis—they break apart"(Lorrah 2004, 62). More accurately put, when they do come together it is difficult to sustain, even for the superhero.

However, Angel's desire to hold onto family is not hopeless simply because it is difficult, it only makes the need to preserve and protect it all the more important. In *The Price*, Angel is unrepentant, after the failure magically to open a portal to Quortoth to get his son back, despite its having endangered Fred's life:

> So, you ask me, was it worth it? Would I do it again? In a heartbeat. Because he was my son. (*The Price*, 3:19)

For Angel, everything is irrelevant in the face of the fact that Connor is his son and he loves him.[9] Similarly Connor, fights for Jasmine, his own evil offspring:

> Wesley: Jasmine's the lie. You've no idea what she is.
> Connor: Yes, I do. She's mine. (*Peace Out*, 4:21)

In the end, Connor fights for her as Angel does for him, because she is his child.[10]

In *Not Fade Away*, before the final battle in the series finale, Connor's memories have returned, he knows that Angel is his father and he deals with having two sets of memories by living with the traumatic one as if it was a bad dream. When Angel sends Connor back to his new family before the final battle, so that he will survive and live a full life, he engages in his final act as a father and Connor accepts him as such. The father will live on in the son and in his son's restored memories. In that sense, fragile as it is, family endures. However, Connor is gone, a disillusioned Lorne has left, Cordelia, Wesley and Fred are dead, and Gunn is mortally wounded. The superhero has not been able to hold his biological or substitute family circle together. As Angel turns to face a dragon and an uncertain outcome to the fight, it seems it is only the "work," the mission, that he has left. The fact that the souled vampire Spike, with whom he has a volatile sibling-like relationship that is centuries old, stands with him does, however, return the show to its overriding theme that family relationships take many forms. Angel, the superhero, does not know how the battle will end but as a parent he does know he has succeeded in the most primal sense. He has kept his son safe.

12

Gibson's *The Passion*: The Superheroic Body of Jesus

Peter Horsfield

Mel Gibson's recent movie, *The Passion of the Christ* (2003), provokes a range of interesting questions. Slammed by many reviewers and the subject of strong criticism by some religious leaders, it has nevertheless become one of the leading box office successes in Hollywood history. Secular critics have commonly criticized its excessive violence, its lack of exploration and development of key characters, its cartoonesque depiction of second-ary characters, and its lack of narrative development and involvement. Craig Mathieson's *Bulletin* review (of the DVD) is entitled "Bloody Awful" (Mathieson 2004). Writing on the *Dark Horizons* website, Garth Franklin said,

> In a two hour movie a good 2/3 of the last hour could've been removed or better yet replaced with a better examination of the characters and Jesus' spiritual message whilst still leaving in vio-lence and brutality cut in such a way that would've had seen more impact than the gratuitous gore fest currently has. By taking the far easier option of displaying excessive violence than exploring spirituality, Gibson essentially lost the message he's trying to con-vey. (Franklin 2004)

The film also provoked a strong reaction and even antagonism among many religious leaders, particularly its suggested anti-Semitism, its vio-lent reconstruction of much more understated Christian narrative texts around the death of Jesus, and its failure to reflect accurately the historical events of Jesus' death as presented in the Christian gospels. Yona Metzger, one of Israel's two chief Rabbis, "expressed deep concerns that Gibson's portrayal of the last twelve hours of Jesus' life could publicly feed stereo-types that Jews were responsible for the death of Jesus." Metzger asked Pope John Paul II "to reiterate a Roman Catholic decision in the 1960s that reversed the centuries old doctrine that Jews were behind the Crucifixion"

(Quoted in Beard 2004; see also Cooper 2004).

Nevertheless, *The Passion* was an overwhelming commercial success. Two months after it first appeared, Gibson's self-financed $30 million production had generated in excess of $386.6 million in box office receipts alone. In 2004, it was the eighth-highest grossing film of all time. It had the highest midweek opening gross ever, and the second-highest opening weekend gross per theatre (for movies in wide release). It was also the highest-grossing R-rated film and the highest-grossing subtitled film. It was the third fastest movie in history to reach $350 million in total U.S. receipts (Maresco 2004). That does not include the merchandising receipts: the additional millions in music, publications and paraphernalia that accompanied the movie.

The movie was more than a simple commercial enterprise for Mel Gibson. It arose from a reported renewal of his own Catholic faith at a time of crisis in his life. But the faith he returned to "with the zeal of a reformed backslider," was not contemporary Catholicism, but "the faith he had known as a boy, the faith of his father," Catholicism of the Latin Tridentine rite (Boyer 2003). Practice of this rite is not easy as it is built around a clerical church with mass performed in Latin by a traditionalist priest, of which there are few around. To follow the rite, Gibson employed, at first, a priest from Canada and then from France to perform mass on the set wherever he was filming. He has since built a traditionalist chapel in the hills near his home in Malibu (Boyer 2003).

Gibson says that the concept of the film had been incubating for 12 years, germinated by the spiritual crisis he found himself in. "I was spiritually bankrupt, and when that happens it's like a spiritual cancer afflicts you. It starts to eat its way through and if you don't do something, it's going to take you. So I simply had to draw a line in the sand" (Noonan 2002). It can be argued, therefore, that the film reflects an interesting personal and cultural synthesising enterprise: an effort by Gibson to bring together his cultural world as a successful Hollywood action film actor, film producer and director with his personal faith and values as a religiously renewed person. On the one hand this synthesis serves to validate his commercial life and cultural activities, sacralizing it through a commercially successful religious product. On the other, it creates a wider cultural validation of his own personal religious vision by reconstructing that vision as a successful public product in the crucial symbolic domain of Hollywood and popular culture.

The personal interest and investment by Gibson in this film is apparent in a number of ways. Gibson's hands hold the nails in the crucifixion scene in the film. A 19th century devotional book that was influential in Gibson's religious life provided much of the narrative structure and detail

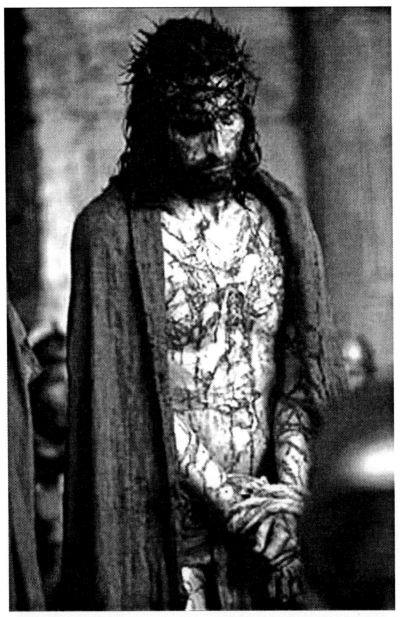

Figure 18: The beaten and bloody body of Christ from *The Passion of Christ* (dir. Mel Gibson). © 2003 Icon Distribution Inc.

in the film. The artistic vision of the film was influenced significantly by traditional religious art that informs Gibson's religious sensibilities. When commercial backers could not be found, Gibson invested $30 million of his own money to finance the film. Personal religious or artistic enterprises such as this often lose their market perspective and frequently become an unprofitable, idiosyncratic labour of love. In line with this, it was widely expected that Gibson's production would be a commercial flop, exacerbated by his stated intention to film using the original biblical languages of Aramaic, Greek and Latin, with minimal English subtitles. It is surprising therefore that the movie was such a commercial success.

In this chapter I want to explore this seeming contradiction. What underlies the box office success of an excessively violent movie, produced by a traditionalist Catholic, spoken in biblical languages with minimal subtitles, that focuses solely on the last hours of a historical religious figure, with minimal narrative development or character exploration? Two factors in particular will be explored: the cultural positioning and marketing of the movie, and aspects within the construction of the movie itself, particularly the complex intertextuality of the production, particularly the reconstruction of Jesus in the ethos of a contemporary action hero movie.

Cultural Positioning and Marketing of *The Passion*

James Wall, the noted religious film reviewer and critic, attributes a good deal of the success of the film to its position within the culture wars in the U.S. According to Wall, Gibson tapped into a Zeitgeist, first flagged by conservative newspaper columnist Pat Buchanan in a speech given to the 1992 Republican National Convention: "There is a religious war going on in our country for the soul of America. It is a culture war, as critical to the kind of nation we will one day be as was the Cold War itself" (Wall 2003). James Hunter describes the culture wars in the U.S. as "ultimately a struggle over national identity–*over the meaning of America*, who we have been in the past, who we are now, and perhaps most important, who we, as a nation, will aspire to become in the new millennium" (Hunter 1991, 50). The conflict, as Hunter sees it, is different from old sectarian antagonisms that have existed in earlier American cultural and political life. "(The divisions) no longer revolve around specific doctrinal issues or styles of religious practice and organization but around our most fundamental and cherished assumptions about how to order our lives–our own lives and our lives together in this society" (Hunter 1991, 42).

On one side are the cultural progressives, a diverse mix of secular and religious groups and individuals who share a common tendency

and desire "to resymbolize historic faiths according to the prevailing assumptions of contemporary life" (Hunter 1991, 44-5). On the other side are the cultural orthodoxy, the right, an alliance of groups who come together around a common commitment "to an external, definable and transcendent authority... a consistent, unchangeable measure of value, purpose, goodness, and identity, both personal and collective. It tells us what is good, what is true, how we should live, and who we are" (Hunter 1991, 44). American evangelical Tom Sine suggests that underlying the culture wars is a deep-rooted fear and insecurity that is given expression in religious and political action.

> To understand the Christian right you need to understand not what they think or even what they believe. You need to begin by discovering what they are afraid of. Those on the religious right live in genuine terror of a liberal humanist elite who they believe are intent on laying siege to their families, undermining their faith, and collectivising America for a one-world takeover by the Antichrist. Those deeply rooted fears motivate true believers on the right to embrace right-wing political ideology with a passion seldom found on the left. Bombarded by propaganda, many have come to believe that the only way to save their families from the "sinister elite," to protect their faith, and to save America is to mount a militant political counterattack on their liberal foes. (Sine 1995, 37)

This fear has been intensified since September 2001 and has produced a large political constituency on which George W. Bush has drawn, and which he has nurtured politically, with different national and international political agendas. Rather than simply "tapping into" a Zeitgeist, as Wall suggests, Gibson in his production and marketing can be seen emerging from it, aligning himself with the orthodox side of the argument, and directly speaking and marketing to the right in the successful promotion of his film. Gibson himself has acknowledged the personal religious motive behind the movie.

The success of *The Passion* illustrates one of the characteristics of the cultural and religious movements that can be seen in the U.S. in the past decades: that cultural divisions are no longer defined as much by theological, doctrinal or ecclesiastical differences as they were in the past, but by "different and opposing bases of moral authority and the world views that derive from them" (Hunter 1991, 42-43). While many aspects of Gibson's religious practice and belief as a traditionalist Catholic would still be anathema to most evangelicals and fundamentalists, his publicly declared

passionate faith, conservative social views, his success in a culture like Hollywood, and his passionate concern to present a realistic portrayal of the crucifixion of Jesus, all resonate with conservative Protestants despite any doctrinal or liturgical differences. Gibson also put together a marketing team and marketing strategy that deliberately tapped the concerns of this eclectic religious market and their interests, even moving beyond mass marketing with personal appearances to local groups of religious leaders to establish common interest and activate the support of the extensive and active local church network system in the U.S.

But such marketing in itself is not sufficient to guarantee the sort of success *The Passion* achieved if there is not also some substance in the product being viewed. Examples abound of large promotion campaigns for high budget films that have not been sufficient to carry a film past its first weekend. Yet there is also much about *The Passion* that goes against normal box office success. It has little narrative development within the text of the film itself to engage an audience; its dialogue is minimal - what dialogue there is, is in archaic languages with only occasional sub-titles; its violence many found offensively graphic, spectacular and unrelenting; with only a few exceptions its character portrayals are wooden and unengaging. What then has made it such a powerful and appealing movie?

I propose that Gibson has produced a cultural product that skilfully and (it can be argued by the box office) successfully uses complex intertextuality to evoke and rehearse multiple dimensions and experiences of one of the fundamental religious myths and stories of U.S. society–and other societies whose undergirding mythology has been dominantly Christian. Peter Steinfels, writing in the *New York Times*, notes that critics who dismiss the film fail to grasp or understand this:

> The movie reignites religious embers that may have cooled over the years. Critics who have recoiled at Mr. Gibson's grim vision are puzzling over the widespread positive response. They do not grasp that viewers are bringing to the film a whole store of religious beliefs and emotions, embracing and kindly as well as apocalyptic. These people are not simply going to a movie; they are going to church. (Steinfels 2004)

Much more extensive work from a reception perspective would need to be done to identify what the film means and how it speaks to different individuals and different religious sub-groups, but a number of apparent inter-textual connections can be identified.

Religious Intertextualities

The film assumes the audience's familiarity with the Christian narrative. Little context is set even at the beginning of the film to understand the history or significance of the subsequent plot that unfolds. The lack of an inherent narrative has been criticized, but its effect is to constitute its target audience as an in-group, a key strategy of the conservative right. It also gives a greater freedom to the audience to contextualize the events being portrayed in their own terms. Knut Lundby argues that any religious "megaspectacle" requires a symbolic construction strategy that maximizes its rallying capabilities through shared symbols while minimizing audience resistance through avoidance of other symbols that would offend or exclude (Lundby 1997, 154-6). To that extent, it could be argued that the minimal narrative interpretation within *The Passion* is one of the factors that enabled its success. Gibson was able to build his audience from a number of Christian groups that traditionally have had not only different theologies but also quite different religious aesthetics and sensibilities. David Goa observes that "Fifty years ago it would have been unimaginable that the Evangelical wing of the Christian community would flock to a film using the template of the Stations of the Cross" (Goa 2004, 151).

Gibson has achieved this strategy of maximizing rallying and minimizing resistance, I would argue, not by presenting a "lowest common denominator," inoffensive Jesus but by building a variety of layers in the film that allow a diversity of identifications and participation from different segments of the population. In the process, it could be argued - given the distinctiveness of his artistic creation, its popular appeal, and the significant cultural debate that has accompanied it–he has contributed to a significant cultural reinterpretation and repositioning of the events and meaning of Jesus, certainly within American and possibly other traditionally Christian cultures.

Edward Rothstein, writing in the *New York Times*, suggests that the film "reinvents the Passion in a late medieval mode, exhibiting a lusty fascination with flagellation, a fetishist's attentiveness to whips and welts, a panting anger at grotesquely caricatured villains" (Rothstein 2004). While such a version of Christianity seems archaic in some ways, it recovers a cultural version of Christianity that is suited to the violence of a lot of contemporary cultural productions and revitalizes that version of Christianity as a culturally relevant religious expression today. This passion-centred spirituality, with mystical fervour and graphic visual imagery has always been residual in many contemporary cultures, in particular Hispanic traditions of Catholicism and also in African-American religious practice.

The Passion evokes and reproduces a number of these residual popular devotional practices and sensibilities, such as the Stations of the Cross, the five sorrowful mysteries associated with praying the rosary, Catholic mystical traditions,[1] performances of past and present passion plays, and even the look and feel of childhood Sunday School religious pageants. David Goa suggests that

> *The Passion of the Christ* is not a film in the normal sense. Rather Mel Gibson has carefully crafted a set of *tableaux vivants* (living pictures) of the Stations of the Cross, a Roman Catholic devotion that began in the twelfth century as a way of accenting the humanity and suffering of Jesus. (Goa 2004, 152)

When these cultural reminiscences and connections are taken into account, what some critics interpret as a lack of character development in the film, and ineffective performances on the part of the actors, may in fact be deliberate or intuitively artistic staging on Gibson's part to replicate his own childhood memories in order to speak to and renew the religious sensibilities and devotional memories dormant in people's lives. Reviewer Peter Steinfels suggests, therefore, that one of the major impacts of the film will be to reignite the residual embers of spirituality and religious practice for many members of the film's audiences (Steinfels 2004).

Gibson and his art director also drew extensively on traditions of religious art in the tones, lighting and dramatic staging of their own work of art. Of this, Gibson said,

> The idea took root very gradually. I began to look at the work of some of the great artists who had drawn inspiration from the same story. Caravaggio immediately came to mind, as well as Mantegna, Masaccio, Piero della Francesca. . . their paintings were as true to their inspiration as I wanted the film to be of mine. (Quoted in Goa 2004, 151)

The result is that at frequent points in Gibson's film the visuality is eerily familiar, evoking the visual traditions of Christianity in a way that creates an underlying feeling of authenticity and tradition to his own distinctive cultural construction and remediation of Jesus. This ascribed and resonant 'visual authenticity' of the film may help explain its ability to bypass religious differences in its eclectic conservative audience, differences that previously had been divisive. Stephen Prothero suggests that the positive evangelical response to a very Catholic film needs to be seen within the context of US national and political identity and the part

played by religious iconography in that identity. Jesus has always been interpreted in different national contexts to meet national needs: as a socialist, a capitalist, a pacifist, a Mister Rogers friendly neighborly fellow, someone to know, love and imitate, a warrior, a sentimental savior. Gibson's *Passion* refashions Jesus for the culture wars, a sign that the friendly Jesus and the self-esteem gospel is on the way out. (Prothero 2004, 30)

The Passion as an Action Hero Film

A key strategy in this cultural and political repositioning of Jesus is his reconstruction in the genre of filmic superhero. In reconstructing Jesus in this action-heroic genre, Gibson has drawn on his own extensive personal knowledge of a popular and successful cultural form as a means of arguing the cultural and political relevance of his own passionate religious outlook. Despite its extreme violence, the attraction of the film to religious conservatives–for whom cinematic and television violence has been a significant focus of social concern and agitation–lies in their perception that their religious hero had made it in Hollywood terms. This evangelical claiming of the US cultural mainstream partly explains the imperative for evangelicals to support the film against its liberal critics and in spite of its extreme violence.

There are several dimensions to the construction of *The Passion* as an action hero film. It is a very violent film, as is characteristic of most action hero films. But one difference is that *The Passion* is almost entirely about violence, and violence done solely to one body–the body of the hero of the film. This was Gibson's deliberate intent: to reconstruct his favoured religious myth in terms relevant to the culture he knew and wanted to evangelize.

> I wanted it to be shocking… And I also wanted it to be extreme. I wanted it to push the viewer over the edge… so that when they see the enormity – the enormity of that sacrifice–to see that someone could endure that and still come back with love and forgiveness, even through extreme pain and suffering and ridicule (Quoted in Webb 2004, 162).

Susan Jeffords, in *Hard Bodies: Hollywood Masculinity and the Reagan Era,* traces the links between portrayals of masculine identity and US popular culture and politics, particularly images of hard masculine bodies in films of the Reagan years in the 1980s and early 90s contrasted with the soft feminized bodies of the politics of the Carter years. She explains that

"The heroes of hard-body films suggest a different kind of social order, one in which the men who are thrust forward into heroism are not heroic in defiance of their society, but in defiance of their governments and in-stitutional bureaucracies" (Jeffords 1994, 19). The hard bodied heroes are those who are pushed to act on behalf of those suppressed or threatened by the system.

> It is important to note how the same story elements–muscular physiques, violent actions, and individual determination–can serve such different social and political ends... (and) on what the hard body came to figure in a particular era, an era that saw a resurgence of both national and masculine power, both of which were embodied in the person of Ronald Reagan as president. (Jef-fords 1994, 21)

Mel Gibson was part of that hard-bodied era, in his *Mad Max* (1979, 1981, 1985) and *Lethal Weapon* (1987, 1989, 1992, 1998) films, and also in a different way in *Pay Back* (1999).

For Jeffords, the early 90s and the end of the Reagan presidency saw a re-evaluation of this hard-bodied image, not replacing it with a return of the soft-body of the Carter era, but with "a rearticulation of mascu-line strength and power through internal, personal and family-oriented values." These were reflected politically in, on the one hand, "a strong militaristic foreign-policy position and on the other hand a domestic re-gime of an economy and a set of social values dependent on the centrality of fatherhood" (Jeffords 1994, 13). This early 90s move identified by Jef-fords needs to be viewed against subsequent events: the different kind of masculinity portrayed by Bill Clinton, his battles with the Christian right over masculinity issues (the influence of Hilary on his presidency, his stances on homosexuality and also his own personal sexual practices), and resurrection of the strong masculinity of George W. Bush reasserted as a muscular foreign policy abroad and a promotion of a clear masculine-feminine agenda and family-centred values at home. In this latter regard, it is interesting to note the role played by women in Gibson's film. Women are present in *The Passion* more prominently than they are in the Chris-tian Gospels, reflecting the influence on Gibson of the visions of Anne Emmerich. But the women's roles are primarily passive supportive and sympathetic ones.

In developing *The Passion* as an action hero movie, Gibson works on the dynamic of action movies, that is, the suffering, endurance and over-coming of the full impact of life's adversities, abrasions and threats; and the tension between restraint and excess as a visual spectacle in that en-

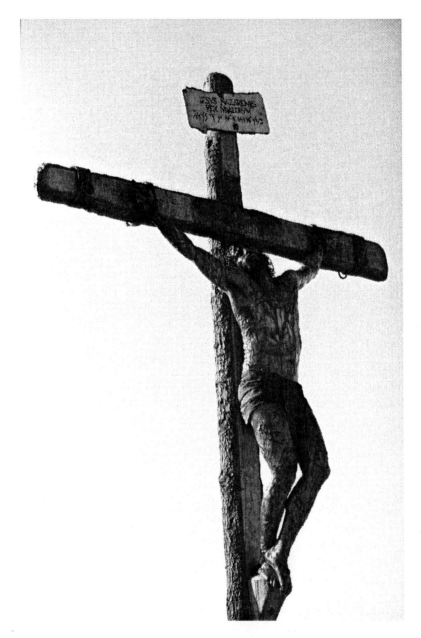

Figure 19: The crucifixion of Christ from *The Passion of Christ* (dir. Mel Gibson). © 2003 Icon Distribution Inc.

durance. As Tasker explains:

> While the hero and the various villains of the genre tend to share
> an excessive physical strength, the hero is also defined by his re-
> straint in putting his strength to the test. And it is the body of the
> male hero which provides the space in which a tension between
> restraint and excess is articulated. (Tasker 1993, 19)

This spectacle of the body is both narrative and aesthetic. In *The Pas-
sion,* arguably, the spectacle is more visual and aesthetic than it is narra-
tive. In contrast to most action hero films, there is little character develop-
ment that leads an audience to identify with the hero. The story is a well
known one, so little tension is generated to create within the audience the
anticipation that there is a greater power here waiting to erupt Rambo-like
and give 'em back what they deserve. There is no *chairos* narrative mo-
ment where the hero's restraint is pushed beyond its breaking point and
he reluctantly asserts his superior power to overcome the evil. The film
grinds inexorably from its beginning to its known and expected conclu-
sion. As Goodacre describes it, the physical challenge is "a single-minded
muscular commitment to following the path God has set for him" (Good-
acre 2004, 34).

The lack of this dramatic anticipatory tension in *The Passion* is an inter-
esting one. There is inherent in the Christian narrative the belief that as the
Son of God Jesus had the power at any time to turn on and vanquish his
tormenters, but refused to do so. This tension is not effectively developed
in *The Passion.* There is no preceding narrative that establishes the portray-
als of suffering within the film in a broader narrative context. In fact there
is little character development at all: the twelve flashbacks throughout the
movie do serve to provide some narrative context, but they are suggestive
rather than constructive and assume a more detailed knowledge on the
part of the audience than is presented in the film. Within the terms of the
film, the primary device that is used to construct this main character as
hero is an aesthetic one: the extreme suffering inflicted on the body of the
primary character and the capacity of the character to endure it.

Tasker suggests that all hero films draw on "those Christian traditions
of representation which offer up the suffering white male body as specta-
cle" (Tasker 1993, 73). Jennifer Ash suggests that those traditions are most
apparent in medieval spirituality and iconography, with its concern with
suffering, and is therefore the tradition that lends itself most readily to this
sort of filmic aesthetic adaptation.

> Late medieval Christianity turned its attention to the events of the
> Passion, obsessively focusing on the battered and bleeding body

of Divinity dying… a Christian discourse which venerates, as its object of worship, a body–passive, suffering, bleeding, dying… a discourse constituted through a rhetoric (both visual and verbal) of violence and death, or pain and suffering: a discourse of the body and the bodily, revelling in the fleshiness of the Word. Transubstantiation was made official doctrine in 1215." (Ash 1990, 76)

In developing this religious aesthetic of the bodily suffering of the hero, it is interesting to note parallels with aesthetic aspects of Gibson's own action hero characters. The nailing of Jesus to the cross has echoes of the smashing of Gibson's character's feet in the film *Pay Back*. The beaten closed-eye of Jesus parallels Gibson's character in *Mad Max*. The raising of the cross has echoes of the raising of William Wallace's body in a cruciform position at the end of *Braveheart* (1995).

For many viewers, this sole indulgence in an aesthetic of violence verges on being pornographic and fails to do justice to the full meaning of the event. (It is worthy of note that Gibson produced a reduced violence version to correspond with Lent of 2005, arguing that the high level of violence kept many away who would otherwise have seen it). Mary Gordon, herself a conservative Catholic, argues that focussing solely on the pain and suffering is an inadequate narrative device that fails to do justice to the story or the person.

If you take the Passion out of its context, you are left with a Jesus who is much more body than spirit, you are presented not with the author of the Beatitudes or the man who healed the sick but with a carcass to be flayed… Jesus as a person with mind or spirit is not present in this film. (Gordon 2004)

This primary focus on the torture and execution of the hero may be explained by artistic decisions to present what Gibson saw as the horror of the event in its extensiveness required removing extraneous elements. It may also reflect, however, a reworking or an alternative vision to the modernist view of suffering and pain as being associated with victimhood rather than human agency. Talal Asad has observed that the relationship between human agency, the avoidance and overcoming of pain, and how pain is to be admitted or administered in a civilized society, has been a significant marker of human power and progress characteristic of the modern consciousness. Modern Christianity, in accommodating a secular consciousness, therefore sees pain as "essentially and entirely negative" (Asad 2003, 106), a significant difference from early Christian martyrologies which "refuse to read the martyrs' broken bodies as de-

feat, but reverse the reading, insisting on interpreting them as symbols of victory over society's power" (Asad 2003, 85). In a political climate in which religiously-motivated political martyrs reflect a similar philosophy, the modernist understanding of pain and human agency may be being reworked. Gibson's production, through its violence, may reflect that sort of reworking from a Christian perspective, recovering a medieval vision as relevant to the cultural rethinking taking place around the body, pain, human agency, power and martyrdom in a post-modernist context.

This separation of the torture and execution of the character from other aspects of the character's life that the audience might identify and sympathize with, may also reflect Gibson's preferred theological understanding of the Christian doctrine of the atonement. That view, commonly understood as the substitutionary or 'objective' theory, argues that in one sense humans have no role to play in salvation. Salvation or atonement is an arrangement between Jesus and God: humans have nothing to do but sit by, accept it, and worship it.

What Gibson has done in his more medieval representation, therefore, is not so much impose his own idiosyncratic version of the Passion, but injected into the cultural mainstream in a genre of the mainstream an older but enduring aesthetic and sensibility of Christianity that is more material in nature and which challenges the more rationalistic Catholic and Protestant versions of Christianity that have dominated modernist religious culture. Susan Jeffords has argued strong links between portrayed masculine identity and the male body, popular culture, and national political identities (Jeffords 1994). The reconstruction of one of the founding myths of Christian culture as a powerful cultural product that achieves an outstanding commercial success by crossing the boundaries of religion and popular culture, adds a significant dimension into the political discussion. In a world in which religion has again become a significant cultural and political force, *The Passion of the Christ* needs to be seen as more than just another religious movie but as a significant cultural event which, in a globalized world, continues the cultural re-interpretation and re-appropriation of the Christian religious myth into the national and political identity of Christian nations.

13

"Perception Is Reality": The Rise and Fall of Professional Wrestlers

Wendy Haslem

The WWE Universe

In late 2005, the impresario of professional wrestling, Vince McMahon, proclaimed: "perception is reality."[1] Under the umbrella of World Wrestling Entertainment, McMahon has created a dynamic, multi-faceted universe of spectacle and excess. In 2006, the WWE's multimedia empire includes magazines, superstar merchandise, film, and a website that offers "WWE 24/7," wrestling on demand. It produces regional house shows, live 'dark' shows, it televises compilation shows like *Velocity* and *Heat*, all of which contribute to the popular weekly television shows: *Smackdown* and *Raw*. These programs are also a part of a larger matrix, functioning to develop 'angles' between wrestlers that are eventually played out in monthly pay per view shows, culminating in the annual event, *Wrestlemania*. This chapter will investigate the rise of professional wrestlers in their depiction as physically agile, powerful and seemingly invulnerable figures who draw from and revise characteristics of the superhero. Like superheroes, wrestlers are larger than life, but also express human frailty. This chapter will also analyze the fall of wrestlers and the impact of the 'reality' of the world beyond the ropes. This 'shock of the real' on the artifice of the wrestling universe results in a shift in address for the wrestlers and a rupture in the illusion that creates a perception of wrestlers as invincible. The rise and fall of the wrestler and the blurring of the illusion contributes towards the development of a doubled vision for the spectator.

The incursion of the 'real' into the wrestling is something that live performances attempt to control. In her meticulous study of wrestlers training at Gleason's Gym in the 1980s, Sharon Mazer notes the slippage between contrivance and improvisation: "[a]lthough a particular 'bit', a setup, or a scenario may be discussed in advance and the victor dictated by the promoter, the overall wrestling performance is improvised" (1990, 98). In a subsequent article, Mazer emphasizes the "fakery" of wrestling

and its interpretation as a "morality play" as two points on a continuum (2005, 69-70). It is the slippage between the layered universe of wrestling and the world outside the stadium that complicates McMahon's conflation of perception and reality. The illusion is dominated by the superhero, and the world outside by the human.

The Rise

The most influential writing on wrestling dates back to 1957 with an essay by Roland Barthes entitled "The World of Wrestling." This was one of the first texts to offer a sustained semiotic investigation of the signs, symbols and language of wrestling. Barthes was also one of the first writers to align wrestling with mythology and high art. Barthes suggests that wrestling is not a sport, but a "spectacle of excess" and that the public abandons itself to the immediate and visceral nature of the spectacle, "what matters is not what it thinks, but what it sees… wrestling therefore demands an immediate reading of the juxtaposed meanings, so that there is no need to connect them" (1973, 15-16). Barthes is referring to the "full signification," the immediacy and momentum developed through live performances organized according to the clarity of overt gestures, where matches are linear and develop chronologically, theatre which leaves "nothing in the shade" (1973, 26). He writes that, "This emptying out of interiority to the benefit of its exterior signs, this exhaustion of content by the form is the very principle of triumphant classical art" (1973, 19).

Almost fifty years later, professional wrestling has evolved towards a more fractured, repetitive and virtual system of presentation. Televised wrestling constructs a rich spectacle based on multiple points of view from numerous still and mobile cameras surrounding the ring. Cameras situated at various angles display the performance from myriad points of view. High frequency editing, cutting on impact and the repetition of the action from almost every vantage point imaginable, works to high-light the performance. The multiple viewpoints also function to conceal the possibility of "showing light," when moves fail to connect. Set against this dynamic visual display, the commentary offers much more than mere context and background for the wrestlers. Commentators actively contrib-ute towards the narrative by linking the histories of the wrestlers to the behind-the-scenes soap. The commentary also adds a layer of frenzy to the in-ring competition. Dialogue accentuates the contest by highlighting the physicality of the match and by expressing concern over possible physical damage caused by the falls. Spectacle and commentary construct a range of hero and villain archetypes. Like the superhero doubles who litter the

pages of comic books, they evolve as characters within a fractured, serialized narrative form. Above all, contemporary wrestling values dynamic performance and fragments of this spectacle are distributed across a multimedia matrix. In its reliance on spectacle, simulation and repetition, the WWE in particular, creates its own hyperreal universe.

Jean Baudrillard's category of abstraction, the 'hyperreal' describes the experience of the postmodern dissolution of grand narratives and the loss of faith in a single 'truth'. Under this model, histories become dynamic and truth, impossible. Hyperreality, according to Baudrillard, is, "a domain where you can no longer interrogate the reality or the unreality, the truth or falsity of something. We walk around in a sphere, a megasphere where things no longer have a reality principle. Rather a communication principle, a mediatising principle" (1988, 8). Hyperreality becomes a landscape of images where mass media dominates and shapes consciousness. Baudrillard suggests that sites like Disneyland are the ultimate in hyperreality, but that it also functions to beguile the spectator into perceiving the space outside the gates as 'real'. According to Baudrillard's framework, we can perceive the universe created by the WWE, where performance is simulation and where images are dispersed and reiterated throughout WWE media, as a kind of wrestling hyperreality. Beguilement also characterizes the experience of the wrestling fan attracted by the fantasy of wrestling superstars performing literally and figuratively as superheroes, because the wrestlers and the space they occupy is one that is larger than life.

Throughout the history of professional wrestling, the influence of superhero archetypes can be seen directly with the incorporation of characters like the Ultimate Warrior, Tigermask, Jushin "Thunder" Liger, Lazertron, The Blue Blazer and Arachnaman, (the last of whom was a superhero wrestler who resembled Spiderman so faithfully that Marvel Comics threatened legal action). The names of each of these superhero wrestlers suggest mutation, technological power and intense forces of nature. Recently Gregory Helms, in the guise of The Hurricane, styled himself as a masked and caped tribute to the Green Lantern. Bouncing off the ropes, perhaps stirring up the air, The Hurricane appeared as an embodiment of the superhero. By day The Hurricane was a mild mannered newspaper reporter, but inside the ropes, he fought "for truth, justice and the WWE way." A tag team partner, Rosey, was produced to accentuate the superhero focus, ultimately creating a dynamic duo without any visible super powers. Like Batman's Robin, Rosey was rarely the dominant dynamic force within the tag team. Although he was masked and caped, Rosey became a parody of the superhero archetype, playing on the acronym emblazoned on his costume, "Super Hero In Training." Eventually, Rosey graduated to "official crime fighter," but the partnership was short-lived.

In an example of the dynamic of reinvention within the WWE, Rosey has disappeared and The Hurricane persona has been abandoned.[2]

Both the superhero and the wrestler contribute towards the creation of self-referential worlds, organized according to a coherent internal logic. In the WWE this logic is based on a link between the past and present. Occasionally, contemporary wrestlers are coded in nostalgic reference to wrestling history and wrestling icons of the past. Wrestlers like Eugene become the embodiment of self-referential signifiers, existing as a reminder of wrestling history. Introduced as the 'nephew' of one time general manager of Raw, Eric Bischoff, Eugene is a wrester with an unlikely physical form, who seems to have little originality. Eugene has become a virtual pastiche of characteristics and 'finishing moves' of prior wrestlers. Eugene re-interprets a range of familiar moves including Hollywood Hulk Hogan's leg drop, his kick with 'the big right boot', and his posturing whilst addressing the audience. He also performs 'the sharp shooter', a move made famous by Brett Hart and then The Rock. Lacking the physicality and the aerial ability of the superstars, the 'mentally challenged' identity of Eugene is invested in images of past wrestlers. Simulating performances of iconic wrestling figures, Eugene provides evidence of, and reinforces, the star system at work within the WWE. Performances like Eugene's result in the fetishization of moves, akin to the superpowers of the superhero. From his position between past and present, Eugene functions to highlight the continuum of wrestling history. He also offers fans the fantasy of the possibility that anyone can become a wrestler.

The universe created by the WWE is characterized by a high degree of nostalgia. This universe values a non-linear, unstable, perhaps even schizophrenic reality characterized by fracture, rupture, repetition and an obsessive return to the past. The black and white opening credits for both *Smackdown* and *Raw* contain images of wrestling icons like Andre The Giant, Hollywood Hulk Hogan, Stone Cold Steve Austin and The Rock, a montage that acts as a weekly reinforcement of wrestling history. The opening credits juxtapose these icons with more contemporary wrestlers like Triple H, RVD and The Undertaker. *Smackdown* also pays homage to wrestling icons with its inclusion of retrospective sequences of pivotal matches and stars from its own history. 'WWE 24/7' functions as an archive of matches delivered 'on demand'. In an annual event, on the night before *Wrestlemania*, the WWE inducts wrestlers into its Hall of Fame. In its valorization of wrestlers of the past, the WWE constantly recreates and rewrites its own history.

The wrestling also directly impacts on the world outside the stadium. Occasionally, wrestlers attempt to transfer their heroic powers to the social sphere. In some cases, wrestlers make the transition from the ring to

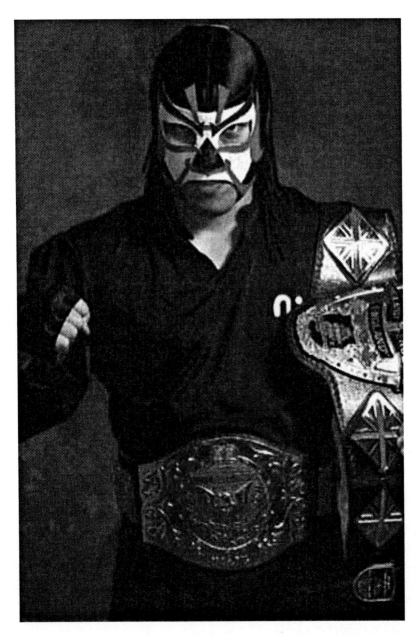

Figure 20: The Great Sasuke. © www.obsessedwithwrestling.com

politics. In 1998, Jesse 'The Body' Ventura, became the 38th Governor of Minnesota. In Japan former wrestlers Antonio Inoki, Hirashi Hase and Atsushi Anita were elected to seats in The Diet. In April, 2003 Manasori Murakawa, or The Great Sasuke won election to the Iwate Prefectural Assembly, and became the first masked legislator. Historically, politically active superhero wrestlers are more common in Mexican *lucha libre*. Although the particular style of wrestling is aerobatic and the wrestlers are often masked, *lucha libre* wrestlers exist within a long populist tradition of political activism and have been more successful in extending their simulated role of hero in the ring into their 'reality.'[3] Mexican wrestlers have actively lobbied for basic rights for indigenous communities. In November of 1988, resplendent in his mask, wrestling tights, cape and boots, Superbarrio was unveiled as a presidential candidate for Mexico City (Levi 2005, 120). The "superpolitics of Superbarrio" was organized around the struggle for housing, education, employment and land rights for Mexicans. Associating the 'real' with the wrestling persona and the performance with politics, Heather Levi describes Superbarrio as both "a real figure and a piece of political theatre" (2005, 120). For the past ten years, Superbarrio has been a one of Mexico City's greatest folk heroes. He understands his role as more hero than superhero. Superbarrio says, "I can't stop a plane or a train single-handed, but I can keep a family from being evicted" (Superbarrio qtd. in Kline, 1997).

Traditionally, wrestlers and superheroes have been constructed according to binary oppositions and established archetypes. In a spectacular display of their 'powers', resourcefulness and agility, both exemplify Barthes' description of wrestlers as the embodiment of exterior signs (1973, 19). Wrestlers and superheroes represent a constellation of real and imagined signifiers. Each produces a dynamic performance organized to exhibit their physical prowess and to display their signature moves. Mazer notes how matches are organized according to a pyramid structure where wrestlers circle one another, "building to a climax with ever more frequent turnarounds, the wrestling action moves quickly from the last reversal to the final pin" (1990, 99).

Professional wrestlers have traditionally been stylized according to two opposing categories: baby face wrestlers and heels. This dyad is also fundamental to the superhero, particularly in their early comic book manifestations where good and evil were clearly delineated. Superman's good was balanced by Lex Luthor's evil. Batman's desire for order was paralleled by The Joker's passion for chaos. For the traditional superhero and the wrestler, good must be rewarded and evil punished and excluded. In *Purity and Danger: An Analysis of the Concepts of Pollution and Taboo* (1978), the anthropologist Mary Douglas offers insight into the use of boundaries

and oppositions in distinguishing the acceptable from the taboo. Douglas investigates how cultures actively construct a specific universe in the course of an internal dialogue about law and order. She focuses on the power of symbolic boundaries and how they are maintained by ritual and cultural tradition. Individuals who ignore these conventions become 'disruptive' and they are designated as polluting or uncivilized. Douglas also acknowledges the link between order and disorder in ritual: "[r]itual recognizes the potency of disorder. In the disorder of the mind, in dreams, faints and frenzies, ritual expects to find powers and truths which cannot be reached by conscious effort" (1978, 94).

This type of challenge to order is played out through the enactment of rituals involving some of the more fascinating, but possibly aberrant, characters within the WWE. One recent example is the Boogeyman, a character of indeterminate origins who is billed as being from "the bottomless pit." Douglas describes those that are marginalized as "left out of the patterning of society who are placeless" (1978, 95). The Boogeyman shimmies down the ramp leading to the ring, shrouded by red smoke, seemingly mesmerized by a voodoo trance. The Boogeyman's face is painted in red and black leopard print. He wears an oversized clock around his neck and speaks in nursery rhyme. His entrance to the ring climaxes as he smashes the timepiece against his head, a literal rejection of time. The Boogeyman celebrates victory by drawing a handful of live worms from his pouch and eating them, much to the horror of his opponents. After he kissed Sharmell with a mouthful of worms, Booker T and his bride took out an intervention order against him. Douglas highlights the status of worms as "an abomination" and their creeping movement as "explicitly contrary to holiness." Douglas writes that: "As fish belong to the sea so worms belong in the realm of the grave, with death and chaos" (1978, 56). As a dark depiction of a super villain, this nightmarish character carries the threat of defilement. In the ring, hierarchies of dominance are contested and matches become enactments of rituals defining boundaries according to inclusion and exclusion. Whilst Booker T might prevail in the ring, the threat of characters like The Boogeyman can never finally be excluded because, marginalized, placeless characters remain a threat to order from the margins. Like the super villain, The Boogeyman exposes the fragility of boundaries distinguishing civilization from pollution. In promising a return, the Boogeyman highlights the impossibility of stability within this hyper-serialized universe. In contemporary superhero and wrestling narratives, traditional oppositions become destabilized in favor of liminal identities.

Contemporary wrestlers move across categories of good and evil and beyond. Such fluidity risks resistance from fans. Whilst the baby face/heel

categories might be controlled by the writers and producers at the WWE, the permeability of this division is also something that reflects the imperative of serial form and the influence of fan culture. Wrestlers need to perform a series of transformations in character and status in order for their characters to survive. The WWE's serial structure demands dynamic transformation from the wrestler. Characters like Kurt Angle transform from "All American Olympic Gold Medalist" to heel and back again in order to maintain interest in his character. But audiences with long memories express their resistance, chanting "You Suck" when Kurt Angle enters the ring, long after he has been recuperated as a baby face wrestler.

Audience engagement with wrestling both subverts and supports the fantasy created. Mazer suggests that the appeal of wrestling "remains close to the circus tour or the Broadway musical road show with its advance hype, its star system, and most of all, its elaborate glitter and pageantry" (1990, 103). Mazer argues that,

> [i]t doesn't matter whether or not the outcome is fixed in advance, although it usually is. The familiar pattern of loss and recovery, of victory snatched from the jaws of defeat, or revenge for previous atrocities seems to satisfy the audience in the same way that a favorite story (or play or movie) with its anticipated ending never fails to excite and reassure. (1990, 101)

The type of direct audience involvement that is cultivated by the WWE at live performances is based on the sense of wonder promoted by early sideshows, boxing contests and in the carnival, where the outcome is less important than the performance itself. But it is through a call and response engagement similar to that of a spiritualist church, that audiences contribute directly to wrestling matches. The ring becomes a site that cultivates an energy similar to that generated within a revivalist church. The wrestling ring functions as a sacred space, similar to that in Sumo wrestling where the ring is purified by a ritual involving throwing salt.

Henry Jenkins has argued that the influence of cinematic melodrama results in the development of a dualistic universe where a display of emotion can be expressed (2005, 33-66). Jenkins draws from the work of Peter Brooks who argued that melodrama functions to provide a post-sacred society a means of mapping its basic moral and ethical beliefs (2005, 40). Barthes argues that the wrestling ring functions to construct gods, surrounded by an audience involved in a type of religious worship: "In the ring, and even in the depths of their voluntary ignominy, wrestlers remain gods because they are, for a few moments, the key which opens Nature, the pure gesture which separates Good from Evil, and unveils a

form of justice which is at least intelligible" (1973, 26). The wrestler JBL interprets this literally, claiming: "I am a wrestling God!" The fractured multimedia focus of the WWE raises the profile of wrestlers to the status of super heroes and super villains, if only temporarily.

The Fall

The link between the spectacle of violence and the wrestling universe can be perceived as a populist revision of Antonin Artaud's "Theatre of Cruelty." In Artaud's concept, cruelty refers to a violent, physical determination to shatter the false reality that clouded perception. Artaud writes, "The Theatre of Cruelty has been created in order to restore to the theatre a passionate and convulsive conception of life, and it is in this sense of violent rigour and extreme condensation of scenic elements that the cruelty on which it is based must be understood" (1958, 66). The aim of Artaud's theatre is to engage and confront its audience. Susan Sontag describes Artaud's theatre as:

> characterized by an absence of any fixed spatial positioning of the actors vis-à-vis each other and of the actors in relation to the audience; by a fluidity of motion and soul; by the mutilation of language and the transcendence of language in the actor's scream; by the carnality of the spectacle; by its obsessively violent tone. (Sontag 1976, xxxvi)

Performance in the wrestling and Artaud's theatre seem chaotic, irrational and highly symbolic. In both, the real and the imagined become inextricably linked.

This link between the real and the imagined manifested in 2002 when Marvel Comics situated their superheroes within the debris of the World Trade Center. The WWE has a history of constructing analogies of political and national conflicts, encouraging its audiences to express their allegiance to or dissatisfaction with, a specific nation or national policy. With an explicit acknowledgement that they are "putting on a show" in a similar way that musicals collapse the distinction between the ring and backstage, the WWE takes their show to Iraq to perform for the American troops. During the second Gulf war, characters like Daivari & Muhammad Hassan emerged configured as Middle Eastern antagonists. At the height of the French government's refusal to condone the war, the WWE produced *La Resistance*, a tag team comprising Rene Dupré and Sylvan Grenere as an embodiment of French resistance. This use of wrestlers as

symbols for global political and social contexts is not new. Henry Jenkins reminds us that the controversy of Gulf War I was restaged in the squared circle through the shifting allegiances of Sgt Slaughter who re-invented himself as a supporter of Middle Eastern politics and provided an opposition for Hulk Hogan's America-centric character (2005, 61-63). In *On Boxing*, Joyce Carol Oates notes the fundamental link between boxing and an anger that transcends the ring, arguing that it functions as an expression of injustice through displacement: "Boxers fight one another because the legitimate objects of their anger are not accessible to them" (1987, 63). Similar to Jenkins on wrestling, Oates notes the potential for the performance of the fight to offer a space to confront and transcend oppressive class structures.

Professional wrestling functions as a ritualized display of masculine excess. Writing about *Fight Club* (Fincher, 1999), Robert Westerfelhaus and Robert Alan Brookey argue that the representation of masculine violence in popular culture offers substitutes for traditional rites of passage, rituals that otherwise might be in decline in contemporary Western culture (2004, 302-326). They suggest that rite of passage rituals often incorporate "rituals of rebellion," that is, a temporary license to violate sociocultural rules. These rituals of rebellion might take the form of stag nights or bachelor parties, rituals that customarily involve an excess of celebration prior to a rite of passage ritual. Westerfelhaus and Brookey focus on the transition to adulthood for Amish males. The aim of these rituals is to immunize Amish youth against the lure of modern society (2004, 309). Westerfelhaus and Brookey understand psychopath films as offering relatively safe, armchair pilgrimages into a utopian fantasy, virtual, vicarious experiences of these rituals of rebellion (2004, 309). Like many superhero narratives, wrestling provides a fantasy that works to effectively 'siphon off' cultural anxieties.

In fantasy, professional wrestling offers its audiences a range of positions through which these rituals of rebellion can be imagined. Mazer suggests that, "With the strong identification between spectator and wrestler, wrestlers act out their mini-rebellions as the spectators' surrogates. Bad guys or good, as wrestlers violate the order represented in and by the ring, they temporarily liberate the spectators from the constrictions of everyday social proprieties" (1990, 116). The WWE offers its fans the possibility of cathartic identification with caricatured positions of revolution against authority, or where physically smaller wrestlers beat larger, more powerful opponents. In many ways, the fantasy of the wrestling parallels the function of the superhero. Both the ring and the world of the superhero become sites for the display of social and class metaphors. Nicholas Sammond has recently argued that the ring can

be interpreted as a site of both resistance to the dominant order and an enactment of its oppressive force (2005, 19). In the context of the ritual of rebellion, professional wrestling offers a fantasy of inversion similar to the carnival, even if only temporarily.

Audiences also bring an element of interactivity to the WWE. They cheer or jeer wrestlers at their entrance, they count "one, two, three" along with the referee and they proudly display signs like "Don't Make Me Come In There," or "John Cena–Will You Come to My Prom?" Not long after John Cena was given a hostile reception at *Wrestlemania XXII*, a sign in the audience during an episode of *Smackdown* asked fans to "Stop Booing Cena." These signs not only collapse the fantasy with the spectator's reality, they also function to provide a meta-commentary which often idolizes and celebrates, but also might present a critique of the wrestlers, of the hierarchy of the WWE, and even of other fans. Audience interactivity also challenges the illusion with a conscious acknowledgement and an exploitation of the limits of fantasy. Fans of Extreme Championship Wrestling were known to bring their own weapons to the ring. They would hand wrestlers frying pans and other utensils in order to facilitate their win. Mazer notes that wrestling culture separates audience members into "smarts" and "marks" according to their level of inside knowledge and gullibility (2005, 73,75). Of equal interest for wrestling audiences are ruptures in the presentation of this illusion.

Wrestling fans are attuned to watching for the slippage within the fantasy. Rituals configured around the revelation and display of blood have a long and secretive history in professional wrestling. 'Blading' is a ritual that describes cutting with a concealed razor blade whilst in the ring. It is often performed by the wrestler himself, sometimes blading is done by the referee, or even the opponent. Wearing 'the crimson mask' is a visual symbol of the intensity of the struggle. It provides evidence of a dynamic match, something that continues to be displayed with great pride by wrestlers like 'The Nature Boy' Ric Flair. In offering evidence of impact, the display of blood provides indisputable evidence of wrestling as 'real'. At other times, the slippage between fantasy and reality is accidental. Wrestlers use the terminology 'hardway' to describe blood that arises under less controlled circumstances. Mazer describes the silence of the crowd watching a live match at Gleason's Arena in 1989 when a wrestler was thrown out of the ring onto the concrete. She writes, "Although the wrestler arose… the man's damp, matted hair vividly reminded us of the very real risks of the game. For a moment, spectacle had collapsed into reality. We had, indeed, gotten our money's worth" (Mazer 1990, 109).

Wrestling culture embraces physical excess and emotional extremes. According to Barthes, wrestling takes up ancient myths of public suffering

Figure 21: Mick "Mankind" Foley with his sock puppet, "Mr. Socko."
© Titan Sports.

and humiliation. "It is as if the wrestler is crucified in broad daylight and in the full sight of all" (1973, 22). Hardcore matches promise extreme gestures of giving and receiving pain. This is also the illusion created within the hardcore match. Hardcore creates the spectacle of power, agility and acrobatic physical prowess, but it also highlights suffering and pain. Henry Jenkins' designation of wrestling as 'male melodrama' reinforces Barthes'

claim that "In wrestling, as on the stage in antiquity, one is not ashamed of one's suffering, one knows how to cry, one has a liking for tears" (1973, 17). The performance of wrestling maneuvers might function as the signature of a wrestler, but it is the selling of these moves by the opponent and the display of damage that is of equal importance.

Hardcore matches can be interpreted as an extreme example of Mikhail Bakhtin's carnivalesque where the collective order is organized to invert conventional socioeconomic and political organization. During the carnival individuals recreate identities through the use of costume and mask. Within this subversive culture, there is a heightened awareness of corporeality and sensuality (Bakhtin 1984, 10). Hardcore is organized along such subversive and sensual lines. It asks wrestlers to violate the rules of conventional matches, and it celebrates devastation. The boundaries that might ordinarily differentiate the performance space from the space of the spectator are often ignored as the contest moves into the crowd, behind the scenes and sometimes outside the stadium. Within the hardcore match, wrestlers are licensed to use a range of weaponry including steel chairs, ladders, traffic signs, thumbtacks, sledge hammers, tables, baseball bats, fire, fire extinguishers and even forklifts. In *Wrestlemania XXII*, the 'Hardcore Legend' Mick Foley wore a belt of barbed wire underneath his shirt. Foley's weapon of choice is a sledgehammer wrapped in barbed wire, affectionately named 'Barbie'. Foley has made his reputation as a wrestler with a high pain threshold, seemingly able to endure more physical damage than most others[4]. During an "I Quit" match at the *Royal Rumble* in 1999, Foley took eleven chair shots from The Rock and he describes his experience of the dislocation between the performance and reality:

> I sincerely believe that professional wrestling is at its best when the performers lose their own sense of disbelief and begin to actually "feel it". In a sense, the match becomes real, or at least real in that they actually "become" their character, and actually feel what the storyline is attempting to make the audience feel. As I took the beating up the aisle, I lost that sense of disbelief and began to actually "feel" that I was wounded (2001, 24-25).

In its focus on punishment and humiliation, the Hardcore match becomes a performance of populist sado-masochistic rituals. Wrestling generally embraces the S and M aesthetic in its display of leather, spandex, boots, studs, chains and masks, and in its exhibition of bodily decoration with ever expanding tattoo art and piercing, but hardcore takes this spectacle into another dimension. Hardcore wrestlers become involved in an illusion of violence and punishment that seems to exceed bearable

limits. Hardcore is particularly reminiscent of Artaud's conception of theatre as a place of risk and danger, based in an "aesthetic of shock" (Sontag 1976, xxxiv). Mazer highlights the sexual aspect of hardcore when she suggests that, "The most violent postures are also the most apparently sexual, as when one man takes the other's head between his legs, turning him upside down in a pile-driver: that often leaves the victim unconscious and ready for the final pin" (1990, 116-117). Wrestlers and wrestling fans share a fascination with the expression of violence and the iconography of suffering and the slippage between reality and illusion.

As much as the wrestling universe is geared towards a display of physical and acrobatic power, it also incorporates moments when the superstar becomes human, when reality infiltrates the fiction in uncontrollable moments of no return. The artifice of the wrestling world was ruptured by two recent historically and personally significant moments. The televised shows immediately following September 11th, 2001 began with a moving scene of tearful wrestlers gathered at the top of the ramp in a show of unity, listening to the ring announcer, Lillian Garcia sing the American national anthem. In instances like these, wrestlers abandoned their preordained oppositions and presented a unified front. Between matches, wrestlers and announcers addressed audiences directly in vignettes that described the impact of this event on themselves and their families. Under these conditions, the fantasy of the physical performance recedes into the background and the focus becomes more emotional, personal and direct. A sense of unity and immediacy is created through this representation of collective and individual expressions of shock and grief.

The death of Eddie Guerrero in November, 2005 shocked wrestlers and fans. All matches scheduled for *Raw* and *Smackdown* that week were dedicated to Eddie and emotion was expressed verbally in eulogies presented directly to the camera between matches. A montage of career highlights that presented Eddie's tale of heroic rise and fall was accompanied by Johnny Cash's rendition of 'Hurt'. At the end of the show, a belt was left in the middle of the ring, signifying his absence as the lights went down. In the ring, tributes to Eddie continued as his friends Rey Mysterio Jr., Chris Benoit and his nephew Chavo Guerrero perform his signature moves 'the three amigos' and 'the five star frog splash.' Eddie's presence in the WWE remains six months after his death as fans continue to wear his "*Viva La Raza*" t-shirts, display posters paying tribute to him and in the "Eddie" chant that seemed unlikely to end when it was announced that he was inducted into the WWE Hall of Fame during *Wrestlemania XXII*.

The death of Owen Hart on May 23rd 1999, after falling during his aerial entrance as The Blue Blazer at a pay per view show in Kansas City, Missouri,

is one of the defining moments when the 'real' ruptured the illusion of the wrestling. In his autobiography, The Rock (Dwayne Johnson) writes about the shock of watching from the guerilla position, just inside the curtain, as the paramedics tried to revive Owen. Vince McMahon warned The Rock against moving beyond the curtain and creating confusion between the accident and the potential to see this as 'a work' (2000, 363). In this instance, within an auditorium of silent spectators in full recognition of the accident, the illusion collapses.

Reality Fractures Perception

This chapter has argued that the wrestler reconfigures the superhero and super villain dynamic and performs it inside the ring. It has also acknowledged that, as the opposition between reality and fantasy dissipates, the wrestler is recognized as human. Within this chapter, the discussion of the impact of the outside world on the illusion constructed by the wrestling reverses the dominant approach in wrestling discourse. Professional wrestling has shifted from the 'world' described by Barthes to a 'universe' constructed by McMahon. This universe amalgamates the hyper-soap of its backstage drama, the physical contest played out in the squared circle and it acknowledges a reality outside the ring. In its hyper-aware, self-referential, 'retcon' style, McMahon's universe also reconstructs its own history. The hyperreal, simulated universe created by the WWE constructs a dynamic cross-media environment where perception becomes beguiled by multiple 'realities'. By building a universe on multiple, fractured realities, wrestling destabilizes visual coherence, separating seeing from believing. Whether 'smarts' or 'marks', wrestling fans often find themselves in a state of perceptual uncertainty. McMahon's description of perception as reality is complicated by the dynamic illusion of this hyperreal universe that sometimes seems 'more real than real'.

14

"No Apologies, No Regrets": Making the Margins Heroic on *Queer as Folk*

Joanna Di Mattia

In the pilot episode of the US version of *Queer as Folk*,[1] Brian Kinney (Gale Harold) is introduced to us as the most desirable man on Liberty Avenue—the fictional gay hub of Pittsburgh in which much of the show's action takes place. The episode opens at Babylon, a gay nightclub. Sweating, dancing, gay men are presented as extraordinary in their costumes of tight t-shirts. This new standard for "superness" is the "beautiful gay man" and the most beautiful of them all is Brian. Up against the bar, Michael Novotny (Hal Sparks) is our Everyman narrator, the cute guy who loves comics and loves his friends. He introduces them, and, in turn, various ways of being male and gay. There's Emmett Honeycutt (Peter Paige) whose flame burns brightly, and explains that "it takes real guts to be a queen in a world full of commoners," and then insecure, thirty-something accountant Ted Schmidt (Scott Lowell). The camera pauses on Michael's best friend, Brian, spotlighted and idolized in the center of the dance floor. Michael explains that Brian is extraordinary because he doesn't suffer the usual anxieties of gay men. If you're Brian, "then it's who gives a fuck what you think, you're lucky to have me."

Superhero narratives are conventionally hegemonic texts. This essay explores the social and representational threat that a queer hero poses to the terms of American masculinity. Heroism, let alone *super-heroism*, is not an identity conventionally associated with gay men, and in the current political climate, the divergence between homosexuality and heroism is writ large in a number of arenas. By examining how *Queer as Folk* interrogates ideas of 'masculinity' and 'heroism' through the central figure of Brian Kinney and the intertextual comic book hero that he inspires—Rage, Gay Crusader—I problematize the articulation of these identities at the *exclusion* of gay men's bodies. This essay poses a number of questions. If the dominant ideal of American masculinity is an explicitly heroic one, what happens to this ideal when it is repositioned in a marginalized narrative space? It asks whether there can be a gay hero, and if so what makes him

heroic? And I ask how this destabilizes and expands 'normal' definitions of heroism itself? What I hope to show, in a wider, political context, is that it is increasingly difficult to maintain discrete borders between straight and queer, heroic and unheroic bodies. As a result, the heroes of *Queer as Folk* become superheroic in their rejection of normalization, while simultaneously repositioning themselves from the margins to the narrative center.

In *A Choice of Heroes: the Changing Face of American Manhood*, Mark Gerzon uses the iconic figure of John Wayne to define the ideal model of American manhood as white, heterosexual, tough, unemotional, individualistic, and heroic (1982, 3). The Bush era is marked by a concern with defining what is 'normal' and 'deviant' in the arena of gender identity, sexuality, and sexual practice that destabilizes the validity of this model of masculinity. The 2004 election, in particular, and the ongoing debate on gay marriage, reveals the pressure on this model of manhood to secure its position of privilege and the equation between bodily and social controls that is at the core of this anxiety. I would suggest that Bush's sex crusade is driven by the need to strengthen conventional 'man on top' gender roles (within a heteronormative context) at a time of increasing anxiety about the weakened status of a mythological, national masculine corpus in the post-9/11 era.

In this era, popular culture is under increasing pressure to offer an ideologically conservative product. It does not, however, always acquiesce to the dominant story of American masculinity. In this context, *Queer as Folk* can be seen as a pop culture product that does not submit to the rules and roles of heteronormativity and its representational conventions. *Queer as Folk* derails a traditional narrative of male heterosexual potency and dominance. It challenges the security and validity of labels like 'normal' and 'moral' by redefining them in a context often devoid of heteronormative representation. *Queer as Folk* reveals the courage and everyday heroism required to live a queer life. In doing this, it makes the margins heroic.

It is my position, here, that queer men play an important part in current debates about the masculine ideal. As they do in *Queer Eye for the Straight Guy*, the men of *Queer as Folk* engage with conventional icons and narratives of hetero-masculinity. By doing so, however, they expand and reconfigure the meaning of these icons and narratives, and interrogate the oppositional parameters of what is 'normal' and 'deviant' in their construction. This visibility is complex, however, and ambiguous in its effects: as Tania Modleski warns, feminists must consider how male power is consolidated in times of crisis by *incorporating* the threat posed by women into male-focused narratives (1991, 7). It is also important that 'gay culture'

be aware of the strategies employed by 'straight culture' to contain it via incorporation. I would offer the media phenomenon of the 'metrosexual' as an example of this strategy.

Queer as Folk interrogates the problem of what makes a gay man heroic, and does this by tracing each character's growth from boys to men. The most obviously infantilized of *Queer as Folk's* five men is Michael, and his immaturity is marked by his love of comics. In addition, his love of comics and 'supermen' is explicitly connected to his homosexuality and his own 'secret identity.' For much of season one, Michael remains closeted in the public arena, unable to tell his co-workers that he is gay, and he lives daily with this fear of discovery or unmasking. For many, even today, homosexuality is tantamount to a 'secret identity' explored in the metaphor of leading a double life and the constant anxiety of exposure that this entails.

The metaphor of 'secret identity' is also central to the tales of comic book superheroes, and research in this area repeatedly points to the potentially queer subtext of the double lives of Superman, Batman, and Spiderman. As Will Brooker suggests: "On the surface, Batman's secret is his alter ego as Bruce Wayne; but it is not hard to imagine that this repeated motif could have acquired a personal resonance for a young man having to hide his sexuality in the early 1950s" (2000, 136). Others have queered the relationship between Batman and Robin, pointing to the fine line that often exists between homosocial and homosexual relationships. Brooker notes that "while there is no 'correct' way to see this relationship, it can possibly be read as 'gay'" (2000, 110). For Andy Medhurst, Batman's double life is particularly interesting to gay audiences, pointing to the 1960s television series as a touchstone of camp (Pearson and Uricchio 1991, 150).

To negotiate their own 'secret identities' queer kids, lacking heroes to identify with, turn to comic books for mutants, those who are different, and defined as 'outsiders' from the mainstream. In season two, Michael, now owning of a comic book store, is invited by mild-mannered Professor of Gay Studies, Ben Bruckner (Robert Gant), to give a guest lecture on the aesthetics of the male body in comic books. Nervous in front of the class, Michael abandons his original notes and speaks about his own experience of identification. He notes that he first started reading comics because they offered him an escape and because it annoyed his mother, and that later, when he realized he was gay, he read them for *other* reasons:

> Because in ways that maybe nobody intended, those superheroes were a lot like me... At work, they're meek and unappreciated. They're the guys that never get laid and when they're around other people they can't let anyone get too close for fear that their

true identity would be discovered. Yet with all the villains and the monsters and the evil forces that were trying to destroy them somehow they *survive*... That's what the comics have shown me, that despite everything, we'll survive and we'll win' (2.6).[2]

Annalee Newitz argues that "it's hard to deny the sexual implications in books that follow the adventures of nerds with secret identities and social outcasts with superpowers" (2003, par. 3). She offers this equation: "Perhaps the figure of the queer is alluring for the same reasons the superhero is. Both are misunderstood, secretive, and dashing; often they live just outside the law. Of course, there's one significant difference between real-life queers and comic book characters: In the fantasy world of comic books, the superhero always wins" (2003, par. 5).

Looking for heroes and protective males in real life, Michael has been Brian's adoring sidekick since they bonded in high school over a picture of *Dirty Dancing*-era Patrick Swayze. Brian is the sexual and moral energy at the center of *Queer as Folk*. He is sexy, masculine, aggressive, penetrative, and powerful—terms that are not conventionally associated with queer men. Although a reluctant hero, Brian lives by an individualistic code that positions him as the show's most heroic character. It is a code that gives this essay its title: his is a life lived with "no apologies and no regrets." From the outset, Brian is an individualistic rebel, "the love child of James Dean and Ayn Rand" (2.10), who refuses to live his life acquiescing to heterosexual rules of conduct. Never apologizing for who he is and never openly regretting what he does, Brian is also unlike any other gay man before him on American television. He is not a clown, like Jack on *Will and Grace,* nor is he a victim struggling to come to terms with his identity, like gay men in countless made-for-television movies. He is neither inoffensive nor asexual, he is not dying from AIDS, nor does he submit to a cultural climate rooted in the politics of shame; he is not filled with self-loathing, wishing he were straight. Brian is defiantly 'out' in the public arena and repeatedly challenges authority figures and any other heterosexual who might have a problem with his homosexuality, declaring that "unless I'm fucking you, it's none of your business!" (2.17). Brian is a potent synthesis of unapologetic sexuality, homosexuality, and masculinity, in conventional understandings of the term.

Writing about current pushes for "assimilation," Suzanna Danuta Walters posits that, "When mainstream gays and their straight allies argue for the inclusion of gays because gays are no different from straights, real inclusion can never take place" (2001, 19). Concerned with the eradication of difference for the sake of cultural visibility, Walters notes that the new cultural visibility (of which *Queer as Folk* is one part), "can therefore erase

and marginalize those who desire something more than mere inclusion in straight society" (2001, 19). Like Walters, Michael Warner cautions that the queer community's embrace of a politics of normalization is an apolitical position that renders it passive, silent, compliant, and invisible (2000, 60). For Warner, the impetus to incorporate queer life into straight life is predicated on a politics of shame (2000, 60). This politics of shame is situated in the denial of and disgust with the queer body: its desires, its fluids, its pleasures, and its risks. Warner writes that, "On top of having ordinary sexual shame... the dignified homosexual also feels ashamed of every queer who flaunts his sex and his faggotry" (2000, 32). Such shame polarizes the community by constructing a hierarchy of good (heroic) gays and bad (unheroic) gays based on sexual activity.

Brian is a hero because he rejects heterosexually defined notions of what is 'normal' and what is 'right.' Refusing to conform, he is proudly promiscuous and self-absorbed, and can be moody and cruel, even to those he loves most if he believes that the ends justify the means. For example, Brian cruelly 'outs' Michael to a smitten co-worker at the 30th birthday party he throws him at his loft, in order to push him away and enable Michael to become someone else's boy toy wonder (1.11). In this context, Brian exposes the complexities of the heroic ideal—he is often concurrently *Queer as Folk's* hero and villain. Even if it's not popular, as a hero Brian does what others can't or won't, instinctively *knowing* what the right thing to do is. Brian looks out for himself so that he can take care of others. He is, in this sense, heroically individualistic for the good of the community, although he rejects his place in such an entity. While Brian is at once the "most fabulous fag in Pittsburgh" (2.1), there is a clash between his status as an ordinary gay man reluctant to embrace his heroic status and these things that set him apart from everyone else.

Not only heroic in refusing heteronormative regulations, Brian's rejection of these rules elevates him to 'superhero' status within the show. Brian's sexuality is at the core of this and how he defines himself as a man. Brian is like an "earthbound god" with sexual powers unlike other men. As Justin notes after their first encounter, "I just saw the face of God. His name is Brian Kinney" (1.1); and Michael also attributes an otherworldly mystery to his powers of seduction, saying that "we'll never know, but whatever it is, he says it for all of us" (1.3). Brian is not defined by heterosexual and patriarchal denigrations of queer masculinity as feminized, 'faggy,' or as ultimately incompatible with the idea of masculinity itself. Indeed, I would argue that with his aggressive, hard, penetrative character, Brian produces a culturally legitimate performance of masculinity that utilizes the penis and what it does as a central marker of his manhood. Being queer is a badge of honor for him—he not only uses it to mark out his

difference to others, but to laud his superiority over them. When local kids spray-paint "faggot" in bright pink on the side of his Jeep, Brian drives his latest conquest, 17-year-old Justin Taylor (Randy Harrison), to school without any shame (1.1). As he explains, it's the straight world's problem, not his, if they can't deal with his sexuality.

Like a superhero, Brian is marked out from society and has reached maturity without having a relationship with his parents. In *Superman on the Couch*, Danny Fingeroth points to the prevalence of fatherless heroes throughout comic book culture. Fingeroth points to the orphaned super-hero who creates himself from scratch and lives by "a code that is created from the visceral *evidence* of his own experience" (2004, 70). Fingeroth sug-gests that the orphan myth plays to the idea that: "we are all alone. We fight our own battles, make our own rules, defy those who would destroy us. We are alone to succeed or fail, to triumph or succumb" (2004, 71). Brian's "father wound" has informed his position as a somewhat solitary man and informs the code by which he lives his life. He tells Michael, "My responsibility is to myself. I don't owe anybody a goddamn thing!" (1.2), and later Justin, "You're the only one you need. You're the only one you've got" (1.5).

In addition, Brian's devotion to justice overrides his devotion to the law—the law, here, being the dominant heteronormative social contract, which he has no regard for. As he famously tells Justin: "I don't believe in love, I believe in fucking. It's honest, it's efficient... Love is something that straight people tell themselves they're in so they can get laid. And then they end up hurting each other because it was all based on lies to be-gin with" (1.2). Michael explains to a love struck Justin, "Brian doesn't do boyfriends" (1.2). Later, when Brian and Justin redefine the rules of their relationship, Brian distances himself further from heteronormative ideals of romance, love, marriage, and monogamy: "Don't get the idea that we're some married couple, because we're not. We're not like fucking straight people... We're queers. And if we're together, it's because we want to be, not because there's locks on our doors" (2.6).

Throughout seasons one, two, and three, Brian rescues all *Queer as Folk's* recurring characters. Brian's greatest moments come when the stakes are the highest—in matters of life and death, and in situations that threaten the foundation of his identity. In the final episode of season one (1.22), the most important of Brian's heroic interventions occurs, when he risks his own life to stop the gay bashing of his 'boyfriend' Justin and rescues him from a potentially tragic demise. In this episode, Brian turns thirty and is convinced that his life is over, despite Michael's assurance that he is no ordinary man. Attempting to recapture his youth, Brian surprises Justin at his prom. It is a brave and romantic act, and when they share a dance that

everyone stops to watch it is a daring public pronouncement of Justin's sexual identity. Throughout the season, Justin has been bullied and harassed at school by a homophobe, who may or may not be queer himself, called Chris Hobbs. As Brian and Justin dance, Chris looks on—it is unclear if he is jealous or disgusted. After their dance, Justin walks Brian to his car, and Brian steps out of character and defines the event as "ridiculously romantic." But as Brian is about to drive away he sees Chris Hobbs swing a baseball bat at Justin's head, knocking him to the ground. Running to the rescue, Brian wrestles the bat from Chris, saving Justin's life.

Brian's heroism is tested and proven here. He intervenes in a hostile act against someone he cares about. His feelings of guilt and helplessness in season two construct him as an ambivalent hero, not sure that he really did anything worthy of heroism. In the tradition of emotionally wounded, masked superheroes like Batman, Brian often performs his acts of heroism under a veil of secrecy that conceals his true motivations. When season two opens, six weeks later, Brian's friends think that he has abandoned Justin and doesn't care for him at all. We know, however, that Brian plays the part of protector and has been keeping a secret nightly vigil over Justin's hospital bed while he recovers.

An important season two episode illustrates Brian's ambivalence towards his status as a hero when he receives an Outstanding Gay Hero Award from the city's Gay and Lesbian Center for saving Justin's life (2.3). Brian repeats, "I didn't do anything," and is doubtful about the honor being bestowed upon him. As he tells Michael, "You want a hero, buy a comic book." He doesn't want the award, and flatly tells Lindsay to "tell them to give it to someone that *needs* their approval." For Brian, this behavior is ordinary and in agreement with his individual moral code. These pronouncements are interspersed with glimpses into Brian's secret identity, his protective nature as he continues to aid in Justin's recovery. He goes home early from the bar because Justin still gets "freaked out" when he's left alone; he helps Justin overcome his fear of public spaces.

But it is when the center decides that giving him the award could discourage their financial backing, that Brian's true courage and strength of character are revealed. An outspoken conservative gay advocate writes a piece for the local gay news, suggesting that there is no one *less* deserving of the title "hero" than Brian. He writes: "Mr. Kinney is a miserable example of a modern gay stereotype… totally promiscuous, completely vain… While we are lead to believe he is a hero, the truth is he's a pedophile, deserving not our honor, but our contempt." The piece urges gays and lesbians to "change the misconception that gay life is all about sex" and suggests, "we are our own worst enemy." Melanie reminds the committee that "the award is for Brian's courage, *not* his sexual conduct." When Brian

Figure 22: The cover of the first volume of the online comic book *Rage* featuring Brian's alter-ego from *Queer as Folk*. Created by Michael Novotny and Justin Taylor. © Showtime.

learns of this hypocrisy he decides that he wants the award after all, not for their approval, but to challenge their limited definition of a hero. Although granted the title of hero, Brian doesn't show up to receive it. Here, heroism is presented as innate, that Brian does what he does because it is the right thing to do without apologies and without judgments on others. And what is clear in his absence is that true heroism is silent and does not announce itself. As Lindsay notes of his absence, "I think he got the message across, loud and clear." Unlike the conservative hypocrite, Brian's words and actions are always aligned.

To further illuminate why a queer man like Brian is an archetype of heroism, the intertextual comic book, *Rage: Gay Crusader,* is created in the middle of season two. Escaping from the confines of the small screen, Issue #1 of *Rage: Gay Crusader*, was actually produced and circulated to fans who pre-ordered the season two DVD box-set.[3] The genesis episode opens with two animated panels that position boy wonder's Michael and Justin at Babylon. Fuelled by E, their comic book collaboration begins as they sketch one of the club's go-go dancers in full superhero garb. Michael notes that "capes are so last century, but he does need a superpower, he wouldn't be a superhero without one" (2.15). But it isn't this topless "twinkie" who embodies the heroic ideal both Michael and Justin admire.

Initially, Michael and Justin create Rage because Michael's comic book hero, the fictional Captain Astro, is killed off over speculation that he was gay (2.10). Rather than wait around for someone else to create an openly gay superhero, Michael decides to create his own, and Justin, who is an artist, joins him in this crusade. *Rage* is created because both Michael and Justin idolize Brian and both believe that he has saved them in different ways. As Michael's mother, Debbie (Sharon Gless) tells Brian, who experiences jealousy when his best friend and his 'boyfriend' spend time together, "They worship the ground you walk on, or can't you see it. You're their fucking hero" (2.15).

Just what it is about Brian that both Justin and Michael idolize is clear when they get together at Brian's loft to brainstorm. At first it seems that all the great comics have already been written (Superman, Spiderman, etc) and that there is nothing heroic left to write about, until Brian hops on the running machine behind them. As they glance at Brian it happens: their love of Brian and their desire for a hero that speaks for them gives birth to Rage. This exchange secures Brian's status as a hero.

Michael: "You know whoever our guy is he doesn't have to be your standard superhero steroid case…
Justin: It's his mind that makes him sexy!
Michael: It's his fierce individualism…

Justin: That gives him courage!
Michael: His uncompromising moral code...
Justin: That makes him strong!
Michael: What if his disguise is that he's a cold-hearted ad exec by day ...
Justin: Defender of queers by night!
Michael: Now all we need is a name..."

As Brian throws his faulty walkman to the ground, Michael suggests "The Fury," Justin jokes, "Pissed Off Man." Then Michael gets it: "Rage!"

It is important to note that Brian doesn't seek superhero status from Justin and Michael—they bestow it upon him. Brian becomes their template, not only for what makes a gay man heroic, but these qualities are raised to the rank of *superheroic* within the narrative: his intelligence, honesty, bravery, strength of character, sexual prowess, beautiful body, individualism, and his refusal to be normalized into the mainstream. And importantly, the scene shows us that Brian's body and its social positioning as queer are central to his articulation of heroism. By situating his lover and his best friend on either side of this body, in both adoration and admiration, it is clear that Michael and Justin, like all gay men, desire a hero that fights for their causes. Inspiring Rage, the Gay Crusader, Brian is made extraordinary—he is ordinary like them, and yet he is better than them, coming from their world and representing the best that it has to offer. Rage does not have a secret identity he struggles to conceal—the point of this queer superhero is that he does not hide, excuse, or apologize for his true self. He lives by the same code of ethics, day and night. In addition, Rage/Brian embodies a new mode of heroism: unlike Superman, who rescues those who best represent the American way, he is heroic in the name of those labeled 'deviant,' 'abnormal,' and therefore 'un-American.'

Importantly, the first issue recounts Justin's bashing and Brian's heroism in the face of homophobia by repositioning Justin as the victimized JT and Brian as the superheroic Rage, with Michael as his trusty sidekick, Zephyr.[4] In the comic's opening panel, Brian appears as he does in the opening episode of the series: the city's most desirable man. After work, Rage and Zephyr (like their alter-egos Brian and Michael) go out dancing at Babylon—a place that reminds our dynamic duo what they are fighting for. Sensing danger, Rage and Zephyr head for the streets of Gayopolis. Flying (without capes) they come across a young man being bashed by a gang of straight men. It is immediately clear this is a hate crime, as a wrench wielding attacker calls the young man a "dirty faggot."[5] Faced with this intolerance, Rage unleashes "the full force of his fury in the form of a mind-distortion ray causing each basher to think the others are gay"

and treating themselves "to the death they deserve." Whisking JT to their secret lair, we get to see the scope of Rage's *other* superpower in action—his sexual prowess—and the healing process begins "with lots of heavy kisses and anal penetration" (2.16).

I would suggest that what is most important about the creation of this intertextual comic book is its assertion that being a gay man in America requires daily acts of heroism and the courage to defy convention. Like Brian's code of ethics, the comic does not acquiesce to heterosexual narratives and norms in defining what makes Brian/Rage heroic, nor does it deny the sexual corpus at the core of queer identity. As Justin says to Michael, the comic shouldn't look like anything else out there, and their hero should be different to others before him. Michael says, "our guy's gay, he lives in a gay world," and Justin adds that their hero also "has gay sex." This new superhero's difference is explicitly articulated through the hero's body—*Rage: Gay Crusader* offers a truly queer superhero whose sexuality is the extraordinary factor that makes him heroic, because his experience of it defines what he stands for, fights for, and is willing to die for. In the context of the gay bashing, Rage's heroism occurs in a political space that emphasizes gay men's difference to straight men as a positive rather than negative force. Here, heterosexual masculinity is depicted as pathological, unreconstructed, and completely out-of-control in its need to protect its borders from incursion by a perceived homosexual threat.

Season Three strengthens Brian's status as a hero. The season's major story arc involves a homophobic Police Chief, Jim Stockwell, who is running for mayor of Pittsburgh and is a narrative that sees politics interrupting life on Liberty Avenue. The "Stockwell for Mayor" narrative consolidates the notion that gay men's heroism is almost always exercised in a political context. Brian is at first innocently drawn into this villain's web, when he attends a fundraiser for the police chief's campaign, hoping to draw business of his own from his corporate supporters. Seeing an opportunity to make even more money, Brian offers Stockwell his card and his services for a new ad campaign. While Brian admits that he knows nothing about politics, he knows what sells, and says that right now Stockwell needs "something that will make him pop" (3.5). When Stockwell finds the thing that goes "pop," it turns out to be something that targets Brian and his friends directly—a spate of drug related deaths in gay clubs that he can use to push a "family friendly" agenda. Liberty Avenue experiences a much heavier police presence, setting out to clean up the street of sex-related businesses, and Stockwell begins criticizing what Brian holds dearest: his sexual freedom. Stockwell doesn't know that Brian is queer, and Brian continues to see his involvement with this man as simply "business."

Inevitably, Stockwell discovers that Brian is gay and fires him. When

he realizes that he actually needs Brian in order to assuage the perception of himself and his campaign as homophobic, Stockwell re-hires Brian. While this confuses his friends, it is clear that Brian's motivations are no longer "just business." With his sexual freedom under attack, Brian seems ready to don his superhero title and become his comic book alter-ego, Rage. But it is his boy wonder, Justin, who plays the role of secret avenger before him, noting that "it's become a bona fide police state here in beautiful loss of Liberty Avenue" (3.10). Justin makes posters that depict Stockwell as a Nazi and plasters them across the city in the thick of night. When Brian discovers his lover is responsible for these attacks against his client, he is initially angry, telling "Superboy" that the fun's over. Spoken like a true disciple of Brian's creed, Justin explains, "I'm doing what I believe in… you once told me you wanted me to be the best homosexual I could possibly be, which includes not giving a shit what anyone tells me, think for myself" (3.10). But when Stockwell begins closing bathhouses up and down Liberty Avenue, and then Brian's beloved backroom at Babylon, he joins Justin on the street as he prepares for the next round of postering.

From this point on, Brian uses his extraordinary powers of mind control to beat Stockwell at his own game. He organizes a speech at the Gay and Lesbian Center that humiliates Stockwell, when Justin questions the police chief on a number of hate crimes that have gone unresolved or unsatisfactorily solved by his department, including his own bashing. When Stockwell recognizes Justin from the ad agency, he rightly deduces that Brian set him up and has been working against him. While Brian's business partner, Vance can't understand why Brian would do such a thing, Stockwell gets it right: "Because he's a fag!" (3.11). Running straight over to Brian's loft, Stockwell and Vance stumble upon Brian and Justin, post-coital, and Justin's posters strewn all over the floor. Brian is promptly fired. What remains unspoken, specifically are Brian's reasons for his actions. It is enough, however, to accept the reason he gives Vance, saying, "You wouldn't understand… because you're straight." When Brian later forcibly reopens the backroom at Babylon, it is clear that the queer revolution begins and ends with the politics of sexual pleasure and the body, and that the repression of this is tantamount to social and political invisibility. If, as Michael declares in *Queer as Folk's* very first scene that "it's all about sex" (1.1), Brian's actions clarify this statement, countering current conservative logic that being gay has *nothing* to do with sex. Being gay has *everything* to do with sex and sexual politics, and this is re-presented, here, as a positive, vitalizing issue for the community.

In a final heroic act, Brian sells off most of his possessions and puts himself in debt to the tune of $100,000, to produce and air a commercial that implicates Stockwell in the cover up of the death of a young gay man

known as "Dumpster Boy." Brian sacrifices everything people falsely believe he holds dear (and that which many stereotypically believe *all* gay men value most)—his Italian furnishings, Armani suits, and other shiny possessions—for the things that actually *really* matter the most to him: freedom, justice, truth, citizenship, and his community. He has taken Justin's advice: that sometimes you have to risk it all for what you believe in. Stockwell loses, and as Justin says, "Thanks to Rage, the streets of Gay-opolis are once again safe for perverts" (3.14).

In concluding this essay, I wish to suggest that if a hero does what others can't and won't, then *Queer as Folk's* US creators, executive producers, Ron Cowen and Daniel Lipman are heroic, and that the cable network, Showtime, which screens *Queer as Folk* in North America, and whose motto is "No Limits," also positions itself in this category of risk-taking and courage. In the hostile climate of Bush's America, where gays and lesbians are regularly demonized as scapegoats in a "family values" campaign aimed at putting straight men back "on top," *Queer as Folk* does not apologize for making the queer world visible in all its flawed complexity (like straight life always is) and refuses to yield to a discourse of deviance. *Queer as Folk* does this not by problematizing difference, but by celebrating it as normal, and by creating a world with few straight characters, little interest in the straight world, and frequent challenges to the norms of heterosexual relations.

Richard Goldstein challenges commentary that *Queer as Folk* is only about sex, offering instead that it is all about a new idea of 'the family':

Though HBO's prison drama *Oz* shows lots of male nudity—not to mention rape—violent images of homosexuality are far more acceptable than what frightens the horses most: relationships. This series is not just about gay sex: it's about the bond gay sex creates... This is what makes the show groundbreaking... this drama shows how the ramifications of desire can form the gay equivalent of family" (2001, 61).

Queer as Folk 'normalizes' gay desire by presenting gay men and women for the first time in a television drama, as multi-dimensional, flawed, and fully functioning human beings. Rather than setting up strict borders between what is 'normal' and what is 'deviant,' *Queer as Folk's* soap opera style, suburbia, and articulation of 'family values' reconfigures a marginalized subject within a mainstream setting. And importantly, it does this, without sacrificing the sexual corpus that is central to queer identity.

The show's first episode contains a much anticipated sex scene that illustrates this challenge. It is a scene which announces *Queer as Folk's*

agenda boldly. By allowing us inside the secret lair/bedroom with two gay men and demystifying the pleasures it contains, Brian's declaration to Justin that "Now you know what rimming is" (1.1) has in fact been an instruction not only to his inexperienced lover but to all watching. When heterosexual viewers deal with the realities of gay sex, they also deal with gay men and women as actual flesh and blood human beings, not marginalized others. In this way, the existence of this show, in a culture where queer desire remains hidden and invisible, is heroic itself. It succeeds in taking something considered extraordinary (as in *not of the everyday*) and making it ordinary, visceral, and authentic without editing out what makes queer culture unique. As Joyce Millman suggests, "Instead of repeating the same well-meaning but vague TV-movie shibboleth that, gay or straight, we are all exactly the same, *Queer as Folk* shows us the many ways that we are *not* the same. And it expects heterosexual viewers to respect the difference" (2000, par. 17).

15
Gods amongst Us/Gods within: The Black Metal Aesthetic

Aleks Michalewicz

> I am a servant of the War Lord
> and of the Muses, knowing their desirable gift.
> (Archilochus, Fragment 1)[1]

In a 2005 interview, Sir Bob Geldof suggested that the *lingua franca* of the modern world is pop music.[2] Such a statement raises many questions, and one of these is how we might approach music that vehemently strives to locate itself far beyond the reaches of popular culture. Black Metal (BM), a music genre that evolved in Scandinavia in the late 1980s, is characterized by "nihilism and a heroic anti-social assertion of the self" (American Underground Nihilist Association).[3] It first exhibited a strong ideological concern with Satanism, and this later developed into a preoccupation with native pagan mythologies: a natural progression in the anxiety regarding Christian influence over traditional Scandinavian cultures. I will argue that, as a text, BM may be understood as creating a radically unique aesthetic, and that the stylistic conventions of this narrative create a space in which the 'heroic' is both developed and embodied.

I participate in BM as a spectator, musician, consumer, woman; my perspective is both academic and that of a fan. As a Classicist, I am continuously struck by the ways in which BM not only explores and negotiates various mythologies, but actively creates a mythology about itself. It is my argument that this self-conscious and simultaneously self-reflexive process of mythmaking allows for its proponents to become a part of something that transcends the everyday, and allows those on stage–through the ritual of performance–to become 'heroes'. Further, those that participate as an audience partake in a discourse that allows for a heroic existence, and the opportunity for elevation into this heroic realm. This chapter will contextualize BM and address the metaphysical concerns of the subculture through an analysis of lyrics, song/album titles, as well as band and stage names. Theory emerging from Bakhtin's work on the carnivalesque will

then be utilized in order to explore the ways in which the 'everyday' is sus-pended through the propagation of the scene's aesthetic qualities, which in the process creates an alternative narrative in which to situate one-self.[4]

Black Metal For Beginners

It would be easy to view BM performers simply as paradigmatic counter-cultural 'super-villains' or 'anti-heroes'. The genre is highly theatrical, both on and off stage: it is characterized by costume, almost without exception in the color black, as well as leather, PVC, spikes and long hair. The light shows at (especially) larger concerts is extreme, with darkness punctuated by intense brightness. The musicians often wear what is known as 'corpse-paint', which consists of white face paint with black embellishments around the eyes and mouth. Perhaps predictably, the BM scene is, in many ways, hyper-masculine. But it also appears to be (almost paradoxically) devoid of preoccupations regarding gender. There are many women in-terested in BM, and their involvement is not unusual. Indeed, BM is much more concerned with exploring the concept of the individual, and each person is judged on his or her own merit: how they actively construct their identity and what philosophies they align themselves with. Nonetheless, the competitive nature of such a hyper-masculine scene promotes intense deconstruction of performance, musicianship and thematic content. This is especially evident at live performances, where one witnesses mainly men performing to and for other men. In such a context, how one appears on the outside truly reflects just who one is within. Jean-Pierre Vernant wrote the following about the Gorgon's mask, but these remarks apply just as pertinently here:

> In this face-to-face encounter with frontality, man puts himself in a position of symmetry with respect to the god, always remaining centered on his own axis. This reciprocity implies both duality (man and god face each other) and inseparability, even identifica-tion... In Gorgo's face a kind of doubling process is at work... [T]o wear a mask means to cease being oneself and for the duration of the masquerade to embody the Power from beyond who has seized on you... The act of doubling the face with a mask, super-imposing the latter on the former so as to make it unrecognizable, presupposes a self-alienation... As a result, man and god share a contiguity, an exchange of status that can even turn into confusion and identification. But in this very closeness, a violent separation from the self is also initiated, a projection into radical alterity, a

distancing of the furthest degree, and an utter disorientation in the midst of intimacy and contact. (Vernant 1991, 137-8)

The notions of 'masking' and altered identity are, of course, recurring themes in the discussion of heroes generally and superheroes in particular. BM is characterized most of all by its 'negative' thematic concerns as expressed through both the lyrical content and the sonic textures of the music itself. Like the hero, musicians are expected to reveal specialist abilities; to be able to play with a prowess rarely found in rock'n'roll and even many other sub-genres of metal. BM is widely criticised throughout the metal scene for its perceived exclusivity, and perhaps this is the case: like Thor, Achilles, Batman and other grand, epic-scale heroes, the BM scene aspires "to the highest realms of human conception and behavior, embracing intellectual élitism and the honorable warrior mentality of the medieval era" (American Nihilist Underground Network). Thus despite protagonists superficially embodying traits of the villain, BM creates an alternative existence and adopts a hero narrative. What then is BM? Michael Moynihan and Didrik Soderlind explain it thus:

The principal elements of Black Metal... reside as much in belief and outlook as they do in the music itself. There is a considerable berth given toward sonic experimentation as long as certain attitudes are prominently displayed by the musicians. At the same time... the boundaries of the ideology shift as time passes (Moynihan and Soderlind 2003, 33).

This is a particularly apt description. Emerging first in Scandinavia, BM has also been described as "ragnarok and roll" (Baddeley 1999, 189). Norway was, in particular, the center for BM's development, with Sweden and other European countries soon to follow. Baddeley refers to the relative inexperience of musicians involved at its inception, and writes that instead, they focused on "producing unearthly, crazed, ugly sounds with guitars, drums, the human voice and keyboards" (1999, 189). Bands such as the Misfits, Venom[5], Mercyful Fate, Witchfinder General, Bathory, the earlier New Wave of British Heavy Metal, Death Metal, Hardcore and Punk were all influential in the genesis of Black Metal. Indeed, it is a "genre [which] includes all of the technique and rhythmic intensity of... [death metal but] with more emotive and comprehensible poetic communication within the music" (American Nihilist Underground Society). The recurring parody of Christian values, as well as those of western capitalism, further allows musicians to project themselves into a heroic realm. This emphasis on poetic and artistic vision is a crucial element of the scene.

And when in 1986, the Norwegian band Mayhem released *Pure Fucking Armageddon*, BM may be said to have been formally unleashed.

An interesting aspect of BM is that most of those who listen to the music are themselves active within the metal scene. This includes, for both men and women, playing in bands and music generally, promotion and distribution, hosting specialist radio programs, and working for metal labels and within the broader music industry. This creates an intimately organic and interactive scene, and one that relies less on album sales than loyal fan participation. BM originally developed via tape trading and fanzines, and this has now progressed to CD burning and the Internet. Indeed, new technologies are warmly embraced, as is reflected in the high production values of later recordings. The scene has since dispersed internationally, with a number of Australian bands touring overseas, amongst these Destroyer 666, The Berzerker and Virgin Black (who could, ironically, be perceived as a Christian metal band).[6] But despite appearing on a global stage, BM remains highly resistant to its features being located in the present, modern world.

If we accept, as John Fiske suggests, that "[p]ostmodernism refuses categories and the judgements they contain: it denies distinctions between fine art, the mass media, vernacular subcultures, and it harnesses the new technologies to shatter these boundaries" (1987, 254) then BM is decidedly *not* a part of postmodernity, even if part of a postmodern world. Boundaries are strictly enforced and reinforced, both in terms of what even qualifies as BM and who may take part in the scene. Technology is used to capture more keenly, the sound a band is after, but there is little doubt that the music and its performance are generally regarded as a very distinct form of high-art. In what is probably the most renowned academic study of heavy metal music, Robert Walser highlights the debt metal owes to blues, classical music of 18th and 19th century European composers (1993, 57 ff). In this regard, BM is no exception. Due to its extreme nature, BM will never be part of more mainstream culture, and this is consciously perpetuated through setting harder, faster and darker parameters.[7] There are, certainly, progressive, avant-garde and atmospheric BM bands. However, such music—for the most part—still falls distinctly into the conceptual ideals of the scene. Keith Booker suggests that "[t]ransgression and creativity have been inextricably linked throughout the history of Western culture" (1991, 3) and this is something repeatedly explored and pushed in the creation of the BM aesthetic. Indeed, through the interlinking of a very specific art form and corresponding philosophy, BM successfully creates the possibility of positioning oneself within a grand heroic landscape. This allows BM to celebrate its exclusivity through a dialogue with popular culture (negotiating a focus of cultural resistance in a similar manner to

other underground subcultures) even whilst utilizing the tools postmodernity has to offer.

Aesthetics and Metaphysics

Kant and Nietchze are two philosophers influential in the construction of BM ideology.

BM contains an anti-social and anti-establishment vision antithetical to the hero's traditional obsession with maintaining social order, traversing into the realm more generally associated with villains. However, the outsider qualities of BM allow for the potential of every individual to extend themselves beyond everyday norms, approaching the world on separate and distinct terms in order to fulfill a perceived heroic potential and destiny – even if there may be dire consequences to and from mainstream society. It is not unique that a music genre would align itself with a particular world view (compare punk and anarchy, reggae and Rastafarianism, etc.). What makes such marriages of expression and belief interesting is the ways in which they are explored and developed within a particular art form. In the case of BM, the process of internalization appears very strongly. Everything a band does, what it represents, and how it behaves is answerable to a specific code of behavior. In April 1991, Dead of Mayhem shot himself in the head, and his bandmate Euronymous took photos of the corpse prior to police being contacted (Moynihan and Soderlind 2003, 49).[8] On June 1992, Varg Vikernes, aka Count Grishnackh of the band Burzum, allegedly burnt down Fantoft Stavkirke, a 12th century church in Bergen, Norway. And in August 1993, Euronymous of Mayhem was stabbed 23 times by Vikernes, who is currently serving out a sentence for both this crime and a number of church burnings. These are just some of the more extreme examples of behavior exhibited by protagonists within the BM scene, especially in its early days. We should not, however, doubt the impact of such actions: thirteen years later, in May 2005, Novak Majstorovic, a fan of Burzum, appeared in the Melbourne Magistrates Court to plead guilty to arson and burglary, having had drunken visions of the Church as the source of society's problems with law, ethics and morality. In August of 2004, he had burnt Ascot Vale Uniting Church, built 1898, in Melbourne, Australia. Clearly then, the influence of BM has not diminished over time.

The way in which BM performers present themselves to the world at large is of fundamental importance to a band's credibility. Many band and stage names are taken from Classical, Mesopotamian and Norse mythology as well as Biblical tradition, and indeed there is even the appropriation

of artificially constructed mythic traditions such as Tolkien's *Lord of the Rings* trilogy.[9] Stage names taken by musicians reflects this interest in literature, mythology and philosophy: Faust, Mortiis, Samoth, Hellhammer, Necrobutcher, Blackthorn, Occultus, Maniac,. Blasphemer, Quorthon,[10] Fenriz, Abbath, Demonaz, Armagedda and Grim are just some examples from more prominent bands. Like both ancient and current heroes, the name appropriated by an individual connotes power, and is instrumental in the creation of a suitable and corresponding image. It again allows for the masking process to occur, resulting in heroic elements of identity being re-emphasized. In album and track titles we similarly witness a preoccupation with darkness, night, Nordic nationalism, nature, fire and ice, evil, death and the transcendental: Satyricon's *Dark Medieval Times* (1994) and *The Forest is My Throne* (1996), Darkthrone's *Under a Funeral Moon* (1993)[11] and *Transylvanian Hunger* (1994), Immortal's *Diabolical Fullmoon Mysticism* (1992)[12], Ulver *Nattens Madrigal: The Madrigal of the Night – The Night Hymns to the Wolf in Man* (1997), Ulver's *Themes From William Blake's* The Marriage of Heaven and Hell (1999). Thus through the referencing of existing mythologies, and using imagery normally associated with an opposition to popular culture, BM creates its own mythological discourse in which the protagonists are heroes.[13]

This is, perhaps, most evident in the lyrics. Of course, these are oftentimes impossible to discern due to the manner in which they are performed, but if anything, this merely serves to reinforce their power. Because this often necessitates recourse to liner notes, fans are forced to interact with the artwork presented to them by the band, painstakingly put together in an artistic package designed to further emphasize the momentum of the music. Upon analysis, BM lyrics exhibit concerns shared by those individuals who find themselves trapped in a heroic predicament. Examine Ved Buens Ende's "Carrier of Wounds":

I slumber throughout my years,
like the desert moves with the wind…
A wanderer I am indeed…
… the son of the moon…
and I will carry mountains soon.
A burden I was for those who woke the sun.
I threw their masks away,
lit my torches and burned their eyes.
Forgiven I never was…[14]

Or Burzum's "Lost Wisdom": "While we may believe / Our world – our reality / To be that is – is but one / Manifestation of the essence / Other

planes lie beyond the reach / of normal sense and common roads / But they are no less real / Than what we see or touch or feel..." This thematic return to the cosmos and transcending that which surrounds us lies at the very crux of BM, and why it is possible for the scene–in ideological terms– to touch upon both Satanic and pagan themes, to identify with historical events and figures (and hence why Viking Metal is so popular), to investigate world mythologies, and to generally take a spiritual and interpretive approach to its subject matter. Satyricon's "Woods to Eternity" demonstrates this exploration regarding the mystical, natural, and divine:

> In grey depressive autumn times I wander the woods to eternity searching for
> Him trying to remember while the same sky still rules the night
> We knew then. That these were the children of god.
> The ones who betrayed me and my desire.
>
> This must be the desolate land. This is the kingdom of the shadowthrone.
> Centuries have gone beyond time, and we in the land beyond the forest,
> We burnt them in the purgatory, them the children of god. Barely forgotten these
> Times are but not for a soul whose rest has not been found.[15]

Of course, it could be argued that for those living in first-world Western countries, it is a simple matter to indulge in this type of subculture. In 2004, *Vice* magazine profiled an Iraqi band, A.Crassicauda, and the conditions under which they pursue their form of expression; emphasizing the far-reaching attraction that BM holds world-wide. The article, by Andy Moore, claims that Slayer, Dimmu Borgir and Mayhem are the three most popular bands in the Iraqi BM scene. Until the overthrow of the Iraqi regime, music was heavily censored, including "all genres of punk and metal (death, gore, speed, black metal, and power electronics were particularly frowned upon)" (2004, 57). Moore refers to the difficulties faced by the band's four members (who, he informs us, work as journalists and translators), not simply as Iraqis currently living in Baghdad, but as struggling artists, who must carry guns simply in order to attend rehearsals. He writes that "[t]his is why they are more 'metal' than anyone you will ever know... The music they played me was so ugly and doomed it made all those face-painted Norwegian black-metal fags who burn down old ladies' churches seem scary as warm chocolate milk" (2004, 57). A.Crassicauda "plugged traditional Iraqi instruments into distortion pedals and used

broken-down TVs as pre-amps... It sounds like hell. Just like proper metal should, right?" (2004, 57). Regardless of their relative musicality, the continued pursuit by A.Crassicauda of their music in a situation such as this truly makes their quest heroic. If their music sounds like hell, we can only imagine what their everyday existence must be like.

B[l]a[c]khtinian Metal and The Carnivalesque

I turn now to Mikhail Bakhtin's theories regarding the carnivalesque. Although, at first glance, the application of a literary theory to a musical aesthetic may seem odd, Berrong rightly indicates that "[t]he success of Bakhtin's book with students of Rabelais, though significant, pales in comparison with the extent of its favourable reception and influence in realms outside that of Rabelais studies" (1986, 3). BM performance is the site of carnival behavior. Bakhtin wrote that carnival "celebrated temporary liberation from the prevailing truth and from the established order; it marked the suspension of all hierarchical rank, privileges, norms and prohibitions" (1984, 10). This, both in performance and at the very crux of its intent, is what BM represents. Further, following a disconnection with folk culture, Bakhtin elaborates on the carnival-grotesque, which acts

> to consecrate inventive freedom... to liberate from the prevailing point of view of the world, from conventions and established truths, from clichés, from all that is humdrum and universally accepted. This carnival spirit offers the chance to have a new outlook on the world, to realize the relative nature of all that exists, and to enter a completely new order of things. (Bakhtin 1984, 34)

BM's aims, when viewed through this lens of the carnival-grotesque, seeks to evoke precisely what Bakhtin is describing. And in creating an otherworldly atmosphere, it is not merely performers who become heroic, for their music has the potential power to elevate all those exposed to a similar plane. Bauman refers to the tendency of performers to be both admired and feared, "admired for their artistic skill and power and for the enhancement of experience they provide, feared because of the potential they represent for subverting and transforming the status quo" (2001, 1833). It is this ability to subvert standard tropes, and by the creation of new ones (which, inevitably, also become stereotypical) that allows for BM to become carnivalesque. Thus in acting as a conduit to an Other, idealized, realm, the music is able to move its protagonists into a "completely new order of things." This is evident in the ways in which BM presents

itself to its audience. For example, on Emperor's album *In the Nightside Eclipse*,[16] we see this demonstrated through the track titles alone: "Into the Infinity of Thoughts," "The Burning Shadows of Silence," "Cosmic Keys to My Creations and Times," "Beyond the Great Vast Forest," "Towards the Pantheon," "The Majesty of the Night Sky," "I am the Black Wizard," "Inno a Satana." Such themes, as found in the artwork, lyrics and stage/band names are repeated continuously.

Bakhtin argued that "[e]xaggeration, hyperbolism, excessiveness are generally considered fundamental attributes of the grotesque style" (1984, 303). Such attributes are exactly what the BM aesthetic is built upon. It is through the development of imagery and sound on these terms that allows for the genre to have so much impact when compared to many music styles (and stylizations) available to audiences and consumers. Of course, this is not to suggest that other genres do not convey similar carnivalesque attributes, but BM in particular seems to embody the carnival-grotesque. Performances are of special interest because it is here that the role of the marketplace–or in our instance, the stage and audience standing area–figures inherently as a principal feature of the carnivalesque. The stage (actual and figurative) becomes a (transient) reality that the audience faces, existing on an epic scale and containing a grand vision. Hence the "text and its readership are in a relationship of mutual activation: a text strives to make its readers conform to itself, to force on them its own system of codes, and the readers respond in the same way" (Lotman 1990, 63).[17] As with the performance of most live music, what occurs on stage is in direct relation to the reaction of what is happening offstage: how the audience responds, what they bring with them to the event and what it is that they expect to witness. Thus it is not only the musicians-as-performers who are masked and embody a frontality and symmetry to the god, as suggested by Vernant. The audience is similarly masked (by the darkness, through its anonymity), in a position of frontality in relation to the band as well as in a symmetrical relationship of 'performance' to those on stage. By together exploring themes of otherworldliness, the two unite to create a different whole. Clearly this is not what the band Marduk is describing in their track 'Infernal Eternal', but their lyrics might be extended to the process just referred to:

> As I looked into the mirror, and saw the creation which was fading, I sailed the darkened waters of my soul on the ship of flaming hate towards the land of the damned... A thousand voices are screaming in pain from beyond. A number of faceless shapes march forth from the darkness within. Life is slowly passing away, poisoned by guilt and sin...[18]

David Danow reflects on narrative as "a mode of human communication and an artistic form for reflecting one world (the actual) in another (which is fictional)" (1995, 5). What I am arguing is that the reflection of this fictional world becomes a reality, however transient, for those who partake in its configuration. For the merrymakers of carnival, the people of the marketplace and, the acknowledgement of (and in Bakhtin's case, movement away from) 'dark' themes reflects the "collective consciousness of their eternity, of their earthly, historic immortality as a people, and of their continual renewal and growth" (Bakhtin 1984, 250). Actively dealing with death allows for it to be "transformed into a celebration of life... such transformations, reversals, or inversions typify the carnivalesque in their relentless shifting from life to death and back again" (Danow 1995, 20). Thus in dealing with themes that many would find either difficult or distasteful, BM practitioners and fans are actively able to negotiate for themselves a temporal and theoretical space where it is possible for them to create an idealized reality. Further, this reality is predicated on the notion that within the individual there exists the heroic.

Creating An Alternative Narrative

BM actively embraces and then inverts the concept of arch-villain. The protagonists of BM may *appear* to be super-villains, but what they oppose is the idea (and indeed–one could argue–the reality) of a society that is 'good' (in the Christian sense), yet corrupt. It cannot be denied that there *is* an element within the BM scene that is, or has been, involved with activities that many people would find highly objectionable. This includes perpetration of violent acts against others, destruction of sacred property, and the taking of neo-Nazi and fascistic ideological stances, which inevitably feeds into action. If we accept that "[t]he potential for violence and death represents the dark side of the carnivalesque" (Danow 1995, 15), then we must similarly acknowledge that in terms of a heroic trope, both the recognition of the human capacity for violence, as well as an acceptance of the potential of darkness of the soul, remain standard features. This is, without fail, also found to reside similarly in the BM aesthetic. Hence BM, it may be argued in the words of Mary Russo, functions as "a site of insurgency, and not merely withdrawal" (1986, 218).

This is what makes BM of particular importance as an oppositional movement. As Danny Fingeroth argues, "somehow, the superhero... has to represent the values of the society that produces him" (2004, 17). Thus, although the BM scene may appear overtly dystopian and misanthropic to outsiders, from within the subculture these meanings take on new

subtleties. This allows participants to become part of something that is both an individual and collective conceptual ideal: identity is renegotiated not only through an overall aesthetic, but likewise through a philosophy that actively pursues metaphysical concerns. Natalie Purcell suggests that metal is "a philosophical response, whether conscious or subconscious, to terrifying questions about nebulous human nature" (2003, 13). For this reason, the reinterpretation of mythology is often used to create an alternate reality in which all are potentially elevated to heroism. This is achieved by explicitly dealing with themes such as im/mortality, death, the divine and the Other;[19] and is further emphasized by exploring particular codes of honor.[20] Keith Booker writes that "[o]ne of the most important effects of transgressive literature [read music] is simply the indication of alternatives, the suggestion that things need not necessarily be as they are" (1991, 244). So how then, might BM performers be interpreted as 'heroic', as embodying the divine? They do so in ways more complex than simply via a process of mythologizing, and the preoccupation with the dark and grotesque, the mythical and otherworldly. Partakers of BM are heroic in that they perceive the possibility of one's behavior according to a much older tradition of 'hero'. There is a very particular code of honor, one that is concerned with courage, honesty (for surely artistic expression can come to nothing if it is not honest), and a grander vision of the surrounding cosmos. BM is not *for* everybody and it was never *meant* be, just as not everyone can become a hero. BM participants model themselves on warriors of the past, and conceive of themselves as such in the present. They create a philosophical ideal of their surroundings and identity to fit conceptions of how the world *ought* to be. Behaving in such a manner, in being true to this elevated notion of behavior, of being loyal to both an artistic and cosmic interpretation of the surrounding world, it ultimately ceases to be about a particular genre of music. Rather, the BM aesthetic sensibility highlights a potential to embody heroic ideals as well as to transcend the everyday.

Obviously, fans of any music genre are passionate about what they listen to. They choose to identify with specific types of music because, in some way, it speaks to them. Even in writing on this subject, I am conscious of the fact that I am further taking part in this process of mythologizing the music that fascinates and which moves me. I must state that in uniting personal musical tastes with my academic work, this has been a challenging process; and I admit to occasionally suffering what I term 'BM fatigue'. It is intense music, and it is meant to be intense. BM is about pushing the envelope of what we are comfortable in dealing with. It is about going above and beyond the expected, the anticipated and the predictable. Although certain elements may have become subsumed into popular culture, BM is not now, nor will it ever be, a lingua franca such

as Sir Bob Geldof perceives modern pop music to be. But it is a means by which musicians and fans can reflect on grander, heroic themes by communicating to themselves and one another their perceptions of the world around them, and reflect upon their place within it. In such a manner, BM successfully evokes a different kind of reality: one that is darker, superior, harsher—and perhaps more beautiful than we might expect.

Collisions: Gods and Supermen

16
Harry Potter and Oedipus:
Heroes in Search of their Identities[1]

Babette Pütz

Centaurs, giants, three-headed dogs—these are only a few of the most striking references to Greek myth in the *Harry Potter* books (Rowling 1997-). Another feature of myth, the opponent of such fabulous creatures, is the hero. This essay will look at such heroes and compare the life-stories and personalities of Harry Potter and Oedipus. Why Oedipus? Of course, one can for the sake of an intertextual study compare Harry Potter to a number of heroes from Greek and other myths whose stories contain similar elements to his.[2] The comparison with Oedipus, however, is particularly fruitful because the two protagonists' life-stories are determined by the same problem, the quest for the hero's identity, which in both cases is facilitated by prophecies, scars, and a number of more or less well-meaning parental figures. Both characters display similar strengths and flaws of character which are admirable but also lead them into difficulties. In both cases good and bad are not easily categorized and are often confused, a looming question being that of the relation of the enemy from the outside to the enemy within. From this I will draw conclusions about both characters as archetypal heroes who undergo trials as parts of their maturation process that is tightly interlinked with their search for identity.

The myth of Oedipus is best known through Sophocles' tragedy *Oedipus Rex* (*O.R.*), which is the version I will focus on.[3] The theoretical approach followed is that of Joseph Campbell and Lord Raglan who list a number of stations in a hero's life that are universal in myth. Many of these fit both Harry and Oedipus. This study treats the most prominent of these patterns, in particular the attempted murder of the hero as a baby, his abandonment, quests, and dealings with threatening father figures. The journeys and struggles serve as rites of passage for the hero, which is underlined in Harry's and Oedipus' stories through the focus on the maturation of the hero.

At first sight there may not seem to be many obvious similarities between these two heroes. In order to understand why we need to take a

second look to discern the parallels between the protagonists we need to take into account the different forms of presentation of the stories as determined by the age of the protagonists, genre, and the audiences they are written for as well as the fact that the *Harry Potter* series is still incomplete. All these divergences result in the stories being very different in terms of style, atmosphere, suspense, and humor. Although I will show that there are very close similarities between Oedipus and Harry, this is not to say that J.K. Rowling uses the myth of Oedipus as a model for the *Harry Potter* books, but that both stories employ many of the same mythological and narrative patterns and themes, especially those of the archetypal hero.

This study will shed new light on both Harry's and Oedipus' search for identity and maturation. It will show that the maturation of the heroes begins at very similar levels, despite their different ages and social positions. Oedipus, although he starts the search for his identity as a grown man, behaves in many ways like the typical teenage character Harry: he flies into fits of rage, thinks he understands matters better than he does, and refuses to listen to other people's advice. This is the ancient Greek stereotype of a tyrant, but it is also reminiscent of the critique of former Hogwarts headmaster Phineas Nigellus: "Young people are so infernally convinced that they are absolutely right about everything (V 438)." The frequent puns on the word *pou*–"where?"–in the play and especially in the Greek spelling of the hero's name *Oidipous*, indicate that he does not quite understand where in life he is.[4] A part of him has not yet completed the transition into adulthood. Only the recognition of who he really is and the suffering connected with this learning experience help Oedipus fully mature and enter a new stage in his life. As for Harry, this study will place his inner and outer struggles and his relationships to paternal figures among the features common to archetypal heroes. Harry's and Oedipus' stories not only share many elements, but they also diverge from the same archetypal hero pattern, i.e. that of a truly happy outcome of the recognition. For Oedipus, finding his identity is connected with terrible pain, as is expressed in his self-blinding. Similarly, when Harry finds out that he is a wizard, although he escapes his miserable life with the Dursleys, he also repeatedly finds himself in mortal danger from Voldemort's attacks, and we do not yet know whether his story will have a happy ending or not.[5]

In the search for their identities the two heroes follow certain clues, the most obvious ones being scars and prophecies.[6] They also learn from solving problems and from their parental figures. Harry and Oedipus each have one or two visible scars that are related to their suffering as infants and give them hints about their identity. Oedipus' scars are emphasized by his name "swollen foot" and numerous puns on feet in *O.R.* (e.g. 130, 445-6). However, either nobody recognizes his scars at such unusual

Figure 23: The cover to *Harry Potter and the Goblet of Fire,* Book 4. Written by J.K.Rowling and published by Arthur A. Levine Books, 2000.

places on the body or they keep their knowledge quiet until the time when *O.R.* is set and the Corinthian messenger speaks up (1032). The only living Theban we can be sure to know about the piercing of Oedipus' feet is the shepherd who remains silent until forced to speak (1152-8, 1166). Oedipus himself apparently does not try to find out more about the origin of his scars. Harry's scar is on his forehead, so it is even more clearly visible than Oedipus' scars, and it is frequently used to identify the boy (I 73). It is as unusual as Oedipus' scars, not so much in terms of its position but because of its lightning-bolt shape. The scar connects Harry with two of his father figures who each play very different roles in Harry's life, his arch-enemy Voldemort who gave him the scar and whose emotions or proximity cause it to hurt (e.g. I 214, IV 20), and his protector Dumbledore who himself has a scar above his knee (I 17). Unlike Oedipus' scars, Harry's is famous among wizards and it is useful, just like Dumbledore's. The headmaster's scar is a plan of the London underground; Harry's is of service in a more serious sense by warning him of Voldemort being near.[7] Harry's first ever question was about his scar (I 20), but he only receives useful information about it when he re-enters the wizarding world. Over the following years he learns more about his scar; and its pains increase the stronger Voldemort becomes until he shuts off the connection (VI 61).

Another source of information on the two heroes' identities are prophecies. They furthermore serve as catalysts for the defining events in the heroes' lives, especially death and abandonment, which have a decisive influence on both heroes' personalities. The importance of prophecies is particularly obvious in *O.R.*, which begins and ends with Creon consulting Apollo's oracle and mentions other oracles. In *Harry Potter* III, V, and VI prophecies play important roles. In both stories before the birth of the hero a prediction is made to an evil father figure of an impending threat from this hero (V 740-1, Aeschylus, *Seven Against Thebes* 745-56).[8] As a direct result of these prophecies both heroes are attacked by the threatened figures, separated from their parents, and grow up with foster families.[9] Later on, the characters themselves receive prophecies that mark turning points regarding their relationships with their opponents. In both cases all the relevant oracles stem from the same source as the ones given before their births, Apollo's oracle at Delphi and the seer Sibyll Trelawney. Oedipus, after having been taunted as a young man that he was not his Corinthian foster parents' real son, visits the oracle and learns that he is destined to kill his father and marry his mother (779-93, 994-6). Still under the impression that the king and queen of Corinth are his biological parents, he decides not to return there but travels towards Thebes and so meets his unknown father Laius at the crossroads and kills him (794-813, 997-8).[10] A third oracle that Oedipus hears during the plague, prompts him

to investigate the murder of Laius (95-8), in consequence of which he finds out that he has fulfilled the earlier prophecy.[11]

The two oracles about Harry are uttered by Sibyll Trelawney, the first one states that Harry either must kill or be killed by Voldemort. Harry hears Professor Trelawney utter a second prophecy in his third year at Hogwarts (III 238). While she is usually depicted as a fraud (e.g. III 84, VI 156), it is emphasized that in these two instances she gives true predictions (III 311). She prophesies that Voldemort will in the same night be re-united with his servant and rise again. Indeed the Voldemort-supporter Wormtail manages to escape (III 279) and in book IV nurses his master back to strength. This is a turning point in terms of the threat that Voldemort poses to Harry: at the end of book IV Wormtail is the most important agent in giving Voldemort a new body by bringing him to his father's grave, taking some of Harry's blood, and cutting off his own hand (IV 554-8) which makes Voldemort much more dangerous to Harry, as he is now able to hold a wand and move independently again.

The oracles all concern death, a major factor in the lives of the two heroes: both have a near escape from death as infants and are doomed to meet their opponents again in a final deathly struggle. Oedipus kills his father and in the course of the play loses his mother and stepfather (942, 1235). Harry's parents are dead and he sees Cedric, Sirius,[12] and Dumbledore die (IV 553, V 711, VI 556). The ghosts of the dead help him to escape Voldemort at the end of book IV and he is attacked by inferi (corpses under Voldemort's control) in book VI 537-9. In book V death is especially emphasized in the lesson in which the students who have seen someone die can see the Thestrals–creatures which are invisible to anyone else–when Mrs. Weasley sees a Boggart (Shape-Shifter) that turns into her family members as dead bodies, when later on her husband barely escapes death after a snake-bite, and when Sirius dies (V 159-60, 392-4, 409, 710-1). Harry's enemy Voldemort is obsessed with achieving immortality, which is why he is after the Philosopher's Stone in book I,[13] and has taken precautions against death (using horcruxes), even though he can still be destroyed (V 718, VI 467-75). Thus, both characters' lives are full of losses and their dilemmas are connected with death, too: Harry has to kill or die, Oedipus unsuccessfully tries to avoid killing his father.

Connected with the topic of death is the topic of the abandonment of the archetypal hero. It is an important recurring motif in myth because firstly it marks a turning-point in the hero's life, the loss of his sense of identity, which he will spend much of his later life striving to re-gain, and secondly, as I will show, it is an experience that has a profound influence on the personality of the hero, especially on his relationships with others. Oedipus is abandoned by his parents and supposed to die (1171-3).[14]

Harry's parents are dead and he is left with his only living relatives, the Dursleys, where he leads a lonely and emotionally abandoned life (I).[15] Oedipus is not an orphan until the end of *O.R.*, but he has no memories of his real parents. Harry likewise barely remembers his parents about whom he basically knows nothing until he re-enters the wizarding world. The topic of orphans is expanded in J.K. Rowling's books. Harry is not the only orphan, but so are two of his father figures, his close friend Hagrid and his enemy Voldemort, much of whose bitterness is caused by his own abandonment by his father (II 231, IV 560). Harry's friend Ron Weasley with his large family is a foil to the orphan Harry and so is Neville Long-bottom, whose parents do not recognize him after having been tortured into insanity by one of Voldemort's followers and to whom the prophecy could have referred instead of Harry (IV 523-4, V 454).

Both characters' experiences of abandonment affect their personalities in that they have a great capacity for compassion and love. Oedipus suffers with his subjects during the plague and tries everything to help them (1-8, 93-94). He also leaves his Corinthian parents in order not to hurt them. Similarly, Harry ends his relationship with Ginny in order to protect her from Voldemort hurting her on his account (VI 602-3). Dumbledore specifically points out that Harry is different from Voldemort because of his capacity for love (V 743, VI 476). Out of this care for others, Harry, like Oedipus, feels compelled to help people. He saves Ginny (II 219-39), not just his own but all the four hostages of the Merpeople (IV 433-40), and rushes to his godfather Sirius' help (V 674-87). He even overcomes his desire for revenge when saving the traitor Wormtail (III 275) and feels some pity for Malfoy (VI 596). Hermione calls this a "saving-people thing" (V 646), meaning that it is developed to a fault, which foreshadows the terrible outcome of Harry trying to save Sirius because sometimes these good intentions backfire: Harry goes into Voldemort's trap (V 689); Oedipus feels he has to exile himself (1518).

Thus, a generally positive character trait in both cases because of the heroes' experiences of abandonment occurs in such a pronounced way that it occasionally turns into a flaw. Both heroes also display less ambiguous character flaws that are revealed in the ways in which they deal with the process of and their successes in solving mysteries. Oedipus solves the enigma of the murder of Laius and at the same time that of his identity. Earlier on he had worked out the riddle of the Sphinx. Harry also unravels mysteries other than that of his identity in every book, e.g. the mysteries of the Philosopher's Stone (I) and the Chamber of Secrets (II). He is learning and maturing all the time, fitting the books' setting in a school. He is called intelligent (V 27) and is brave in confronting Voldemort, as Oedipus is in facing his past.[16] They both face challenges directly and deal with

DESTINATION:- C E M R (F)

NAME:-

ADHIKARI, JWALA

STUDENT NUMBER:-

1209782

DATE TO COLLECT BY:-

16·11·15

them as they come, thinking rationally.[17] This is particularly obvious when Oedipus faces the deadly Sphinx and Harry the dragon in the Triwizard Tournament (IV 309). Harry, of course, also has very strong magical powers. The closest comparable asset for Oedipus is his extraordinary intelligence. These powers make both tokens of hope for others, as Oedipus has saved Thebes once before when he solved the riddle of the Sphinx (see also below), and Harry is seen as having freed the wizarding world from Voldemort when his curse rebounded onto himself (VI 323).

Whereas Harry hardly takes credit for his achievements in solving these problems (V 292-3, 306), Oedipus prides himself on his intelligence (391-8)–a strong source of tragic irony since the audience knows that he in fact does not fully comprehend everything.[18] Here, we need to take into account that, as opposed to modern thinking, humility and modesty are not virtues typical of Greek heroes. Oedipus' tendency to *hubris* because of his special intelligence is his flaw together with his bad temper and rashness in judgment but not the reason for his terrible fate which has been decreed even before his birth.[19] Harry's flaws are his bad temper and rashness rather than arrogance. He also is not directly punished for his flaws–he cannot influence the fact that Voldemort is pursuing him, as this has started in his earliest childhood.

The mysteries that the two heroes solve do not only function to highlight these character traits, but they also help underline the heroes' learning process: in order to figure out the mysteries of their own identities the heroes have to solve other riddles and problems and learn from their experiences. But even though they often believe that they have understood, they later find out that they have gained only partial knowledge. Oedipus solves the mystery of Laius' murder and the riddle of the Sphinx (391-8): "What is it that has a single voice, and has four feet, and then two feet, and then three feet?"[20] However, he fails to realize that it does not only refer to humankind in general but specifically to his own life, as he eventually changes into an old man supported by a stick. Harry also solves a riddle set by a Sphinx (IV 546-7).[21] This riddle is not as philosophical as that of Oedipus' Sphinx and, unlike Oedipus, Harry could not have figured out a further meaning through deeper pondering of the riddle, but it warns him of the danger of a spider hidden in the labyrinth of the Triwizard Tournament. Harry helps Cedric, the other Hogwarts Triwizard champion, fight off the spider and is injured by it. It is at this point that the two boys unite which leads to them touching the Triwizard cup together and as a result both being trapped by Voldemort who kills Cedric and regains a body through Harry's blood (IV 550-1). Here Harry is warned of the danger of the spider, but he is unable to see that an even worse peril awaits him.

Finally, both heroes rely heavily on various (positive and negative)

paternal figures when figuring out their identities. They both have complex connections with these characters. Each has several father figures and fewer mother figures.[22] Oedipus' father figures are Laius, Polybus, Tiresias, Creon, the shepherd and the Corinthian messenger. Harry's father figures are James Potter, Hagrid, Dumbledore, Sirius Black, Uncle Vernon Dursley, and Voldemort.

Oedipus' biological parents, Laius and Jocasta, are royalty, as befits a hero. Harry's parents are special in another way: they are a wizard and a witch. They also are wealthy and leave a large pile of gold for Harry in their Gringott's bank account (I 58). About James and Lily Potter's parenting we only know very positive things. They sacrificed their lives to save his (I 216) and Harry has one happy memory of them talking to him as a baby which is highlighted in the film version of *Harry Potter and the Prisoner of Azkaban* as the memory which is strong enough to conjure the protective patronus charm.[23] In contrast, Oedipus' parents wish their son to die. The piercing of the feet seems to be an additional unnecessary cruelty as the infant would not be able to crawl into safety in the wilderness.[24] Harry also has negative parental figures. Voldemort tries to kill him repeatedly; Vernon Dursley and his family treat Harry like "something very nasty... like a slug" (I 22), blame him for everything that goes wrong, and abuse him through severe punishments (e.g. II 21-2). However, despite their abuse they protect Harry by keeping him in their house on Dumbledore's orders (V 736-7). In contrast to Harry, Oedipus seems to have a very good relationship to his foster parents who are childless and thus happy to take him in (1024, 1394-6) and whom Oedipus leaves in order not to endanger them after hearing the oracle about himself as a young man. In both cases, unlike those of other archetypal heroes, the step-parents are not poor and lowly but wealthy, the difference being that Oedipus partakes in their wealth while Harry does not.[25]

For Harry the thought of his parents is generally a source of comfort. He tries to find out more about them and in this way about himself. Oedipus also tries to enquire about his parents but is not given clear information by the oracle and thereafter does not further question whether Polybus and Merope are his real parents. He moreover is given hardly any information by Jocasta about her former husband until he questions her in *O.R.*

Both heroes are rescued by one or two rustic, lowly father figures as infants. Laius' servant does not leave Oedipus to die but passes him on to a shepherd who delivers him to the royal couple at Corinth (1022, 1040). Harry is brought to his step-parents by Hagrid, the Hogwarts gamekeeper (I 16-7). It is striking that both heroes are handed over to their step-parents by characters that take care of animals, which is reminiscent of other

heroes, such as Romulus and Remus being reared by beasts. It also hints at the animal side in the heroes' natures, which Oedipus reveals through his crimes, while Harry's is alluded to in his dream from the perspective of the snake that attacks Mr. Weasley.

The three rustic protector figures reappear later in the heroes' lives at decisive moments. The former Theban servant (now shepherd) and former Corinthian shepherd (now messenger) are witnesses who help Oedipus discover his identity and crimes. Hagrid is the one who delivers Harry's letter of admission to Hogwarts to him, reveals his identity as a wizard, and thus rescues him from the abusive Dursleys (I 38-48). Hagrid always protects Harry (e.g. II 156) and sometimes gives him advice (e.g. III 202). The shepherd, similarly, tries to protect Oedipus from unhappiness, by trying to conceal his true identity from him (1144-65).[26]

Oedipus and Harry both have further related or quasi-related father figures as mentors and protectors. Creon, Jocasta's brother, helps Oedipus with questions of government and is the one who goes to consult the oracle for him which indirectly triggers Oedipus' search for his identity (69-72, 590-8).[27] Harry's godfather Sirius was his parents' best friend and thus constitutes a connection to them. He gives Harry advice and takes the great personal risk of coming close to Hogwarts in book IV to protect Harry. These two figures display similar ambiguities: Creon represents moderation in *O.R.* (543-4, 583-615), but not in Sophocles' *Antigone* (639-80). Sirius advises Harry to behave more moderately by controlling his temper (V 113), but he himself acts often recklessly (e.g. V 85, 733). Despite these similarities, the two young men are presented as viewing their relationships with these older "relatives" quite differently. Whereas Harry regards Sirius as "a mixture of father and brother" (V 732), Oedipus is worried about competition from his brother-in-law (380-9, 532-42).

Both heroes in addition have a very old wise man as mentor and protector (*O.R.* 300-4, 326-7, *H.P.* I 156-7, 214-8):[28] Tiresias and Dumbledore. Both Harry and Oedipus are dependent on their old wise mentors in the search for their identities. Dumbledore has been called "the perfect parent", but he is more like a grandfather figure who allows the boy very much freedom.[29] He is present at the ends of book I, II, and V to rescue Harry from his encounters with Voldemort, after first letting him explore his own strength and courage.[30] In book VI he sacrifices himself for Harry, drinking poison in order to retrieve one of Voldemort's horcruxes (VI 533-6). However, both heroes run into conflicts with these wise mentors. Oedipus rages at Tiresias when he tries to save him from the truth by not telling him all he knows (334-71, 429-31). In return Tiresias shows his weaker side by angrily revealing his knowledge and showing his contempt for Oedipus (350-3, 362, 366-7, 449-60). The argument that Tiresias is on the

one hand Oedipus' double because he is "superhuman" and "only too human", and on the other hand his opposite because he is connected to the divine, while Oedipus is worldly, underlines the complexity of the conflict between these two characters.[31] Dumbledore turns out to be an equally complex figure, being near-divinely omniscient and powerful most of the time, but also very human. Harry rages at Dumbledore in book V because he feels ignored and misunderstood (V 726-735). Dumbledore then reveals his weaker side, too, but in a very different way from Tiresias. He does not become angry but sheds a tear and admits his "old man's mistake" of not having told Harry the full truth why Voldemort wishes to kill him (V 728, 730, 744, cf. also VI 187).

Many of the heroes' conflicting relationships with certain father figures are caused by problems of distinguishing appearance from truth. Oedipus gets into conflicts with all his father figures, except his stepfather Polybus who is not present throughout the action of the play. He kills Laius and threatens Tiresias, Creon, and the shepherd whom he unfairly suspects of having negative intentions (345-9, 810-2, 1166).[32] He displays a tendency for tyrannical paranoia and unfairly accuses Creon of wanting to undermine his authority (378-89, 532-42).[33] Harry, likewise, gets into conflicts with Voldemort, Vernon, and sometimes with Dumbledore and Sirius (I 26, V 273, 726-7), but not with James who, like Polybus, is not present, and Hagrid who is extremely good-natured and dotes on him. In book III Harry attacks Sirius Black whom he suspects of having betrayed his parents, only to find out that he is innocent.[34] On the other hand Harry wrongly trusts Tom Riddle in book II, the impostor pretending to be Mad-Eye Moody in book IV, and the "Half-Blood Prince" in book VI (594). In all cases he sees the truth only after the damage has been done, just as Oedipus does with the people he mistrusts wrongly.

Thus, although both heroes have more positive than negative father figures, both–because of their bad temper and impulsiveness, which are triggered by their frustrations in finding out their true identities–misjudge and clash even with those who have their best interests at heart.[35] It is striking how successful both characters are in these conflicts with men of higher standing, following the David and Goliath motif of folk-tales. More disturbingly, both characters find out unpleasant things about themselves in the conflicts with their father figures, Oedipus that he has committed the crimes he tried to avoid, and Harry that he has a close connection to Voldemort. He believes he was involved in Voldemort's attack on Mr. Weasley and feels polluted until his friends convince him otherwise (V 435-42).

These negative revelations indicate that they share characteristics with their bad father figures. When Laius and Oedipus meet at the crossroads,

Figure 24: Oedipus and the Sphinx, from Project Gutenberg's e-text Stories from the Greek Tragedians, by Alfred Church.

both display their bad temper and impatience,[36] as Oedipus does again later on when trying to find out about the murder of Laius (e.g. 73-5, 287-9). We also hear that he looks similar to Laius (742-3). Harry shares bonds with Voldemort, as is particularly obvious in book V where Harry not only feels Voldemort's emotions but also is shown visions from his viewpoint (V 409). Dumbledore thinks he "saw a shadow of (Voldemort) stir behind (Harry's) eyes" (V 730); and Voldemort briefly possesses Harry's body (V 719-20). Like Laius and Oedipus, Voldemort and Harry share a bad temper. Similarities between the two characters as students are pointed out in book II 181, 233, 244: both are half bloods, orphans, and look alike. Even their most important implements, their wands, share a bond. Already in book I we learn that Harry's wand has a "brother" in Voldemort's (I 65); and the two wands connect at the end of book IV (575). Dumbledore explains at the end of book II that Voldemort in his attack on Harry seems to have transferred certain characteristics to him, obviously the ability to speak Parseltongue (snake language), but also generally positive characteristics, such as determination and resourcefulness (II 245). Harry is compared to both Voldemort and James regarding his character and physique, underlining his close resemblances to both the good and the bad father figure (e.g. I 39, II 181).[37] A similar ambiguity applies to Oedipus who on the one hand cares for his people's well being (58-67), while on the other hand he has inherited some of Laius' negative character traits. Both heroes in the search for their identities find their positive and negative fathers within themselves.

Oedipus' mother figures are Jocasta and Merope, Harry's are Lily Potter, Molly Weasley, and Petunia Dursley. Lily dies for Harry and so leaves a lasting protection of love on him (I 216, V 736). This protection is continued through Lily's blood connection with her sister Petunia (V 736-7).[38] However, Petunia strongly favors her own son and treats Harry badly. The second positive mother figure for Harry is Mrs. Weasley. She cares for him just as she does for her own children (V 85), serving as a foil to Petunia.

Oedipus has no one who sacrifices himself for him, only the shepherd who saves him at what can be assumed to be a personal risk. Jocasta gives Oedipus away (1173), but later on she loves and protects him, not as a mother but as his wife and surprisingly equal partner for the 5th century BCE (579). Jocasta serves as a mentor to Oedipus and tries to save him from grief by telling him to not inquire further about his identity (707-25, 1056-64).

The unambiguously positive mother figures for both Oedipus and Harry are removed from most of their current lives: Lily is dead, Harry only sees Mrs. Weasley sporadically, and Oedipus has avoided Merope for years.[39] The mother figures who are most present in the heroes' lives,

Jocasta and Petunia, combine abuse and protection in them, which is a hint at that appearances do not always reflect the truth (see also above). Although both heroes have more parental figures who look out for them than those who threaten them, their relationship to the menacing ones is what determines much of their lives.

In summary, both heroes are guided in their search for identity by what they learn from their scars and prophecies, from solving mysteries, and from their relationships with a large number of positive and negative parental figures. Both display strong personality traits, most of which are admirable such as intelligence and love, but neither of them is flawless. Their flaws, however, are not the primary cause for their suffering. The problem both heroes face is an external enemy on the one hand, but also an enemy within. This is more obvious with Oedipus who is threatened by Laius and unjustifiably feels threatened by Creon and Tiresias but in the end finds out that he mostly needs to fear his own deeds. Harry has to fear Voldemort. His inner enemy is his bond with Voldemort, which allows him to be manipulated by his archenemy, supported by his tendency to judge and act too rashly. At the point in Oedipus' life when *O.R.* is set he needs to fear the inner enemy alone, Harry in books I to IV and VI needs to fear an enemy from the outside only, but in book V an enemy inside himself, too. Facing these inner and outer enemies is an important part of the heroes finding their identities.

To conclude, the stories and characters of Oedipus and Harry display a large number of similarities, although they are written for different audiences in different genres. Both follow many of the patterns of archetypal heroes, but diverge from them in a crucial point, a thoroughly happy outcome of the recognition.

The comparison of Oedipus and Harry Potter accentuates certain aspects of the characters which otherwise might be overlooked. Firstly, Harry's character qualities as an archetypal hero are highlighted. He is, like Oedipus, a marked man who signifies hope, but who is not flawless. Yet he is not responsible for his sufferings which are determined through an oracle. His character, like Oedipus', is defined by intelligence, courage, and strong emotions, especially love and anger. They both have complex relationships with their numerous parental figures and discover an enemy within themselves. These external and internal conflicts are crucial for both heroes' character development, search for identity, and maturation. Thus, Harry is a hero who is part of a continuing and universal group of hero types. It is exactly this repetition of a typical mythological pattern which gives the series an appeal beyond a readership of children alone: adult readers consciously or sub-consciously appreciate and enjoy the adaptation of these well-established mythological and narrative patterns to

a new and modern hero.[40] Thus, the fact that Harry Potter follows in many ways the archetypal hero structures is one (though certainly not the only) explanation for the success of the series with readers of all ages.

Secondly, the comparison indicates that Oedipus as we meet him at the beginning of *O.R.* has not yet reached the maturity of a grown-up, even though he is king and a father of four and sees his subjects as his children. In the light of his teenager-like level of maturity, the great confidence Oedipus has in his wife and mother may be less a sign of his openmindedness than of his not having completely grown up; and his conflicts with his well-intending father figures appear not only like the paranoia of a tyrant, but also like a sort of teenage rebellion. *O.R.* deals with the limitations of man and the traditional heroic vision. These limitations can only be overcome through learning by suffering,[41] i.e. Oedipus after his moment of recognition starts a new phase as a fully grown-up man.[42] His life as a young hero begins in late adolescence,[43] but only the self-created part of his persona makes the transition into adulthood then, taking on the relevant responsibilities as king and father. Another part of himself, that is determined by his lack of knowledge of his identity, stays adolescent and is revealed in the stress situation dramatized in *O.R.* Oedipus matures radically when he recognizes his true identity and thus the unknown part of his persona.

17
Hercules Psychotherapist[1]

Ruby Blondell

Herakles, mightiest of all the Greek heroes, made the world safe for human civilization by ridding it of countless savage and terrifying monsters. But he was also the most bestial of heroes, standing outside the pale of civilized life even as his exploits made that life possible for others. He was prone to murderous rages, voracious gluttony for food and drink, and rampant sexual promiscuity towards both women and men. In one incident he has sex with fifty women in a single night; in another he kills his own children in a fit of madness. His story is replete with episodes of murder, rape, and pillage which underline the high cost of his heroic achievements and cast doubt on his value as an ethical exemplar.[2]

In 1994 Herakles was reborn in the person of Kevin Sorbo, star of the television show *Hercules: The Legendary Journeys* (hereafter *HLJ*).[3] *HLJ* transforms the ferocious Greek Herakles into a model of conventional, respectable, middle-class American values, a bourgeois fantasy hero of late twentieth-century popular culture.[4] This reinvention of Herakles, which takes place in the pilot telemovie, *Hercules and the Amazon Women* (hereafter *HAW*), hinges on the psychotherapeutic discourse of popular culture, i.e. on contemporary psychotherapy as filtered through the mass media for a general audience consisting primarily of women. The self-help industry exhorts us incessantly towards "personal growth," to be obtained by understanding one's "inner child," which will result, ideally, in the "self-fulfillment" of "healthy" heterosexual romance and the rewards of parenthood. In this essay I shall argue that *HAW* draws upon such discourse to situate the hero both as a desirable male for the contemporary female audience and as a therapeutic authority who reinscribes male dominance in a way that reflects the "postfeminist" backlash of the 1990s. The victims of this reinscription, and of the reinvention of Heracles as a model of "enlightened" late twentieth-century American masculinity, are the Greek Amazons, whose identity as independent women is undermined by Heracles' newfound therapeutic authority. Women, the primary consumers of self-help books and other forms of popularized

Figure 25: *Hercules and the Amazon Women* (1994) was the first of four telefeatures that started the Hercules television series. © Renaissance Pictures.

psychotherapy, become the postfeminist victims of a hero whose power over them now lies not in his enormous physical strength but in his skill at manipulating therapeutic discourse.

I begin by sketching the persona of Kevin Sorbo's Hercules, before turning to look more closely at the way it is constructed through his encounter with the Amazons. Finally, I shall analyze the ideological price that is paid for this transformation of masculine heroism by women, as embodied in the Amazons.

HLJ grew out of a set of five interlinked made-for-TV movies, broadcast as part of a larger collection of "Action Pack" films made by Universal Television.[5] In these telemovies Hercules was reimagined as an American "regular guy" (Weisbrot 1998, 10-13). In keeping with the limitations imposed on much of contemporary popular culture, directly or indirectly, by its target audience and the marketplace for media products and advertising, he was explicitly envisaged by his creators as a role model who would send the "right message," especially to children.[6] Sorbo's Hercules avoids unnecessary bloodshed, rarely killing anyone besides monsters and often trying to reason his way out of awkward situations before resorting to muscle-power. He repeatedly concerns himself with righting social wrongs, from slavery to the stigmatizing of innocent minority groups such as centaurs, cyclopes, and other assorted misfits and pariahs. These "causes" typically have a late-twentieth-century resonance, often of a specifically American kind.

As for physical pleasures, this Hercules is, in the words of his companion Iolaus, a "goody-two-sandals" (*The Enforcer*).[7] In contrast to his ancient forebear he is distinguished by a sunny moderation. He refrains from overindulgence in food and drink (cf. Weisbrot 1998, 160), and his attitude towards sex is not only self-controlled but exceedingly romantic. The telemovies present him as a monogamous, strictly heterosexual family man, utterly devoted to his wife Deianeira and their children. In the first episode of the weekly series, however, Deianeira and the children are killed by Hera, Hercules' wicked stepmother, which enables him to follow a life of adventure without becoming a neglectful "absent" husband and father (something with which he is quick to reproach his own father, Zeus).[8] Their death allows him to elide the tension between heroic and domestic roles that characterizes Greek male heroism from its earliest expressions and evade–rather than confronting–contemporary concerns regarding "fractured families." Such anxieties are transposed from the hero himself to his divine dead-beat dad, enabling Hercules to sustain his persona as the ideal modern male without upsetting the ideology of the nuclear family. The death of his wife and children in a fireball sent by Hera is evidently a preferable fate.

Despite their death, however, Hercules continues to evoke the popular fantasy of the "intact" nuclear family, grounded in romantic heterosexual monogamy, to a remarkable extent, considering the circumstances. He remains devoted to the dead Deianeira, even visiting her occasionally in the Underworld (e.g. *The Other Side*). Though not entirely celibate, he is exceedingly slow to seize the countless opportunities for sexual adventure thrust upon him by eager (and often very attractive) women.[9] These include characters who have nothing to do with him in the mythic tradition. Even the notoriously man-shy Atalanta comes on to him–and is rejected (*Ares*). He has no interest in casual sex, being by nature monogamous ("I'm a one-woman man!", *Eye of the Beholder*).[10] Often thoughts of Deianeira prevent him from succumbing to other women (cf. Weisbrot 1998, 249, 251). In Season Three he meets and marries his second wife, Serena, but before doing so visits Deianeira in the underworld to obtain her blessing. He leaves her with the words "I will always love you" (*When a Man Loves a Woman*).

The establishment of this romantic persona is a central theme of *HAW*, the first of the telemovies to be aired. The opening of the movie situates Hercules as an anti-marriage misogynist, who explains Hera's malice in sending the Hydra as "a perfect example of what happens when a woman gets too much power." By the end, his encounter with the Amazons has transformed him into a fervent devotee of heterosexual romance, thus paving the way for his brief but happy marriage with Deianeira. That encounter is derived, albeit distantly, from an incident in Greek mythology. The ninth of Herakles' traditional twelve labors was to steal the war-belt of the Amazon queen Hippolyta–a feat that not so subtly betokens both military and sexual conquest.[11] In the process he kills numerous Amazons, including Hippolyta herself. Countless vase-paintings show him slaughtering them brutally, often with his distinctive–and distinctively brutal–weapon, the club.[12]

Our earliest mention of the Greek Amazons labels them αντιανειραι (Homer, *Il.* 3.189, 6.186), a word that suggests both equality and hostility to men.[13] As men's equals they defy the strict gender ideology of ancient Athens and live in their own separatist society, without the protection of the conventional patriarchal household and without any sexual need for the male beyond an occasional roll in the reproductive hay. This reversal of gender roles poses such a serious threat to 'civilized' Greek life that the Amazons are standardly portrayed as a dangerous physical threat, competing with men on their own military turf. The peculiar nature of the Amazonian threat is also expressed through their clothing and equipment, which varies from Greek hoplite weaponry–indicating their equivalence to Greek men–to 'barbarian' pajamas and crescent shields, indicat-

Figure 26: Ancient greek vase depicting the Amazons in battle with Hercules. Vase by Euphronius. Museon Civico, Arezzo, 1465.

ing their savagery and otherness. Because of the threat they present to the normative social order their conquest came to be seen as part of Herakles' civilizing mission.

The Amazons of *HAW* are clearly recognizable as the descendents of their mythological forbears. Like their Greek counterparts they represent a repudiation of 'normal,' 'civilized,' patriarchal life as enshrined in conventional gender roles. ('Normal' life is portrayed in the movie's opening scene, where women wash men's feet and boys exclude girls from their games.) Like the Greek Amazons, they have abrogated to themselves the autonomy and power over the other gender–specifically, over the structure and perpetuation of the household–that are the historical province of men. They are descended from a group of women who seceded from an ordinary village called Gargarencia, where they used to live in individual households with their husbands.[14] They left the village because those husbands were insensitive to their womanly needs, and proceeded to establish their own autonomous female community.

In contrast to Greek representations, none of these modern Amazons is armed like a conventional male warrior. They are all heavily barbarized or orientalized in their appearance and mode of warfare. The messenger who comes from Gargarencia to beg Hercules for help calls them "ferocious beasts." They are monkey-like, jungle-dwelling tomboys who swing down from trees to attack, wearing "primitive" animal masks that betoken both savagery and "feminine" deviousness. They lurk in ambush and dig pit-traps rather than fighting in an open, "manly" fashion. When they do come out into the open, they use orientalized martial-arts techniques that betoken their otherness. Their stick-like weapons are laughably phallic, but appear to be useless for actually penetrating anything. In short, they fight like girls–and girls in fishnets, to boot. One unseen Amazon, hidden in a pit-trap, actually deprives Iolaus of his sword by pulling it into her hole, nicely encapsulating the threat these creatures pose to the patriarchal order.

Not surprisingly, these Amazons are terrifying to the spineless village men. They have killed off all the village's warriors and hunters, and the remaining males are utterly emasculated. The women even kill Iolaus after taking his sword. But they pose no real threat to Hercules. Nor does he pay any of them the compliment of killing her. To do so would seem merely brutal, and brutality is no longer part of his persona. The slaughter of the Amazon Queen, in particular, was deemed "too dark" for "family viewing" (Weisbrot 1998, 18). At the movie's climax, Hercules actually refuses to kill her, even though he has her at his mercy and she has challenged him to finish her off. It is all a far cry from the graphic Greek representations of Herculean slaughter.

The Amazons do succeed in capturing Hercules. Later we discover that this was only because he *allowed* them to do so, in order to penetrate their female stronghold and learn their ways. (He calmly walks free when he so chooses.) The effect of his brief stay is, however, transformative. After binding and gagging him, and making him wash her feet, Hippolyta informs him that women want to be respected and explains that the roots of his misogyny lie in his childhood acculturation. By means of a magic candle, which transports him into his own past, she shows him (and us) how he has been influenced by his misogynistic, philandering, henpecked father Zeus (Anthony Quinn) and by the training in manhood at his all-male school, where the boys are taught that emotions are for girls and weaklings. Hercules responds well to this repudiation of essentialized gender roles, asking Hippolyta, "What if I tried to change?" After all, "If I learned to be the way I am, I can learn to be another way." And he does! He is instantly transformed into a 'sensitive' late twentieth-century middle-class male, integrating a newfound 'feminine' respect for feelings with his 'masculine' strength training: "It's not weak to admit what you're feeling. It takes strength and courage."

Hippolyta's psychotherapeutic strategy and its success reflect the enormous influence (especially among women) of the self-help movement of the late twentieth century, catering to the heterosexual female viewer's recurrent fantasy of reforming the intransigent male. But it also holds the seeds of Hippolyta's own destruction as an independent woman. Hercules, the therapeutic "client," will learn more than she meant to teach, turning the tables to become a better psychotherapist than his teacher. The insights he acquires from her are an essential step in preparing him to meet and marry the love of his life, Deianeira. But they also apparently qualify him to set the queen of the Amazons straight on the question of female desire. Newly wise in the ways of women, he informs Hippolyta that her subjects "feel an emptiness they cannot explain." His assessment is endorsed by the movie's representation of Amazonian desire. The Amazons prepare for their sexual 'assault' on the village men by sensuously oiling their perfectly hairless bodies and donning thong underwear in the firelight. They are svelte, beautiful, and eroticized for the presumptively male gaze. Aside from its obvious appeal to certain audience-segments, this eroticizing of the Amazons simultaneously suggests their desire to be desirable to men and underlines the wasteful impropriety of allowing such nubile women to exist outside the dominion of heterosexual male use.[15]

Hippolyta herself, the militantly feminist leader, is by far the most petite, least martial, most glamorous and 'feminine' of the Amazons. It is therefore hardly surprising that she is, in the end, seduced away from her

feminist separatism by the newly sensitive Hercules. This is configured, however, not as seduction on his part, but as courage on hers for resisting Hera, the goddess these Amazons worship.[16] Hera is portrayed as a divine feminazi who has been enslaving the Amazons' wills and teaching them to hate all men. She never appears as a character, but we see her image in a magical "mirror", where she has the twisted face and distorted, masculine voice of a stereotypical post-menopausal woman. By undermining the influence of this creepy, asexual figure over the Amazons, Hercules plays the role of those late-twentieth-century counselors who took it upon themselves to 'cure' women of the 'disease' of independence from men and the 'infection' of feminism.[17] The price of successfully training men in 'sensitivity' is not, as one might think, a male endorsement of female self-assertion, but the re-empowering of the "sensitive" male as an authority figure qualified to reinstate patriarchal gender norms.

Hercules' advice to Hippolyta puts a distinctively modern spin on the occasional Greek image of Herakles as a repository of wisdom,[18] by turning him into the contemporary American 'wisdom' figure par excellence: therapist/pop-psychologist/advice-columnist/self-help-guru–a persona to be sustained in many episodes of the weekly series. His newfound therapeutic authority also qualifies him to serve as a sensitivity counselor for the men of Gargarencia. The next time the Amazons show up for their periodic rape of these men they are greeted with romantic toasts, flowers, love-songs, and improved personal hygiene, by men who want nothing better than to *talk* about their *feelings*. ("We talked about her, we talked about me, we talked about everything!") This ignites the Amazons' secret yearning for normative domesticity and (hetero)sexuality, inspiring them to rebel against Hera's evil authority. Thanks to Hercules' intervention, these tough yet sexy babes choose to settle down with the ill-groomed dolts whom they have been serially raping for years. Like late-twentieth-century American career women, they are assured that they will only be really happy if they give up their independent lives and devote themselves to maternity and "nurturance" (cf. Faludi 1991, 82-108). Accordingly, they replace their masks with conventional female attire, Gargarencia returns to 'normal,' and its inhabitants presumably live happily ever after. Under the phallic woman's bestial mask lies the face of a monogamous homemaker.

The means by which Hercules achieves this transformation include not only an antifeminist discourse of personal fulfillment, but also, paradoxically, a related feminist rhetoric of self-determination. The Amazons' embrace of conventional heterosocial domesticity is represented as a newfound 'freedom': Hercules has 'freed' them from the shackles of radical feminism as embodied in the man-hating Hera. This is accomplished by

appropriating the feminist rhetoric of 'choice,' which is manipulated, in an Orwellian fashion typical of the postfeminist backlash, to validate the rejection of feminist ideals.[19] Under the influence of Hera the Amazons chose a life of separatist community in a utopia reminiscent of the ideals of some second-wave feminists–a thriving community that is, on its face, much more appealing than the village they left behind; but this choice is delegitimized by configuring Hera's influence as tyrannical mind-control, which discounts it as a choice at all. Hercules' competing influence, by contrast, is configured as liberation, since it is naturalized as corresponding to the inner necessity of female desire as such. Women are "free to choose," but only one choice is 'natural' and therefore right, indeed inevitable. As corollaries to heterosexual domesticity, monogamy and biological parenthood are also naturalized: since each woman has been returning to the same man on their periodic visits, no tricky problems arise regarding female promiscuity or the paternity of the children.[20] Like the postfeminist backlash, the movie tells women that "they must choose between a womanly existence and an independent one...; if they [give] up the unnatural struggle for self-determination, they [can] regain their natural femininity" (Faludi 1991, 452). The rhetoric of the natural–always dangerous–became more loaded than ever in the 1990s, as biological determinism, especially regarding sex-roles, swept triumphantly through the popular media in a trend that shows no sign of abating.

There are, to be sure, a few changes at Gargarencia as compared with the old days. Hercules sternly admonishes the men that they must not slip back into their old habits–the flowers and conversations *must* continue. We are given to understand that in this newly enlightened village the foot-washing will be reciprocal, at least "every once in a while." The old-fashioned sexism of the opening scene has thus been tempered with a whiff of Amazonian feminism, permitting the movie to be read by a sufficiently determined viewer as pro-woman, even a "feminist parable" (Weisbrot 1998, 24). Lip service is paid to gender equality, despite the manifest superiority of these women over these men in every way. Far from being feminist at its core, however, the kind of 'respect' that Hercules advocates is the reinstatement of an antiquated romantic ideal, or deal, in which such gestures as flowers and love-songs are the price men pay for female domestic labor. In the past, the men of Gargarencia failed to keep up their end of this bargain. Hercules reinstates it without questioning its terms. There is no sign that the men will continue to perform any of the domestic chores that they carried out perforce in the women's absence. The men will persist in their romantic gestures, but these serve to underline the traditional hierarchical division of labor, not to challenge it.[21] Occasional reciprocal foot washing is offered as a metonym for a newfound equality

that is not substantiated in any structural way. On these terms, domestic harmony is restored and another monster–the monster of female separatism–contained by our hero.

The Greek Amazons are thus domesticated in *HLJ* much as Herakles himself is, by the use of therapeutic discourses characteristic of the late twentieth century to incorporate them into a bourgeois, pseudo-enlightened model of the household, an incorporation that not only echoes Herakles' own domestication but enacts it under his therapeutic regime. The result is a taming of the Amazons more insidious than the unapologetic Greek representations of slaughter. I refer here not to their taming *within* the TV show, but to their taming *by* the show. Despite their physical prowess and self-sufficiency, what proves effective for these Amazons in the end is the passive mode of female power exemplified most famously in Aristophanes' comedy *Lysistrata*, where women achieve their goals by withholding domestic labor and marital sex. This kind of power, which is dependent on the institution of the household, is very different from the actively transgressive power of the Greek Amazons (raw physical violence grounding, and grounded in, a lack of interest in, or need for, men)–a power whose strength is its repudiation of the household altogether. The televisual Amazons' repudiation of the household turns out, by contrast, to be nothing of the kind: their rejection of domesticity is fueled by a desire for a *better* domesticity. They want nothing more than to be treated with the respect due to a good wife. The Greek Amazons exist in order to define the 'civilized' normative male (and female) through the reversal of culturally coded gender expectations; the televisual Amazons perform the same function by embracing those norms. Female power is shown to serve, in the end, only the interests of bourgeois domesticity with which female interests are held to be identical. And the therapeutic discourse that has been embraced predominantly by women, as a means of improving both themselves and their men, is used to reinscribe the gender roles that many women, in their quest for 'self-fulfillment,' have attempted to escape.

Though widely divergent from Greek myth, Hercules' encounter with the Amazons in *HAW* performs similar ideological work. As Tyrrell puts it, myth serves (among other things) to "obfuscate, circumvent, or mediate [cultural] conflicts and tensions... [A myth's] purpose is the diminution of anxiety and resolution of conflict, not truth" (Tyrrell xiv). Popular culture in general, and television in particular, plays a comparable ideological role.[22] Accordingly, both the Greek myth of Hercules and the Amazons and its treatment in *HAW* serve to obfuscate and naturalize the tensions and contradictions inherent in the institution of marriage. But the ways in which they do so are tailored to their specific cultural contexts.

In the Greek imaginary, Amazons function in many respects as an an-

tithesis to 'civilized' society, and their myths enact a prohibition on disrupting the roles and relationships between the sexes enshrined in the institutions of marriage and the household. Classical Greek culture so dreaded the prospect of female power, and the threat it presents to such structures, that it kept its women in an explicitly subordinate position based on their supposed inferiority to and need for men. It had no compunction in portraying women who defy such subordination as a force so terrifying that they represent a real threat to the 'civilized' patriarchal order and must therefore simply be killed off. Their slaughter is the prerogative of one Greek hero after another, but most especially of the paradoxically brutal 'civilizer,' Herakles.

In the ideology of contemporary popular culture the patriarchal family's ability to reproduce itself is likewise threatened by female autonomy and power. Male anxiety on this score was on the rise in the post-feminist 1990s, when *HAW* first aired. In contrast to classical Greece, however, modern American popular culture purports to *respect* the powerful female and give a voice to 'feminine' needs even within the bourgeois family. This aspect of contemporary ideology is pervasive in *HLJ*, which frequently displays a superficial veneer of feminist values as popularly conceived (women are 'powerful' and their voices must be heard), while constantly undercutting it. (This undercutting often takes forms that are all too familiar to the student of Greek mythology, such as the representation of powerful females as monsters with supernatural powers, and the location of women's power in their sexual allure.) The 'mythic' strategy for neutralizing the Amazons adopted by *HAW* therefore diverges somewhat from its Greek sources.

For the Greeks, the Amazons' "masculine" independence is itself the problem, and must be erased in the interests of "civilization," which requires the suppression of women's "natural" wildness. But a culture that purports to respect female independence and choice cannot simply kill off such women. Instead it must maintain that while women do indeed have the *capacity* for autonomy, this is not what they really *want*, since it militates against their "natural" domesticity. Civilization can therefore be restored not by killing them, but by helping them to understand their own intrinsic needs and desires so that they will re-embrace the status quo, leaving the hero's hands unbloodied. As different as he is from the early Greek Herakles, Kevin Sorbo's Hercules too is an agent of 'civilization,' as defined by the patriarchal ideology of his own time. But civilization now comes in the psychotherapist's office, instead of at the end of a club.

18

Someone to Watch over Me: The Guardian Angel as Superhero in Seicento Rome

Lisa Beaven

The superhero's origins have often been traced back to the gods and demi-gods of ancient mythology (see Reynolds 1994), and obviously there are strong links between mythological heroes such as Hercules and superheroes such as Superman, Spiderman and Marvel Comic's Thor. However, in this essay I will argue that the Christian figure of the Archangel has also played an integral role in prefiguring the idea of the superhero in a number of fundamental ways. Archangels were powerful and popular images in sixteenth and seventeenth century religious art that attracted worship in their own right. Two Archangels in particular, Michael and Raphael, achieved widespread fame in Italy during the period. Raphael's popularity derived largely from his appearance in the *Book of Tobit* (2nd century B.C.), in which he served a protective role as the guardian of the boy Tobias, a role which led to the creation of a new, more approachable superhero in the form of the Guardian angel.

While on the one hand there was widespread support for the cult of the Guardian angel and the cult of the angels within the church hierarchy, on the other it was also recognized that Archangels were dangerous precisely because they attracted worship in their own right, which for the Catholic reformers came dangerously close to idolatry and encouraged superstition. Therefore in spite of the fact that by 1630 the cult of the guardian angel had attracted the official backing of the church, by mid-century relics and shrines associated with the material presence of angels were quietly removed from churches in Rome. The appealing concept of a Guardian angel watching over each of us persisted however, to re-emerge in the form of secular superheroes such as Superman in the twentieth century.

Archangels fulfill many of the criteria of superheroes (Reynolds 1994,16): appearing to humans in times of crisis or extreme need, they have supernatural powers, wage battle against evil, sometimes travel

about in disguise, provide moral support and consolation to saints, and protection for ordinary people, save people and souls, and of course, fly. And they are Holy men with their own costume, even if they wear dresses and sandals rather than tights.

Angels had, of course, already appeared in art for centuries, and play a major role in medieval and Renaissance painting and sculpture. In the decades immediately following the Council of Trent (1534-1549) however, an increased emphasis was placed on the mystical experiences of saints, and angels moved in from the margins to become the protagonists of narratives depicted in paintings.[1] Artists began to treat traditional devotional subjects with a different emphasis in order to incorporate the theme of angelic consolation.[2] Caravaggio, in *The Ecstasy of St Francis,*[3] c. 1595, for example, treats a tender moment of intimacy between angel and saint, and his angel is extraordinary, real and tangible, much larger than the frail saint he holds, his strong young body bathed in light, and his thick feathery wings the only visible sign of his heavenly origins. The angel here is not an Archangel, who were associated with specific stories and deeds; rather he is a new phenomenon, a guardian angel.

The cult of the seven archangels (Michael, Gabriel, Raphael and four apocryphal angels by the name of Uriel, Selachiel, Jehudiel, and Barachiel) became immensely popular in the sixteenth century and was supported by the Jesuits in Rome.[4] Although by the 1590s the church forbade the use of the four apocryphal angels' names (Bailey 2003, 70), painters continued to illustrate them, but without naming them all.

Two archangels in particular, Sts Michael and Raphael, became extremely popular in Counter-Reformation Italy, such that they developed an almost totemic significance. St Michael, who did battle with the fallen archangel Lucifer (who, in many respects, is the paradigmatic supervillain) and cast him out of heaven, is usually shown as a youthful, handsome and stern holy warrior, fully equipped for battle with a helmet, sword, shield and sometimes a lance. He is almost always shown in visual images in his role as solider, defeating the devil in battle. Raphael's late painting of St Michael poised with his lance on top of the devil, who lies helpless before him on the ground was to become an extremely influential image.[5] This visual prototype was taken and adapted in the seventeenth century by Guido Reni[6] who created a more dynamic version of the composition with a strong diagonal movement, as the youthful, and powerful angel steadies his foot on the head of the devil who writhes and twists under him and prepares to gracefully deliver a blow with his sword, his wings fully outstretched, red drapery fluttering around him. Cardinal Antonio Barberini commissioned Reni's painting for the church of S. Maria della Concezione. The militant soldier archangel vanquishing evil was a crucially

important metaphor for the Catholic church in the sixteenth century, as they struggled to regain the ground lost to the reformation in Northern Europe and engaged in battles with Protestant forces. Depictions of his victory over the devil as well as more propagandistic images of him defeating heresy were skillfully used by the Catholic church in their campaign against the Protestants. But St. Michael also had a special meaning for Romans: he was thought to have appeared to Gregory the Great in Rome in 590. The city was being ravaged by a terrible plague and the Pope had organized a procession in which an icon of the Virgin belonging to S. Maria in Aracoeli, and which was believed to be that painted by Saint Luke, was carried through the city. During the procession the crowd looked up to see a vision of the Archangel Michael standing on top of the mausoleum of Hadrian, sheathing his blood-stained sword, a signal that the plague had come to an end.

McGuiness has shown that the martial language and imagery in preaching immediately after the Council of Trent, particularly prevalent in the Jesuit preaching, was associated with a real sense of the church being under threat (McGuiness 1995). After 1600, however, with the Catholic church gaining ground and confidence, the preaching shifted away from martial and military imagery to become 'more triumphant and conciliatory (McGuiness 1995, 136), and at this point the concept of a guardian angel, based on Raphael's protective role over the boy Tobias, became a more attractive metaphor for the church.

One of the most potent images of the Guardian Angel was Domenichino's painting from 1615 showing a very youthful, serious angel with golden curls standing guard over a child, pointing to heaven with one hand while protecting him with a large shield from the devil who leans forward to peer in frustration around the shield. The painting illustrates the battle between good and evil over the soul of a child, and was much copied. While the illustration of such a battle was not new, making a Guardian angel the subject of a painting was.

Domenichino's composition was taken up and adapted by Pietro da Cortona in his painting of the Guardian Angel from 1656 shows a beautiful smiling angel dressed in white fluttering drapery who leads a small boy by the arm while pointing heavenwards with the other hand. Cortona's painting differs in several important ways from Domenichino's. First, the devil is absent, so the sense of a conflict between good and evil is removed. Second, the scene is repeated in the background, but this time with the angel leading an adult man. This reinforces the identification of this angel as a guardian angel, that remains by the side of every man as he goes through life, and protects him. And finally, the angel's feet do not touch the ground, rather he hovers above it, which, combined with his gesture,

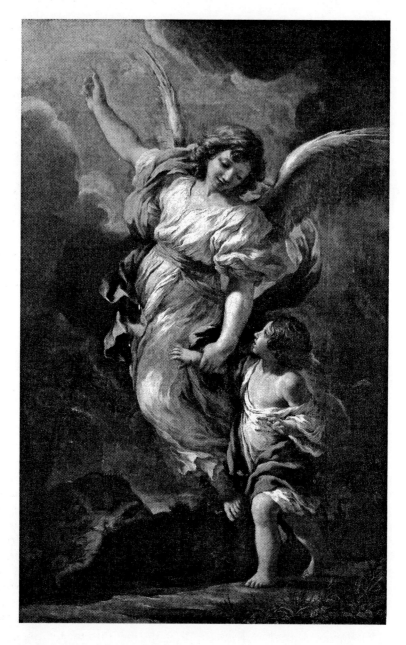

Figure 27: A C17th painting of a Guardian Angel by Pietro da Cortona (*L'Angelo Custode*, inv. 1753). © Galleria Nazionale d'Arte Antica, Rome.

reinforces his heavenly origins. The child strides forward purposefully, creating the sense of a journey through a landscape. This painting was commissioned by Pope Alexander VII as one of a pair, the other being an image of the Archangel Michael.[7] Between them these two archangels combined the fighting power and guardianship roles of the modern superhero. Cortona's painting also provides us with a clue as to the origins of the image of the winged guardian leading a child by the hand. His image is strikingly similar to depictions of the archangel Raphael and the boy Tobias journeying through the landscape.

The concept of a Guardian angel, assigned to each person as they go through life, dates back to the thirteenth century, but for the reasons outlined above the worship of the Guardian Angel became immensely popular only in the first decades of the seventeenth century. A confraternity was formed, and approved by the Borghese Pope, Paul V. The Jesuit Francesco Albertini's *Trattato dell'angelo custode*, or treatise on the Guardian Angel, published in 1613 contributed to this surge of interest in the guardian angel as he wrote of each person going through life with an angel watching over him and helping him:

> It was not enough for God our Lord to have set the angels to govern the universe, and consequently to govern humanity; but in order to demonstrate the special care that he has for every person, he in particular deputised an angel for each of us, to guard us from the beginning of our birth, and who was dedicated to promoting our well-being, and defending us from evil, as all the theologians and church fathers tell us (Albertino da Catanzaro 1613, 17-18. My translation).

He goes on to reassure the reader that there is no chance of there not being enough angels to go around, because, as S. Bernardino of Siena stated, the angels exist in such numbers that they are like the stars in the sky. He also mentioned they were more likely to appear to the virtuous, or to those in life-threatening circumstances. Translated into different languages Albertini's treatise was immensely popular and prompted the formation the Confaternità dei SS. Angeli Custodi (Confraternity of the Most Holy Guardian Angels) at Santo Stefano del Cacco in Rome in 1614. It was raised to the status of an arch confraternity in 1621 and due to burgeoning numbers moved to a new church, which was built around 1650, the church of the Guardian Angel (Lumbroso and Martini, 1963, 42). On its façade was a stucco sculpture showing an angel leading a child by the hand (Lumbroso and Martini 1963, 42).

Proof of the popularity of the cult and belief in the guardian angel can

also be found in documents and wills of the time. For example Claudio Acquaviva's biographer wrote of the devotion he displayed to the guardian angel: "As soon as the office of the Guardian Angel was approved by Pope Paul V, [Acquaviva] embraced it with great happiness, and he said it every year with equal devotion, reciting every part of the prayer that is included for that angel" (Bailey 2003, 55). Lorenzo Altieri wrote in his will: "that they may keep my memory alive, to each one I leave, as here below, some devotional pictures, which I keep in my room, where I am used to say my prayers: that is to Mgr. Gianbattista I leave the ivory Crucifix within the furnishings, where it stands, with two small pictures, one of St. Laurence and one of the Guardian angel" (Schiavo n.d., 168-9. My translation). In this case Lorenzo Altieri had two small paintings in his room of the two saints he felt were watching over him, his name saint Laurence, and his guardian angel.

Another treatise on Guardian angels was that credited to Aloysius Gonzaga, which was published in Rome in 1792 (Gonzaga 1792). This treatise is particularly revealing about the origins of the guardian angel as it explicitly uses the model of the Archangel Raphael and his protection of Tobias as an example of how guardian angels interact with those humans they are responsible for. The author describes how, just as the ancient Tobit was sent Raphael when he was looking for a companion for the young Tobias, so too is each person sent a guardian angel by God as they set out on life's path. He writes "Now in each of these states, conforming to all the actions of the Angel Raphael, contemplating his particular offices, is how the Guardian angels behaves to you" (Gonzaga 1792. My translation).

Both the imagery and iconography associated with the Guardian Angel, therefore, derived directly from the Archangel Raphael as he appears in the *Book of Tobit*. The *Book of Tobit* was written sometime in the second century B.C., originally probably in Aramaic—part of the story was found among the Dead Sea scrolls—but surviving mainly in Greek versions (see Charles 1913, 174-201). It tells the story of the devout merchant Tobit, who suffers several major reverses due to an oppressive ruler, becomes blind and loses all his possessions. Waiting to die, he prays to God and begs his son Tobias to go to Media to redeem a debt from a relative. Tobias goes in search of a man to accompany him to Media, and finds the archangel Raphael before him, but fails to recognize him: "So he went out and found the angel Raphael standing before him. Of course, he did not know that he was an angel of God."[8] Only reluctantly, after some questioning, does Raphael identify himself as Azariah,[9] a kinsman, and agrees to be Tobias's paid companion on the journey to Media. The angel, Tobias and a dog set out on their journey. On the banks of the Tigris they catch a large fish and Raphael urges Tobias to kill the fish and keep the gall and entrails. As they

approach Ecbatana, Raphael advises Tobias to wed Sarah, a kinswoman who lives there. Sarah had been married to seven husbands, all of who had died on their wedding night, as she was possessed by an evil demon, Asmodeus. In despair, she had contemplated suicide, and prayed to God. Tobias is naturally apprehensive about becoming the eighth husband but Raphael gives him detailed instructions on how to break the spell of the demon. Tobias and Sarah marry and on their wedding night Tobias burns the fish heart and liver in the hearth to dislodge the demon, while he and Sarah pray through the night. Once he breaks the demon's hold on Sarah, Raphael chases him to the upper reaches of Egypt and shackles him. Raguel, Sarah's father, is overjoyed to find his son-in-law survived his wedding night and arranges lavish festivities that last for two weeks. At the end of that time Tobias and Sarah return to Nineveh, and Tobias administers the medicinal gall to his father's eyes, thus curing his blindness. Tobias and Tobit offer Azariah half of the redeemed money, at which point he reveals his identity as one of the seven archangels, stating:

> I am Raphael, one of the seven angels who stand by and enter before the glory of the Lord". Then they were both amazed and fell upon their faces, and they were afraid. But he said to them, "Be not afraid, peace be to you, bless God unto all eternity"... then he vanished! And they rose up, but they could no longer see him.' (Zimmerman 1956, 111).

Although the *Book of Tobit* explicitly refers to Raphael traveling in disguise as Azariah, in the text he is referred to as 'the angel' and in paintings he is always represented as an Archangel with wings. This is reminiscent of *Smallville* and the depiction of Clark Kent. Frequently in the series (including the pilot episode), the viewer is shown Clark in Smallville's cemetery with the statue of an angel with spread wings looming behind him or seen in the background. The series' writers are clearly aware of playing on the imagery of the guardian angel, and on associations of the guardian angel with Clark's future as superhero/Superman–the guardian of the American people.

The sheer number of low-grade paintings of Raphael and Tobias traveling through the landscape, attests to the enduring popularity of his protective role with ordinary people during the baroque period. The fact that seventeenth century paintings always show him in this alter ego form when he is supposed to be in disguise suggests that patrons wanted the reassurance of knowing it was really St Raphael on their wall, so they were in on the secret from the beginning.

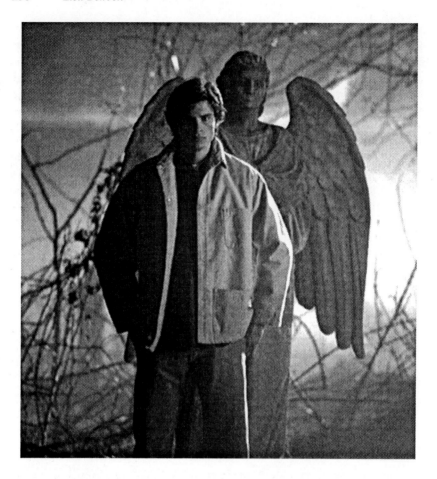

Figure 28: Clark Kent standing before a statue of a Guardian Angel in the Smallville Cemetery. From *Smallville*. © Warner Bros.

The story contains many of the essential components of the superhero myth. Lawrence and Jewett summarize the American monomyth, which is integral to the superhero narrative, in the following way:

> A community in a harmonious paradise is threatened by evil: normal institutions fail to contend with this threat; a selfless superhero emerges to renounce temptations and carry out the redemptive task – his decisive victory restores the community to its paradisiacal condition: the superhero then recedes into obscurity (Lawrence and Jewett 1977, xx).

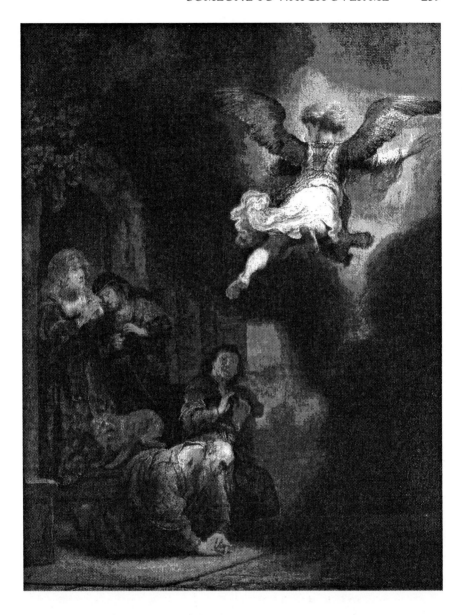

Figure 29: This painting by Rembrandt van Rijn of an angel in flight pre-empts the later ability of many superheroes by three centuries. (*The Archangel leaving the family of Tobias*, 1637, oil on wood, 66 x 52 cm).
© Musée du Louvre, Paris.

The *Book of Tobit* fits perfectly into this framework. The Archangel Raphael is a selfless and sexless superhero working alone in the style of a vigilante, focused on his mission, which is to save a community too helpless, incompetent, or unfortunate to save itself. He is sent to earth to assist the virtuous Tobit and Sarah, both overwhelmed by misfortune, and who have prayed to God for help. Compared with the angst-ridden, flawed superheroes such as Batman who is fuelled by vengeance, Raphael in his invulnerability and mysteriousness is much closer to Superman as the altruistic man of steel. Raphael, an angel sent from heaven, also parallels Superman's origins as an alien. Always on the side of right, always ready to save the world from villainy whether it wants to be saved or not, Raphael and Superman function as metaphors; Superman for America in a particular historical moment (1938), and Raphael for the Catholic Church in the Counter Reformation, providing people with a vision of how their experience is related to a larger reality or purpose.

Raphael is all-powerful but appears in disguise as a humble traveler, thus has both super and normative identities. He is a force for good, who protects and guards young Tobias on the road, battles evil (in the form of the demon), cures illness and rewards virtue. He uses magical and medicinal powers to overthrow evil, a compelling parallel to the use of advanced technology in modern superhero stories. Mattias Stomer, in an unusual baroque painting, actually shows Raphael instructing Tobias on how to burn the heart and liver of the fish on a small fire in the foreground, while in the distance he includes the more commonly depicted scene, of Tobias catching the fish.[10] In this version of the story the use of magic and medicinal powers to overpower the demon becomes the prevailing message.

After keeping his identity secret, at the end there is the essential transformation scene as Raphael reveals himself in all his shiny brightness as an Archangel, to the amazement of the family of Tobit, before flying off (a trait rarely found in mythological heroes), invoking the key ingredient of transformation or metamorphosis into the superhero alter ego. This scene, with the family prostrate in front of him as he disappears skywards in a pool of light, was the other point of the story which was sometimes illustrated, and can be compared directly to similar images of Superman hurtling skywards. Rembrandt, for example, shows Raphael taking flight, wings fully stretched and brightly illuminated while the old man Tobit lies prostrate in front of him and the family cower in the doorway.[11] In a more personal image, Gianantonio Guardi shows Tobias on his knees farewelling his friend, with the dog beside him, while the archangel, in a dazzling display of Venetian coloring, rises up into the air, wings beating, his garments shimmering in the light.[12]

The appeal of the guardian angel, based on Raphael's protection of Tobias, differs in some respects from the appeal of the comic-book super-hero, although the combination of older caped crusader and young boy has certain compelling visual parallels to Batman and Robin. The contemporary popular-culture superhero has a normative identity as a regular guy, or angst-ridden, geeky teenager, and thus is a figure that its reading audience can relate to. Instead the *Book of Tobit* is designed to promote prayer, and the belief that God will help the virtuous. The geeky teenager in the *Book of Tobit* is guided and protected by the archangel, but does not himself morph into a superhero. Instead of the "mapping of the adolescent subject onto a social order that is perceived by that subject as arbitrary, exclusionary, and incomprehensible" (Bukatman 2003, 70), Tobias stands in for the average believer, guided and protected as they go through life by the Catholic church.

The parallels between archangels, guardian angels and the modern superhero may not be a coincidence, given the widespread diffusion of religious thought in all aspects of American life. Certainly there are striking similarities between the resurgent Christian fundamentalism in America and the language employed by preachers in the counter-reformation, in particular the Jesuits, whose spirituality was distilled through a tense world of a constant struggle against sin, where preachers described good and evil in terms of salvation and damnation. They were concerned not simply with saving souls but with transforming society. This concept has re-emerged in American political life since 9/11. Bush has conceived of his war against terrorism (the 'axis of evil') in the simple and literal terms of polarized extremes of good and evil; a mindset common to both the *Book of Tobit* and any superhero comic book. As Capps has written, "a salvation religion is being recommended to guide the affairs of the nation... the fundamental axiom is that salvation religion can effectively function as an operational civil religion" (Capps 1990, 182).

19

Smack-Head Hasan: Why Are All Turkic Superheroes Intemperate, Treacherous, or Stupid?

Claire Norton

Turkic myth and literature abound with both heroes and superheroes.[1] This chapter will explore how and why an early seventeenth-century Ottoman military commander, Tiryaki Hasan Pasha, was, in one narrative of events, re-imagined as a Turkic superhero through references to older myths and literature. Specifically it will focus on how, by intertextually linking this military commander to the ambiguous and contradictory notion of a Turkic superhero, the scribe-author problematized the status of the 'hero-commander' in contrast to his portrayal in other works. The chapter will be divided into two sections: the first will provide a brief introduction to medieval and early modern Turkic superheroes and their contested and often liminal nature or character. The second section will examine how and why an eighteenth-century Ottoman *gazavatname* narrative drew upon this heroic genre of literature in retelling the events of the siege of Nagykanizsa in 1601 by the Ottoman commander Tiryaki [or opium addict] Hasan Pasha.[2]

While Turkic heroes can be found in all genres, superheroes (like their more modern counterparts) tend to inhabit genres that permit a greater degree of fictional flexibility and a lesser degree of realism. In particular, they can be found in epic narrative prose or verse cycles originating in Central Asia, which were transmitted between Anatolia in the west and the western borders of China in the east. These narrative cycles are known to us today from extant manuscripts dating variously from the late medieval, early modern, and modern period. The narratives would have generally been performed in vocality although their medium of transmission and mode of composition may have been either oral or written.[3] As the various epic cycles shifted between different Central Asian communities, contexts and time periods so the tales were re-constructed and re-told to reflect the concerns and experiences of diverse audiences.

In general the epic cycles take as their central themes key elements from the largely nomadic life of Central Asian peoples: the theft of herds,

combat, acts of revenge, births, marriages, sporting events, the entertainment of guests and preparation of feasts or long journeys (Chadwick and Zhirmunsky 1969, 27 and 85). The cycles of tales generally center around the actions of an eponymous hero although occasional 'episodes' may focus on the adventures of more minor characters; often members of the hero's retinue of faithful warriors.[4] The lives and adventures of the heroes and unacknowledged heroines are generally portrayed in a naturalistic setting with occasional supernatural elements.[5] Religion is not a key factor in the epic cycles and although the heroes are overwhelmingly Shamanistic or Muslim, their religions frequently have a very fluid and heterodox character. For example, when the Muslim hero engages in combat with Christian adversaries as happens in the *Dede Korkut* cycle the conflicts are not depicted as religiously motivated, but rather as arising from more traditional causes of tribal strife: the kidnapping of family members (Başgöz 1978, 313-4). Historical elements and events are also reflected in the narrative cycles and the various re-tellings constantly reflect and respond to new contexts, enmities, historically significant events, and issues of concern to different audiences. However, much of the content of the epic cycles still has a highly imaginative or fictive content.

Early modern Turkic superheroes share a number of key characteristics with their more modern counterparts which identify them as 'super' rather than ordinary heroes. Specifically they often have supernatural powers or virtual invincibility; a sidekick; mysterious origins; magic tokens; and they engage in personal duels with evil arch-villains. Moreover, their adventures are narrated in a serialized form. For example the Muslim Kirghiz hero, Manas is described as being abnormally strong and invincible, and he possesses a coat of mail that no lance can pierce. The Shamanistic hero Joloi similarly possesses great strength, fortitude and stature such that he is capable of doing battle single-handed against a whole troop of Kalmucks (Chadwick and Zhirmunsky 1969, 152). Köroğlu owns a miraculous horse that can fly and speak; a common feature of Turkic myths and tales and which is also found in the *Dede Korkut, Manas* and *Er Töshtük* epic cycles (Başgöz 1978, 316).[6] Similarly, the mysterious origins of the heroes are often hinted at. Folk etymology provides two different backgrounds for Köroğlu: in the Anatolian and Azure version he is considered the son of a local notable cruelly blinded by a tyrannical pasha, but in all other Central Asian versions, he is thought to have been born in the grave from a dead mother (Chadwick and Zhirmunsky 1969, 302 and Başgöz 1978, 316-7).[7] Manas is also credited with having a miraculous birth (Başgöz 1978, 322).

Despite their re-imagination as they shift between Central Asian communities Turkic superheroes of myth and legend possess character traits

quite distinct from their more modern western counterparts: they are generally intemperate, licentious, dishonorable, or stupid. Turkic heroes are a law unto themselves and they only intermittently, and generally unreliably, uphold the heroic code of honor and standard of conduct shared by other superheroes. Their failings can generally be classified as including: an intemperate nature leading to overindulgence; dishonorable behavior–the breaking of accepted and normative social codes; negligence of, or even callousness towards, their wives and families; cowardice; incompetence; cruelty; and a disregard for the spilling of innocent blood (Chadwick and Zhirmunsky 1969, 89). Jolio is described as gluttonous, slothful and often so drunk that he has to be shaken awake by his wife or horse (Chadwick and Zhirmunsky 1969, 89). Similarly, Köroğlu has an uncontrolled appetite, coarse table manners, and legendary powers of drinking (Chadwick and Zhirmunsky 1969, 59 quoting Chodzko 1842, 48 and 103). On one occasion he induces consternation amongst onlookers when he consumes not only an entire sack of rice, but also the bag in which it was kept (Chadwick and Zhirmunsky 1969, 60). Moreover, he kidnaps young girls and boys for his sexual pleasure, and commits acts which even his friends think of as dishonest and which cause them to rebel against him (Chadwick and Zhirmunsky 1969, 89 and Eberhard 1955, 49). Manas also is described in both the Kazakh and Kirghiz version of the *Manas* epic cycle as behaving treacherously to his 'spiritual kinsman' (Chadwick and Zhirmunsky 1969, 209).

Similarly, very few Turkic heroes can be described as courageous. While their sisters, wives and horses often show remarkable bravery the heroes themselves tend to exhibit degrees of cowardice (Chadwick and Zhirmunsky 1969, 88). Joloi presents an especially pathetic figure who despite his gigantic size and strength needs to be saved from his enemies by his wife's prowess and bravery on countless occasions (Chadwick and Zhirmunsky 1969, 39 and 82).

The motivations of Turkic heroes differ from both their contemporaneous and more modern counterparts. They undertake quests and become embroiled in adventures not through any desire for heroic honor or through the pursuit of justice or the public good, but rather for personal gain and aggrandizement. Moreover, their activities are not particularly well thought out, and they frequently undertake desperate or even hopeless enterprises with a total disregard of the consequences (Chadwick and Zhirmunsky 1969, 94). At times the hero's own stupidity or indiscretion also acts against him: Köroğlu's horse is about to grow magic wings when his indiscretion causes them to disappear and on another occasion his horse is even stolen from him by a kitchen servant (Eberhard 1955, 46 and Chadwick and Zhirmunsky 1969, 58).

To this extent these Turkic superheroes may be thought to exhibit the traits of the 'super-villain' or the anti-hero, as opposed to those of the superhero. However, their dishonorable tendencies are not as tenacious or pervasive as those of the super-villain and in general, Turkic superheroes, in the eyes of their audiences, either remain honorable despite these acts, or regain their honor through redemptive acts. My concern in this chapter is to explore the dissonance created by these contradictory attributes: heroic and possessing superpowers, yet dishonorable, licentious and intemperate. Dumézil has argued that this ambiguous nature is an essential characteristic of the Indo-European mythic warrior. The dichotomous character is a reflection of both the liminal position of the warrior, and society's ambivalent and antithetical attitude towards him (Dumézil 1969 and 1992). Such mythic heroes are depicted as flawed as a result of sins that they have committed: generally those of deceit, treachery, cowardice, disobedience, regicide, rape or adultery. However, they are also frequently depicted as physically flawed or monstrous. Both the heroes' physical and character flaws are, in effect, a reification, or projection, of society's fear that the violence and force that the warrior uses in its defense could easily be turned against it. In addition, the warrior constitutes a direct threat to those exemplifying Dumézil's first function; the priest-king. The warrior's strength and power could be used to usurp and replace the ruling class (Dumézil 1969, 106-7). For representatives of the third function–artisans and agriculturalists–there are also ambiguities located in the body of the warrior: the defending warrior through his very success is likely to gain membership of the élite class of rulers and thus may potentially become their oppressor and not their defender.

The Turkic superheroes in the epic cycles mentioned above are guilty of the sins described by Dumézil: they are cowardly; treacherous; deceitful; and physically marked. Therefore, their narration in this manner presumably reflects similar societal tensions surrounding the warrior. It is probable that the Central Asian audiences of these epic cycles found the concept of the warrior problematic: although the warrior-superhero protects the community and redistributes wealth, he also possesses a strength and force that could be turned against them. These tensions and contradictory attitudes towards the warrior-superhero are expressed or ameliorated through the employment of particular narrative tropes–the cowardly or treacherous hero–and the effective containment of the hero through laughter. Their enormous appetites, drunkenness, physical stature and incompetence all provide comic relief.

This idea of an ambiguous Turkic superhero is not limited to early modern, Central Asian epic literature: it is indirectly referenced through intertextual allusions in a more realistic genre of Ottoman Turkish writing:

the *gazavatname*. Before I address why and how references to such Turkic superheroes have been employed in one particular narrative's description of a seventeenth-century Ottoman military commander in his defense of a castle in Ottoman Hungary, I will provide a little background information on the Ottoman Empire, the siege of Nagykanizsa and the Ottoman commander, Tiryaki Hasan Pasha.

The Ottoman Empire originated in northwestern Anatolia at the end of the thirteenth century and continued until the early twentieth century. It included territory in Europe, Asia and Africa: stretching from the gates of Vienna in the west to Baghdad in the east; from the Crimea in the north to the Yemen in the south. The empire thus included a variety of communities of numerous cultural, linguistic and religious backgrounds. However, while it incorporated individuals from a variety of ethnic or linguistic backgrounds into its ruling élite, the dominant cultural influences were Islamic and Turkic.

Nagykanizsa Castle was located on the Habsburg-Ottoman border just south of Lake Balaton in what is today Hungary. It was captured by the Ottomans from the Habsburgs in 1600 after a three-month siege. It represented one of the Ottomans' most significant military acquisitions of the 1593-1606 war because it was a key fortress in the Habsburg defensive line. The following year (1601) a coalition of Habsburg imperial troops and European mercenaries besieged the castle in an attempt to re-capture it, but they were ultimately defeated by the Ottoman provincial governor or *beylerbeyi* of Nagykanizsa, Tiryaki Hasan Pasha. The castle was to remain in Ottoman hands for most of the seventeenth century.

The most detailed Ottoman description of the retaliatory Habsburg siege of Nagykanizsa in 1601 is contained in a corpus of twenty five Ottoman manuscripts dating from 6 *Muharrem* 1025 (25 Jan.1616) to 16 *Receb* 1230 (24 June 1815) which are today known collectively in library catalogues by the rubric *Gazavat-i Tiryaki Hasan Paşa* (The Campaign of Tiryaki Hasan Pasha). I have described these manuscripts as a corpus rather than as copies or recensions of an original work because they are not verbatim copies of each other–there are small, but significant differences in rubrication, framing, and narrative description. However, they are not sufficiently different that they could be classified as distinct 'original' works. These variations cannot be adequately explained as a consequence of scribal ignorance or oral transmission and thus ignored or glossed over. Trying to categorize and analyze manuscripts such as these within a typographic model with its concomitant assumptions of authorial originality, textual stability, and the figuring of the scribe as a vital printing press is not adequate from a heuristic perspective. It is preferable to acknowledge the existence of alternative models of text production: many Ottoman manuscripts

were not produced and consumed within a discourse of authority and fixity, but were part of a more fluid discourse which embodied different concepts of style, language, authorship and text.[8] Manuscripts produced and consumed within such a fluid discourse can best be understood as re-inscriptions or performances by scribe-authors who read, interpreted and re-wrote the manuscripts to account for, and reflect, alternative religious and political perspectives and different textual functions.[9] The *Gazavat-i Tiryaki Hasan Paşa* manuscripts with their various differences can best be described as a corpus of inter-related, but essentially unique, manuscripts: therefore each manuscript represents a re-inscription or re-performance of the narrative by a scribe.[10]

In the context of Turkic superheroes I am interested in manuscript O.R.12961 located in the British Library, London. This version of the narrative is entitled *Hikaye-i Tiryaki Gazi Hasan Paşa* (The History of Tiryaki Hasan Pasha) and was inscribed by Salih Ağa Divitdar on 21 March 1789. It is the longest and possibly the most distinct of the corpus and includes a, perhaps unique, thirty folio narrative of Tiryaki Hasan Pasha's exploits in the region prior to his famous defense of Nagykanizsa. Differences in vocabulary, narrative and framing practices in this manuscript intersect to present a markedly different ideological position from many of the other manuscripts in the corpus: O.R.12961 is more heterodox, earthy, and politically liminal. This suggests that the politico-cultural cartography of the scribe-author and implied audiences of O.R.12961 was very different to that of certain other manuscripts in the corpus. For example, manuscript O.216 in the Magyar Tudomantos Akademia Konyvtara, Budapest, presents a more orthodox perspective and depicts Tiryaki Hasan Pasha as a devout Muslim and an exemplary military-administrative leader; definitely not a superhero.

Tiryaki Hasan Pasha is the hero of all of the *gazavatname* accounts. In O.R.12961 he is described as the ideal Ottoman commander: religious, just, competent, and generally considerate of his men. He is a wise and learned councilor, a competent administrator of affairs; he has an honored place in the court and advises the grand vizier and sultan. However, in this narrative Tiryaki Hasan Pasha is more than just the hero: he is also a superhero. Through the employment of select mnemonic frameworks of definition, and intertextual references to *menakibname*, *kesik-baş* and Central Asian Turkic epic literature he is presented as a warrior-saint, a doer of exemplary or miraculous deeds.[11] Moreover, Tiryaki Hasan Pasha is described as possessing miraculous skills and abilities similar to those of the *menakibname* warrior saints and the Turkic heroes in Central Asian epic cycles: he predicts the future from natural omens; can discern an individual's true intent; controls the weather; manages to cross previously

impassable rivers; appears to conjure up fire; and easily traverses uncharted mountains.[12] Because O.R.12961, is constrained by the conventions of the more realistic *gazavatname* genre that it employs, the powers of Tiryaki Hasan Pasha are generally either indirectly alluded to, or presented as being the result of divine intervention, rather than explicitly described as supernatural.[13]

The first indication that the audience has of Tiryaki Hasan Pasha's extraordinary, or super, abilities is when he is encamped at Görösgál, near Szigetvár. Here he interprets the unusual behavior of two flocks of birds as signifying or predicting a Habsburg-led attack and siege against Nagykanizsa castle that will however, ultimately be unsuccessful. First a flock of rooks and subsequently a flock of black-faced crows appear above the camp fighting and screaming. They circle the tents before flying off in the direction of Nagykanizsa castle. For the audience, this event retrospectively prefigures the future war in that the enemy will besiege the Ottomans defending Nagykanizsa castle in two waves. It also positions Tiryaki Hasan Pasha in a specifically Turkic Shamanistic context as someone who is able to divine, or interpret, the future from signs in the natural world.

The specific naming of Görösgál and Szigetvár in conjunction to this premonition helps to reference a physical cartography but, primarily it maps a heterodox spiritual and cultural world in which the mythification of religious locations or battle sites creates a territorial symbolism which helps to construct a particular identity. Szigetvár is not mentioned in order that the audience can locate Nagykanizsa on a physical map, rather it locates the siege of Nagykanizsa on a cultural map of famous sieges, desperate last sorties and Ottoman and Hungarian heroes. Likewise Tiryaki Hasan Pasha's encounter with the strange bird phenomenon at Görösgál recalls the scene of a previous *kesik-baş*, or 'severed head' event. Ottoman legends tell of a young man named Deli Mehmed, who just before the Ottoman conquest of Szigetvár in 1566, was involved in a skirmish with the enemy in which his head was cut from his body.[14] When the enemy soldier fled with his head Deli Mehmed's body valiantly leapt up and gave chase. Ultimately, after killing many of the enemy his body regained his head and he 'died'. The association of Tiryaki Hasan Pasha's interpretation of the flock of birds with the site of a known supernatural event reinforces the mystical or supernatural aspect of Tiryaki Hasan Pasha's prediction.

Tiryaki Hasan Pasha's extraordinary perceptiveness is further illustrated in his ability to discern an individual's true intent manifested in his distinguishing between true and false converts to Islam. During the siege three enemy soldiers are commanded by their king to try and trick the Ottomans and gain entry to the castle by approaching the battlements and declaring that they want to be taken inside because they wish to 'follow

the Turks', or convert to Islam. Tiryaki Hasan Pasha judges that it is a trick and orders that the cannons be fired at them and two are killed. In contrast, some time later, just before the Ottomans make a final sortie from the castle a Genoese captain from the enemy camp comes beneath the walls and requests to be taken inside as he wishes to convert. Tiryaki Hasan Pasha perceives that he has honest intentions and he is allowed inside where he promptly embraces Islam.

While the two above events occur in all extant manuscripts of the *gazavatname* narrative of the siege, the next event is only found in O.R.12961. Prior to the siege of Nagykanizsa, while engaged in a surprise attack on a enemy settlement, a day's journey from the capital of the enemy Zirinoğlu, Tiryaki Hasan Pasha is involved with three miracles: firstly, he locates a route through the mountains unknown to the knowledgeable local guide and thus turns a four-day arduous journey into a leisurely one requiring less than three days; subsequently, when he and his men are in position around the settlement in readiness for their planned attack, fire suddenly appears on three sides which aids them in their assault; and lastly, despite his soldiers' fears that they will not be able to move all their captured booty and slaves back to Buda, Tiryaki Hasan Pasha again locates a route previously unknown even to local guides so comfortable that none of the wagons loaded with booty are damaged and none of the animals are hurt (O.R.12691 16b, 17b, 19a).

This ability to traverse seemingly impassable physical obstacles is recalled again in the events leading up to the sieges of Nagykanizsa.[15] Enemy soldiers from Habsburg-held Nagykanizsa castle having raided Ottoman territory and burnt Osijek bridge and the *palanka* of Baranyavár, are subsequently pursued by Tiryaki Hasan Pasha and his men. The enemy flee across the Danube and burn the bridge behind them. Not to be deterred Tiryaki Hasan Pasha locates a previously undiscovered ford and crosses the river. In O.R.12961 when the enemy witness this they imagine that Tiryaki Hasan Pasha has cast a spell and frozen the river so facilitating his traversal of it (O.R.12961 32b). This image of Tiryaki Hasan Pasha as a sorcerer who can control the weather is reinforced by his interpretative naming by the enemy as a *cadu* or sorcerer.[16] In Turkic folk literature, the term *cadu* has the additional connotation of a Shamanistic rainmaker or weather monger (Chadwick and Zhirmunsky 1969, 163). This latter reference is re-invoked with the causal conjunction in the narrative of Tiryaki Hasan Pasha praying and weeping, in a state of mystical ecstasy, the night before the Ottoman defenders' planned final sortie from the castle, and the appearance of a severe snowstorm that decimates the enemy and contributes to the raising of the siege. It, therefore, implies that the prayers of Tiryaki Hasan Pasha, the weather monger, resulted in the storm.

However, despite Tiryaki Hasan Pasha's superhero persona, he, like the other Central Asian Turkic heroes mentioned above, is flawed both physically and in terms of his character. He is described as "a worn out old, dilapidated, drug addict and scoundrel" with "snot running down one nostril, very black, watery eyes with speckled irises [...] limbs [...] like mint stalks" who "if he sat, he couldn't get up and if he was up, he couldn't sit down, perhaps [without even] the strength to tie up his trouser cord" (O.R.12961 7b). Although it is the enemy who describe him thus and this accords with one of the meta-motifs of appearances being deceptive, there is no contrasting physical description given to counteract this view. Furthermore, his crookedness or bent back are also noticed and commented upon by the other viziers and commanders (O.R.12961 3a). His physical infirmities are a source of amusement, but they can also be read as a sign of the warrior, recalling Dumézil's "stigmata of valor" (Dumézil 1969, 162).

His mental capacity and character are also frequently doubted by both the enemy and his own men. His soldiers frequently describe him as a scoundrel and as senile, while the grand vizier describes him as an old, senile, addict and rascal (O.R.12961 3b, 13a, 39a, 40b and 59b). In addition to being physically and mentally marginalized, the enemy and his own men frequently comment upon his opium addiction and the latter query his commands assuming him to be intoxicated (O.R.12961 3b, 7b, 39a-b and 60a). These comments can not simply be explained as a result of his soldiers being confused and not fully understanding the reasoning behind his extremely cunning commands because not only are his men described as being his loyal retainers who have fought with him for years, but Tiryaki Hasan Pasha and his stratagems were allegedly famous and had become "an epic in many languages" (O.R.12961 30a). Moreover, Tiryaki Hasan Pasha himself makes a self deprecating remark playing on his name and alleged opium addiction: Tiryaki translates as opium addict, or in colloquial modern English, "smack-head" (O.R.12961 2b). His addiction can thus be seen as a counterpart to the gluttonous excesses of Köroğlu and the heavy drinking of Jolio.

In a virtual contradiction to the above references to his weaknesses and frailty, Tiryaki Hasan Pasha is also described in O.R.12961 as being rather fearsome and threatening: the enemy describe him as a bogeyman who could stop a baby crying through fear (O.R.12961 30a). Moreover, although he is generally depicted as an ideal, fair commander who encourages his men through financial incentives and inspiring words, he also intimidates his soldiers and threatens to twist off the head of his deputy, Arab Oğlu and to kill his men if they flee the battle field (O.R.12961 10b-11a and 17a).

It is obliquely suggested in the narrative that Tiryaki Hasan Pasha, like the Turkic epic superheroes, is also motivated by greed and a desire for material wealth. Despite being depicted as a paragon of frugality and as not desiring of high office, at the beginning of the narrative Tiryaki Hasan Pasha comments rather bitterly that his ability was not previously recognized in monetary terms and he is angry that his worldly goods were sold (O.R.12961 2b).

It is important to note that Tiryaki Hasan Pasha is only depicted in such an ambiguous manner in this particular narrative. The other *gaza-vatname* manuscripts, while indirectly alluding to his 'super' abilities, essentially present him as an exemplar of a successful military commander, a good orthodox Muslim or a competent and professional member of the provincial military-administrative élite. He is not depicted as greedy or threatening and there are no direct references to his drug addiction. Indeed many of the other *gazavatname* manuscripts erase this aspect of his character entirely by both eliding the epithet 'tiryaki' and re-naming him Tiru Hasan Pasha and also by explicitly declaring that he is abstemious and ascetic in nature.[17]

Likewise, in contemporary and later histories of the sieges the mystical or 'super' abilities of Tiryaki Hasan Pasha are erased and he is depicted simply as a hero–not a superhero. Moreover, his character in these works is unambiguous: he is an uncomplicated hero to be emulated. Seventeenth-century Ottoman historians Katib Çelebi and Naima position Tiryaki Hasan Pasha as a devout, orthodox, competent commander, a loyal member of the central military-administrative bureaucracy and as a role model for other soldiers, commanders and officials (Katib Çelebi 1869-70 and Naima 1864-6). Similarly, more modern Turkish (re)interpretations of events within a nation-state dominated cartography have positioned Tiryaki Hasan Pasha less as a superhero and more as a national hero fighting to defend national territory (Baysun 1950). To this end, the depiction of Tiryaki Hasan Pasha as a mystical warrior saint or heterodox dervish is effaced with the removal of the *menakibname* intertextual elements, references to his supernatural powers and his depiction as a sorcerer. Instead he is presented as an exemplary national role model for Turkish audiences; he desires to further his education; he is not avaricious; he is prepared to fight and die for his homeland; and he knows what his duty is and does it expecting no reward (Baysun 1950, 5, 8, 21 and 45). Ersever is so anxious to ensure that Tiryaki Hasan Pasha is read as a suitable modern role model that he re-interprets his nickname, Tiryaki from opium addict to coffee addict (Ersever 1986, 2).

However, in O.R.12961 Tiryaki Hasan Pasha is full of contradictions: he is a military hero, yet is slyly mocked for his physical and mental

weaknesses; he has extraordinary powers similar to those of Turkic warrior saints or shamans yet seeks material riches and threatens his own men; he is part of the central military-bureaucratic officialdom yet outside of it; he is religious, yet heterodox references overshadow his orthodoxy. Hasan Pasha's status as the hero is ambiguous and is contested through his depiction as an opium addict, his frequent threats of violence against his own men and his being named as a 'senile scoundrel' (O.R.12961 3a-b, 13a, 39a, 40b, 41a and 59b). Such different, and often contradictory, facets of his character further reflect the multiple persona of the modern superhero. But more importantly, they reveal multiple tensions which can perhaps best be interpreted as arising from the implied audiences' plural, ambiguous, and often contradictory attitudes towards the figure of Tiryaki Hasan Pasha, who was not only a just, brave commander, but also a member of the military-administrative élite. This tension and incoherence reflects, I believe, Tiryaki Hasan Pasha's liminal and contested status as a hero and member of the élite for the particular audience that the scribe-author of O.R.12961 had in mind when re-inscribing or re-performing the narrative. If Tiryaki Hasan Pasha is read as a site of contestation for 'popular' audiences' competing attitudes and emotions towards heroes and members of the ruling élite, these contradictions can be plausibly explained. The audiences' hostility or ambiguous attitude is often expressed through laughter (Stitt 1998, 132): Tiryaki Hasan Pasha is the hero, but he is also laughed at and mocked throughout the narrative. However, it is also reinforced by the resigned complaint of one of Tiryaki Hasan Pasha's men that regardless of the sense of the order they must obey Tiryaki Hasan Pasha because he is the commander (O.R.12961 12b and 39b). In this respect Tiryaki Hasan Pasha can be seen as akin to other, earlier Turkic heroes such as the gluttonous and slothful Jolio and the greedy, dishonorable Köroğlu.

Other textual, linguistic and narrative characteristics suggest that the scribe-author of O.R.12961 envisioned a geographically, politically and culturally liminal audience for his text. Evidence suggests that O.216 and Katib Çelebi's history were primarily, although not exclusively, consumed by an educated and élite audience located in the center of the empire: Istanbul. In contrast, the unusual proverbs and expressions, Ottomanized foreign phrases, references to Christianity, the extensive military and local border knowledge, intertextual references to epic cycles and *menakibname* literature, an implicit imagining of self which includes Christians and Hungarians and a conception of the 'other' as polytheist infidels rather than Christian infidels, suggest an implied audience for O.R.12961 familiar with the borderland between the Ottomans and the Habsburgs—an audience whose cartography of conflict was less mapped on a Christian-

Muslim dichotomy, but was situated in a more general border culture and network of allegiances and alliances: in particular allegiances to a specific individual seen as a warrior, rather than as a representative of central government. I would therefore tentatively suggest that the implied audience of this particular manuscript would have consisted of people of mixed religious, ethnic and linguistic backgrounds located on, or around, the Balkan border area. This coheres with other evidence that this border area was not necessarily the religiously and ethnically segregated place it is often described as (Norton 2005 b). Furthermore, the colorful language, the tension expressed towards the state élites and commanders including Tiryaki Hasan Pasha, the sympathy expressed for the enemy soldiers, and the concern for booty, monetary reward and its fair distribution, indicates that the implied audience may have consisted of soldiers garrisoned on this border. Hypothesizing such an audience would therefore explain the tensions in the depiction of Tiryaki Hasan Pasha as hero. For this culturally, politically and geographically marginalized audience a representative of the central ruling military élite cannot unproblematically be depicted as a hero. In order to express these tensions and ambiguities recourse is made to an already existing and well known genre of narrative: the epic cycle, and to its flawed eponymous heroes. Tiryaki Hasan Pasha is thus in this work (re)presented as a typically Central Asian Turkic superhero: heroic, but flawed; admired, yet distrusted; victorious, yet mocked.

20

Conqueror of Flood, Wielder of Fire: Noah, the Hebrew Superhero

Estelle Strazdins

I have begotten a strange son...and he is not like us (*1 Enoch* 106:5).[1]

This verse, from the third-century BCE apocalyptic text known as *1 Enoch*, is spoken by Lamech and describes his newly born child Noah. This is not the kind of Noah we know from the bible–a man saved from the Deluge because he was obedient to God's will–but a more active individual who has special heroic characteristics. This essay explores the Flood hero's nature as he appears in *1 Enoch*, *Jubilees*, and the *Genesis Apocryphon*, all second-third century BCE, Palestinian Jewish texts.[2] Although the superhero is generally considered to be a modern invention for a modern context (Eco 1972, 15; Reynolds 1992, 18-19, 74-83; Harney 1993, 196-7), I argue that Noah is a surprisingly apt ancient prototype of the superhero by comparing his attributes and function to that of both the mythic (or 'traditional') hero and the superhero. The chapter is divided into four sections. The first contrasts the traditional mythic hero with the contemporary superhero, and considers Noah's place in these schemes. The second explores Noah and his Nemeses as a paradigm of the superhero/super villain duality. The third studies Noah's birth in the context of the superhero origin story, and the final section considers Noah's function as a superhero.

Mythic or Super Hero?

In these texts, Noah is unusual because he has a greater affinity with the superhero than with the 'traditional' or 'classic' hero of myth.[3] Otto Rank and Lord Raglan both studied numerous legendary and mythic heroes, and produced separate but similar paradigms for the pattern of a heroic life. Both authors proposed that there are difficult circumstances surrounding the hero's birth; he is often rumored to be the child of a god (and in many instances does have divine parentage); his father is threatened

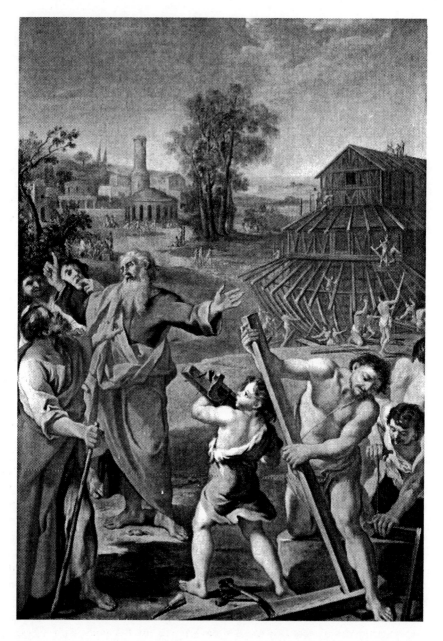

Figure 30: Noah's Ark, by the *Französischer Meister* ("The French Master"), Magyar Szépmüvészeti Múzeum, Budapest. c.1675.

by him; he is exposed (often in water), but saved; he returns home once grown, kills his father and assumes the dead man's place (Raglan 1934, 212-13; Rank 2004, 47). Alternatively, Umberto Eco defines the mythic hero as a character whose story is always already in the past and who "embodies a law, or a universal demand, and, therefore, must be in part *predictable*" (1972, 15). Richard Reynolds follows the lead of Raglan and Rank by constructing a paradigm of the superhero. He shows that the superhero tends to be an orphan, or has a difficult relationship with his parents. He is often a mixture of man and god. He is driven by moral justice rather than the law. His own extraordinary nature contrasts with the mundanity of his environment (like the mythic hero, he operates outside the bounds of normal human experience). He often possesses an equally mundane 'secret identity', and can be particularly patriotic and morally loyal to the state. Finally, his adventures are mythical and blur the line between science and magic (Reynolds 1992, 12-16).[4] Importantly, both science and magic represent power in the form of knowledge (Reynolds 1992, 24).

As this essay illustrates, Noah partially conforms to the above definitions of the mythic hero: his birth is fantastic, he has divine qualities, and he has one great mythic accomplishment in that he survives the Flood. He differs, however, in several significant ways that bring him closer to the modern superhero. As with Superman, although Noah is apparently divine, he is actually mortal (unlike the mythic hero, who often is a god or descended from a god).[5] Eco explains that mortality is key to the superhero, commenting that "[a]n immortal Superman would no longer be a man, but a god, and the public's identification with his double identity would fall by the wayside" (1972, 16). This is equally important in the case of Noah, whose parents are unquestionably human. Although the stress placed on his humanity can be traced to Judaic monotheism, since in Hebrew myths there can be only one god (VanderKam 1992, 231), it also serves a more crucial function: Noah's humanity allows him to stand in for all mankind and to mediate between heaven and earth. So, Superman and Noah are paradigms of perfect humanity rather than divinity. Like the Fantastic Four and many others, Noah undergoes a transformation that gives him a super-power: he experiences a fiery birth that signposts his later ability to wield fire, as well as his particular righteousness and wisdom. Additionally, as with all great superheroes, Noah has nemeses–a group of fallen angels known as 'Watchers' and their human-angel, hybrid children. Essentially, these angels are super villains, who also have a strong connection with fire and who are the ultimate cause of the Flood.[6] They are Noah's antitypes, his equals and opposites.

Despite these parallels, however, Noah's function reflects his unique context. As Michael Harney comments, '[h]eroism is not a uniform phenomenon,

but rather varies according to the persons or peoples delivered, redeemed, or rescued' (1993, 189). Unlike the superhero, who, in an urban context, allows the anonymous 'everyman' to become someone vicariously (Reynolds 1992, 18; Harney 1993, 205; Eco 1972, 14-16), Noah's purpose is to define humanity's place in the cosmos and their relationship with God. So, in the post-diluvian world, Noah's super-heroic actions ensure that mankind is equipped with a means of saving itself from God's wrath through the institution of sacrifice. This ritual ensures cosmic stability by symbolically separating the human and divine realms. However, Noah also brings God's power to earth and makes righteousness attainable for all mankind. Consequently, he becomes a figure of identification for the average person in the same way as the superhero.

Eco adds that the superhero is a combination of the mythic hero and the hero of the novel: he is both emblematic and undergoes character development (Eco 1972, 15). He achieves this state by operating in a hazy temporal sphere, in which the temporal relationship between each of his adventures is unclear. This allows him to develop as a character but also avoid the inevitable progression towards death that a protagonist, whose story is temporally linear, experiences (Eco 1972, 15-17). Noah does die and has one great mythic accomplishment that is situated in the past; however, as argued below, the sacrificial ritual he establishes, symbolically re-enacts the Flood hero's story and purpose each time it is performed.

Importantly, both the mythic hero and superhero operate on a parochial level: their activities are centered on a specific community (Eco 1972, 22; Reynolds 1992, 18-20). Superheroes, however, also act to preserve the status quo (Reynolds 1992, 77). In contrast, Noah functions on a cosmic level. Nevertheless, the whole human race is his community and the action of these inter-testamental texts occurs in a localized area (*1 Enoch* 7:6-8). Significantly, Noah also acts to preserve the status quo, in that he reinforces previously existing cosmic boundaries. Yet, by his very designation as the 'Flood hero', Noah presents a threat to all creation, whilst paradoxically, he is its savior. As a consequence, he enacts the tension between the superhero and super villain. Like the superhero, he is an enforcer of justice (except that he deals with cosmic rather than moral justice), who is also a law unto himself. Hence, he has the capacity to destroy the humanity he protects, to cross the line between hero and villain (see Reynolds 1992, 16-25; Eco 1972, 22). This is a clear departure from the 'traditional' hero, who presents the greatest threat to his own father.

The Superhero/Super Villain Dichotomy: Noah and His Nemeses

The super villain possesses many of the same traits as the superhero, except that he privileges personal power over moral justice and his loyalty is to his own interests rather than the greater good (Reynolds 1992, 16-18). Reynolds argues that the superhero is reactive to the super villain, making the villain the protagonist to the hero's antagonist (Reynolds 1992, 50-2). This is also true of Noah, who in many ways is created by his nemeses and his times. The Flood hero is born into an unstable universe, in which the boundary between heaven and earth has been blurred. This chaotic state is caused by rebel angels, called 'Watchers', who descend to earth and take human women as wives (1 Enoch 6-11; Jubilees 4-7). These angels have the potential to be a positive influence on mankind, and the tension between superhero and villain is reflected in the etymology of their name. 'Watcher' could derive from a word meaning 'to protect' (Murray 1984), a function that is emphasized in Jubilees 4:15, in which the Watchers are sent to earth by God to 'perform judgment and uprightness'.[7] This is also how their actions are viewed in Genesis 6:2 and 6:4:

> And the sons of God saw the daughters of mankind – that they were beautiful – so they took wives for themselves from any whom they chose| ... The Nephilim were on the earth in those days – and also afterward – when the sons of God went to the daughters of man, and they bore them children, these are the heroes, who were there of old, the men of renown.

In Jubilees, however, their congress with human women is viewed as a sin, and in 1 Enoch, the Watchers' transgression of cosmic boundaries has dire consequences for creation. These celestial beings mingle with chthonic, human matter, producing giant human-god hybrids, known as 'Nephilim', who wreak havoc upon the earth (see Strazdins 2005, 293). The Genesis version above, describes the Nephilim positively and, although their story immediately precedes the Flood narrative, there is no direct causal relationship between the two tales (Harland 1996, 23). In contrast, 1 Enoch strips the Nephilim of any favorable characteristics in an attempt to make the link between their activities and the Flood explicit:

> These consumed the produce of the people. When men were unable to supply them, | the giants turned against them, and began to eat them. | And they began to sin against winged creatures and wild beasts and reptiles and fish, and to devour the flesh of each other, and they drank blood. (1 Enoch 7:3-5)

The word used for "heroes" in *Genesis* (*gibborim*) is the same word that comes to mean "giants" in *1 Enoch*. This is probably because *gibborim* and *nephilim* are interchangeable in this text,[8] and "Nephilim" has negative connotations since it derives either from a verb meaning "to fall," or a noun meaning "miscarriage" or "abortion" (Klein 1987, 422).[9] So, *1 Enoch* twists the account of *Genesis* and turns righteous heroes into murderous, blood-drinking cannibals.[10] Their experiences on earth render them aberrations of the superhero, thrusting them into the role of super villains.

These angels' greatest crime is to teach mankind heavenly secrets and the central ingredient of their teachings is fire, an element that affects transformation. The Watchers themselves are Seraphim, a name that comes from a Hebrew word meaning "to burn" (Klein 1987, 683). In the form *seraphim*, this word is active and intimates that this variety of angel likes to burn things; in other words, the Seraphim are pyromaniacs *by nature* (see Strazdins 2005, 288, 295 n.7). In *1 Enoch* and *Jubilees* their targets are humanity and the fire that they transfer to mankind enables it to become more technologically advanced. Although, the Watchers' fire is divine, it does not stem from God himself. Instead, humanity's interaction with this fire is illicit and unsanctioned by the Supreme Being.[11] Moreover, it alters the nature of humanity from a beast of the earth to an elevated creature with aspirations to divinity: "they hope to live an everlasting life" (*1 Enoch* 10:10). With the angels' fire, mankind learns to make weapons: "[The angel] Azael taught men to make knives and swords and shields and breastplates" (*1 Enoch* 8:1). These implements and the desire for immortality put humanity on a collision course with God, a situation that leads directly to the Flood. The kind of superior knowledge passed on by the Watchers is a characteristic of both the superhero and villain, who wield power in the form of knowledge. The difference between them is that the villain uses knowledge to increase his personal power and to affect change, whereas the hero uses it to maintain the status quo (see Reynolds 1992, 20-5, 77). Thus, humanity, the Watchers, and the Nephilim, whose evil plan is to dissolve the boundaries between heaven and earth, act as super villains in these texts.[12]

Noah is born as a direct response to this situation, as illustrated in *1 Enoch* by his father's name. "Lamech" carries the sense "to be brought low" or "to be humiliated" (VanderKam 1992, 218-19; Grabbe 1988, 177-78; and Klein 1987, 324), as Enoch explains: "My son Methuselah took a wife and she bore a son and his name was Lamech. Righteousness was brought low during that time" (*1 Enoch* 106:1). So, Lamech can be seen as the embodiment of his generation, in which evil is dominant, and Noah enters the world to reverse this trend. Thus, the 'modern' concept of the superhero/super villain dichotomy clearly stems from a much earlier era, a notion also reflected in Noah's origin story.

Noah's Origin: Fire, Righteousness, Wisdom.

> And when the child was born his body was whiter than snow and ruddier than a rose, his mass of hair was all white and like white wool and glorious fleece. When he opened his eyes, the house lit up just like the sun. I And he sprung up from the hands of the midwife; he opened his mouth and praised the Lord. I And Lamech [his father] was afraid of him and fled and went to Methuselah his father, and said to him, I 'I have begotten a strange son, not resembling any man but like the children of the angels of heaven; and his form is different, and he is not like us I ...and I am concerned that something may take place upon the earth in his days'. (1 Enoch 106:2-6)

Clearly this birth narrative fits the criteria of the mythic hero and the superhero described above. More importantly, this is Noah's origin story. His birth is remarkable because of his unusual appearance and peculiar abilities.[13] The child oozes fiery radiance and, when the infant praises God, a connection is established between this radiance, unnatural intelligence, and righteousness. Generally, a superhero's origin explains his super power, his costume, and his purpose (Reynolds 1992, 47-9). Noah's radiance clothes him and separates him from the rest of humanity; it is symbolic of his super power (fire); it defines his righteous mission. Righteousness is a key characteristic of most superheroes, including Superman, Spiderman, and Batman, and is a function of their super abilities. The strongest message of the first Spiderman film is "with great power comes great responsibility" (Spiderman, Raimi 2002).[14] Clearly, this idea separates Noah from the Watchers, whose irresponsible actions lead to mankind's destruction.

In contrast, his fiery costume actually connects Noah to the Watchers and Nephilim, just as a super villain's costume and origin connects him to his opposing superhero (Reynolds 1992, 49). Lamech's fear of Noah because he believes he is one of the Nephilim illustrates this. Fear of the superhero is a common theme, particularly highlighted in X-Men II (Singer 2003), in which the mutants' special abilities are mistaken for a mark of inherent evil. So, Bobby 'Ice Man' Drake is feared and rejected by his family, and Kurt 'Nightcrawler' Wagner reveals that the only place he was received without fear was in the circus. Like the non-mutants of X-Men II, however, Lamech is wrong: Noah is his son and a human child, if a very special human, whose birth portends fantastic events (VanderKam 1992, 216; Nickelsburg 1998, 145). Noah's great-grandfather Enoch makes this link: "There will be a great flooding and deluge on the earth, and there will be great destruction I ...this child is righteous and holy... he will be

a remnant for you" (*1 Enoch* 106:15, 18). So, like Superman or the X-Men, from the very beginning Noah is singled out as being more than human, so much so that his own father mistakes him for a mixture of man and god, and ultimately, the future of the human race lies in his hands.

Noah's appearance is the same as the Nephilim, yet, he does not share their violent, destructive natures. In fact, throughout these texts, Noah is distinguished by righteousness, as he himself claims: "all my days I practiced truth" (*Genesis Apocryphon* vi:2). This point is reiterated in *Jubilees* 5:19: "[h]e did not transgress from anything that had been ordained for him."[15] In fact, in inter-testamental literature Noah and righteousness are synonymous.[16] This connection is nothing new, he is also the first character in *Genesis* to be labeled righteous (*Genesis* 6:9) (VanderKam 1980, 13); however, Noah's agency in his own righteousness is a marked departure from *Genesis*, in which he is solely God's instrument (Harland 1996, 52-53).[17] Moreover, Noah's fiery nature must stem from a different source from that of the Watchers, who are evil creatures acting against God's will. The most likely alternative is fire that comes from and is sanctioned by God. Enoch's description of God during his tour of heaven supports this claim, since he uses the same imagery that is applied to the newly born Noah: "[h]is garment was like the face of the sun, more brilliant and whiter than any snow" (*1 Enoch* 14:20). Because of the emphasis on Noah's agency in his own righteousness, he is cast in a similar role to the title character of *Constantine* (Lawrence 2005), who, in punishing 'half-breeds' who break cosmic rules (as the Watchers do), acts with God's sanction but without his instruction. So, Noah is transformed by God-sanctioned divine fire and the Nephilim by illicit divine fire; as such, Noah and the Nephilim are two sides of the same coin, equal but opposite, and the Flood hero's birth marks him out as being on God's side (Dimant 1998, 130; Reeves 1993, 111). This dichotomous superhero/super villain relationship recalls the plot of *Superman ii* (Lester 1980), in which the hero confronts three criminals from Krypton who possess the same abilities he does, or that of *Batman Begins* (Nolan 2005), in which both hero and villain aim to eliminate crime but in very different ways that ultimately bring them into conflict.

The super power of both the Watchers and Noah is fire, a force that is both magical and scientific. The differences between their fires can be explained by the symbolic qualities of fire itself. An element of oppositions, it represents divinity, wisdom, and technology.[18] In the Flood narrative, three such polarities play a prominent role: illumination and deception, creation and destruction, purification and pollution.[19] The first duality, illumination and deception, is symbolic of knowledge and its positive or negative application. As argued above, superior knowledge distinguishes the superhero and villain from the rest of humanity, and the way they use

knowledge distinguishes them from each other. Noah's fire is sanctioned by God, whereas the Watchers' is not. Accordingly, this is how the negative outcome of the Watchers' wisdom can be understood: the illicit nature of their fire enhances its deceptive qualities, and humans become endowed with technology, but they use that technology to harm each other. Equally, humanity uses the Watchers' teachings to *create* weapons, which are solely instruments of *destruction*. Noah's wisdom, on the other hand, has the opposite effect.

Both Noah and Enoch possess superhuman intelligence and function outside the realm of normal human experience, which is a key characteristic of the superhero that is partially countered by their secret identity (Reynolds 1992, 15). Additionally, both men receive divine wisdom either directly from, or with the sanction of, God. At *Genesis* 6:9 Noah is described as 'walking' with God, a distinction shared only by Enoch, who also disappears from the face of the earth because God 'takes' him.[20] *Jubilees* 10:13 adds that Noah learns healing from angels: "Noah wrote down in a book everything [just] as we had taught him regarding all the kinds of medicine..."[21] Once Enoch is singled out by God, he stands in a teaching relationship to the rest of mankind. He is an oracle at the ends of the earth, who dispenses knowledge and advice. This aspect of Enoch is borne out in the etymology of his name, which derives from a Hebrew verb meaning "to train" and is used especially of children (VanderKam 1992, 220; Richardson 1994, 334).[22] So, it is likely that Enoch is the mentor not only of his own son, but also Noah.[23] The mentor-student relationship between Enoch and Noah is also a common trope of superhero films such as *Batman Begins* (Nolan 2005), in which Bruce Wayne is mentored by Henri Ducard/Ra's Al Ghul. Thus, Noah's wisdom is opposed to the Watcher's and it counteracts the destructive effects of their teachings. The Flood, sent by God, has the same purpose.

Fire and the Flood Hero: Cosmic Symbiosis and Cosmic Order

The Deluge functions on the level of the third set of fire's oppositions: purification and pollution. It purifies the earth of the polluting effects of the Watchers' fire. Therefore it acts to re-establish the boundaries between heaven and earth. Both the Watchers and humanity have been polluted by each others natures: mankind now possesses an element of divinity and the Watchers have engaged in a human activity that is instrumental in determining mankind's mortal state. God himself clarifies the polluting effects of these mortal actions:

Surely you, who used to be holy too, existing with eternal spirit

> have defiled yourselves in the blood of women, and in the blood
> of flesh you have begotten...like those [men] who produce flesh
> and blood, those who die and perish... I And you began as eter-
> nally living spirits and immortal in each generation of the world.
> And, because of this, I did not make you wives. For the dwelling
> place of the spirits of heaven is in heaven. (*1 Enoch* 15:4, 6-7)

The Watchers' and humanity's ambiguous natures threaten cosmic
stability (the status quo). Purification and balance is achieved through fire
and flood: one wielded by Noah, the other by God.

Following the Flood, purification and the reinstatement of cosmic sta-
bility is incomplete, since a remnant of antediluvian humanity survives
in the form of the Flood hero and his family. Noah is a righteous man af-
fected by God-sanctioned fire; however, his wife is equivalent to the rest of
antediluvian humanity: a chthonic creature polluted by the Watchers' fire.
Consequently, their children will also be a mixture of divinity and human-
ity, a situation that can only lead to a similar degeneration as that which
brought the Flood. Indeed, Enoch predicts this outcome after the birth of
Noah, saying "each generation will be more evil than the last" (*1 Enoch*
107:1). Additionally, another source of evil survives the Flood. Prior to
the Deluge, God forces the Nephilim to kill each other in battle; however,
when they oblige, they do not perish altogether but become evil spirits:
"[a]nd now the giants born from [the mingling] of spirits and flesh will
be violent spirits on the earth... I Wicked spirits have come out of their
bodies" (*1 Enoch* 15:8-9). These spirits also survive the Deluge, and be-
gin to corrupt Noah's grandchildren. After the Flood hero intervenes God
punishes them, binding most of them beneath the earth; he leaves one
tenth, however, free under the command of their leader Mastema (*Jubilees*
10:9). Accordingly, the earth continues to be afflicted by sources of evil: the
wife of the Flood hero, polluted by the Watchers' fire, and the souls of the
Nephilim. Why, then, does history fail to repeat? Why, if the destruction of
fire-altered humanity is necessary, is there no second Flood to cleanse the
earth of the continuing effects of this fire? These questions are answered
by Noah's first use of fire following the Deluge, which ensures mankind's
continued survival and also establishes the post-diluvian relationship be-
tween humanity and God.

Noah disembarks from his vessel and immediately instigates a sac-
rifice to God. The significance of this act is twofold: it establishes cosmic
symbiosis, and it re-establishes cosmic boundaries. God's reaction to the
sacrifice is telling: "he offered up a burnt offering on the altar...and... a
sweet aroma which was pleasing before the Lord" (*Jubilees* 6:3).[24] God's
pleasure is clarified through comparison with the Akkadian *Atrahasis*

epic, a likely source of the biblical Flood narrative.[25] When the Flood hero Atrahasis performs his sacrifice, "[t]he gods sniffed] the smell, | [t]hey gathered [like flies] over the offering" (*Atrahasis* III:v:34-5).[26] These Akkadian gods suffer terrible hunger pangs after the Flood destroys mankind and their desperation is apparent in their resemblance to flies. Hence, Noah's sacrifice must fulfill some need that God feels. However, in performing this sacrifice, Noah's intention is to purify the earth further of the Watchers' transgression as much as it is to satisfy God: "He…took a kid, and atoned with its blood for all the sins of the earth because everything that was on it had been obliterated except those who were in the ark with Noah" (*Jubilees* 6:2).[27] Essentially, the sacrifice is a means of negotiating with God, who brings invaluable wares to the bargaining table by promising that such destruction will not be visited upon the earth again.[28] So, with a simple fiery offering mankind, destined to succumb to evil, can appease its God and remove pollution from the earth. Thus, the sacrifice negates the need for a further Flood. This circumstance is elucidated at *Jubilees* 5:17: "If they return to him in righteousness, he will forgive all their sins and he will pardon all of their transgressions."[29] Noah, whose super power is righteousness, stands in for all humanity and saves it from destruction, as he himself explains: "For all the earth I atoned… " (*Genesis Apocryphon* x:13). Accordingly, this sacrifice, the first use of fire by the Flood hero following the deluge, creates a symbiotic relationship between men and God: the supreme-being needs mankind for the offerings that acknowledge his pre-eminence and provide him with sustenance; mankind needs the good-will of God for its continued existence.

Additionally, the post-diluvian sacrifice is symbolic of the division between men and gods, and it celebrates the oppositions which plague mankind and which derive from the influence of the Watchers. The interaction of mankind with their illicit fire polluted the chthonic substance of humanity with an element of divinity; this led to cosmic instability represented by the presence of evil in the world. The sacrifice of Noah symbolically enacts the separation of chthonic and celestial matter present in humanity: fire consumes the offering, reducing its terrestrial substance to ash and releasing the heavenly elements skywards. Consequently, sacrifice is performed following an act of transgression and purifies the transgressor of his sin; the evil released by the interaction of transgressive fire with the earthly realm is symbolically eradicated, and for this reason, mankind is able to appease its God and avoid destruction. The sacrifice re-enacts Noah's survival of the Flood each time the ritual is performed. Thus, Noah reveals himself as the perennial savior of mankind through his continuing ability to negotiate with God: to conquer flood and wield fire. In this way, he moves beyond the hero of myth, whom Eco defined by

a single extraordinary act contained in the past (1972 15), since although he does die (unlike the superhero), his story and accomplishments are re-invigorated in a unique manner with every sacrifice. Moreover, in performing the sacrifice, Noah is acting as a priest, a holy man who speaks God's language (VanderKam 1980, 20). So, with his elevated status and his understanding of the cosmos, Noah is able to teach mankind how to relate to their maker. Fire is not to be used to *become* like God, fire is to be used to *negotiate* with God. Thus, Noah reveals his superiority over the Watchers and their offspring: he wields fire which is sanctioned by the Supreme Being and which functions to protect humanity from the wrath of God. Consequently, he finds humanity, a creature which is neither beast nor god, a tenable position in the cosmos.

Conclusion: Noah, the Hebrew Superhero

Noah's super power is fire, which endows him with wisdom and righteousness (both distinctive qualities of the superhero). In these texts, Noah uses his power to two ends: first, his sacrifice acts to counteract the super villain Watchers and reinstates the status quo by keeping the divine and human worlds separate; second, he teaches mankind to communicate with God through the correct usage of fire. Additionally, his divine medicinal wisdom acts to keep mankind safe from the spirits of the dead Nephilim, who assume the super villain role of the Watchers after the Flood.[30] Noah operates on a mythic plane beyond normal human experience, in that he is unusually radiant, intelligent and righteous, but in doing so he reinforces mortal limitation. Importantly, although Noah is superhuman, he is definitely not divine. The author of *Jubilees* clearly makes this point: 'On account of his righteousness in which he was perfected, his life was more excellent than [any of] the sons of men' (10:17).[31] His humanity allows him to stand in for all mankind as the mediator between heaven and earth, another key aspect of the superhero (Reynolds 1992, 12-18, 60-2). Furthermore, he is a law unto himself, driven by his own idea of cosmic justice (cf. Reynolds 1992, 12-16; the figure of Constantine). Noah cannot save antediluvian humanity from destruction because Judaic monotheism dictates that God's will cannot be averted, but through his own survival and the divine deal sealed by his post-diluvian sacrifice, Noah ensures the continued existence of future generations. Noah acts in the best interests of both mankind and God. Consequently, Noah is the ideal candidate for the ancient prototype of the superhero. His relationship with fire is his superpower. He mediates between the divine and the human. The Nephilim are his super villain nemeses, and he protects humanity through his super-

heroic intelligence and righteousness. Most importantly, the institution of sacrifice enables his super-heroic function to be re-performed time and again for different reasons but with the same purpose: to save humanity.

MEDIA CONVERGENCE & SELLING HERO CULTURE

21

RIPPED OFF! Cross-Media Convergence and 'The Hulk'

Gareth Schott & Andrew Burn

Introduction

The story of *The Incredible Hulk* was originally created by Stan Lee and brought to life in 1962 by artist Jack Kirby for Marvel Comics. Despite its cancellation after the first six issues, *The Incredible Hulk* went on to become one of popular culture's most recognizable superheroes as its franchise expanded beyond comic books to animation (1982), television (1977), a Hollywood 'blockbuster' and computer game (2003). The transformation of Dr. Bruce Banner into *The Incredible Hulk* can be interpreted as a concrescence of different elements and their absorption or integration. At a cultural level the Hulk was deliberately pieced together from fusing Frankenstein's misunderstood creature and the transformative personalities of Dr. Jekyll and Mr. Hyde. The excrescence of the Hulk is triggered at both a psychological and a physical level; indeed, the physical transformation of Jekyll into Hyde in Stevenson's novella represents a fragmented identity culturally influenced both by the shock of Darwinism and by the antecedents of psychoanalytic theory in the experiments of Freud's mentor, Charcot. Bruce Banner's Id emerges from his buried emotions, his abusive childhood identity and the death of his mother at the hands of his father (#312 *Monster!* 1985), while the physical metaphor is rationalized by his accidental exposure to 'gamma rays,' itself a signifier of contemporary Cold War anxieties.

One of the first dilemmas one faces when researching the media-lineage of *The Incredible Hulk*, is whether or not to attempt to produce a comprehensive account of the episodic and sometimes disjointed existence of the character and his ever-present supporting-characters. Different manifestations of the Hulk, within the comic book genre alone, produce a complex history of character changes that often distort the appearance of chronology, continuity and the boundaries of the superhero's universe. The annals of *The Incredible Hulk* comic books reveal a colorful array of

transformations for each character during its forty-plus-year history. In discussing the increasing convergence or inter-connectedness of *The Incredible Hulk* representational media, this chapter does not seek to reproduce accurately the expertise that participatory fan cultures develop and chronicle through various collective practices of fandom (online archiving, plot summaries, forum discussions etc.). Instead, the aim is to consider the perceived political and economic power bestowed upon different groups of fans during cross-modal transformations of *The Incredible Hulk* into new media spaces that bring with them extended possibilities for audience engagement. Likewise, this chapter does not seek to examine convergence from a technological viewpoint, endorsing the vision of the single 'black box'. Indeed, while certain media forms converge in some of their characteristics (such as the use of the moving image and of screen displays across TV, film and game), in other respects these media have distinctive properties which pull apart (such as the ludic dimension of games, or the persistently different distribution and exhibition regimes of film and television). Notwithstanding, a sign of a degree of convergence is the significant and unprecedented act of Universal Studios placing a playable demo version of the videogame on the DVD release of the film (both playable on the single black Xbox).

Unlike the more recent and first generation of Harry Potter fans who experienced the birth of a franchise and the subsequent crossover to film and videogame from the book, fans of *The Incredible Hulk* came to Ang Lee's film and/or Vivendi's videogame from more divergent cultural paths. In recognition of the history of *The Incredible Hulk,* Gilles Deleuze's statement, that every "actual is surrounded by a cloud of virtual images" (2002, 148) might be considered useful here. The concept of a 'virtual cloud' need not be explored further than its role here as a useful trigger for considering the virtual relations that are evoked by the intertextual references to previous incarnations of the Hulk (and its associated media history) within the film and videogame. Drawing on Deleuze's notion of 'time-image,' Aumont refers to a "stratified time in which we move through different levels simultaneously, present, past(s), future(s)" (1997, 129-130). For fans, time surrounding Hulk cultural artifacts is often fluid, allowing its different elements to co-exist. Thus, a spatial conception of the networks of Hulk representations undermines the fluidity of the processes of connection and disconnection that operate in and around the different depictions of this character for fans. Furthermore, the cross generational longevity of the character means that any actualized set of relationships or connections, that might exist for one kind of fan, marginalizes the myriad of virtual connections that remain available but not necessarily accessed. To avoid such assumptions the focus for our analysis rests with catalytic

moments embedded within these modern texts that serve either, to reinforce an existing understanding of the Hulk and become assimilated into the schematic knowledge structures of the fan, or create new links to the Hulk universe and drive the process of actualization.

Historical Lineage of the Film and Computer Game

The HEROIC nature of the Hulk is less aligned to the nobility of purpose of other popular superheroes, such as Superman or Spiderman. The Hulk obviously differs from those who carry their powers with them at all times. Rather than undergo a radical physical transformation, Superman and Spiderman undertake a costume transformation that overtly represents their intent and preserves their everyday identities. These heroes possess a strong social conscience and use their extraordinary powers to uphold and maintain truth and justice. Although the 'misunderstood' intentions of the superhero, forms a common narrative in all superhero tales, it dominates that of *The Incredible Hulk*. Indeed, the most recognized narrative of *The Incredible Hulk* centers on how Bruce Banner's life is destroyed by his inability to control his transformation into the easily enraged Hulk who is forever chased and hounded.

The Hulk, like Marvel's *The Punisher*, is more closely aligned to the 'anti-hero,' which avoids categorizing the character as 'good' in opposition to an identifiable 'evil.' As we know, the antihero is not the antithesis of the hero, rather, they are positioned closest to the 'vs.' in a continuum of 'good vs. evil.' The antihero is nevertheless, characterized by a lack of traditional heroic qualities, such as idealism or courage, and is often freed from having to operate by the dominant moral and social rules that other heroes abide by. In the case of the Hulk this is evident by the lack of distinction made between enemies and bystanders during the economic devastation that he inflicts when he becomes enraged by entrapment or pursuit. The Hulk will use objects in his immediate environment (such as cars) as weapons, tear through buildings in order to escape and comes into direct conflict with those who enforce the law and defend the country.

A point of interest when taking into account Ang Lee's adaptation of the Hulk might center around which version of Banner's potentiality was transferred to the big screen. After all, Lee's choice of alignment had implications for the level of conscious connection that exists between Banner and the Hulk, which has varied dramatically throughout the comic book depictions. The Hulk's comic book incarnations have included the original gray-skinned behemoth (#1 *The Incredible Hulk*), the green-skinned immature 'Savage Hulk' (#2 *The Terror Of The Toad Men!*), the balanced intellect

Figure 31: The cover of the first issue of *The Incredible Hulk*
(May 1962). © Marvel Comics.

of Banner and power of the Hulk in the 'Professor' (#377 *Honey I Shrunk the Hulk!*), a Banner controlled Hulk (#123 *No More The Monster*), a 'Mindless Hulk' (#296 *To Kill or Cure*) and a 'Savage Banner' (#426 *One Fell Off*). These incarnations have emerged in a somewhat linear fashion, as Banner has either encountered them within his subconscious (e.g. 'Guilt Hulk', #12 *Snake Eyes*) or they have been released through therapeutic interventions by the character Dr. Leonard Samson. Differences in the personification of the Hulk would often constitute an amalgamation of prior discharged versions, such as Dr. Samson's merging of the Grey Hulk with the Savage Hulk in the creation of the idealized version of Bruce Banner with The Professor. This illustrates the plurality of the Hulk psyche structures and the multifaceted complexity of repressed psychic energy residing within Banner's subconscious. The Hulk characters are both manifold and compound, and therefore most apposite to being retold with distinction across several representational media.

As is often the case when a well-known character of popular culture is re-launched in a new medium, the makers elected to narrate the story of the Hulk's 'becoming', thus attempting to capture and equip a new generation of fans. In doing so, the context of a military research facility and Thunderbolt's encounter and conflict with nuclear physicist Brian Banner (the father of Bruce Banner, called David in the film version) is retained by Ang Lee. One of the film's deviations from the comic book story is the manner in which Bruce Banner's nature eclipses nurture, leading him to mirror his father's work. In the comic book Bruce works at the same base as his father, designing and overseeing the construction of the "gamma bomb" or "G-bomb," a nuclear weapon with high gamma radiation output. In 1962, Stan Lee's story utilized the Cold War hysteria as the creation myth for his atomic superhero. In the film, Banner's scholarly work is transferred to a prestigious University research facility. The purpose of research is also adjusted from the construction of destructive weaponry to a new bread of hysteria, the medically oriented repair and restoration of damaged tissue using gamma radiation. In his book *Eco Media*, Sean Cubitt (2005) gives a detailed examination of the bio-political and bio-ethical themes associated with *X-Men*, another Marvel/Hollywood crossover. In Lee's film, a distinction is made between the military motivation of the father's work and the humanitarian orientation of Bruce's work in the film.

Lee's version of the Hulk also shares traits with the special effects constrained live-action television version of *The Incredible Hulk*. Both align themselves to the comic book incarnations that were able to demonstrate gentleness and compassion. The television series has an important role in Hulk history having spanned 82 episodes over five series between 1977 and 1982. Even after the cancellation of the show (despite continued high

ratings), its enduring popularity led to a further three reunion movies, the last of which was 1990's *The Death of The Incredible Hulk*. The series starred Bill Bixby as David Bruce Banner with former Mr. Universe, Lou Ferrigno, taking the role of the Hulk. Ferrigno's significance is acknowledged in a cameo appearance in the Hollywood film and his prominence on the DVD release of the film. The Hollywood film version also utilized the Banner catchphrase, popularized by the television show: "Don't make me angry. You wouldn't like me when I'm angry." The similarity of Ang Lee's version to *The Incredible Hulk* television series is expressed neatly in Universal's press release for the television version, which described it as "fantasy with scientific reality in a unique blend of mystery and romance backgrounded by very human emotions." The television series took General Ross' contempt for Banner from the comic book, and turned it into self-loathing by Banner motivated by his inability to rescue his wife from a car accident. A key fan site devoted to the television show similarly describes it as focused on "Banner's pathos and inner turmoil. Even Joe Harnell's simple piano theme, *The Lonely Man*, was unbelievably mournful" (www.universal-playback.com).

Reactions to the Film

Much of the context for reactions to the film can be situated in the marketing preparation for the Ang Lee 2003 film. This was expectedly wide-ranging, fully embracing the history of *The Incredible Hulk* but also containing a number of innovations, such as the web-campaign in which browsers would rumble before large Hulk film lettering burst through the screens of generic entertainment sites[1]. There is also the example of the unprecedented move of acquiring 100% of the advertising space on Yahoo for twenty-four hours. An increasingly popular marketing strategy innovation can be found in mobile-marketing (www.hulkmobile.com) in which Moviso and Marvel Enterprises offered fans content from the film and comic books as ring-tones, games, graphics and sound effects. More traditionally, the release of the film sparked the re-release of the popular television series and films on DVD, supplemented with a 'making of' featurette for the Ang Lee film and a preview of the accompanying videogame. A message posted by a contributor to one of The Hulk online discussion forums (www.comicboards.com), who purchased these releases, proclaimed that "the preview for the new Hulk game BLEW ME AWAY! I MUST own this!" (Mark). The release of the Hollywood film provided an excellent example of how superhero characters can operate in many modes at once and in interconnected ways. In this sense, the presence of multiple incarnations

of the Hulk at the same time does not imply a convergent stability or an end-point of unification for the character, but a *process* where moments of convergence are matched by equal moments of divergence.

Regardless of its lineage to past incarnations of the Hulk, the Hollywood film version of *The Hulk* was labeled both a critical (dubbed *The Introspective Hulk* by film critic Scott Holleran) and economic failure. After an impressive opening weekend in the US ($62,128,420) that secured the number one position, the audience radically dropped away and the film ground to a box office total of $132,122,995 domestically. One of the key issues to emerge from the inquiries into *The Hulk's* failure was the expectation set up during marketing for the film, in particular its marketing to a family audience through its child-oriented merchandising and the strong connections made to the "Hulk Smash" era, through elevating the status of action sequences in trailers and promotional material. As Naeriksgurl posted on The Superhero Hype! Boards online:

> Hulk was everywhere… toys, cereal, candy… things marketed towards younger kids. X-Men was never really marketed that way (esp. not the first film) because it wasn't really kid friendly (PG13 rating folks!!!)… it had a more serious tone than folks were used to concerning comic book adaptations. (http://superherohype.com)

Audiences were unprepared for emphasis given to the 'scientific' foundations of the story and Ang Lee's 'psychodrama'. In an interview posted on the British Broadcasting Company (BBC) website, Lee stated prior to the release of the film that he "really wanted to prove that a big summer blockbuster doesn't have to be simple… I don't want to lose the so-called Ang Lee touch, the dramatic touch, the sense of relationship and emotion". One fan who posted a reaction on another discussion thread on the Superhero Hype! Boards, acknowledged Lee's dilemma when he argued:

> I respect that he took a different direction in exploring Bruce Banner instead of going the "HULK SMASH" route, but the fact is, when a lot of casual fans think of the Hulk, they think "HULK SMASH". There is a lot of hardcore fans out there, but not enough to make the movie a blockbuster. That's up to the casual moviegoer–they didn't see enough smashing by the Hulk, so they said it sucked (USM Whore).

Addressing the issue of pleasing Hulk fans actor Eric Bana (2003)—who played Bruce Banner—was quoted as saying:
I'm interested to see what [fans] think of the film now that I'm

actually finished with it, but… I never once even asked anybody what was going on out there. Because you can't, you end up servicing the wrong God so to speak (http://www.superherohype. com/).

Many fans of the Hulk also appeared to be stuck in a dilemma between their appreciation of the seriousness of Ang Lee's interpretation and understanding of the complexity of the character, whilst at the same time harboring a need to emphasize and present the SUPERhero appeal of the character to a mass audience. As another contributor to the debate similarly stated:

> I happened to like the focus, making the movie more of thinking movie (sic) than just blown actions. I expect that now Hulk has been introduced to the mass movie goers, the second one will be far more action oriented with buses being thrown or buildings collapsed (jonty30).

Lee's film may also have underestimated the rivalry between fans of different superheroes and how the comparison of super powers forms an important component of superhero fan culture. This is often acknowledged within crossover comic book stories that feature exchanges between different superheroes (e.g. Hulk verses The Fantastic Four's The Thing or X-Men's Wolverine).

The Flow Across Multiple Media

With the exception of genre blending comic book adaptation of *American Splendor* (Berman & Pulcini, 2003) that successfully combines cinematic techniques with the comic book aesthetic and framing, *The Hulk,* unlike other comic book adaptations, gave audiences a heightened sense of the spatial dynamic attached to the practice of reading a comic book. In doing so, the comic book audience experienced hypermediacy (Bolter & Grusin, 1999), or a conscious awareness of how the film was explicitly drawing on comic book devices from multiple time periods concurrently. Film critics also acknowledged Ang Lee's attempts to transpose comic books and film through his editing techniques. As Peter Debruge's (2003) review of the film for *Premiere.com* argues:

> Where *The Hulk* excels is in Schamus [scriptwriter] and Lee's al-

most academic attempt to reinvent the superhero movie according to the rules of its source material. The very idea of montage … applies just as strongly to deciphering comic-book narratives, in which the illustrators may "cut" from a wide tableau to an extreme close-up or radically alter angles between panels… Lee's use of split-screens and dynamic transitions makes the process of actively interpreting his monstrous vision a fresh and unrivaled experience (www.premiere.com).

In addition to the intersection between old and new media, the film release of *The Hulk* also functioned to re-launch the character simultaneously across two new media platforms. One of the successes attached to the release of the film was the accompanying Hulk console game for Sony's Playstation 2 and Microsoft's Xbox. Indeed, in recent years, videogames have succeeded in breaking out of the merchandise category to assume a more substantial role in the success or failure of films. As a result, many filmmakers now seek creative control over such tie-in and spin-off products that form a brand (e.g. the Wachowski brothers use of the game *Enter the Matrix* to enhance a plot-line in the film *Matrix: Reloaded, 2003*). It has long been recognized in both industries that some films, such as *Star Wars* (1977) or *James Bond*, possess techno-ludic qualities (Bittanti, 2002) that make them appropriate for the interactive medium of games (e.g. LucasArts' *Knights of the Republic*; Nintendo's *GoldenEye*) that revel in 'second act' obstacles, setbacks and conflicts faced by a protagonist.

Another of these synergies is the crossover in the production process of games and films that allow the two media to operate in parallel. The film version of *The Hulk's* remediation of games occurs most explicitly in its use of digital graphics and SFX in the creation of the totally computer-generated Hulk, illustrating how both now form part of the same audio-visual media landscape. Commenting on this aspect of the film, again De-bruge (2003) states that:

> Industrial Light & Magic's Hulk is a major improvement over the body-painted Lou Ferrigno… For the spoilsports who don't think he looks "real," I challenge you to define how a 15-foot green-skinned monolith should look. (www.*premier.com*)

Despite sharing similar foundations, some fundamental differences continue to exist between the film and game representation. The standard attained by the film version of *The Hulk* could in no way be matched by the videogame representation of the character (in terms of both texture and 'realism'), due to the demands placed upon processing power of game hardware. In a discussion on CGI on the 'Gojistomp: Godzilla Stomp Fo-

Figure 32: Cover of *The Hulk*, Playstation 2 game released in 2003.
© Universal and Marvel Comics.

rums', contributor OverPowered Godzilla argues that: The Hulk's move-
ments, skin textures, pores, wrinkles, veins, muscles, emotion and mus-
cle movement were the best of any CGI and makes him look like a real
creature because of the most realistic features ever (www.gojistomp.org).
When discussing the overlap between game and film production, King
and Krzywinska argue: "The relative scales at which all of these qualities
are produced vary greatly from one medium to the other, because they are
driven by substantially different agendas and priorities" (2002, 20). Yet, in
the case of *The Hulk* videogame this constraint was not perceived as a sub-
standard replication of the film character as the game developers opted
to re-align the character to the technologies employed in the comic book
with the use of cartoon cell-shading to good effect.

We can argue, then, that traditional conceptions of realism are inade-
quate to explain the representational power of the respective media here–
comic strip, live action, 3-D animation. Kress and van Leeuwen (2000),
in their account of multimodal semiotics, make two relevant points. One
is that in the past, semiotics (and linguistics) has paid relatively little at-
tention to the physical medium (paper, stone, ink, paint, pixels) as op-
posed to the abstract modes of language, visual design, musical form, etc.
Multimodal semiotics makes a clear distinction between design (choice of
mode) and production (choice of medium); but argues that both of these
contribute importantly to meaning. In this case, then, the way in which
'the real', or the claim of fantasy to the status of 'real', is made in these
texts, is differently constructed in the line-drawing and flat color of com-
ics, the flesh and makeup of the actor's body, and the wireframe and skin
textures of animation.

Secondly, Kress and van Leeuwen argue that the claim to reality, ve-
racity, authenticity, made by the text (its modality), is not rooted in any
absolute verisimilitude in which the key relation is between the text and
its referent in the world, as is the case in classic debates about realism in
cinema. Rather, what is proposed as 'real' by the text is a matter of negotia-
tion between text and audience–what Lemke calls the *orientational function*
of the text (2001, 300). The claim to be 'real' must be completed by the
audience's modality judgment. This judgment cannot be made against an
absolute standard of realism, but against different kinds of cultural affili-
ation. So, the apparent naturalism of the live actor of the TV series of *The
Incredible Hulk* would have a lower modality for devotees of the comic;
while the apparently less naturalistic surfaces of the computer game's ani-
mation as compared with the hyper-real textures of the film, do not neces-
sarily result in weaker modality judgments for those fans who recognise
the reference to comic art.

Unlike other videogames released from films (if we choose to view it

this way) that are often negatively appraised, there are several significant reasons why *The Hulk* videogame was able to benefit from its association with the film. The game holds continuity with the film, as it is set one year after the events of the film, includes the voice of Eric Bana (Bruce Banner in the film version) and equivalent environments to the film sets, whilst also presenting fans with the additional presence of enemies from the comic universe (for example: Half-Life, Flux & Ravage) that did not appear in the film. With it an impression of 'immediacy' is also created "by the player's expectations derived from the medium of the film" (Bolter & Grusin, 1999, 98). Game developers, Radical Games, offered fans "an interactive world where the player will have all the freedom and the larger than life abilities of the *Hulk* in enormous and interactive 'sandbox' environments which really capture the essence of the character" (www.nintendospin.com). This contrasts neatly with the apparent failings of the film, allowing fans to inhabit and explore not only Bruce Banner's world, but also the Hulk's. A component of the experience offered by the game is thus linked to the cinematic dimension of seemingly placing the player in the film context in which a sense of immediacy is achieved through awareness of mediation (hypermediacy).

The orientational function of the videogame game packaging serves to address fans in a way that no other can. The game lets you BE the Hulk as you "smash your way through this epic adventure"; an adventure that picks up where the film left off. The simulational nature of this media allows the player to perform actions that modifies the behaviour of the system, conforming to what Poster (1995) describes as the second media age where reality becomes multiple. Indeed, very few games can compete with The Hulk for its levels of environmental interactivity and destruction. The transformative theme of the narrative is also played out in the game with the player adopting both Banner and the Hulk as protagonists with their different abilities, characters and motivations. Here the player no longer just witnesses the spectacle of the destructive power of the Hulk, but also experiences the frustration of Banner when he loses control and becomes the Hulk, altering the game experience from the appropriate and required use of stealth and furtiveness, to unlocked rage and immediate exposure as the Hulk. In some senses the game reinforces Ang Lee's approach to the film, as it strengthens fans' appreciation of Bruce Banner (further supporting the shift away from the deliberately feeble Stan Lee creation). As these fan comments from www.comicboards.com confirm:

> I like the notion of using different styles of play between Banner and the Hulk. Particularly Banner... I'm a sucker for stealth-based *Metal Gear* style games (Charlie).

Good story. Good action. Good Banner stages. Good extras. And Eric Bana as Banner... Banner wasn't TOTALLY defenseless (Ygor-Monster).

The differences in use of space and time in videogames also appears to have had significant implications. Films utilize ellipses to eliminate dead time, time that is not essential to the storyline or building of character or emotion, whereas videogames present a different model of time. Countless time can be spent in small parts of the game environments created by developers repeatedly testing reflexes, timing or logic. In some senses, for those who experienced the film and videogame as a package, the latter appeared to counterbalance and correct the lack of screen-time given to the Hulk in the film. In utilizing the convention of the training (or tutorial) level as a precursor to the game-proper, the game developers were also able to offer an immediate Hulk experience to players with no impact upon the storyline. In general, the *presentational modality* of the game is considered "true to the spirit of the genre, and the values that underpin it in its context" (van Leeuwen 1999, 180). As more fans from www.comicboards.com comment:

> You couldn't do a fraction of the SWEETASS moves in all the Hulk games combined when compared to this thing. Leaping? Slamming? Picking up soldiers and throwing them into each other like ragdolls? I love this game so much (Captain Nate).
> You definitely feel like the most powerful creature in the world ... this game makes me actually feel like the Hulk (Boxxer).

Unlike the use of live-action that constrained the television series, both the film and videogames realise aspects of the Hulk's superhero powers, such as his ability to leap great distances or 'thunderclap' that appeared early on in the comic book (e.g. in #4 *The Monster and the Machine*).

> He has cool Hulk moves, Super Thunderclaps and Super-Landslams. You can throw people off stuff and into walls. The Banner Levels require you to use your head, he sucks to fight with. But they are interesting to play (Nivek).

Thus it would appear that the modality of the game is not solely being judged on its cinematic qualities, but the manner in which it firstly positions the player in a pro-active relation to the events attached to the film, and secondly, brings to life a system of transitivity (that describes the performance abilities of the player as Hulk) found in the comic books.

This is a point not overlooked by Eric Holmes (Lead Designer at Radical Entertainment), responsible for translating Bruce Banner and the Hulk into interactive characters, as he described the process as "a great opportunity ... [that] brings a lot of baggage in the form of expectations too". Yet, narrative resonances from other Hulk representational media are successfully carried over into the videogame, with the genre well suited to represent the dimensions of this action-oriented character. The nature of the Hulk as a character offers an exception to King and Krzywinska's (2002, 16) argument that videogames' ability to "vicariously explore and interact with a world akin to that found in screen fictions" is a source of *additional* pleasure that counterbalances videogames' failure to emphasize narrative and character dimensions with any subtlety. The Hulk does not require that subtlety–indeed, many game protagonists, and superheroes in general, are similar to the 'heavy hero' of traditional oral narratives (Ong, 2002), who solves problems through external conflict rather than interior psychological processes (see Burn and Schott, 2004, for an extended discussion of this idea).

Convergence Qualities of the Videogame

Like the film, the videogame facilitates the flow of content across multiple media, not only embracing film to videogame content integration, but also inviting further participation in the Hulk Universe. In moving deeper into the superhero universe of *The Incredible Hulk,* the authority of the foundational narrative is further reinforced.

> Certainly it's the best Hulk game I've ever played. I'm hoping they'll make a sequel and feature more villains from the comics. I'd like to see the Maestro, the Abomination, Mr. Hyde, Mercy, Speedfreek, and Armageddon, to name a few. Maybe even an appearance by the Harpy (Ygor-Monster, www.comicboards.com).

Not only has a sequel videogame, *Hulk: Ultimate Destruction* (Vivendi), been released while the sequel to the film continues to languish in 'rumour mills', the game forms a continuum that also contains two comic book miniseries explicitly based on the videogame, a further encouragement to the migratory behaviors of media audiences. These comic books were of limited print runs and separate from the main Marvel distribution pattern and print schedule. The miniseries *Unchained* featured a Hulk versus Abomination battle, while *Gamma Games* featured the Hulk battling the Leader (written by film screenwriter John Turman). The second videogame

promises *fully* destructible environments set in a massive free-roaming fully interactive world. Eisner-Award winning comic book writer Paul Jenkins (*Hulk, Spider-Man*) has been enlisted to write the storyline and script, whilst the game will also reportedly feature artwork created by signature comic-book artist Bryan Hitch.

Consistency with, and links to, the film are further guaranteed by the inclusion of DVD-like film and game special features that are unlocked as part of an additional layer of reward-system, as well as explicit need for the film to unlock different modes of game-play. As a review of the game on ign.com outlines:

> Radical [game developers] has added three difficulty settings and tons of unlockable bonuses. From trailers and teasers pertaining to the movie to behind the scenes featurettes about the videogame. Other modes in addition to the story feature have been included as well, including what could be the coolest aspect of The Hulk: a super secret bonus mode that adds a third type of gameplay apart from The Hulk and Banner... In true cross-platform platform promotional form, the only way to access it is by watching the Hulk film when it comes out in June and putting together clues that create a code for the videogame. It's with that code that the special third mode can be unlocked (www.ign.com)

The third mode of game play referred to in the above quotation, is the retro quality of the Grey Hulk that, when played, added a comic feel through the addition of dialogue, such as: "Idiot, meet pain. Pain, this is an idiot," and "Get the HELL outta my WAY". Michael Donovan, who provided the voice for a cartoon version of *The Incredible Hulk* returns to the franchise to complete the dialogue for the Grey Hulk of the videogame. However, while on the one hand, this complex set of texts and media is densely intertextual, a network of transformed elements, allusions, in-jokes, shared stylistic markers, on the other hand, the media remain distinct and distinctive, offering experiences to fans which are organized quite differently in temporality, audience address, spatial design, and so on. As we have observed above, the connectedness in this network is concluded in the cultural practices and loyalties of fans; and the connections will be differently configured in every case.

Conclusion

The story of media texts is a story of ceaseless transformation and flux. The lineage of The Hulk as comic strip reveals a changing iconography

and a changing set of social interests and concerns represented by it. The newer transformations into flesh and makeup, CGI and game animation extend this iconography into the different meanings of texture, skin and designed movement, along with new social preoccupations, cultural affiliations, and critical meta-discourses. This diachronic process of change and difference, however, is also one of identity and continuity. What remains constant about the Hulk as metaphor for anguished, fragmented modern man is sneakily persistent, binding together fan communities across generations as well as global space:

> The genesis of time draws a repetition of events, defined by micro-changes,which gives rise to non-chronological time , a global present as a continuous ecstasy: an... ecstatic present (...) The same event takes place in different presents by the power of repetition-change. (De Gaetano 1996, 83)

22
Transforming Superheroics through Female Music Style

Kim Toffoletti

Introduction

It's 2002. Electroclash is the sound of the moment, 2 many dj's release *As Heard on Radio Soulwax Pt.2* and New York three-piece the Yeah Yeah Yeahs perform at an obscure rock festival in country Victoria, Australia. So what does this have to do with superheroes, you ask? From each of these musical moments emerged a new incarnation of the female superhero, in my mind at least. Let me explain.

It was during this time that Peaches, aka, former Canadian schoolteacher Merrill Nisker, aka the 'Jewish Suzie Quattro', aka the 'female Iggy Pop' (Nourse 2004, 30) penetrated mainstream consciousness with her superwoman attitude and the following unforgettable lyrics– "Sucking on my titties like you wanted me/ Callin' me all the time like Blondie/ check out my Chrissie be-Hinde"–which were sampled for the now immortal 2 many dj's recording. 2002 also saw the emergence of Electroclash, a smutty, slutty celebration of electronica and DIY chutzpah. Anyone with a mike and a Roland MC505 joined in. And leading the charge was all-girl outfit, Chicks on Speed. With an already established reputation as kooky art-house musos, the trio cemented their status as Wonder Women for their age through their hand-made, futuristic outfits. The musical-girl-superhero phenomenon was confirmed with the debut of the Yeah, Yeah Yeahs and their feisty front woman Karen O. When Ms O cavorted on stage flashing her fluorescent wristbands in an image of lycra-clad loveliness it became apparent that there was simply too much stretch material going around to dismiss this as mere coincidence.

These spandex-wearing chanteuses share an image, look and attitude that draws on superhero style, eighties fashion, and heavy metal iconography, prompting the descriptor 'Chicks on Spandex' (Toffoletti 2003/4). Donning a pastiche of shredded tights, underwear as outerwear, wristbands, and in Peaches case, a strap on dildo, they soar across the stage

and leap into the crowd, fists flying in a chaotic and spectacular frenzy of musical cathartics. Through the appropriation of masculinist super hero-ics Peaches, Karen O and Chicks on Speed destabilize the relationships between gender, sexuality, identity and power in music culture.

What follows is not a survey of traditional superheroes, nor do I pre-tend to know much about comic book culture. Rather, I draw on the visual tropes and characteristics associated with superheroes to demonstrate the complex cultural interrelations that inform contemporary female subjec-tivities. An analysis of the stylistic elements of comic book and cinema su-perheroes constitutes but one aspect of this chapter. It is where superhero discourse crosses over into music culture that the performance of gender is scrutinized to question conventional interpretations of female power and identity. By situating Chicks on Spandex within the '80s revival in popular culture (heavy metal, fashion, comics) this essay locates tough girl discourses in music and other mainstream sites such as cinema within broader postmodern tendencies for play and nostalgia, with the aim of examining its potential to promote new gender identities.

Like the 'tough girls' of mainstream media lauded by feminist schol-ars of popular culture (Inness 1999, 2004; Hopkins 2002), these women challenge the stereotype of the passive female to-be-looked-at identified by Laura Mulvey in her psychoanalytic account of women in film from the 1970s (1989). Instead they are characteristic of an active, autonomous, physically powerful heroine that embodies the new roles and status of western women in the wake of second-wave feminism (Inness 2004, 5). For Susan Hopkins, it is more accurately in the context of the current third wave or 'post' feminist climate that the phenomenon of what she terms the girl hero can be understood. Reflecting on the notion of 'girl power' she writes:

> Girl power is a post-feminist movement, in the sense of coming af-ter and perhaps overcoming feminism. While postfeminism does not necessarily imply anti-feminism, it does suggest a reworking of the familiar feminist approaches of the 1960s and 70s. The Girl Power of the 1990s and beyond marks a generational shift in femi-nist-inspired thinking toward more optimistic but individualistic positions and perspectives (Hopkins 2002, 2).

As Hopkins goes on to note with regards to the "superheroic ideals of young femininity" (2002, 3) proffered by institutions such as the mass media, girls are imagined differently now than previously:

> To some extent the new girl hero is in fact an anti-heroine–she is everything the traditional heroine was not supposed to be. Where

the traditional heroine is dutiful, gentle and invariably 'good', the new girl hero thrives on sexual and moral ambiguity. In the traditional stories of our culture, boys take active roles while girls are usually peripheral or decorative figures. By contrast, the new girl hero doesn't need a man to define her–she has staked her own claim to the privileges of both femininity *and* masculinity. She is not the overly emotional victimised heroine–she does her own hunting, fighting and monster-slaying (Hopkins 2002, 3).

Such feminist approaches to the representation of gender interpret the fluid and multiple contemporary configurations of subjecthood as offering new and productive models of female identity in the process of challenging the gender order. In cultural studies scholarship this post-structural and postmodern approach to theorizing identity is the dominant means of understanding the strong and assertive woman in music who challenges prescribed gender roles. Certainly with their tendency for wild stage antics and sexually provocative, subversive outfits, Chicks on Spandex can be viewed as exemplars of the postmodern, super-heroic girl, alongside contemporaries in the music industry ranging from the Spice Girls to riot grrrl, through to the tough girls of cinema and television such as Buffy, Xena and Charlie's Angels. In part, this inquiry will examine the construction of the powerful woman in music culture, and popular culture more broadly, to consider the various modes through which women have been able to access this power and its accordant constraints and possibilities. These models will then be assessed to consider how Chicks on Spandex 'do' gender differently from their predecessors, and evaluate how their mutated version of the superhero disturbs traditional formulations of gender, identity and power in the music industry.

Female Power, Music Style

When Karen O from the Yeah Yeah Yeahs screams "I'll take you out boy"[1] while vigorously pogo-ing across the stage and wielding her microphone cord like it's Wonder Woman's lasso, it is difficult not to conceptualize her as powerful. Her physical agility, the way she assertively occupies the stage, her direct gaze at the audience during a performance, are all markers of an active, powerful subject. She is, however, not an isolated example of the empowered woman of popular music.

While there is a long history of strong women in music, a sample that immediately comes to mind when thinking about powerful women

in contemporary music culture includes the Spice Girls with their 'girl power' slogan, leather clad rockers such as Suzi Quattro and Lita Ford, take-no-shit rappers like Missy Elliot, the 'ballsy' diva typified by Renee Geyer and Alicia Keys, the sexually empowered, industry heavyweight Madonna and her protégées Britney and Xtina, the politicized riot grrrl, and the 'independent women' of Destiny's Child. By no means is this list exhaustive, but it indicates that the idea of female power can take a variety of forms.

Feminist cultural criticism has recognized the productive possibilities music offers for gender rebellion, transgression and transformation (Stein 1999, Reynolds and Press 1995). Of the many manifestations of the powerful woman in music, each can be said to enact a particular 'toughness' that subverts traditional formulations of femininity differently and to varying degrees. One of the most visible examples of the tough woman in popular music is the female rocker exemplified by Joan Jett and Suzie Quattro. Embodying what Joy Press and Simon Frith have termed "female machisma," this kind of musician emulates a male rock ideal to garner musical respect and credibility (1995, 233). Jeffrey Brown notes a similar phenomenon in the tough women of action cinema, who enact masculinity in order to access the rights and privileges of male power (Brown 2004, 48). By deferring to a male model of being, Brown argues that women such as *Alien's* Ripley fail to offer a positive formulation of female subjectivity outside of a dualistic model. As femininity is coded as passive and weak, the tough woman of action cinema must reject femininity in favor of masculine attitudes and behaviors to be powerful. This gender ordering is also present in music discourse, which divides rock and pop along gender lines, ascribing greater value and status to rock music and its attendant masculine characteristics over the feminized, hence inferior, sphere of pop music (Frith and McRobbie 1990, 374-5; Schippers 2003, 283). Accordingly, one of the strategies through which female musicians may gain visibility and status in the music world is by being "one of the boys." This interpretation, however, has subsequently been critiqued for constructing female rock musicians as uncritically recapitulating male models, rather than examining the extent to which such performances might be "strategically ambiguous" (Auslander 2004, 7).

In contrast to the female machisma model are those performers who celebrate female strength via a socially sanctioned representation of female sexuality that is busty, buffed and beautiful. An early incarnation of this image can be seen in Dolly Parton, who like her postfeminist contemporaries such as the Spice Girls, Destiny's Child and Britney Spears, sing about women's experiences and often inequalities, while performing a stereotypical, idealized and sometimes hyper femininity. For these

women, being self-reliant and being feminine are not antithetical. Their lyrics, attitude, performances and style say that women can be strong, sexually liberated and successful without having to reject conventional feminine qualities. This does not necessarily imply that any of these performers are promoting a feminist agenda, despite often adopting a pro-woman attitude in their music, or that their actions could be construed as explicitly feminist. Rather this phenomenon is characteristic of the commercialization of feminist principles and ideas by mainstream culture (Greer 1999, 313). Despite celebrating female sexual autonomy and independence, postfeminist performers are valorized within the music industry for enacting an approved model of femininity–girl power in stilettos and tight skirts, if you like. Their power resides not in a display of physical strength or a challenge to hegemonic standards of feminine beauty, but in faithfully performing a model of womanhood that, visually at least, does not disturb the gender order.

So, too, has girl power been critiqued as a white concept. As Kimberly Springer notes, female power has different connotations and implications for women of color than their white contemporaries. The stereotype of the "strongblackwoman" (2002, 1069) is built on racist and sexist assumptions that vilify black women as "hard bitches," so denying the possibility of collective or individual "emotional, psychic and even physical pain" (Springer 2002, 1070). The modes by which gender intersects with race in the formation of female power raises important questions around who has access to this power and its effects. For example the 'power' of Destiny's Child could be construed as operating along girl power lines, where their blackness is secondary to their status as influential female celebrities who, in every respect except skin color, fit the white mould. This is seen in the use of their single "Independent Women" as the anthem for the quintessential girl power flick *Charlie's Angels*, and the accompanying video clip, in which the white Drew Barrymore and Cameron Diaz, Asian Lucy Liu and the African American singing trio exemplify beauty, kick-ass toughness and independence without any acknowledgement of the race or class divisions that accord some girls more power than others.

The depoliticization of power in this version of today's young woman finds its antithesis in the riot grrrl movement of the nineties and beyond. Unlike a model of female empowerment that upholds the status quo, riot grrrl rejects a patriarchally-prescribed ideal of femininity, seeking to carve out a new space for women in rock through strategies such as girls-only music nights, rejecting female stereotypes of dress and behavior, and the incorporation of "anger, defiance and rebellion into their own self definition, construing female rage as essential and intrinsic to their collective punk identity" (Gottleib and Wald 1994, 266).

Although Chicks on Spandex share with riot grrrl the aforementioned qualities of rebellion and defiance of gendered codes of behavior, they use different tactics to critique the patriarchally prescribed values of music culture. Consistent with Hebdiges' thesis on subcultural style as enabling the articulation of stable identity via resistance to mainstream practices (1979), riot grrrl promotes an alternative, collective female identity in its rejection of an idealized femininity. It is by resisting male-stream notions of gender, music and identity that riot grrrl transforms traditionally male subcultures of punk and hardcore (Gottlieb and Wald 1994, 264). In contrast, Peaches, Chicks on Speed and Karen O seek to disable identity through a humorous parody of masculine characteristics, rather than their outright rejection. The appeal of performers such as Peaches and Karen O does not lie in their resistance or conformity to certain constructions of femininity and masculinity, but in the pleasure of gender play. To this end, their approach is not dissimilar to that of Madonna whose brand of female-centered sexuality and image manipulation functions on multiple levels to disturb gender norms.[2] Despite these shared qualities, the most significant differences between postmodern artists such as Madonna and Peaches are found at the level of musical genre and the affective response of audiences. While an exploration of these aspects of their respective performances is beyond the scope of this chapter, it is briefly worth noting, as reviewer Terry Sawyer does, that Peaches elicits a comic response from her gender bending antics. Writing about a 2004 show in Austin, Texas, Sawyer observes,

> For the "Fuck the Pain Away" finale, Peaches opened up the tasks of performing to stage-horny audience members and the result was an *American Idol* orgy that had me spilling my beer because I couldn't stop laughing. Peaches has everything you could possibly want in going out to see a rock show: fuck all transgressiveness, ass jiggling, unkempt sexual energy and music so tight and powerhoused that even that most shy among you won't be able to resist the pelvic twitching salvos that make up the musical mantras in the teaches of Peaches (2004).[3]

Peaches and her contemporaries offer a performance of femininity that promotes female sexual autonomy, as well as drawing on male models of the hero (both super and rock) to assert their toughness. What distinguishes them from other female musicians is the way that they parody this machismo, rendering it ridiculous through excessive gestures and extreme outfits that reference the superhero. By simultaneously enacting gender stereotypes of male toughness and female beauty, these modern-

Figure 33: Peaches from Chicks on Speed from the Peaches Rocks website (www.peachesrocks.com). © Lynne Porterfield.

day Wonder Women rupture a binary logic that demands the character-istics of masculinity and femininity are distinct, even when traits such as toughness and sexiness are present simultaneously on the one body.

Postmodernism, Retro and Subversion

Like many of their musical predecessors, Chicks on Spandex represent other ways of being female that extend beyond traditional female stereo-types. What they do differently, however, is draw on a distinct set of refer-ences to enact this subversion–the fantasy worlds of comic book culture and '80s glam rock.[4] Central to their performances are the postmodern gestures of pastiche, parody and bricolage; features that are by no means unique to these musicians, but have been pervasive elements of contem-porary music style since the days of punk (Cartledge 1999, Taylor 1988). While postmodern aesthetics are widely understood as disabling grand narratives of history, place and identity, the displacement of meaning does

not preclude an attempt to theories contemporary cultural artifacts within the context of any given socio-historical and political moment. Particularly for a postmodern feminist project which seeks to expand the range of gendered subjectivities beyond binary categories, it is crucial to consider the means by which new models of gender identity emerge, how they function to enable alternative subjectivities, for whom and to what ends.

While the significance of this band of scream-goddesses can be understood in terms of postfeminist debates around tough girls and new formations of gender identity, it is within the recent '80s revival in commercial culture, as identified by Lara Zamiatin (*The Australian*, 11 October, 2003), that their actions offer a novel subversion of the gender order.[5] An example of the cultural fascination with the '80s is the 'return of rock' as a mainstream phenomenon. The elevation of the band t-shirt to mainstream fashion accessory offers an illustration of the commercial popularization of '80s rock, glam and metal (Jane Rocca, *The Age*, 30 March, 2005). Reincarnated for the new millennium, the band t-shirt is no longer worn only by die-hard rock fans as a marker of subcultural alliance, to be bought in heavy metal music stores or at a concert. Now Ramones, Metallica, and G'n'R logos grace the shop fronts of department stores and the shirtfronts of young, clean-cut television celebrities—emblems of a generation for whom music fandom isn't requisite for adopting a particular music style. So too can movies such as *Rock Star* (2002), *The Wedding Singer* (1998), *The Last Days of Disco* (1998) and *American Psycho* (2000) be understood in part as products of the western consumer market for 'old skool' nostalgia and retro products and entertainment (such as the return of Commodore 64, the market for vintage trainers, Star Wars prequels) (Ian Johns, *The Times*, 10 January, 2002).

In speaking about the nostalgia film Frederic Jameson explains the cultural tendency for retrospective reinvention as a way of going "beyond history" (1983, 117), of estranging the past in favor of an eternal present. This consequence of such a vacuum, he warns, is an inability to define or secure a representational language to describe the present cultural situation (1983, 117). For Jameson, the postmodern phenomenon of "retrospective styling" can tell us little about social power and identity in a current age, hence constitutes a pointless exercise (1983, 116). Arguing against this assertion, I suggest that the significance of this tactic, as it is used by Karen O, Peaches and Chicks on Speed, is its ability to offer new understandings of gender identity.

In appropriating the stylistic tropes of comic book heroes and glam metal, Chicks on Spandex partake in a dynamic process of referencing by which images are understood in relation to each other in the formulation of meaning (regardless of how unstable, fleeting or subjective this meaning

might be). Even if adopting the premise that the recycling of past eras in an age of consumer capital results in a disengagement with time and history, this doesn't bar us from analyzing cultural practices and their effects in the context in which they emerge. Just as Angela McRobbie identifies the significance of second-hand clothing in the process of post war "youth cultural expression" (1994, 137), so too is the imagery, performance and look of Chicks on Spandex more than blank parody. In preference to simply appropriating the past so that it is made meaningless, these performers create a dialogue between various formations of gender as they have been represented and understood historically. By referencing glam rock of the '80s, as well as highlighting its return in a new context, Chicks on Spandex show the ruptures and continuities in the formulation of gendered identities over time and across the shifting terrain of mass culture.

Superhero Style: The Image, the Persona, the Performance

As previously noted, these performers look to multiple genres in their image construction. Karen O's wristbands, Peaches combination of knee-high boots and lycra underpants, and Chicks on Speed's mask-like face paint all make reference to distinguishing elements of superhero garb. So too are these visual tropes consistent with the aesthetic of '80s heavy metal, which has been identified as drawing on comic and science fiction cultures in its performance and iconography (Denski and Sholle 1992, 49). In particular, it is the glam proponents of metal such as Mötley Crüe, Guns n Roses, Twisted Sister, Poison and Van Halen, whose emphasis on spectacle via stage theatrics, pyrotechnics and outlandish outfits display a super heroic quality. From David Lee Roth's signature high kick in the video clip for 'Jump', to Kiss' lycra suits and glitter boots, these spandex wearing show-ponies perform a super masculinity.

The tendency toward fantasy and excess in glam rock is itself a parody of the male rock hero. Eighties metal takes this persona to extremes by wielding flashy, oversized guitars; partaking in exaggerated and highly sexualized performances; donning over-the-top, feminized outfits comprised of jewelery, skimpy clothing and big hairdos; and publicly reveling in sexual promiscuity, drug use and drinking binges. This amped-up version of masculinity ruptures the seamlessness of maleness as a natural given by rendering it excessive, constructed and performed (Denski and Sholle 1992). It also suggests a 'super heroic masculinity', whereby mere mortals are made larger than life through their celebrity status and spectacular antics.

But while glam metal in many respects is emblematic of male heroism, certain elements of this persona challenge a sanctioned model of white, western masculinity. As documented in Mötley Crüe's autobiography, *The dirt* (2001), glam rockers sought alternative models of masculinity to those found in suburban America at the time. As Nikki Sixx recounts:

> Even when I tried to fit in, I couldn't. One day my cousin Ricky was kicking a ball around the yard with some friends, and I tried to join them. I just couldn't do it: I didn't remember how to kick or throw or stand or anything. I kept trying to motivate them to do something fun, like find some alcohol, run away, rob a bank, anything. I wanted to talk to somebody about why Brian Connolly of the Sweet had bangs that curled under, and I didn't. They just looked at me like I was from another planet.
> Then Ricky asked, "Are you wearing makeup?"
> "Yeah" I told him.
> "Men don't wear makeup" he said firmly, like it was a law, with his friends backing him up like a jury of the normal.
> "Where I come from, they do," I said, turning on my high heels and running away. (2001, 26-7)

Although this incident may be understood as a self-reflexive performance of gender that critiques an ideal of manliness typified by sporting prowess and the eschewal of the feminized realm of fashion and glamour, Nikki nonetheless conforms to a type of masculinity associated with risk taking behavior. He wants to "find some alcohol, run away, rob a bank" (Mötley Crüe 2001, 27).

The ability of '80s metal proponents to simultaneously problematize and celebrate the ideal of 'super' or 'hyper' masculinity is made possible by hegemonic masculinity, which according to Connell, is a culturally contingent and contestable construction of dominant masculinity (1995, 76). As it is with the case of heavy metal, not all men comply seamlessly with a normative idea of masculinity, nonetheless, "the majority of men gain from its hegemony, since they benefit from the patriarchal dividend, the advantage men in general gain from the overall subordination of women" (Connell 1995, 79).

So while the men of '80s metal can be seen as critiquing masculinity by emphasizing its performative nature, it is a critique that is limited as it fails to contest the inequalities of gender power relations. The effects are different, however, when women such as Peaches adopt the tropes of male heroism. The blatantly over-the-top representations of male dominance and female submission in the live performances, video clips and

photographs of glam bands are picked up on by Peaches, whose pastiche of knee-high white boots, big hair and a dog collar draw on such imagery, evoking both the male protagonist, as well as the female subordinate to simultaneously parody glam rockers and invert the conventional way women are represented in heavy metal as "dehumanised and degraded, fulfilling simply their role to sexually gratify the male, wanting to be humiliated, suppressed and physically harmed and objectified" (Whitely 1998, 165). In refusing to take a firm position, Peaches redefines the roles of male subject as hero/female object of male desire.

As Krenske and McKay argue "much of the imagery of HM is resonant with men's power, typically articulated through technology, men's bodies, the voyeuristic male gaze of the sexually objectified female body, or the threat of violence" (2000, 290). This iconography, which includes long hair and satanic motifs, serves to accentuate a mythical, heroic masculinity; a model of masculinity that traditionally spoke to disenfranchised suburban male youth (Straw 1983, 107-8). Not only is such iconography evoked by the typeface of Peaches' album *Fatherfucker*, but branded on her famed Def Lepard pants. When Peaches teams these gold-edged undies with a sleek, black push-up bra and nifty neck kerchief, she echoes Wonder Woman's briefs and bustier outfit. Most notable about this ensemble, however, is the penis sheath dangling from her Y-fronts.

Peaches' 'penis' plays on several levels with notions of heroic male power. What is immediately evident in images of Peaches wearing the pants is that this mock penis is flaccid. A psychoanalytic understanding of the phallic substitute as a compensation for female 'lack' implies that this is a failed attempt at mastering phallic power, in that the marker of male authority goes limp when ascribed to the female body. Alternately, her 'mock manhood' may be viewed as an inversion of the female lack/hole/vaginal passage. In this scenario, female sexuality is not completed by the penis substitute, but is instead expelled, extruded and made visible so as to offer a version of female sexuality that is neither inadequate relative to a male norm, or an unidentifiable female essence. Instead it implies 'something else' that complicates definitions of female sexuality and its attendant gender characteristics. Peaches' direct gaze and assertive stance suggest that mastering phallic power isn't requisite to being powerful. The impotent phallus doesn't necessarily imply a failure to take power or access authority. Rather, these gold-edged panties mock male potency, rendering a male-defined notion of power as ineffectual for tough women.

The Superhero Alias

Another quality of the superhero shared by these performers is the dual identity. Like Wonder Woman's Diana Prince persona, Peaches and Karen O are the alter egos of the far less-glamorous sounding Merrill Nisker and Karen Orzalek. In the vein of the superhero team like the Fantastic Four, Chicks on Speed are a renegade trio. Their website (Chicks on Speed n.d) declares that "Chicks on Speed will Save us all!," while their 2003 release *99Cents*, a tirade against the evils of global capital, is testament to the trio's fight against corporate greed and the evils of the big, bad, music industry.

Within superhero literature, the secret identity or mask has multiple purposes: to obscure the 'true' identity of the wearer, to signify power, to intimidate (Fingeroth 2004, 50-3). Or as Gary Engles has suggested, the dual nature of the superhero is a metaphor for the fluidity of identity that typifies the American immigrant experience (Engles, cited in Fingeroth 2004, 53-4). The 'real' identity of the protagonist is often not resolved in the superhero narrative, just as the location of the migrant between and across cultures results in an ambiguous rather than fixed sense of identity and self. For the Jewish Merrill and non-Anglo Karen, it is difficult to distinguish which 'self' is marginal–that of the feminist rock hero, or the non-heroic other? So, too, does the multicultural bent of Chicks on Speed (comprised of an Australian, American and German) problematize an attempt to locate the group's identity in terms of origins.

The alias here operates as a strategy to reverse the model by which the superhero "dresses up as one of us" (Poniewozik 2002, 77) to mask an authentic identity. Yet neither are the Chicks on Spandex "one of us, dressed up as a hero," as James Poniewozik suggests is the case with a superhero such as Spider-Man (2002, 77). For thinking about dual identity in oppositional terms enforces the idea that these performers enact superhero style on stage before returning to their 'real' selves. If this is the case, the subversiveness of these women can only operate at certain times and spaces sanctioned for performance, such as the stage or video clip. Evelyn Mc Donnell's observation that 'performance' and 'image' exist in tension–"*performance* is what the artist does, *image* is what the audience receives" (1999, 73)–is a valuable distinction. For it is through the *performance* of masculinist super heroics and the ensuing *image* of these performances that Peaches, Karen O and Chicks on Speed contest established representations of femininity and masculinity in a way that extends beyond spaces such as the stage and the video clip to pervade image culture more broadly. As noted earlier, it is the relationship between images relative to each other that enables multiple modes and contexts through

which to understand the powerful woman. Moreover, it is in the act of performing a flawed version of the hero that Peaches and her ilk rupture the distinction between 'authentic' and 'masked' self.

Acting like a Superhero

The physical actions of Chicks on Speed, Karen O and Peaches are akin to the feats of the superhero. Their preference for bounding across the stage, climbing up speakers, leaping into the crowd and tearing off their clothes echo super heroic acts such as Spiderman's ability to scale tall buildings, the Hulk's shirt-ripping transformation and Superman's leaping and flying prowess. In order to perform such actions, superheroes require super-strength (Middleton 1992, 34); a quality that is for the most part embodied in the male physique. More specifically, it is the silhouette of exaggerated shoulders and chest, muscular thighs and biceps that signifies this strength. Both Scott Bukatman and Charlotte Jirousek have linked the prevalence of this body type in superhero comics with changing cultural representations of masculinity and the emergence of the sporting spectacle. Noting the "steady rise in the popularity of football was concurrent with the increasing augmentation of the player's body" (Jirousek 1996, 4), Jirousek draws parallels between the idealized male sporting physique and the comparative evolution of the male superhero form. Bukatman draws similar links between comic heroes and the phenomenon of body-building to argue that the hyper muscular body gives an appearance of strength and power that is only ever illusionary (1994, 108).

It is an illusion that extends to new girl-heroes such as Buffy the Vampire Slayer and Charlie's Angels. While these women do not display excessive musculature as a sign of toughness, their super-heroic abilities to leap, run, slay and smash their way through any obstacle are pure fantasy. It is a fantasy, however, that the Chicks on Spandex do not sustain. When the indomitable Karen O and the mighty Peaches fly, they fall. Their high kicks and jumps are not effortless but result in sweating, panting bodies. They are all too human, as evidenced when Karen O fell and broke her arm while attempting to clamber up stage scaffolding during a recent Australian tour. Such antics, while seamless for the superhero, are complicated by these tough girls, who rupture the heroic ideal through their performance of this myth.

Conclusion

A visual analysis of the stylistic tropes adopted by Peaches, Chicks on Speed and Karen O demonstrates the extent to which such acts operate

politically to contest gender power relations in the sphere of popular culture and its representations. In parodying male heroics, these women reformulate masculinity, as well as creating a 'new' femininity, one that does not seek to emulate male models, nor commodify female sexual power, but take pleasure in gender play. By looking at how the retro revival and play of signification operate in contemporary western social relations and image consumption, this chapter offers a complementary framework to the 'girl power' discourse of third wave feminism through which to theorize contemporary female subjectivities. In order to make sense of Chicks on Spandexes' challenge to the gender order, it is useful to cast our theoretical net beyond 'tough girl' literature or a genealogy of female musicians, and acknowledge the broader context of '80s revivalism in contributing to the destabilization of gender identities.

It is purely at the level of image analysis that these conclusions are drawn, leaving scope for further investigation of the Chicks on Spandex phenomenon through a study of musical genre, audience reception, the commercial and institutional structures of the recording industry—all of which are important aspects that contribute to the construction and effects of gender identities in popular culture (see Fiske 1989, Kaplan 1987). An examination of audiences, fandom and industry, while not fully addressed here, would prove beneficial to ascertain the global reach of these performers, who consumes their images, and how fans' engagements with Peaches, Karen O and Chicks on Speed *as cultural products* informs perceptions of gendered power relations in society.

23
Check The Use-By Date: Shelving an Icon as Superheroes Become Super-brands in Advertising to the Junior Generation.

Holly Stokes

In the early part of the 1930s, a working-class sailor by the name of Popeye was credited not for saving a damsel in distress, but rather a struggling U.S. spinach industry. The protagonist's consumption of this green vegetable as a supernatural aid is believed to have encouraged its popularity amongst young children. Though this phenomenon presents much of itself as a mythic tale within Western commercial culture, it does serve as grounds for questioning the relationship between product and popular hero. I believe that the endurance of the heroic character is owed not to *his*[1] superhuman feats but to his flexibility in being reworked and revamped across a myriad of disciplines. A study of his motives, narrative and character is exercised throughout the fields of literature (Avery 1965, Propp 1968, Hourihan 1997), motion pictures (Elley 1984), anthropology (Carlyle 1935), mythology (Campbell 1956), religion (Burns & Reagan 1975) and psychology (Jung 1985, Tatham 1992, Byrne 2001). This cross section of approaches provides the oxygen which sustains this archaic figure, with a continual re-examination of his appropriation within our current cultural climate.

The hero as a by-product of capitalist inventory is not a new concept by any means. His position within major motion pictures or their merchandising which has spawned from this collaboration offers one example. However, what performs as the catalyst for renewed debate in this paper, is the morphing of brand into hero: when this lead character is literally birthed within a corporation, with his "call to adventure" shaped entirely around an allegiance to a basic, domestic food product. Coco Pop Monkey (Kellogg Pty. Ltd.) and Paddle Pop Lion (Streets Unilever) offer the quintessential example of this brand-hero hybrid and will be used in detail to examine the hero's textual transgression from classical literary discourse to promotional text. Unlike traditional forms of literature and even film, the hero in advertising is not afforded the luxury of lengthy narrative space. Furthermore, the hero now has a shelf-life and has been collected

by the capitalist wave of tastes, trends and fads. Buoyed by the support of a new generation of consumers, whose opinions proceeding focus group discussion on this figure's worthiness and relevance to contemporary kid-culture, have been documented as a conclusion to determine whether the skepticisms of a young audience coupled with the homogenization of his character through the mass production of his image, may well result in the death of this typically and historically recognized immortal figure.

Method: The Value of Kid-Speak

The research methods employed in conducting this investigation stem directly from the opinion that children are capable of expressing a valid and worthy opinion about themselves and their cultural and social environment (further supported by Garbarino 1989, Greig and Taylor 1999, Lindstrom 2003). Furthermore, the methodological framework used to encompass the debates regarding the impact of the brand-hero hybrid on children, has been structured in a manner which is not geared by a negative preconception that views this generation as passive victims of a capitalist upbringing.

Thirty children (fifteen boys and fifteen girls) were extracted from a youth organization[2] located in an upper-middle class suburb in Adelaide who meet on a weekly basis[3]. The organization divides its members into four different groups according to their age–all research participants were taken from the two youngest groups. Group A consisted of children aged between four and seven years, while members of Group B were aged eight to ten years. The division of these two age groups occurs primarily in respect of a child's capacity for "language, action and self-reflection," skills which develop and improve at each age level (Greig and Taylor 1999, 37). The research design used to achieve the results presented in this paper, was structured around image-based activities, which invited participants to respond to questions by circling or pointing to various pictures. Open-ended questioning was also employed in order to counter balance the multiple-choice style of questioning outlined above; which could be criticized for its directive approach in encouraging a categorical response. The foundations of this research design were formed around a semi-structured focus group discussion[4]. The focus group performs as a catalyst for peer consensus and generates an awareness of other's thoughts (Hansen, et al. 1998, 262), which is of particular benefit to observations of peer group pressure. While it is argued that the focus group discussion may invite the continual domination of one individual over the others (Hansen, et al. 1998, 263), this consideration is paramount in determining the key social-

ization agent which prompts a child's behavior as a consumer, as it can elicit whether the voice of a peer is stronger than the voice of a parent or heroic character.

The Hero as Icon of Commercial Culture

> It is a thing forever changing, this of Hero-worship: different in each age, difficult to do well in any age. (Carlyle 1935, 57)

Time becomes a value determinate when addressing the construction of the hero and searching for an accurate definition of heroism. From a contemporary perspective it is becoming more difficult to pin down a concrete description of this archaic figure and provide an example of his character today. Carlyle initially argued from a traditional and historic sense that the hero was a rock within revolutionary surges, maintaining much of his core values and qualities regardless of cultural shifts (1935, 18). Yet as he mapped the decline in status of this prominent figure throughout the ages, he offered foresight that the hero would eventually become a chameleon to his epoch (1935, 110). Essentially, we see examples of this very foresight mirrored in the construction of such characters as Coco Pop Monkey and Paddle Pop Lion, who are unquestionably a reflection of the capitalist arena within which they perform. These commercialized protagonists evolve not from mythological writings, but from the supermarket shelves; directing our attentions not to the supreme status of their actions but towards the supreme status of a brand. If the hero's quest is symbolic of the culture he is from (Hourihan 1995, 51), what does this say of the society responsible for the anthropomorphic characters above? Is it laughable to suggest that we are a nation whose thoughts and values are shaped around pre-packaged food items? Would Carlyle argue in respect to our current society, that our icons of worship are no more than the solidified visions of corporate marketers and brand consultants? These questions seem relatively unproblematic when accounting for Western commercial society's skepticism and rejection of traditional belief systems, which manifests what Carlyle termed as a "universal spiritual paralysis" (1935, 17). Campbell professed that a society which did not accommodate a mythology ("religious content"), was a society structured from "self-determining individuals" with a preoccupation for "material supremacy and resources" (1956, 387).

The rise of the individual in Western culture has provided a significant hurdle for the hero, who's past success depended more upon a state of social solidarity and conformity. Jean Baudrillard noted similar shifts

resulting from capitalist influences which drove the individual away from the group and more towards a mode of self-conformity (1996, 186). This change has served to empower the people over the protagonist, whose role it has now become to validate the worth of his actions. So in defining heroism today, we are likely to concern our discussion with the protagonist's *accountability* rather than his ambitions, as we have come to measure the heroic figure not by his intentions, but rather by the greater influence and effect of his work (Carlyle 1935, 130-1). The heroic figure now echoes the beliefs of his people and not the reverse, so performing in this sense as an accurate barometer of social value, while his presence—or lack thereof—indicates a level of social consciousness. Carlyle predicted that we would eventually come to deny the existence of such a Great Man, while questioning the relevance of worshiping such supreme icons in contemporary times (1935, 16-7). He addressed a concern for the utility of the hero and his need for self-justification within a culture obsessed with the function, purpose and use value of objects (1935, 130-1).

Indeed, what is the use of the hero in contemporary times? Originally his purpose within narrative was to demonstrate a clear example of the very good as distinct from the very bad, in a manner which inculcated didactic behavior (Avery 1965, 45). Today we are more likely to connect the purpose of the hero with his face as an entertainer, needing only to look at the resurgence of hero films currently being released for clarification of this point[5]. It is from this position that we may herald the new breed of protagonist, one who is capable of transgressing traditional literary boundaries, whose character holds the flexibility to be continually reworked within the democracy of a multi-mediated environment, and whose level of appeal is resilient to an ever-increasing audience of skeptics and non-believers. The hero's survival is dependant upon a state of unconsciousness and submission from his people, an absence of which would render this mythological character incapable of penetrating a new era (Carlyle 1935, 110; Campbell 1956, 391) and influencing a new generation who do not support the traditional belief systems synonymous with this character.

The hero as icon of commercial culture demonstrates an inevitable relationship. For this archaic figure to survive another era it has become necessary for him to develop a vocabulary and style which was in tune with the brand-manic atmosphere of the 21st Century. While this paper attempts to refrain from associating with the anti-advertising and anti-capitalist expressions common to most academic writings on this subject (see Gilbert 1998, Klein 2001, Latham 2002)[6], I will acknowledge to some extent the purely commercial role of the hero in this contemporary climate. The collaboration of brand and hero has become almost parasitic. In one sense

the protagonist is dependant upon the mass appeal created by his revival in a capitalist culture, while on the reverse side, corporations have collected this figure as the result of a new corporate philosophy which is dependant upon a "seizure of every corner of unmarked landscape in search of the oxygen needed to inflate their brands" (Klein 2001, 8).

In deconstructing this latest promotional concept it appears that the brand-hero collaboration manifests itself on two levels, the first being a sketchy attempt at ideological decoupage (or postmodern pastiche) whereby a pre-existing and popular hero is pinned next to the logo of an already well established brand[7]. This unification is less successful from the perspective that the relationship between the two images has been forced, highly manufactured and consequently will visibly display the persuasive seams of advertising. Much of promotional culture's success (and subsequent criticism of it) arises from its ability to hide the symbols of its coercive rhetoric (Williamson 1978, 17). The marriage of brand and heroic icon in such a dislocated manner is a clear demonstration of how advertising attempts to persuade through a "recycling of social categories" in order to stimulate the ideal "aura" for a product (Williamson 1986, 68).

The second level of this brand-hero unification attempts a more fluid and seamless merge between two popular icons. Coco Pop Monkey and Paddle Pop Lion offer the ideal reflection of this hybridization, recognized foremost by the appellation of their characters. This style of protagonist is literally birthed in the boardroom, created with the sole intention of joining in promotional tandem with one specific brand, and so generating a more solid and dependable frontline for a corporate ethos. In contrast with the first type of brand-hero merge outlined previously, marketers are here afforded the flexibility of what could technically be described as an empty signified. This is a concept which surfaced in Roland Barthes' writing on mythology which defined the empty signified as a vacant vessel available for the personal investment of the reader (2000). Rather than structuring a brand around a pre-established hero, this alternative approach creates a new character from a list of fundamentals. Providing the protagonist can display such expected qualities as bravery, intelligence and victory (Hourihan 1997, 60), the styling of this personage is relatively unbridled.

Furthermore, the creators of Coco Pop Monkey and Paddle Pop Lion have accounted for an advertisement's time restrictions through the employment of anthropomorphism, with both lion and monkey as immediate signifiers of bravery and intelligence respectively. The human-animal hybrid is a creature of great significance in the history of mythological tales. Campbell noted that this alliance represents humanity's psychological link with the wilderness, whereby animals perform as tutors through imitating traits of the human ego in order to restore social harmony (1956,

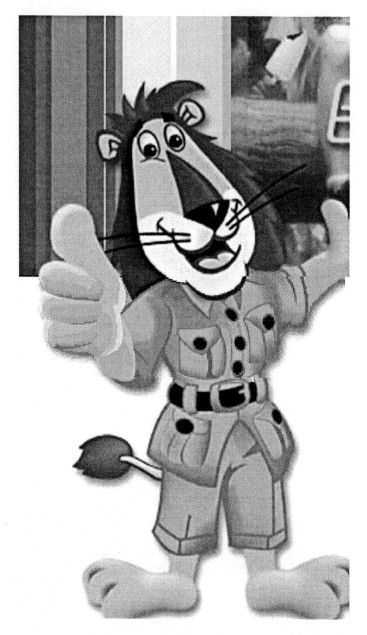

Figure 34: The Paddle Pop Lion. © Street/Unilever

390). The human-animal combination also holds universal appeal for young children who exercise a greater capacity for fantasy and delight in characters which subvert from the "restrictive boundaries of traditional thinking" (Lindstrom 2003, 29). The choice of animal is also paramount in establishing the purpose of other characters who perform alongside the hero, this is of particular benefit to a young audience who are still learning the codes of the adventure narrative. Consistent in both Coco Pops and Paddle Pops commercials, the heroine is represented by the same animal as the hero (only with eyelashes), sidekicks pose as smaller or less intelligent animals such as turtles and cows, while the supernatural helper—a character outlined by Campbell (1956, 97) who acts as the possessor of wisdom and distributor of magical amulets—is signified by an owl. In addition, the specific selection of animals serves to reinforce Carlyle's notion of the "*Hero*archy," a system of governance which satisfies and establishes all dignities of rank, providing a model which directs a society's manifestation of Hero-worship (1935, 15). When the protagonist assumes the name of the product they promote, as is the situation for Paddle Pop Lion and Coco Pop Monkey, a narrative's allegiance to hierarchical structure will always ensure the supreme and most élite positioning for the brand name.

Advertising takes advantage of this structure with the sporadic insertion of product and logo shots during those moments in the narrative which best serve to reinforce the benefits of that brand. This is particularly evident at the time of the hero's victory, where triumph is usually celebrated through consumption of the product being promoted. In respect to this, it is fair to attest that advertising serves to gain the most from the format of the hero narrative. Its popular, predictable and unassuming style (Hourihan 1997, 9 & 57) complements the short time frame afforded to most television commercials, where sophisticated and in-depth character development are not an option.

In Vladimir Propp's *Morphology of the Folktale* (1968), he constructs a grammar which accounts for every component common to the traditional tale, detailing how these components relate to one another and to the narrative as a whole (19). Propp labels these components as "functions" which total 31 in a traditional tale. His sequence of functions is useful in application to a study of the promotional hero narrative, providing a more exacting format in determining the absences and presences of certain actions and how this constructs the image of the brand. Consistent across both Coco Pops and Paddle Pops commercials is the fact that these texts have inherited only five (functions 15-19 outlined below) of his 31 functions, with three of them (functions 16-18) making a more significant and involved contribution to the narrative.

Propp's functions from number 15-19:

> XV. The hero is transferred, delivered, or led to the where-
> abouts of an object of search (*Guidance*).
> XVI. The hero and villain join in direct combat (*Struggle*).
> XVII. The hero is branded (*Branding, Marking*).
> XVIII. The villain is defeated (*Victory*).
> XIX. The initial misfortune or lack is liquidated. (Propp 1968,
> 50-55)

This particular segment is central to the narrative and signals its peak (Propp 1968, 53). Campbell defined this section as the *initiation*, indicating its status as "a favourite phase of the myth-adventure" as it was symbolic of the hero's transgression from known to unknown worlds and the trials he would face and overcome (1956, 97). While Propp maintained his formalist approach to textual deconstruction, he acknowledged the structuralist outline of this particular phase of the narrative which centered itself on a dualistic foundation (1968, 65). This framework offers a reliable empowering mechanism for a brand name due to the hierarchical nature of oppositions. The hero is consistently associated with the more superior binary, while anything opposed to his actions is labeled homogeneously as the inferior group, as "otherness" (Hourihan 1997, 16).

When brand becomes hero, it positions itself in this same seat of superiority, associated only with all that is good in the struggle between good and evil. An advertisement's bias towards this section of the traditional adventure narrative allows the brand name to establish itself in an environment characterized solely by success and victory and so generating a flawless appeal to its target market. While this approach seems idealistic from the perspectives outlined above, the seamless integration of brand and hero above all else is dependent upon a successful reception/recognition from/by its audience. In the face of an increasingly media-literate and skeptical viewer, the results of an original research investigation involving 30 children and a collection of hero-branded products, will cause us to question whether a branding war may well see the defeat of an otherwise immortal figure.

The Hero's Final Resting Place: From "Justest, Wisest and Fittest" to "Cutest, Coolest and Tastiest."

While Carlyle predicted the demise of the hero across the ages, his focus was always concentrated more towards the depreciation of this figure's

spiritual and intellectual wealth (1935, 110). It appears that what has since occupied the space left by the absence of spiritualism, intellectualism and depth of character in the hero, is a preoccupation with the aesthetic. In reflection of the responses generated during focus group discussion, it seems the definitions of heroism are both highly critical and stem from the realm of the superficial. When asked to define the hero, nine year-old Justin commented: "He doesn't always save the world." While eight year-old Charlotte replied: "It's usually the star of a movie or something."

These responses demonstrate a significant shift in the perception (if not enthusiasm) of the hero and his narrative. To be more specific, what we are witnessing through the creation of the brand-hero hybrid is a division in the meanings of aesthetics. Originally, the hero narrative was used to encourage good behavior in children through a frightening demonstration of the consequences resulting from ill performance (Avery 1965, 45). Sigmund Freud named the catalyst of this fear "the uncanny," claiming that the aesthetic could also represent that which created repulsion and distress (2003, 123). His work is of particular relevance to a deconstruction of hero mythology and its relation to children, as his notion of the uncanny can explain the shifts from hero as moralist to hero as entertainer. Freud noted that,

> ...an uncanny effect often arises when the boundary between fantasy and reality is blurred, when we are faced with the reality of something that we have until now considered imaginary (2003, 150).

This theorizing is applicable to traditional versions of the hero tale which relied on the child's need to solidify fantasy and stabilize their intellectual uncertainty through an opinion that mythic creatures truly existed (Freud 2003, 125 & 137). While the educationalists and their narratives of yesteryear took advantage of the child's unquestioning belief in the unknown, one could conclude that such a role still exists today, exercised in the capitalist domain which relies extensively on our desperation to actualize our desires (Baudrillard 1996, 167). Within the commercial realm it is merchandising which connects the junction between the aestheticism of the hero and a child's solidification of fantasy. The abundance of hero-branded food products, plush toys, figurines, stationery items and collector cards reflect this idea of bringing the unknown (or imagined) into the known (or lived space). Lindstrom commented on this transition as being the result of markets responding to a youth demographic who are no longer "fantasy-driven but fantasy-receiving," and place strong demands on an active fantasy life they can become involved in (2003, 30-1). These

observations were further confirmed when a research participant shared her excitement of dressing-up to imitate her favorite hero,

> I dressed-up as Hermione [Granger from *Harry Potter*] in a school thing [disco]. And someone from a different country was visiting and they asked me if… *I* was the *real* Hermione.

While such a comment echoes this idea of the physicalization of the imagination and an active involvement in a fantasy element, the practice of imitation (specifically through merchandise) presents a saving blood for the heroic character of any era. Freud's reference to this act of imitation or cloning which he termed "doubling," spoke of a new level of power which performed as an insurance against mortality (2003, 142).

The consumption of the hero in this manufactured form fuelled discussion within the focus groups, as participants recognized a hero foremost by their personal ownership of the merchandised icon. Even Lindstrom noted that the open-ended hero narrative was no longer a literary tool to insight imagination in its reader, but rather a marketing tool to extend the possibilities for merchandising and use across other media platforms (2003, 28). This synergistic environment which now embraces the hero seems to generate confusion as to his origins, while causing a wider questioning of his authenticity. This became evident when the research participant cited previously discussed her surprise at being mistaken for the 'real' Hermione. While the hero's replication through merchandising offers this figure a life form and future, his detachment from the solid foundations of originality does seem to perform as a disempowering mechanism in consideration of our ease at adopting the hero aesthetic. The function of traditional hero narratives as a disciplinary tool have now yielded in response to what Freud termed as a transition from "an infantile fear to an infantile wish," a shift in aesthetics whereby "the uncanny"–while still defined as the grotesque and the deformed–is no longer received with distress, but with excitement (2003, 141).

Despite the resurgence of the hero's popularity being the result of his capital potential as a merchandized icon, his acceptance by a new generation is largely dependant upon his ability to satisfy the most challenging criteria of his epoch. The hero is literally powerless unless he is considered by this demographic to be 'cool.' During focus group discussion this term surfaced most frequently as a means for participants to rationalize their preferred choice of heroic figure. As predicted, a number of the protagonists did not suffice to the rigors of 'coolness' with Barbie and Astro Boy dismissed for this title. Indeed 'coolness' is born from Freud's very idea of the uncanny, as it extends from a 'sense of threat' (Harris 2000,

52), and represents a rejection of convention (Pountain and Robins 2000, 163). While this would justify the disdain for Barbie, who represents the overly typical and predictable, it does not supply us with an explanation for the dismissal of Astro Boy. His expulsion from the discourse of coolness was due to the participants' unfamiliarity with his character. This signifies to us that the construction of coolness walks a fine line between the familiar object outside of convention, or the unfamiliar object which is still conventional enough to gain acceptance and be understood. This hazy and ungrounded definition of the term 'cool' speaks volumes of the junior generation who enjoyed the flexibility and liberation of this word, using it when struggling to concoct a description of a character they admired. This term further provided relief for research participants when questioned on the appropriation of villains used as the stars of advertisements. Does this make the product appear good or bad? Perplexed in the face of this rigid polarity, participants groped at "cool" as the alternative gray matter which bracketed something which was neither good nor bad. Zao, the villain from *James Bond: Die Another Day* (Metro-Goldwyn-Mayer Studio Inc. 2002), was awarded this title. This satisfies the description from Harris who states that "the basic credo of coolness is nihilism" (2000, 62), so it is not surprising that its example has been discovered in a villain. It could be suggested that this juxtaposing love of the unloved has lifted the lid to a cohort of moral panics from consumer activists, as they watch children embrace the very objects which were once employed to discipline them. Cool advertising with its rejection of standards can encourage "adventurous and more discriminating modes of consumption" (Pountain and Robins 2000, 166), which ultimately challenges Carlyle's traditional construction of the *hero*archy (1935, 15). A consumer's "worship" is now rechannelled towards recognition of the underdog whose position furthest from the seat of supremacy epitomizes coolness and radicalizes hierarchical structure by vacating the top position with a character who sustains the lax and liberal definition of cool.

This paper has attempted so far to emphasize the merits for the hero, in stimulating our appreciation of looking and listening to an archaic figure who was traditionally just a product of our imagination. However, it is the hero's ability to satisfy yet another of our five senses, which has possibly led to the demise of this otherwise immortal character. When the protagonist decorates the packaging of a food product, he comes to associate himself with a taste. I use the word 'taste' not only to incorporate the sensory experience of our engagement with food, but further to recognize the use of this term in defining our cultural and social positioning. The disjoining of these two separate meanings felt necessary upon reflection of conversations and results which emerged during focus group discussion.

In response to an activity which required research participants to select between a range of hero-branded and generic-branded confectionary items, in all but one case the generic-branded products were the preferred choice. When consulting Baudrillard's perception that packaging and labeling is the only language a product has to communicate with consumers (1996, 191), it becomes difficult to debunk the motives behind the popularity of a product with a monochromatic label and weak promotional front. Pierre Bourdieu's definition of taste can assist in a deconstruction of this outcome to some extent, as he removes its affiliation with the aesthetic. He states that once we look beyond the "sacred frontier which makes legitimate culture a separate universe," we will be able to determine why otherwise incommensurable objects can function together harmoniously (1989, 6). Indeed this explains why cultural taste can conflict with corporeal taste. The "glossing" of product packaging with heroic portraiture, while recognized, did not distract research participants from pursuing products which satisfied their desire for a sensory enjoyment. As confirmed by eight year-old Maddison, "Well, I definitely think the Buzz Light Year packet is more colorful, but I like the [Homebrand] Tiny Bears."

This comment encourages the divorce being experienced between the "aesthetic of deliciousness" and the "sensation of taste" (Harris 2000, 176). Hero-branded products are a culprit to this masking as they shadow the highly manufactured, processed and un-nutritional products behind a fanfare of images and color. In response to this, it was claimed that product packaging therefore liberated food through this disguise (Harris 2000, 162), yet in light of focus group results I would argue that it is actually the food which liberates the packaging.

The participants' embrace of generic-branded products resulted from its incorporation within children's playlore. Known as the *Wish Chip* game,[8] participants demonstrated this ritual which was only available to them through Homebrand style chips. A practice uniformed across all age groups — which further required a strong audience of peers — demonstrates an extratextual approach to products that have not clearly been written into by commercial culture. Generic-branded products were further identified by participants as their parents' preferred choice of brand, common in school lunches and heavily woven into their daily routine. This consistency familiarized participants with the product, allowing them to access a bank of sensory knowledge which rationalized their preference for generic brands. While advertisers aim desperately to achieve such intimacy between product and consumer, these results reflect notions of consumer sovereignty where brands pass from parent to child. Such debates appear to straddle the line between Bourdieu's citation of our tastes as "a gift of nature" and as a "product of upbringing" (1989, 1), further acknowledg-

ing parents as the key agents of socialization in a child's life, and so finally lifting this responsibility from the shoulders of the fictional heroic figure.

It is easy to incorporate Carlyle's pessimisms on the difficulty of hero-worship to perform well across the ages (1935, 57). While it initially appeared that commercial culture could provide buoyancy to this dissolving icon through its mass appeal, this archaic figure in turn has been given a shelf life. Where once the protagonist sat comfortably within the literature-rich confines of his mythology, the rigors of commercialism have imbued this character with a renewed sense of competitiveness. His call to adventure now commences in a corporate boardroom, where upon successfully crossing the threshold of "coolness" he is replicated through the plethora of merchandising opportunities. His narrative is reduced to the momentary display of a battle scene which inflicts upon his development and depth as a character. Within this new narrational form, integral components to the hero adventure—such as his transition from boy to manhood—have been sacrificed to compensate for the time-space compression required by a promotional discourse. In this sense the hero becomes homogenous, recognized foremost by his aesthetic accessorization through his graphic and animated design and defined secondly by his general "save the day" capabilities. Should he exercise his ability to "save the day", his supreme position is likely to be shared by his defeated arch nemesis who is prized and celebrated out of pity or through pervasiveness. Finally, the hero's positioning as the face on product packaging in an attempt to mask its processed contents, acts as the solidification of his slow demise with a label announcing his expiry date.

Despite the hero's manipulation and degradation within the commercial realm, it is necessary to acknowledge that this arena has enabled an archaic figure to continue his performance. In reflection of the focus group results the research participants, though critical at times, expressed a genuine liking of this character. Their adoration of this icon through associated merchandise, films, games and food products should signal to researchers to readdress Carlyle's notion of hero-worship, perhaps replacing it with the more befitting title of fandom, which accommodates for the changing trends, opinions and politics of this age group. As the hero shifts away from his position as the inculcator of moralistic behavior and moves into the uncertain role of promotional icon, the assurance of his future can be verified across the ages.

Hero-worship, is nevertheless, as it was always and everywhere, and cannot cease until man himself ceases (Carlyle 1935, 16).
 And sometimes they die and then they come back and fight again … then the hero wins.
 – Toby aged seven.

24

I Outwit Your Outwit: HeroClix, Superhero Fans, and Collectible Miniature Games

Michael G. Robinson

On Monday night, the gathering begins. People trickle into their local comic book store, prepared to do battle. Tucked under their arms or gathered into tackle boxes are their weapons of choice—dice, counters, and small plastic figures. These modern day totems represent their favorite superhero characters. The players greet each other as they enter. Old comrades from battles past, on this night, these players will use their knowledge and skill to outwit one another in a HeroClix tournament.

HeroClix is a flexible game system developed by the WizKids company that aims to simulate the action found in superhero comics. The HeroClix system encompasses 3 related game lines: DC, Marvel, and Indy. Each line represents a licensing arrangement to produce a game based on superhero properties from major comic book publishers DC and Marvel, with Indy HeroClix drawing from a group of smaller publishers. Marvel Comics was the first to license in a deal announced on August 17, 2001. The game was released in the summer of 2002 ("WizKids Announces").

This analysis examines HeroClix as a cultural phenomenon. The first goal is to capture a sense of the game and the interactions built upon it. No one could be surprised by the fact that popular culture is dynamic. One duty in the study of popular culture should therefore always be to archive moments and to preserve description. The study of popular culture is the study of meanings and the contests that surround the making of meanings. The second goal is to investigate the resulting cultural dynamic that exists between the creators and the players of the game.

Fans are creative. Textual poaching is a concept developed by Henry Jenkins to describe the activities of fans who develop their own takes upon texts (Jenkins 1992). While the expressions take on a broad range of forms and types, from the production of items associated with media texts to the complete reworking of those texts, all the expressions represent a proprietary political statement to some degree, as the fan reworks the materials of a corporate entity into a personal statement. Unfortunately there are

limits to this freedom. In his investigation of *Doctor Who* fans, John Tulloch has described fans as kind of "powerless elite" (Tulloch and Jenkins 1995, 169). For all that fans know of a text, in the end they do not truly own it. Since *Doctor Who* is a commercial text dependent upon ratings, fans are also at the mercy of a wider public. Fans may feel proprietary, but fans alone cannot determine the program's success. Fans have an obvious mastery of texts, but that mastery comes with little reward of power over that text and what happens within it.

As a game, HeroClix has many appeals for its players: competition, fandom, and collectibility. The game allows superhero fans to experience new freedoms and expressions of fan identity. Ultimately, the game serves as a resource upon which players have build a community. However, as an evolving game system, HeroClix challenges players' identities as superhero fans. With elements beyond their control, fans must negotiate with WizKids if this game is to be the basis of their community.

Methodologically, this analysis has been a curious adventure. Academics like to sell themselves a fiction from time to time. Born perhaps from quantitative studies in social science, academics like to pretend that they arrive at cultural phenomena fresh, somehow unsullied by past contacts, prepared to cast an objective eye out upon what they discover. Debates about the desirability of such a position aside, the actual stance would be impossible to take with most matters of popular culture for even academics live immersed within that culture. The simple fact of the matter is, most popular culture scholars discover something is academically interesting just as or after they discover it is personally interesting. Thus, the passion of the field is born.

I started playing HeroClix several years ago after some people began recruiting me to play the game. The first person works at a local comic book store (and we will meet him later in this analysis as the judge). Excited about the game, knowing my interests, and seeking to build a group of players for tournaments, he encouraged me to play. I resisted, making excuses about not wanting to spend money. Then, while visiting another friend, I sat down and played my first game. I was hooked and when I returned home I started playing regularly. As I played for several months, I began to experience "TAPITS" moments. TAPITS is an acronym created by my friend Dana Johnson about a decade or so ago to abbreviate the many times I had said "There's a paper in this someplace" while discussing various popular culture phenomena with her. So, while enjoying the game, I also kept an academic eye out. Ultimately, the TAPITS pressure grew to the point where I had to begin study. To some, a TAPITS approach might be an academic sin, but I saw it as advantageous. I had made an entry into the field. Plus I had a ready set of people to provide information.

Such a stance is influenced to some degree by Clifford Geertz. Although Geertz was largely concerned about anthropological study of other cultures and not popular culture (at least directly), for decades Geertz has been the champion of emic understandings (Geertz 1973) and the appeal of local knowledge (Geertz 1983). Geertz has always maintained that we should understand a culture from the point of view of its participants. I argue that a popular culture scholar is a participant in his or her own popular culture. Henry Jenkins has taken a similar approach in his study of fandom (Jenkins 1992). Jenkins admitted his own fandom and argued that by having his feet in both the academic and fan worlds, he was uniquely responsible to both (7).

While perhaps not ethnography in the strictest sense, this analysis is ethnographic. I communicated with the players at a HeroClix venue in central Virginia, asking them for information and clarification through direct conversation, e-mail conversations, and electronic bulletin board posts. All of the participants were aware of the study. Not all of the participants are mentioned by name. When they are, they have been assigned aliases in the reporting of data. All participants contributed something. The participants ranged in age from about their mid-twenties to their mid-thirties (with one, Nathan, being in his late teens). This analysis is built upon the understandings that were generously shared with me, but it proceeds first with an understanding of the nature of the HeroClix game itself.

HeroClix is a game played in pieces. As computer and video games continue to grow in popularity, it is somewhat nostalgic to consider a game in which physical objects are moved about on a table. HeroClix is not the only game of its type. Rather, it is part of a family of similar games, such as MageKnight and MechWarrior, that WizKids calls "Collectible Miniatures Games". The essential feature of HeroClix is a piece representing a particular superhero or super villain. Each piece includes a pre-painted sculpture ("sculpt") of a character glued on a combat dial. During play, the player physically "clicks" the base of the figure itself simulating combat effects. Clicking reveals a new set of numbers and color-coded squares on the dial in four categories: speed, attack, defense, and damage. Colored squares indicate superpowers such as "invulnerability" which protects against damage or "outwit" which cancels out other superpowers of opponents. This creates an interesting system of jargon, with players saying phrases such as "perplexing up" (adding to a combat value through the perplex power) or "I outwit your outwit" (when a player uses one figure's outwit power to cancel another figure's outwit). When clicking reveals a "KO", the character is knocked out and removed from the game. Each dial also features a point value for the piece that will be used in assembling teams. Some dials are also stamped with insignia representing the special teams

to which a character belongs such as Batman Ally, Minions of Doom, or the Ultimate X-Men. While the rules themselves may become quite complicated, on a basic level the game is played by rolling six-sided dice and comparing values on the combat dials.

Figures are released in "sets." Each set's name, such as "Hypertime" or "Armor Wars" evokes an important moment or concept in the licensed comic continuities and includes 100 figures or more. There are two main kinds of figures in each set, "REVs" and "uniques." The term REV is an anagram for 3 descriptors. Most characters in the game are represented by 3 different versions of the character at different times in his or her career represented by colors on rings around their dials: "rookie" (yellow), "experienced" (blue), and "veteran" (red). While the stats on the combat dial vary, and sometimes represent wholly different incarnations of the character, the REV system allows WizKids to re-use some sculpt designs. Uniques represent special versions of REV characters, or as is more often the case, special characters in their own right. Uniques usually feature their own sculpts or some addition to the pre-existing sculpt design.

For example, a character such as IndyClix's Hellboy has 4 different figures in the set. The sculpt for the rookie, experienced, and veteran version of Hellboy are all the same, featuring the hornless, trench-coated paranormal investigator in a familiar pose from the comics. Each version has different statistics on their dials and a different point cost. Hellboy's unique version is more demonic, representing the character when he bears the full horns of his heritage. The Xplosion set features an REV of the X-Men's Kitty Pryde, while the unique from the same set has her pet dragon Lockheed mounted on her arm. Some characters, such as Infinity Challenge's Thanos, have only appeared as uniques. Other characters may be represented in a number of different sets. For example, in each Marvel set, there has been at least one version of Spider-man. These figures are distinguished from one another by different sculpt poses and abilities on their dials.

Sets are sold in "boosters." Each booster contains 4 figures in a sealed box. Figures are randomly placed with some characters assigned a higher frequency than others. Assuming no attempts are made to penetrate the security of a sealed box, the player has no way of knowing what figures he or she will find within a booster. Uniques are almost always the hardest to find in a given set and they thus become "chase figures" that motivate more purchases. Some players manage this risk by purchasing a "case". A case contains 48 boosters and based upon the experience of buyers it should contain on average 6 to 8 unique figures. While it is not possible to guarantee everything, a case does, for a considerable price, take much of the uncertainty out of the process.

Players must be strategic in purchasing, balancing their desire for particular figures with their own available funds. Purchases of cases are sometimes shared, as Dan Connors explained: "When the case arrived I notified Cain and Nathan. We met at my house at about 11:30 PM. We then sat around my kitchen table along with Tammy and took turns opening boosters to see what we got. It was very exciting, almost like a party."

This example is also interesting because the opening became not just a commercial purchase but also a social event involving his friend, his brother, and his wife (who does not play the game).

Once players have figures, games are played by 2 or more players on a colorful foldout map. Maps depict places like the Batcave or generic locales like construction sites. All have grids to coordinate the HeroClix movement and terrain rules. Using a predetermined point cost, players assemble their teams using the point value found on the dials. Generally, the higher the point total, the more powerful a character tends to be, although there are also figures that provide a great range of abilities at a lower cost. Thus, the player must strategize in very complex ways about team construction.

HeroClix is played in one of two ways. A "friendly" game can take place at any time and progresses in whatever way the players' desire. All they must do is agree upon a point total and the victory conditions of the game. "Tournament" play is held at official venues, typically comic book shops or gaming stores, which must be vetted by WizKids. Tournaments are presided over by a judge who functions as a referee and judges are approved by WizKids.

At this particular venue, Barry, an employee of the comic shop, serves as a judge for weekly events. This is a role that draws upon skills of hosting and rules knowledge equally. Barry announces the number of points and any other special conditions that must be met to form a team in advance of the contest. Players bring pre-designed teams with them to play to meet these requirements. Prevented from participating in an event himself, Barry enjoys creating a fun and challenging tournaments. Barry strives for variety, holding a number of different types of events. He seeks to keep a large number of players returning week after week and by those standards he has been successful. As with many competitions, referees must sometimes make difficult calls about rules, but Barry has avoided many of the potential problems that could arise in his role by keeping his focus on the fun of the game.

While no part of this tabletop game is electronic, HeroClix would be difficult to play without the invention of the internet. Although the elements of the combat dial and the rules themselves are relatively simple, they combine quickly into complex issues that must be resolved. One

function of the judge is to resolve problems, but in any given game a question could arise that cannot be answered. Although full sets of rules have been published, the most recent being a small, 39 page booklet released with the Icons set (Weisman et al., 2005), the amount of time between sets makes for slow updates and many problems can arise in the game. In order to address these problems, WizKids maintains an updated How To Play section on their website for players and judges. This is the official ruling page concerning rule changes and interpretations. For this reason, HeroClix can become a very lawyerly game, forcing players and judges to remain current on rules interpretations and precedents.

Tournament play features official "prize support" from WizKids in the form of limited-edition (LE) figures given to the players and to the judge as compensation. These figures are distinguished from normal figures by a bronze ring around their base. Most LE figures re-use existing sculpts and are named after the secret identity of another character in the set. Thus, an LE of Spider-Man is labeled Peter Parker. The combat dials of an LE usually differs from the dial of the figure upon which it is based as well. Although some recent sets have featured LEs mixed into the boosters, most LEs are received only as prizes at official tournaments and thus they can desired even more than some unique figures. An official tournament typically has two prizes. One figure is awarded to the winner of the contest. The other is awarded to the person who showed the most "fellowship", a quality that is not explicitly defined but tends to embody good play, spirit, and humor. Since all players at a tournament vote on the fellowship prize, it serves to counterbalance any conflict that can result as players compete for the LEs.

The player strategies towards both friendly and tournament games can be divided into two broad modes. In "competitive" play, the players design their teams for maximum game efficiency. The idea is to win and players approach the construction of their teams with the planning of professional sports coaches or military generals. A competitive team demonstrates the player's creativity in mastering the intricacies of the game rules. By contrast, in "theme" or "thematic" play, the player seeks to build a team that represents the spirit of the superhero properties upon which HeroClix is based.

The HeroClix system has therefore three very broad appeals. The first is competition. Like any other game, from chess to poker, HeroClix offers a set of challenges, rules to master, and prizes to win. There are some players who have gotten into the game from different WizKids CMG or tabletop miniatures game systems. Most players of the game, however, also bring with them a sense of their own comic book fandom. While it is not the only game to ever do so, HeroClix thus offers a superhero fan

a second appeal, the opportunity to manipulate favored characters and to play out favorite scenarios. The third appeal to players is collectibility, a feature obviously encouraged by WizKids in the booster distribution system. By varying the frequencies that some figures are available, by producing special LE figures, and by limiting amounts of figures in sets, WizKids has encouraged a system of questing and trading. While no player has to have every piece to play, some seek to complete their collections and every player will eventually have a figure he or she wants or needs to complete a team.

Competition, fandom, and collectibility, have extended the profit making ability of the figures out beyond just WizKids. The value added to an item in a shadow cultural economy comes from its cultural importance (Fiske 1992). Philip, the owner of the venue, suggests that HeroClix "neatly compliments" his business. While comic books remain the major economic thrust of his store, the game's connections to fans of the superhero genre are obvious. A comic book shop thrives from the direct sale of comics but also through a shadow economy by drawing profit on the limited supply of certain comics. In a similar way, the shop can also profit from the sale of boosters and the sale of individual HeroClix figures from open boosters. The importance of HeroClix is reflected in the design of the venue in this study, where two glass cases of loose single figures sit next to the cash register, with the wall rack of rare comics just behind them. Comic shops are not the only places to benefit from this shadow economy. Online businesses selling figures (e.g. Popular Collections) and trading on eBay is vigorous.

Teams become representative of the person building them. Each player is thus a bricoleur, assembling a mosaic of pre-existing pieces into a personal statement of strategy and, more importantly, superhero fandom. One night, Dan might build a team featuring Spider-Man and his Amazing Friends or Rick might favor all-space alien teams of Skrulls or Kree. A theme team thus creatively demonstrates the player's knowledge of the superhero genre. At this venue, players who are not thematic are looked down upon. A team that is too competitive is labeled as "cheese". Since the three HeroClix systems use the same rules, players are also able to live the fan dream of mixing comic universes together without the complex legal wrangling normally required in the source comic books. Within the confines of the rules system at least, HeroClix can allow Batman to team-up with Spider-Man or can finally settle a fan debate about whether Superman could beat Thor.

The players at this venue sometimes call HeroClix "chess with superheroes" or "nerd chess," but unlike chess these tournaments are far from quiet. While rules and figures are the focal point, a successful evening of

HeroClix is made as much by conversation as it is by gaming. Although the fellowship prize encourages collegiality among players, at this venue genuine friendships have formed. In this way, tournaments are the resource for the formation of community, a small weekly reunion.

As one-on-one games run, players chat about their lives. People talk back and forth to each other among the tables or shout up to "Canada", "Finland", or "Iceland" (a nickname for any map put near the cold of the front door in winter). One can have a friendly argument with Jason about whether Jack Kirby is the god of comics or hear a sample of Floyd's wacky repertoire of comments. The social quality of the evening is such that some players will come by to hang out, even though they don't wish to play. As Jason describes it: "My decision to play or not depends usually on the workload I have that night or if I am in the mood to play. Whether it is the prizes that I am apathetic towards or whatnot, I am not certain. I usually stay for the camaraderie and such."

Not surprisingly, many conversations circle about superheroes and comics, but they can also extend out to related topics like other games, movies, and television. In-group joking occurs and gaming folktales spin into lives of their own. Nathan, for example, is often teased about his "rigged" dice (even if he's not using the same set). One evening after rolling five critical hits in a row (two sixes on the dice that have beneficial consequences for the player rolling), Barry jokingly insisted that Nathan's dice be tested. Nathan rolled the dice on the table saying "They're not rigged, see!" Of course, he rolled double-sixes again and the room exploded with laughter. Humor is valued in this environment, and in many senses, players are out-*witting* each other in conversation as their figures use the power of outwit on each other in the game.

At this venue, the interaction extended out beyond the weekly tournaments and into cyberspace when Clark started an electronic bulletin board for the HeroClix gamers. Other sites were always available, most notably HCRealms, the companion site to the official site for the game. Players can and do go there. However, they have also invested an enormous amount of time and energy online within their own community. Some areas on the site deal directly with the game, where players discuss rules and product updates or trade figures. In another area, players "review" pieces. While they follow a format similar to the small textual write ups that appear on the HeroClix site with many of the figures, the reviews go into more detail. A review assesses how well the comic book character has been represented in game terms and how useful the figure is in the game. At the same time, it allows the reviewer to another aspect of fan identity. Other areas on the site have very little to do with the game itself. There the players discuss comics, other media texts they have seen, or

activities. Again, the emphasis is on avoiding potentially hostile conflicts. As one topic string for Polls on the board says: "No Bush vs. Kerry BS either! For that matter, no political questions!" The players have even used the site to announce important life events, like the birth of a child or the emergency hospitalization of one of the players. HeroClix is the foundation of community.

As such, that community is somewhat vulnerable. For no matter how enjoyable the interactions are for the players, at the core of this community is a game owned by a company using characters licensed from several corporations. One major way the players feel this impact is through the design of the figures themselves. While HeroClix does allow a fan to live the dream of controlling their favorite superheroes, that control is achieved only insofar as the game designers have captured the essence of the character. Every player experiences some disappointment when the figure does not live up to their knowledge of the character. Floyd, for example, sees problems with Deathstroke and Superman: "Deathstroke is a master assassin, as we both know... yet he can't leap/climb and have stealth. Same with Supes. He's Impervious, but no super senses. He can use his team ability as an offensive threat... but he can't see the attack coming?" Although most players concede that the rules would not allow every character to be represented, some players find particular offense though when they perceive that a designer did not try. As Cain states "... my blood boils just remembering how poor Lady Shiva and Cassie Cain [Batgirl] got ripped off cause this guy couldn't pick up a comic to read." In the comics, both of these characters are supreme martial artists, known for rivaling Batman himself. In the game, they are far from that.

In marketing its product to a broader group, WizKids differentiates HeroClix from other miniatures games like Warhammer by selling a prepainted product. Thus, it is not necessary to master the skill of miniatures painting to participate in the game. It is somewhat surprising to find, therefore, that some players participate in "customizing" or "modding". As textual poachers, these players create their own superhero figures by reworking sculpts and dials of existing characters to make new ones.

As a form of poaching, modding can be as simple as replacing a head or repainting a costume. It can be as complex as cannibalizing the parts of other pieces to assemble a new pose or form, a Frankenstein-like ambition made easier by the abundance of duplicates pulled in booster hunts. Modding is strongly influenced by the player's fan identity. A series of complicated motivations enters into the decision to customize a piece. As with collecting or thematic team construction, modding pieces becomes an expression of the player. Cain is motivated by the desire to have characters that aren't available and to fill out missing members of teams. He also

fixes mistakes he sees in sculpts: "Supergirl and Lady Shiva both made me sick and Penguin wearing white? Not the Penguin I remember by golly." Todd, for example, is into "characters that will NEVER be made into real HeroClix". A fan of all things Spider-Man, Dan has developed a number of characters from the extended Spider-family. Some modders have even gone so far as to create pieces using characters outside the licensed super-hero continuities. Nathan Connors loves to make customs based on video games instead of comics. Like many textual poachers, Nathan is proud of what he did: "It was such a sense of accomplishment to have made a video game character off of my video game knowledge and memory." However, Nathan is also aware that his hopes may not be fulfilled: ". . . maybe I'll get lucky one day and they will actually make video game clix. Until then, I have custom work to do."

As a form of textual poaching, modding puts the players in a political dynamic with WizKids. In re-working these figures, the modders are suggesting that their fan knowledge is on par with, if not greater than, the official game designers' knowledge. Yet the activity does not have a completely rebellious edge. Modding is not explicitly about replacing the HeroClix game system. Cain may have hated certain figures, but he does not hate HeroClix. These players still collect the pieces, still play the game. Modding is a side activity, a way to use the extra pieces generated during the collecting process to express some individuality. This interpretation is supported by the fact that modders will sometimes give their customs as gifts to others. Such gifts once again suggest the strong social element of the game. WizKids contains this creativity though. Customs are not allowed in official tournaments. So if a player wishes to win an LE, he or she cannot use these pieces. In this way, WizKids may only be outwitted so far.

Closely related to this issue of design is retirement. WizKids has ruled some older sets and figures as ineligible for official tournament play. Wiz-Kids has an obvious commercial motivation, as the retirement of old sets encourages the consumption of new sets. While retirement is not an issue for friendly games, anyone who wants to win in an official tournament cannot use customs. Retirement invalidates all of the effort that players made while booster hunting, particularly if the player spent money to ac-quire rare pieces in a secondary market. The popularity and game versa-tility of the X-Men's Nightcrawler unique, for example, drove the price of the figure beyond $100. Along with the rest of the Clobberin' Time set, Nightcrawler is now retired. Finally, retirement can also affect fan sensi-bilities. The retirement of Clobberin' Time left fans without classic mem-bers of the Fantastic Four.

However, many players also recognize a benefit to retirement. Hero-

Clix is an evolving game system. Many rules have changed over the years and there is a general sense among players that in hindsight some early parts of the game were not quite right. The retired Firelord is cited as an example of a figure whose design was off. While no player knows the formula the designers use to calculate a figure's point total, Firelord's offensive capabilities in the game clearly outstripped his low cost. Retirement is also a way to get rid of pieces that did not pass muster against fan knowledge. There is little mourning for the loss of early versions of Juggernaut and Magneto, for example, which were not nearly as tough as their comic book incarnations.

Interestingly, WizKids has yielded some political power back to the venue. Each venue is allowed to have "house" rules. At this venue, for example, house rules impose a lack of offensive attacks on the first round and use the "Highlander" system (a tribute to the film of the same name) where there can be only one version of each character on a player's team. These house rules aim to prevent the first player from having too much of an advantage and to keep teams at least minimally thematic. The power ceded by WizKids is limited though. House rules may not substantially alter the game.

In some ways, this situation is reminiscent of many other popular, if less complex, games. For example, many American families have for generations played a version of Monopoly in which all money collected by the bank in the game goes into free parking and any player landing on that space wins that pool. Much to the surprise of many, there is no official rule for that in Monopoly. Yet some players prefer to play the unofficial way. WizKids has found a way to adapt this rebellion. After all, in friendly games, anything goes as long as the players agree. In sanctioned tournaments, to a limited degree, house rules allow the unofficial to become official. Ultimately, the judge is the primary enforcer of these rules. In many ways, the judge arbitrates between the needs of the players and WizKids.

WizKids also has another form of enforcement. WizKids representatives make checks on official tournaments. These are random and unannounced. At this venue, when rumors of the first retirement of Marvel HeroClix sets began to circulate (but had not been officially announced), some players began to wonder if it was possible to just ignore the decision. Any rebellious thought was quickly squelched when the players learned that another venue in a neighboring city had been shut down by a WizKids representative. While the violation apparently had more to do with holding an event earlier than allowed and not rules violations, players quickly realized that any rebellion could lead to loss of venue. While the social aspects of HeroClix are a draw, players were not willing to give up their access to exclusive LE figures.

346 *Michael G. Robinson*

In the end, this is the cultural place in which HeroClix players exist, free to pursue the game in any manner. Free that is, until a prize is desired. Then the player must enter the tournament world and adapt to the confines established by WizKids and the social expectations of fellow players. The player must negotiate, working to mesh a fan's vision of superheroes with the company's game design. There are ways to resist this vision, but just as the outwit power in the game only cancels another figure's powers temporarily, so too must the player recognize that the powers to resist can go only so far if the player wants a prize.

Yet this does not always seem to bother players too much. It was hard to find outright resentment for WizKids. Yes, players do complain. Sometimes in a post a player will even make a Freudian slip, adding the extra "h" to make it a more derogatory, excretory *Whiz*Kids. Yes, players do customize or mod. However, they keep playing too. Their overall sense is that as a game system, HeroClix is good if imperfect, that it needs work but is largely playable. These players are willing to keep working with it, for in the end, HeroClix is a foundation upon which their community rests.

25
Cyborg Girls and Shape-Shifters: The Discovery of Difference by Anime and Manga Fans in Australia

Craig Norris

This essay explores how manga (Japanese comic books) and anime (Japanese animation) fans in Australia construct ideas of manga and anime's difference and Japanese-ness. It is based on a number of interviews I conducted with members of anime clubs around Australia, particularly looking at how fans' racial and gender identities were being constructed through their experiences of manga and anime[1]. While the manga and anime characters I'm looking at are not conventional superheroes–they don't have special costumes, and rarely do they battle against clearly defined villains for a noble cause–there are some general connections where the fans' favorite characters do perform heroic acts, saving cities from marauding cyborgs, terrorists, and malicious government and military organizations. Saving and helping the people they love around them, and so on. And, if we consider one of the acts of superheroes to provide role models to others–then these characters and their flaws and differences do provide fans with 'super herioc' role models of difference they can use to critique racist, culturally exclusivist identities they perceive in Australia. It is also the moral ambiguity and often all-too-human weaknesses of the characters that many of the fans I interviewed pointed to as an important element of their enjoyment–saying that because these stories were not American superhero adventures gave them a way of exploring and promoting a different type of cultural capital and identity.

The Discovery of Difference

A critical stage in the 'identity project' of anime fans in Australia is the discovery of *difference*. Many fans I interviewed mentioned a shift in their perception of anime from initially accepting it as an integral part of mass media entertainment, to seeing it as "different," and then recognizing that difference as coming from its Japaneseness. Fans often articulate this

difference to the language, art style, characters, and story lines of manga and anime, and can express it in two significantly different ways. First, fans can appropriate anime as an ideal object, as suggested by the experience of Neil:

> My first experience was at school about three years ago, a friend bought a *Super Nintendo* magazine to school that had a section called anime world, and I was looking through it thinking "Oh My God!" It was like a revelation, "I'd seen the light". I thought that looks so cool but where would I be able to find it? So, I began looking through the *Yellow Pages* for comic book stores and I found *Phantom Zone* in Parramatta and that's where I started. (Neil, 20, student)

Neil describes his experience of the distinctive character of anime as an epiphany, a "revelation" in which he had "seen the light". In other words, anime became appropriated and identified with as an idealized object. While Neil's story is about the appropriation of anime as a perfect object, Brian relates a different type of relationship towards anime:

> The original anime I saw was *Ranma ½*. After spending a couple of days in that video room I had received whole new story concepts and ideas, a different and exciting cultural slant on reality, and the concept of an ongoing story that progressed logically and was not bound by individual episodes. (Brian, 22, student)

Brian describes emerging from the video room with a "different and exciting cultural slant on reality"; he claims this life-changing experience caused him to reflect on how he understands certain textual processes: "an ongoing story that progressed logically". Furthermore, he believes he has gained new approaches to "story concepts and ideas". Brian identifies textual codes and symbols that hint at a recognition in manga and anime of cultural otherness and difference experienced at a cultural and social level, while Neil's idealization of anime and desire to accumulate more— "where would I be able to find it?"–suggests the psychological dynamics of identification and appropriation.

Shape Shifting

Here I will focus on the appropriation of two manga and anime forms by Australian fans that further reveal the process of identification and experi-

Figure 35: The cover of the DVD version of *Ranma ½* (1987-1996).
© Viz Media

ence of anime that Neil and Brian articulate. First, the gender transformation offered by the character of Ranma from *Ranma ½* (1989-1992) and his shape shifting into a female in cold water or a male in hot water. Second, the union of humans and machines into cyborgs or pilots cocooned within giant robots. Ranma's sexual transformation offers an exploration of gender politics, while the depiction of cyborgs, particularly Asian female cyborgs, offers gender and identity politics merged with new technologies. Water and machines are symbols of physical metamorphosis that transform those who engage with them; they offer power to change one's identity and body, to become someone or something different.

 Ranma ½ is a martial arts comedy by the popular female manga artist Rumiko Takahashi. The series blends slapstick comedy and melodrama, a rich cast of supporting characters, and a contemporary setting in a Japanese town and school to create a long running and popular television and manga series. *Ranma ½* is the story of young martial artist Ranma Saotome. While training with his father in China they both fall into a cursed spring causing Ranma and his father to transform into whatever had perished there. The water of the spring transforms Ranma into a buxom female version of himself, and he is cursed to become his female alter identity whenever cold water is thrown over him. He can be changed back into a male only when doused with hot water. Ranma's father, Mr. Saotome, becomes a giant panda cursed to continue his transformation by cold and hot water like Ranma. However, Ranma's gender transformations are the central comedy dynamics of the series.

I Wish I Had a Japanese Bath

Sarah, a 19-year-old University student I interviewed during my field research, described herself as a big fan of *Ranma ½* and other similar comedy/action anime such as *Fushigi Yugi* (Kamegaki 1995) and *Project A-KO* (Nishijima 1986). During our interview, she frequently mentioned the escapism and creative freedom that these favorite anime offered her. As we discussed what was innovative and different about manga and anime, we narrowed our attention to the "Japaneseness" of anime and the unusual characters, settings and themes within *Ranma ½*. I asked her how she felt this "Japaneseness" was expressed in anime:

 Initially when one first watches something like *Ranma* with the bath sequence, one can be very conscious of it, I wish we had baths like that! Less so with things picked up by the Americans for dubbing for early morning children's shows like *Tekkaman*. I became

less aware of any "Japaneseness" as I watched more of it and it became normal for schoolgirls to have huge eyes, cute voices, and *seira fuku*.[2] Now it's a question of how to define a person's normal cultural perception as opposed to a *Japanesed* one. Perhaps mine is a little skewed in the direction of Japaneseness as normal. (Sarah, 19, student)

The bath scene Sarah describes is an example of the outrageous comic world of *Ranma ½*. During the first episode, Ranma, in female form, is taking a hot bath to change back into a male, when Akane, the woman to whom Ranma is betrothed, walks in expecting to find a woman in the bath. Akane's confusion and Ranma's embarrassment when his masculinity is discovered helps establish the reluctant love-hate romance between Ranma and Akane that is the centerpiece of the *Ranma ½* world.

For Sarah, however, it is the act of bathing, and the transformation it offers, that fascinates her. The bath is the site where a magical transformation is possible. In a way, Sarah seems to recognize that immersion in the text itself is a valuable source of appropriation and borrowing. It has changed her, predisposing her to consider "Japaneseness as normal". In her interpretation of the scene, Sarah transforms the bath from an everyday object into an object of transformation and an opportunity to take on a new identity. Ranma's bath is a Japanese object for the Western fan, unremarkable in itself for many Japanese but different from a Western bath (for further information see Clark 1992). The bath is a sign of difference and foreignness that can be understood and employed by the Western fan, as an element with which to construct an imagined life for oneself (with "Japaneseness as normal"), and the other of a different land ("I wish we had baths like that"). The bath and Ranma's contact with water to alter gender, is an appealing metaphor for gender and identity change, as well as suggesting a desire for knowledge of a hidden, perhaps forbidden, self. The metaphysics of a "bath like that" offers an imaginary bi-sexuality through the humble act of bathing. Sarah's play with gender and identity is typical of the fan activity identified by Henry Jenkins (1992) in which a mainly female fan culture scrutinizes and appropriates their favorite programs through online discussions, convention participation, and through writing fan fiction and producing fan videos. Jenkins (1992) points out that fans interpret popular culture in sophisticated ways, they deconstruct and reinvent plots and characters using a broader knowledge of their favorite program's history and larger social, cultural, economic and political issues relevant to their interests and desires. Sarah's reading of Ranma's bath responds to, and complements, her interest in anime and Japan and shows how fans make sense of their interests and sustain their investment

in popular culture through intertextual means and broader associations.

In looking at how a fan of *Ranma ½* constructs their interest in the text it is possible to see the rich intertextuality and play offered by the shape-shifting motif in anime. Napier's (2001) critical analysis of *Ranma ½* points to a conservative agenda within the story's gender transgressions and amusing sexual content. Napier argues that Ranma's transformations, unlike that of the more explosive character of Tetsuo in *Akira* are always contained within the "normal" world. As Napier explains:

> While boundaries are crossed and re-crossed to often riotous effect, the inevitably more conservative format of a weekly television series ultimately leads to a conservative resolution in which, at the end of each episode, the boundaries are reinscribed into the conventions of heterosexual hierarchical society. (2001, 50)

While she acknowledges that *Ranma ½* draws upon the tension between the construction of gender identity at the individual level and society's enforcement of gender norms at a public level, most of the comic situations generated by Ranma's transformations "never actually unsettles society's basic assumptions about the gender" (Napier 2001, 50). As Napier points out, *Ranma ½* is set within a relatively normal, everyday world, compared to the hi-tech dystopia of cyberpunk anime such as *Akira*. Stripped of its fantasy elements, argues Napier, Ranma's story offers a view of the difficulties of adolescence, body development, loneliness, and maturity:

> Neither boy nor girl, Ranma occupies a liminal space that, although played for comedy, is actually a forlorn and isolated one. Unlike the typical narcissistic adolescent who simply *feels* "different," Ranma *knows* he is different, and therefore isolated. Or as he puts it at the end of the episode, "Friends, she says, so much for being friends when she found out that I'm a boy." (Napier 2001, 54)

In the context of the superhero, Ranma is a significant departure from the obvious superhero character. That is, what's interesting here is that, rather than the transformation of identity being from the everyday to that of the secret and powerful super identity, it's about a different metamorphosis—one that explores transformation from one kind of everyday identity to another. This can be seen in Ranma's transformation from a male into a female resulting in a loss, rather than an increase, in power. He is shorter and weaker, causing his skills—such as his martial arts abilities—

to diminish. Becoming female is a humiliating and shocking experience that is coded entirely negatively (Napier 2001; Newitz 1995). His father is deeply disappointed in his girlish transformations; at one point, he throws Ranma into a pool shouting: "I am so ashamed of you". Napier draws upon Eve Sedgewick's term, *homosexual panic*, to suggest that Ranma-as-girl represents "the fear of the heterosexual male that he is really homosexual" (Napier 2001, 54). Within *Ranma ½*, this reading is established by the character of Kuno, a master kendo swordsman, becoming infatuated with Ranma, who he believes to be a woman. Newitz (1994; 1995) furthers the idea of a "homosexual panic" within male readings of *Ranma ½*, arguing that the male anime audience in the United States is emasculated by watching romantic anime. "Quite simply," claims Newitz, "*Ranma ½* demonstrates to the young man who enjoys romantic comedy *anime* that he is constantly in danger of becoming a girl" (1995, 6). Newitz argues that because the romance genre of anime consistently portrays women as passive, the loss of power that Ranma's female form suggests, is transferred onto the male fan population, with an equivalent loss of their 'power'. "Like Ranma," points out Newitz, "the male *anime* fan has a 'feminine half' who enjoys passively consuming animated fantasies about love. His attachment to non-sexual romance might be said to feminize him" (1995, 6). Newitz implies that any ambiguous feminization, bisexuality, or homosexuality suggested by ambiguously gendered characters, is, at the very least, a source of discomfort for male fans, and at the worst, some form of gender victimization of fans in the United States:

> Especially for the heterosexual male fan who watches *anime* in an American context, this fear would be particularly acute, since American romantic comedies are aimed at a largely female audience. (Newitz 1996, 6)

Newitz's identification of a "homosexual panic" within the male reception of anime appears to be generated by a broader fear of Japanese cultural imperialism, in the wider United States culture. Newitz reads anime as endorsing, in this case, gender conservatism by reinforcing stereotypical sex roles.

Sarah's privileging of the bath as a site of pleasure is centered on the appeal of transforming into the different and exotic. She sees the transformation into "masculinity" as appealing, and her dissatisfaction with the "feminine" form confirms Napier's reading of the conservative subtext within *Ranma ½*. In addition, while Newitz may have focused on *Ranma ½*'s male fans and their emasculation, Sarah demonstrates the other side, the benefits of being male for women.

Cyberpunk

While the transformation of Ranma departs from the traditional notion of the superhero as a shift from a normal identity to a secret and powerful super-identity the cyborg in anime often reveals a more conventional function of the hero. That is, the cyborg offers the transformation from human to super-human through the merging of human and machine. However, just as in *Ranma ½*, gender plays an important role in contextualizing the transformed body and providing anime's "Japanese" difference from western forms for its fans. The central female characters of two of the most well known cyberpunk anime: the films *Akira* (Otomo 1988) and *Ghost in the Shell* (Oshii 1995), are deeply introspective and associated with an exploration of spiritualism and existential contemplation. Kei, in *Akira*, develops her telekinetic powers during the story to help restore the chaos unleashed by Tetsuo, while *Ghost in the Shell*'s Major Kusanagi questions her identity and sense of self as a human/machine hybrid. Many male anime fans I interviewed described how appealing they found these strong female characters. The female cyborg's (and female psychic's) combination of masculine and feminine qualities provided a different image from the sports heroes or outback explorers that dominate Australian male stereotypes, such as Paul Hogan's Crocodile Dundee (Faiman, 1986) character or Steve Irwin's *The Crocodile Hunter* (Stainton 2002) figure. I analyze the similar appropriation of *bishōnen* (beautiful boy) characters by female anime fans who want to explore alternative gender politics. However, the male fan's appropriation of strong female characters in anime, as an icon of resistance and difference, raises significant issues regarding how the image of Asian femininity is contained within existing notions of exotic and sexually available stereotypes.

The term "techno-orientalism" (Morley and Robins 1995) is an extension of the concept of orientalism which, put simply, is the idea that the West invented the concept of "the Orient" to define and legitimize its own cultural identity. Within the appropriation of anime in Australia, techno-orientalism seems an appropriate description of the hi-tech fantasies some fans create from the cyberpunk imagery offered in anime like *Ghost in the Shell* and *Akira*, and the image of a futuristic, technologically superior Japan. Tom, a 19-year-old student, spoke of the similar cyberpunk representation of Japan he constructed through the imagery of anime and manga:

There's gangs of juvenile bikers clashing with police, if you're lucky you get experimented on genetically and get telekinesis, huge demons lurk in the shadows, all women are there for is to have sex, want sex, and get raped by the demons, and in the middle

of Osaka there is a huge monster called 'the Chojin' constantly destroying the city with a ray of light from his mouth. Tokyo is the same, except the monster is called Godzilla. (Tom, 19, student)

The fantasy of gendered violence that dominates Tom's image of the techno-orient is one imagined world of the cyberpunk, which is drawn from titles such as *Akira* and *Ghost in the Shell*, or the soft-porn occult stories such as the *Legend of the Overfiend* (Takayama 1989). In these stories, women play central roles, whether it is as the strong, independent character of Major Kusanagi in *Ghost in the Shell*, or as the passive and submissive women in the 'tentacle rape' scenes of *Legend of the Overfiend*. These images evoke both new and old fears and desires of a techno-orient. During my interview with John, he described his admiration of the assertive and independent femininity Japanese animators had been able to depict in cyberpunk anime:

> Craig: I'm interested in the cultural differences you pinpoint between Japanese animation and the cultures it enters. I'm wondering if you can define the 'Japaneseness' of anime or manga. Is there any 'Japaneseness' in there?
> John: When you talk about who Japanese animators choose for lead roles and how their lead roles are defined, women in Japanese manga always play a prominent role. Such as in the cases of a recent manga that I've seen, *Ghost in the Shell*. The main character is a female cyborg who is strong, assertive, very intelligent, and the leader of the police team she's in. Often in Hollywood films, you'll see the woman falling into that role, becoming that role, but not starting off in that role, not being the leader to start with. (25, student)

In the Australian male's fantasies of the techno-orient, the exotic woman may perpetuate or challenge dominant notions of femininity. For John, Major Kusanagi, the female cyborg of *Ghost in the Shell*, is a symbol of a new alternative power of Asian femininity. Compared to Tom's "all women are there for is to have sex" imagining of the exotic Asian woman as a sex object, available and submissive, John's perception of exotic Asian femininity is associated with a symbol of new Asia, an Asia that is cosmopolitan, rich, modern, and technological; populated by women modeled on a "female cyborg who is strong, assertive, very intelligent, and the leader". The powerful and intelligent female Asian cyborg has become an alternative heroic model that challenges the stereotype of the passive Asian woman. The female cyborg hero such as Major Kusanagi in

Ghost in the Shell, may be beautiful, exotic and sexy but defeats the villains and overcomes her challenges with an intelligence, strength and cunning beyond any man. The female cyborg commands and controls the techno-oriental future. The new exoticism of Asian femininity indicates the possibility for a new politics of transgressive pleasure and resistance that may reformulate the concept of the exotic and offer an Asian female hero as normal and accepted.

Fans conceptualize the transformations into the hard bodies of machines or the softer bodies of another gender within inwardly focused stories that ask: how could my life here in Australia be different? The desire for transformation, or the experience of some different identity, is a central concern expressed in the appropriation of anime by Western fans. Part of this desire for difference is because many fan's feel some level of alienation from the dominant culture. Scott, for example, complained of the lack of alternative identity choice offered within Australian culture, and the cultural hostility towards all things Japanese:

> Some people mock me about the eyes of manga characters, but that just means they haven't seen any real manga. Most people are interested, and once exposed to the real thing, want to see more. Some of the more closed-minded "redneck" type Australians who are just plain racist, hate anything that's not a Holden Ute, and just tend to despise anything that they don't know about sometimes give me flack. But who cares anyway? Their lives suck. Maybe manga would be too cool for them. Probably. (Scott, 17, student)

The resistance and frustration Scott expresses towards what he perceives as the dominant "redneck" culture of Australia, reveals both a motivation for finding an alternative identity in anime, as well as suggesting a certain level of shame at not living up to the image of Australian masculinity. A masculinity idealized through such heroes as Michael J. "Crocodile" Dundee from *Crocodile Dundee*. Karl, a 23-year-old Information Technology student, sees a parallel between the illusions of a Japan defined by manga and a masculine Australia defined through popular movies:

> Hmm the good thing is that I don't get my views of Japan from anime. It'd be like getting your views of Australia from *Crocodile Dundee* or *Priscilla Queen of the Desert*. It's a form of entertainment, it's a part of the culture. It's not "the" culture. I get my ideas and images of Japan from Japanese friends and Australian friends who have lived there. (Karl, 23, student)

Karl and Scott take refuge in the hybridity and diversity of identities offered in anime and in the way these identities connect with the life experiences of friends and acquaintances. It indicates the difficulties many Australian male anime fans find themselves in as they attempt to assume identities or interests that may stray from dominant stereotypes of male behavior. Ideals that are often enshrined in the male hero through an exaggerated display of masculinity showing physical strength and courage, aggressiveness, and emotional detachment. While Karl and Scott offer a critique and rejection of the hero stereotypes of machismo such as the laconic bravado in *Crocodile Dundee* there is equal rejection of the glamorous, gay, city slicker alternative offered in *Priscilla Queen of the Desert* (Elliott 1994). It also reveals that the appropriation of anime elements, that can then be transformed into imagined lives or other worlds, are only ever partial escapes from the pressures to conform to sexual identity and broader societal expectations of "normal" behavior or the ideals of the male hero.

Alternative Identifications

The potential new identifications that Karl and Scott perceive in anime offer an alternative from the culturally exclusivist identities offered in Australia—the racist redneck, the bushman, the outback worker, or gay city dweller. The enjoyment of the manga and anime forms, and the freedom they allow to explore spaces that are not restricted to a national or regional level, reveals the global scale many of these fan 'identity projects' operate on. Karl describes how he doesn't rely on manga and anime forms to frame nationalist images of Japan—"It's not 'the' culture,"—suggests that his enjoyment of manga and anime lies outside national or inter-national spaces and within other 'identity projects'. The racism, prejudice, and nationalism associated with essentialist identities of Australianness create feelings of disaffection that generate a desire for new kinds of identifications.

The consequences of these new kinds of identifications fans explore through manga and anime can be seen most clearly at the domestic level of the family. Most of the fans I interviewed during my research were aged between 15 and 23 years old and still living at home with their parents. Because of this, their use of anime was often initially appraised by both siblings and parents. Conflicts would sometimes arise over the time allowed to watch videos on the family television and VCR, or parental concern over the amount of money their son/daughter was spending on anime and manga. Often the problems would be over issues of enforcing

time management and better consideration for other members of the household. In some cases, however, anime became central to wider tensions and difficulties within the family. Some fans described sudden and unpredictable strains on the family group that occurred as anime and other entertainments provoked disagreements over identity, control, and family unity. Greg described the suspicion and criticism he received from his parents upon their discovery of his enjoyment of anime:

> Well, I have a real problem at the moment, because my parents are English and my grandparents are English and they all grew up during the war, and you mention anything Japanese and you're out the door basically... My parents just talk about the war, they would always talk about the war when I was over at my grandparents place. So, I've got to watch what I say. I can't watch anime when they're home, I have to wait until everyone's gone before I can watch anything... I've never spoken to them about my interest in manga and anime. I know that they don't want to talk about it. I mean they know that I watch it, but they strictly say, "No, you don't watch it while we're home". So I have to watch what I do. It's not so much the stuff that they hate; it's the being Japanese that they hate. They just basically don't want to know anything Japanese. They don't watch much TV. (Greg, 23, sales clerk)

Greg's story is significant for a number of reasons. First, we can see how anime—as a new commodity—is negotiated within existing structures and beliefs of the family that are enforced by the parents. At a larger, political level, one can see how, as Appadurai puts it: "larger politics sometimes penetrate and ignite domestic politics" (1996, 44). Here, anime performs a more significant heroic function. That is, the anime itself and the way fans appropriate it reveals possibilities for social change – a role traditionally assigned to the hero. Using motifs within anime, fans challenge the frustrations around them and hold out the hope of some change for the better. Greg has split from his parents and grandparents on a key matter of "political identification in a transnational setting" (Appadurai 1996, 44). His parents and grandparents remain strongly committed to the image of Japan as their wartime enemy of World War II, while Greg has become a fan of manga and anime, a popular culture that both he and his parents see as distinctly Japanese. Thus, Greg must hide these interests so that he can still get along with his parents: "I have to wait until everyone's gone before I can watch anything." Greg realizes that it is not the animation itself that is the problem but its "Japaneseness." The dilemma of Greg's attraction to anime hints at the almost illicit fantasy of imagining

and even identifying with this taboo other. Greg's story suggests that he is torn between the independence that watching anime gives him from his parents and grandparents, and the dominance of his English family heritage.

Greg's dilemma also reveals the important role that the media plays in providing images and information offering the potential of cross-cultural affiliations and construction of imagined worlds. Significantly, Greg concludes his story by mentioning that his parents do not watch much television. The television, then, becomes a symbol of the changes in attitudes towards Japan since World War II. First, it is a literal example of the type of hardware that Japan exported since World War II to establish its rise as an economic superpower and foster its image as a hi-tech economic superpower. This image now dominates the image of modern Japan for the youth generation Greg is part of. Second, television is a medium used to distribute content such as anime so that fans, such as Greg, can imagine different identities and worlds through the political and cultural formations he perceives within these images.

Conclusion

One issue that these shape-shifting bodies provoke is the problem of how to analyze the significance of the Japanese origins and content of manga and anime. Anime bodies appear to have no clear ethnicity; their hair and eye color, comic-book features and proportions can divorce them from any realistic representation of ethnicity (Iwabuchi 2002). The softening of the "Japaneseness" of these anime bodies means they can be easily domesticated into any local market (Iwabuchi 1998). However for others, these anime bodies are strongly bound to the aesthetic traditions and cultural peculiarities of Japan (Schodt 1983; Levi 1996; Schodt 1996). The various readings of anime as global commodities, culturally removed of a Japanese presence, or as an extension of a uniquely Japanese approach to image and narrative, are, of course, dependent on context. While some bodies may look very Western, with blonde hair, blue eyes, and so on, often their actions are "Japanese." This is evident in the case of *Sailor Moon*, a character who may have blue eyes and blonde hair, but nevertheless reveals her "Japaneseness" through banal disclosures, such as using chopsticks and eating Japanese food, visiting Shinto shrines, wearing a Japanese school uniform, and so on.

Napier locates anime's appeal in its ability to be both distinctively Japanese and universally appealing:

[Anime] is both different in a way that is appealing to a West-
ern audience satiated on the predictabilities of American popular
culture and also remarkably approachable in its universal themes
and images. The distinctive aspects of anime—ranging from nar-
rative and characterisation to genre and visual styles—are the ele-
ments that initially capture Western viewers' attentions (and for
some viewers these may be the main keys of attractions), but for
others it is the engrossing stories that keep them coming back for
more. (2001, 9-10)

Thus, a central feature of anime today is its dual identity as both fa-
miliar and different for fans. In this way, anime can be considered as part
of the transnational flow of cultural material; it is both "triumphantly uni-
versal" (Appadurai 1996, 43) in its capacity to be exported globally and
domesticated to suit many different local environments, while also being
"resiliently particular" (Appadurai 1996, 43) in the differences that can
be found between Western and Japanese visual aesthetics. Here, I have
shown how the familiar and different forms of manga and anime have
been used by fans to explore the possibility of shape shifting into different
sexual identities and global cultures as a way to resist and negotiate the
exclusivist national identities they perceive in Australia. The theme of fans
escaping from an alienating domestic/national space into a global manga
and anime culture through the hybrid texts that fans construct performs
a significant heroic function. The possibility of social change revealed by
the way fans appropriate certain anime forms evokes the role traditionally
assigned to the hero. Instead of a hero fighting to uphold the idealized
virtues of truth, justice, and a way of life, it is the fans who draw upon
this function of the hero to respond to, complement, and even challenge
social and cultural assumptions around them. It occurs in the establish-
ment of different transformations of the hero, such as Ranma's metamor-
phosis from one kind of everyday identity to another rather than a secret
or powerful super identity, or the acceptance of the female Asian cyborg
as an alternative heroic model. The social dynamics fans locate these iden-
tifications within–pressures to conform to a gender identity and broader
societal or family expectations of "normal" behavior–shows how fans
make sense of their interests and validate their ideals through intertextual
means and broader associations. As Napier suggests:

Anime's immense range enforces that there is no single anime style
and that the "difference" it presents is far more than a simple di-
vision between Japan and not-Japan. Anime thus both celebrates
difference and transcends it. Creating a new kind of artistic space

Borrowed Items 11/10/2010 14:44
XXX0231

Item Title	Due Date
Wallace and Gromit : the cur...	15/10/2010
Where the wild things are [vid...	15/10/2010
* World mythology: the illustr...	01/11/2010
* Super/heroes: from Hercule...	01/11/2010

* Indicates items borrowed today
Thank you for borrowing today

University Library Rochester
libraryroch@ucreative.ac.uk
01634 888734
www.community.ucreative.ac.uk/library

University for the Creative Arts

Borrowed Items 11/10/2010 14:44
XXX0231

Item Title	Due Date
Wallace and Gromit : the cur:	15/10/2010
Where the wild things are [vic	15/10/2010
* World mythology: the illustr:	01/11/2010
* Super/heroes: from Hercule:	01/11/2010

* Indicates items borrowed today
Thank you for borrowing today

University Library Rochester
libraryroch@ucreative.ac.uk
01634 888734
www.community.ucreative.ac.uk/library

that remains informed and enriched by modes of representation that are both culturally traditional and representative of the universal properties of the human imagination. (2001, 33-34)

As Napier proposes, the denial (Ueno 1999; Iwabuchi 2002) or celebration (Levi 1996; Schodt 1983, 1996) of an essential "Japaneseness" within manga and anime, is part of a more complex, transnational uncertainty of manga and anime's representations of identity, and cultural value. The appreciation of manga and anime's "Japaneseness" by some fans and scholars creates a space where new and different aesthetics and experiences are explored. The many different communities, from cultural industries, Anglo and Asian-diaspora anime fans in Australia, to Western scholars, use a variety of manga and anime forms to explore gender politics, reconstruct identity, and reiterate the cultural value of these forms.

Contributors

Lisa Beaven is an art historian and lecturer in art and visual culture at La Trobe University. Her M.A. was from the University of Canterbury, New Zealand and her PhD from the University of Melbourne (2000). Her research interests are concentrated on art patronage and collecting in seventeenth century Rome and her current project is a study of landscape painting and malaria in the Roman Campagna.

Andrew Burn is a senior lecturer in Media Education in the School of Culture, Language and Communication at the Institute of Education, University of London. He has published on many aspects of the media including the use of horror films in schools, young people's digital production and the semiotics of computer games. He is the contributing editor of the international journal *Changing English* and an associate editor of the journal *ECI (Education, Communication, Information)*.

Ruby Blondell received her PhD in classics from the University of California at Berkeley in 1984. She is now a Professor of Classics at the University of Washington in Seattle. Major publications include *Ancient Mediterranean Women in Modern Mass Media* (co-edited with Mary-Kay Gamel; *Helios* 32.2 [2005]); *The Play of Character in Plato's Dialogues* (Cambridge University Press 2002); *Women on the Edge: Four Plays by Euripides* (with Bella Zweig, Nancy Sorkin Rabinowitz and Mary-Kay Gamel; Routledge 1999); *Helping Friends and Harming Enemies. A Study in Sophocles and Greek Ethics* (under the name Mary Whitlock Blundell; Cambridge University Press 1989).

Peter Coogan is the writing specialist for the Kinkel Center for Academic Resources at Fontbonne University in St. Louis, Missouri. In 2002 he completed his dissertation, *The Secret Origin of the Superhero: The Emergence of the Superhero Genre in America from Daniel Boone to Batman*, for his doctorate in American Studies at Michigan State University. In 1992 he co-founded

and continues to co-chair the Comics Arts Conference, an academic conference held at the San Diego Comic-Con International designed to bring comics scholars and professionals together to discuss comics in a public venue.

Joanna Di Mattia has a PhD in Women's Studies from Monash University in Melbourne, Australia. Recent publications include chapters in *Reading Sex and the City* (I.B. Tauris, 2004) and *Reading Six Feet Under: TV To Die For* (I.B. Tauris, 2005), and *Seinfeld, Master of its Domain: Revisiting Television's Greatest Sitcom* (Continuum, 2006). Her current research explores the place of sexual practice and pleasure in debates about queer visibility.

Jamie Egolf graduated from the University of Wyoming with a BA in Psychology/Sociology and The Catholic University of America (Washington, DC) with an MSW. At St. Elizabeths Hospital in DC, she studied Psychodrama and later began The Magic Theatre of Life, workshops in psychodrama and drama therapy. She studied art at Purdue University in Indiana and practiced there as a Psychotherapist. She was trained by the Interregional Society of Jungian Analysts in Denver, Colorado. She co-authored the *PreMarital Inventory* and writes on Jungian Psychotherapy. She practices in Laramie, Wyoming and has a grown daughter, Sarah.

Wendy Haslem is a lecturer in the Cinema Studies program at the University of Melbourne where she teaches courses in film history (including film noir, cinema in the 1950s, avant-garde film and Australian cinema). In her research she writes about Hollywood film in the 1940s and censorship practices, links between American and Japanese cinemas after WWII, Maya Deren, Clara Law, experimental cinema and innovations in exhibition. She has contributed a range of articles on directors, films and festival cultures to the *Oxford Companion to Australian Film*. Currently she is writing a book on the Gothic in 1940s Hollywood and developing a multimedia project on Godzilla.

Peter Horsfield is Associate Professor of Communication and Program Director of the Bachelor of Communication at RMIT University, Melbourne. He has published extensively on media and religion, including *Religious Television: The American Experience* (Sage 1984), *The Mediated Spirit* CDRom (www.mediatedspirit.com, 2002) and the recent co-edited volume *Belief in Media: Cultural Perspectives on Media and Christianity* (Ashgate 2004).

Louise Krasniewicz is the Senior Research Scientist at the University of Pennsylvania Museum of Archaeology and Anthropology. She injects her

analysis of American media and popular culture with an anthropological spin and has published widely on a range of topics including memetics, rituals and symbolism, digital media, and the connections between dreaming and films. She is also a digital media artist and producer, and designed the website, "Dreaming Arnold Schwarzenegger" which documents 20 years of Schwarzenegger analysis. With Michael Blitz she is co-author of the 2004 book, *Why Arnold Matters: The Rise of a Cultural Icon* which examines Schwarzenegger's cultural influence and election as governor of California.

Chris Mackie is Associate Professor in Classical Studies and Director of the Centre of Classics and Archaeology at the University of Melbourne. His areas of specialisation include myth and heroic narratives, on which he has published widely.

Paul M. Malone is an Associate Professor of German in the Department of Germanic and Slavic Studies at the University of Waterloo, Canada. In addition to his book, Franz Kafka's *The Trial: Four Stage Adaptations* (Frankfurt: Peter Lang, 2003), he has published on literature, film, theatre/performance theory, and virtual reality computer technology.

Aleks Michalewicz is currently completing a Masters Degree in Classics and Archaeology at The University of Melbourne. Her thesis, 'Demigods at Troy: Fall of a City, End of an Age', examines the role of divinely descended heroic figures, and their impact at the sacred Troy site.

Gabrielle Murray is a Lecturer in the Cinema Studies program at La Trobe University in Australia. She has published in several journals, edited anthologies and is the author of *This Wounded Cinema, This Wounded Life: Violence and Utopia in the Films of Sam Peckinpah*.

Angela Ndalianis is Associate Professor in Cinema Studies at the University of Melbourne. Her research focuses on contemporary cinema, the convergence of entertainment media, and media histories. Her book *Neo-Baroque Aesthetics and Contemporary Entertainment* (MIT Press 2004) explores the parallels between C17th & contemporary baroque culture, and she is currently writing a book about the history and cultural significance of the theme park.

Craig Norris is a lecturer in Communications and Media Studies at Monash university, Australia. He graduated with PhD from the University of Western Sydney in 2004, and studied at Tokyo University for two

years, 1999-2001, on a Monbusho research scholarship. His research interests include global media and new knowledge economies (with an emphasis on the innovation and creativity of industry and fan alliances). His recent publications includes an article in *Alter/Asians* (2000) edited by Ien Ang and the online journal *Refractory* (Vol 8, 2005).

Claire Norton is a lecturer in Islamic history at St Mary's College, University of Surrey. She has recently edited a book entitled *Nationalism, Historiography, and the (Re)Construction of the Past* (Washington: New Academia Press, forthcoming 2006). She has published articles on the impact of nationalism on the construction of the past, identity formation on the Ottoman-Habsburg marches and the epistemological status of history.

Erin O'Connell is Assistant Professor of Classics at the University of Utah, Salt Lake City. She received her Ph.D. in comparative literature from the University of California, Santa Cruz. In addition to her book *Heraclitus and Derrida: Presocratic Deconstruction* (Peter Lang 2005), she has published articles on the contemporary reception and performance of Ancient Greek drama.

Robert Peaslee is a doctoral candidate in the School of Journalism and Mass Communication at the University of Colorado in Boulder, Colorado, USA. His dissertation deals with the *Lord of the Rings* films and their role in the tourism industry of Aotearoa New Zealand, a line of inquiry which has led to an interest in an epistemology of "mobility" influenced by the field of cultural geography. He thanks the editors of this volume for their thorough and constructive critique and support, as well as the organizers of the delightful conference on superheroes which generated this anthology.

Babette Pütz is a lecturer in Classics at Victoria University of Wellington in New Zealand. Her interests are in ancient drama and myth. She is the author of the book *The Symposium and Komos in Aristophanes* (2003, second edition forthcoming 2006). Before moving to New Zealand, Babette taught in the UK and the USA and studied in Germany and the UK.

Mike Robinson is an assistant professor in the Communication Studies program at Lynchburg College (USA). With a doctorate in American Culture Studies from Bowling Green State University, Mike's interests range across popular culture topics including fans and audience research, media history, and media criticism. Mike taught a course entitled The Superhero: Genre, Media, and American Culture. He has published in

Refractory and *Popular Music and Society.* Mike likes high point HeroClix theme games. His favorite team is Defenders. His favorite LE is Elektra (Xplosion)-- you just can't beat stealth with 3 damage, 8 range for just 18 points!

Gareth Schott is a trained psychologist with a background in critical psychology (social constructionism & post-modern psychology) including qualitative and quantitative research techniques. As a psychologist he is principally interested in the ways new media technologies mediate human behavior and personal and social development. Over the past four years his research, publications and conference papers have focused on 'players' of digital games. Recent and ongoing projects include: girl gamers and their relationships with game cultures, game fan-cultures, textuality in videogames (narrative, interactivity and role-play) and educational applications for game technologies. He continues to be a Research Associate at the Centre for the Study of Children, Youth and Media at the University of London, UK.

Holly Stokes is currently a post-graduate student in psychology at Flinders University. The research presented in this paper was conducted as part of her Honours dissertation undertaken within the school of Communication, Information and New Media at the University of South Australia. She has an avid interest in both the practice and theory of advertising, having tutored in the subject as well as having completed the prestigious New Limited AWARD School and AADC mentorship program. She is also a strong advocate in promoting the voice of the child and a proud member of the Paddle Pop Lion Club.

Estelle Strazdins is a PhD candidate and tutor in the Centre for Classics and Archaeology at the University of Melbourne. She recently completed an MA that studied cultural identity in the works of the satirists Juvenal and Lucian of Samosata, and is currently investigating 'mutliculturalism' and 'cultural hybridity' in the second-century CE Roman empire.

Gwyn Symonds is a PHD candidate at the Department of English at the University of Sydney writing on images of violence in contemporary texts. She has published on audience reception and popular culture texts such as Buffy, the Vampire Slayer and The Sopranos. In her other life she is a special educator and has published on issues in that field.

Kim Toffoletti co-ordinates the Gender Studies Program at Deakin University, Melbourne, Australia. Since obtaining her doctorate in 2003, she

has published articles on posthuman representations in popular culture from a feminist post-structural perspective, and has undertaken gender analyses into sport media. Her current research involves speaking to female fans of Australian Rules Football. She is also working on a beginners guide to Baudrillard for visual culture students.

Lucy Wright completed her MA in anime and spirituality at RMIT and is currently a doctoral candidate in the Cinema Studies Program at the University of Melbourne. Her PhD focuses on themes of transcendence, Jungian archetypes and Japanese anime.

Ray Younis was educated at Sydney and Oxford and is particularly interested in the relationship between philosophy (particularly the metaphysics and ethics of Nietzsche and Heidegger and the epistemology of Wittgenstein and Derrida) and cultural studies. He has co-edited a number of books on religion, myth and cultural studies and is currently working on a book length study of nihilism, post-modernity and deconstruction. He co-ordinates the communication, media and cultural studies programs at CQU (Sydney), teaches applied ethics and cultural studies and is a consultant in philosophy at the University of Sydney. He suspects that he was conceived during a late night screening of "The Wild Bunch."

Notes

Introduction — *Angela Ndalianis*

Bibliography:
 Campbell, Joseph. 1988. *The Power of Myth*. New York: Broadway Publishers.
 Decker, Kevin S., Jason T. Eberl and William Irwin, eds. 2005. *Star Wars and Philosophy*. Chicago: Open Court.
 Doty, William G. 1986. *Mythography: The Study of Myths and Rituals*. Tuscaloosa: University of Alabama Press.
 Lévi-Strauss, Claude. 1969. *The Raw and the Cooked*. New York: Harper & Row.
 Reynolds, Richard. 1994. *Superheroes: A Modern Mythology*. Jackson: University Press of Mississippi.

2. The Definition of the Superhero — *Peter Coogan*

Notes:
 1 This year, 1942, also marked the earliest appearance of the word *superhero* on the cover of a comic book, according to Will Murray (1998, 20). Koppy McFadd is shown reading a copy of *Super-Hero Comics* on the cover of *Supersnipe Comics* #1 (October 1942).
 2 Jim Sterenko (1989) refers to the chest insignia as a chevron (4).
 3 The Sandman likely debuted in *New York World's Fair Comics of 1939* (April 1939), which was published before *Detective Comics* #27. See Steve Gentner, 1992, "Will the Real First Appearance of Sandman Please Stand Up?" *Comic Book Marketplace*, December, 62-63.
 4 The Sandman's gas gun marks him as a pulp mystery man and has an ancient provenance, ancient in popular fiction terms. It derives immediately from the Green Hornet, but goes back to Johnston McCulley's heroes the Crimson Clown (added to his arsenal in 1928) and Black Star (in possession from his inception in 1916). For a brief history of the weapon see Sampson 1997, 40.
 5 The Fantastic Four were clearly intended as superheroes. Lee and Kirby created them in response to a request by Marvel's publisher Martin Goodman to

create a superhero team to compete with the recently launched Justice League of America (Lee 1974, 16).

6 This demand points to Schatz's (1981) notion of the feedback system that exists between producers and consumers in the genre system (12-13).

7 The adventure meta-genre includes the genres of war, western, superhero, spy, knights, etc.—stories of the hero "overcoming obstacles and dangers and accomplishing some important and moral mission" (Cawelti 1976, 39). Cawelti provides a useful framework for distinguishing between different levels of commonality of story types. The first and largest level is what Cawelti refers to as archetype. He lists adventure, romance, mystery, melodrama, and alien beings or states. I prefer the term *meta-genre* because of the other more common uses of *archetype*, particularly following Joseph Campbell's use of the term. Each meta-genre has several genres within it. Each genre has several formulas within it.

8 See *dhampir* and vampire hunter entries in J. Gordon Melton,1999, *The Vampire Book: The Encyclopedia of the Undead*. Farmington Hills, MI: Visible Ink Press.

9 To blur matters slightly there are cross-genre superheroes, those characters who fully identify both with the superhero genre and another genre. Examples include Marvel's western superhero, the Phantom Rider, a cowboy in costume; the Punisher, an aggressor superhero; and the Legion of Super-Heroes, science-fiction superheroes. In each case, the hero's adventures fit firmly within a genre—western, the aggressor formula (which derived from Don Pendleton's Mack Bolan Executioner series) (Kettredge and Krauzer 1978, xxix), or science fiction, but the characters fulfill the mission, powers, and identity triad as well as incorporating many of the superhero-genre conventions that signal generic distinction. Cross-genre narratives exist in most genres—*Blade Runner* is noir science-fiction, *The Wild Wild West* is a secret agent western, *Cop Rock* is a musical cop show, *Million-Dollar Baby* is a boxing melodrama, and *Idle Hands* and *Shawn of the Dead* are comedy-horror films.

10 The term *superhero* is often applied to all sorts of characters and people, from Gilgamesh and Luke Skywalker to Tiger Woods and Michael Jordan. These applications come out of a metaphoric use of the term to describe characters and people who seem a step above others in their class, whether epic, science fiction, or sports. This metaphoric use has its base in genre, as does referring to George W. Bush as a cowboy because this use of *cowboy* emerges more from western genre than from an identification of the current president with nineteenth century ranch hands. Most people understand that referring to the president in this way is a metaphoric use of *cowboy*, but many people do not understand that referring to Tiger Woods as a superhero is similarly metaphoric. The difference between recognizing the metaphoric use of *cowboy* and *superhero* originates in the fact that western is well defined both scholarly and popularly, but the superhero genre is not.

Bibliography:

Beatty, Scott (w), Chuck Dixon (w), Scott McDaniel (p), Andy Owens (c). 2005. Friends in high places. *Nightwing*, March.

Benton, Mike. 1992. *Superhero Comics of the Golden Age: The Illustrated History*. Dallas: Taylor Publishing.

Cawelti, John G. 1976. *Adventure, Mystery, and Romance: Formula Stories as Art and Popular Culture*. Chicago: U of Chicago P.

Detective Comics, Inc., v. Bruns Publications, Inc. (2d Cir., 1940) (111 F.2d 432). *Lexis-Nexis Academic Universe*. 14 Apr. 2000.

Frye, Northrop. 1957. *Anatomy of Criticism*. New York: Antheneum.

Gross, Terry. 1991. Stan Lee interview. *Fresh Air*. NPR. 17 Oct. www.freshair. org (accessed July 30, 2000).

Goulart, Ron (ed.). 1990. *The Encyclopedia of American Comics*. New York: Facts on File.

Henderson, Brian. 1986. Romantic comedy today: semi-tough or impossible? In *Film Genre Reader*, ed. Barry Keith Grant, 309-328. Austin, TX: U. of Texas P.

Kane, Bob, and Tom Andrae. 1989. *Batman and Me*. Forrestville, CA: Eclipse Books.

Kettredge, William, and Steven M. Krauzer (ed.), 1978. *The Great American Detective*. New York: New American Library.

Lee, Stan (w). *Origins of Marvel Comics*. 1974. New York: Simon and Shuster.

_____. and Jack Kirby (a). 1978. *The incredible hulk*. New York: Pocket Books.

Mayer, Sheldon. 1981. Scribbly. In *A Smithsonian Book of Comic-book Comics* (ed.), Michael Barrier and Martin Williams, 42-61. New York: Smithsonian Institution Press.

McCloud, Scott. 1993. *Understanding Comics: The Invisible Art*. Northampton, MA: Kitchen Sink Press.

Murray, Will. 1998. The roots of the superman! *Comic Book Marketplace*, October, 19-21+.

_____. 1998. Epitaph for Robert Kahn. *Comic Book Marketplace*, December, 28-33+.

Robseson, Kenneth. [Lester Dent]. 1964. *The Man of Bronze*. New York: Bantam.

Sampson, Robert D. 1987. *From the Dark Side*. vol. 3 of *Yesterday's Faces*. Bowling Green, OH: Popular Press.

Schatz, Thomas. 1981. *Hollywood Genres: Formulas, Filmmaking, and the Studio System*. New York: McGraw-Hill.

Siegel, Jerry. 1997. *Superman: The Action Comics Archives*. Vol. 1. New York: DC Comics.

Slotkin, Richard. 1985. *The Fatal Environment: The Myth of the Frontier in the Age of Industrialization, 1800-1890*. Middletown, CT: Wesleyan UP.

Sterenko, Jim. 1989. Foreword. *Superman Archives*, Vol. 1, 4. New York: DC Comics.

Sundell, Abner. 2000. Crash the comics. *Alter Ego*, Spring, 27-34.

3. Superheroes, Moral Economy and the Iron Cage: Morality, Alienation and the Super-Individual—*Robert Peaslee*

Notes:

1 Since the bulk of this essay was completed, another interesting entry into the genre has addressed Weber's thesis directly. *The Incredibles* (2004), about which

an entire essay could be written in this regard, is a explicit commentary on individuality in society, with particular emphasis on the atrophy of special abilities circumscribed within bureaucratic expressions of normativity (industry, public schools, etc.).

2 The analyses related to these three films assume some level of familiarity with their narrative structure, though I have tried to fill in the gaps where most appropriate. Space does not allow full synopses of the films.

3 New York as a setting, since September 11, 2001, also carries a great deal of semiotic weight. *Spider-Man 2*, which was quite famously altered prior to release due to its inclusion of the World Trade Center buildings in its action sequences, is especially imbued with this coloration. An argument I have chosen not to engage here would position law enforcement and science as systems which have particular difficulty addressing the urgencies of terrorist activity. Alternatively, my positioning, at the end of the essay, of traditional superheroes in comparison with characters like *Fight Club*'s Tyler Durden, also positions terrorist activity itself as a more provocative expression of the superhero ethos (cf. The recently released *V for Vendetta*, 2006). My thanks to my reviewers for suggesting this brief discussion.

4 My thanks to Angela Ndalianis, who pointed out the cinematic decision to not only change Catwoman's alter ego from Selina Kyle to Patience Phillips in translation from the comic, but also to elide her past as a prostitute. Clearly this is another consideration in framing *Catwoman*'s feminist message.

Bibliography:

Eco, U. 1972. The Myth of Superman. *Diacritics* 2(1): 14-22.

Radway, J. 1986. Identifying Ideological Seams: Mass Culture, Analytic Method, and Political Practice. *Communication* 9(1): 93-124.

Thompson, E.P. 1971. The Moral Economy of the English Crowd in the Eighteenth Century. *Past and Present* 50: 76-136.

Weber, Max. 1958. *The Protestant Ethic and the Spirit of Capitalism.* Translated by Talcott Parsons. New York: Charles Schribner's Sons.

_____. 1947. Bureaucracy. In *From Max Weber: Essays in Sociology.* Edited by H.H. Gerth and C.W. Mills. London: Kegan Paul.

Filmography:

Catwoman. 2004. Dir. Pitof. Warner Bros. Pictures.

Fight Club. 1999. Dir. David Fincher. Art Linson Productions.

Hellboy 2004. Dir. Guillermo Del Toro. Revolution Studios.

The Incredibles. 2004. Dir. Brad Bird. Walt Disney Pictures and Pixar Animation Studios.

One Flew Over the Cuckoo's Nest. 1975. Dir. Milos Forman. Fantasy Films.

The Passion of the Christ. 2004. Dir. Mel Gibson. Icon Productions.

Spider-Man 2. 2004. Dir. Sam Raimi. Columbia Pictures.

V for Vendetta. 2006. Dir. James McTeigue. Warner Bros. Pictures.

4. El Santo: Wrestler, Superhero and Saint—*Gabrielle Murray*

Notes:
1 All subsequent translations of this text are mine: Álvaron A. Fernández Reyes, *Santo el Enmascarado de Plata* (Michoacán: El Colegio de Michoacán; 2004), 15.

2 See Scott Rhodes, "And in This Corner…El Santo: El Mascarado de Plata," *Filmfax*, 49 (March/April, 1995): 44. Rhodes claims that "Huerta wore the mask so often, it affected his features: his skin became very sensitive and his ears became permanently pinned back against his head."

3 The length and focus of this chapter does not allow me to deal with the comic books. For further discussion, see Álvaron A. Fernández Reyes, *Santo el Enmascarado de Plata* (Michoacán: El Colegio de Michoacán; 2004), specifically pp. 107-122.

4 Many of the younger men do not wear masks, as they want to be seen and eventually become recognizable figures.

5 For discussion of U.S. wrestling as a ritual form see Michael R. Ball, *Professional Wrestling as Ritual Drama in American Popular Culture*. Lewiston: Edwin Mellen Press, 1990.

6 For further discussion, see Jeremy Bentham, *The Theory of Legislation* [originally published in 1802] London: Kegan Paul, 1931.

7 Elsewhere I have discussed the ritual elements of cinema, specifically in the western. See Gabrielle Murray, *This Wounded Cinema, This Wounded Life: Violence and Utopia in the Films of Sam Peckinpah*. Connecticut: Praeger, 2004.

8 Although the sport is dominated by men, women known as *luchadoras* also wrestle.

9 Tag teams of middle-aged, girdle-wearing men display amazingly flexibility; whereas some of the younger wrestlers with U.S. inspired gym-buffed bodies are incapable of such high-flying feats.

10 For further discussion, see also Valerie Walkerdine, "Video Replay: Families, Film and Fantasy," in *Formations of Fantasy*, Victor Burgin, James Donald and Cora Kaplan, eds. London: Methuen, 1986.

Bibliography:
Barthes, Roland. 1982. "The World of Wrestling," In *A Barthes Reader*, edited by Susan Sontag. New York: Hill and Wang.

Clendinnen, Inga. 1991. *Aztecs: An Interpretation*. Cambridge: Cambridge University Press.

Cordry, Donald.1980. *Mexican Masks*. Austin; London: University of Texas Press.

Cotter, Michael "Bobb." 2005. *The Mexican Masked Wrestler and Monster Filmography*. Jeffferson; North Carolina; London: McFarlane.

Fernández Reyes, Álvaron A. 2004. *Santo el Enmascarado de Plata*. Michoacácan: El Colegio de Michoacácan.

Geertz, Clifford. 1976. "Deep Play: A Description of the Balinese Cockfight," In *Play: Its Role in Development and Evolution*, edited by Jerome S. Bruner, Alison Jolly and Kathy Sylva. New York: Basic Books.

Jenkins, Henry. 1997. "'Never Trust a Snake': WWF Wrestling as Masculine

Melodrama," In *Out of Bounds: Sports, Media and the Politics of Identity*, edited by Aaron Baker and Todd Boyd. Bloomington: Indiana University Press.

King, John. 2000. *Magical Reels: A History of Cinema in Latin America*.London; New York: Verso.

Lopez, Ana M. 1995. "Our Welcome Guests: *Telenovelas* in Latin America," In *To be Continued--:Soap Operas Around the World*, edited by Robert C. Allen. London; New York: Routledge.

Mazer, Sharon. 2002. "Watching Wrestling/Writing Performance," In *Hop on Pop: The Politics and Pleasures of Popular Culture*, edited by Henry Jenkins, Tara McPherson and Jane Shattuc. Durham; London: Duke University Press.

Ortega, Nelson Hippolyte. 1998. "Big Snakes on the Streets and Never Ending Stories," in *Imagination Beyond Nation: Latin American Popular Culture*, edited by Eva P. Bueno and Terry Caesar. Pitttsburg: University of Pittsburg Press.

Rhodes, Scott. 1995. "And in This Corner...El Santo: El Mascarado de Plata," *Filmfax* 49 (March/April): 44.

Sullivan, Kevin. 2005. "*Lucha Libre's* popularity grows in the U.S.." *The Herald Mexico*, 8. March 28.

5. Homer and Rap: The Ancient is Fresh—*Erin O'Connell*

Notes:

1 It is also interesting to note that this most lucrative contemporary music genre is flourishing during a overall resurgence of interest in film and other media in Greek and Roman antiquity, as well as adaptations of classic superhero narratives , e.g. Superman, Batman, Spiderman, Hercules, Xena Warrior Princess, etc.). Television programming also features the superhero genre in popular shows such as *Buffy the Vampire Slayer*, and *Smallville* (Superman).

Bibliography:

Homer, *Iliad*. tr. Stanley Lombardo, 1997. Indianapolis. Hackett Publishing Company.

Rose, Tricia. 1994. *Black Noise: Rap Music and Black Culture in Contemporary America*. Hanover, NH. Wesleyan University Press.

6. Men of Darkness—*C.J. Mackie*

Bibliography:

Boichel, Bill. 1991. 'Batman: Commodity as Myth' in *The Many Lives of the Batman* (eds. Pearson, R.E. and Urrichio, W.). New York: Routledge, 4-17.

Eliade, M. 1965. *Rites and Symbols of Initiation* (trans. W. Trask). New York: Harper and Row.

Kullmann,W. 1956. *Das Wirkin der Götter in der Ilias*. Berlin.

Mackie, C.J. 1998. 'Achilles in Fire' *Classical Quarterly* 48, 329-38.

Martin, R.P. 1989. *The Language of Heroes*. Ithaca, New York: Cornell University Press.

Meuli, K. 1974 (orig. publ. 1921). *Odyssee und Argonautika*. Utrecht.

Nagy, G. 1979. *The Best of the Achaeans*. Baltimore: Johns Hopkins University Press.

Pearson, R.E. and Urrichio, W. 1991. 'I'm not fooled by that Cheap Disguise' in *The Many Lives of the Batman* (eds. Pearson, R.E. and Urrichio, W.). New York: Routledge, 182-213.

Powell, Barry B. 2004. *Homer*. Malden, MA: Blackwell.

Reynolds, Richard. 1992. *Superheroes: A Modern Mythology*. Jackson: University Press of Mississippi.

Turner, Frank. 1997. 'The Homeric Question' in *A New Companion to Homer* (eds. Morris, I and Powell, B). Leiden: Brill, 123-45.

Van Gennep, A. 1977. *The Rites of Passage*. London: Routledge and Kegan Paul.

7. "Restlessly, Violently, Headlong, like a River that Wants to Reach Its End": Nihilism, Reconstruction and the Hero's Journey—*Raymond Younis*

Bibliography:

Bambach, C. 2003. *Heidegger's Roots: Nietzsche, National Socialism and the Greeks*, Cornell University Press: Ithaca, N.Y.

Berthold-Bond, D.1993. *Hegel's Grand Synthesis: A Study of Being, Thought, and History*, Harper: New York.

Campbell, J. 1974. *The Mythic Image*, Princeton University Press: Princeton, N.J.

_____. 1976. *The Masks of God*, Penguin: Harmondsworth.

_____. 1991. *The Power of Myth*, Anchor Books: New York.

_____. 1993. *The Hero with a Thousand Faces*, Fontana: London.

_____. 1993. *Myths to live by*, Arkana: New York.

Clark, T. 2003. *Martin Heidegger*, Routledge: London.

_____. 2005. "Heidegger" http://www.morose.fsnet.co.uk/reviews/Clark_Heidegger.htm (Accessed April 12, 2005).

CNNS. 2005. "Centre for Nihilism & Nihilist Studies" http://www.nihil.org/

Crosby, D. 1988. *The Specter of the Absurd*, State University of New York Press: Albany.

di Giovanni, G. 2005. "Friedrich Heinrich Jacobi" http://plato.stanford.edu/entries/friedrich-jacobi/ 2001

Dreyfus, H. L. 2005. *Heidegger on the Connection between Nihilism, Art, Technology and Politics* (http://ist-socrates.berkeley.edu/ ~hdreyfus/pdf/HdgerOnArtTech-Poli

Eliade, M. 1959. *Cosmos and History: The Myth of the Eternal Return*, Harper: New York.

_____. 1959. *The Sacred and the Profane: The Nature of Religion*, Harcourt Brace: New York.

Freydis. 2005. "Nihilism Defined" http://www.geocities.com/liudegast/nihilism.html pdf)

Heidegger, Martin. 1949. *Existence and Being*, Vision: London.

_____. 1958. *The Question of Being,* College and University Press: New Haven, Conn.

_____. 1961. *An Introduction to Metaphysics,* Doubleday: London.

_____. 1962. *Being and Time,* SCM Press: London.

_____. 1966. *Discourse on Thinking,* Harper and Row: New York.

_____. 1971. *Poetry, Language, Thought,* Harper and Row: New York.

_____. 1973. *The End of Philosophy,* Harper and Row: London.

_____. 1976. *The Piety of Thinking: essays,* Indiana University Press: Bloomington.

_____. "Only A God Can Save Us," *Der Spiegel,* May 31, 1976.

_____. 1977. *The Question Concerning Technology and Other Essays,* Harper and Row: New York.

_____. 1979. *Nietzsche, Volume One,* Harper and Row: London.

Hibbs, T. 2005. "Nihilism & Popular Culture"
http://www.bc.edu/bc_org/rvp/pubaf/chronicle/v9/o19/hibbs.html

Hughes, William E. 2005.
http://www.firstthings.com/ftissues/ft9312/articles/hughes.html (Accessed April 13, 2005).

Irwin, R. 2003 "Heidegger and Nietzsche; The Question of Value and Nihilism in Relation to Education", *Studies in Philosophy and Education,* May 2003, Vol. 22,Nos. 3-4, pp. 227-244.

Irwin, William, ed. 2002. *The Matrix and Philosophy,* Open Court: Chicago.

Korab-Karpowicz, W. J. ("Martin Heidegger") http://www.iep.utm.edu/h/heidegge.htm (Accessed April 12, 2005).

Löwith, K. *Martin Heidegger and European Nihilism,* New York: Columbia University Press, 1995.

Nietzsche, Friedrich. 1967. *On the Genealogy of Morals and Ecce Homo,* Vintage Books: New York.

_____. 1968. *The Will to Power,* Vintage Books: New York.

_____. 1968. *Twilight of the Idols and the Anti-Christ,* Penguin Books: Baltimore.

_____. 1969. *Thus Spake Zarathustra,* Penguin Books: Harmondsworth.

_____. 1974. *The complete works: The First Complete and Authorised English Translation,* Gordon Press: New York.

_____. 2001. *The Gay Science,* Cambridge: Cambridge University Press, Palmieri, A. 2003. "Nihilism" http://www.newadvent.org/cathen/11074a.htm (Accessed April 12, 2005).

Pratt, A. 1994. *The Dark Side: Thoughts on the Futility of Life.* New York: Citadel Press.

_____. 2006. "Nihilism," *Internet Encyclopedia of Philosophy,* http://www.iep.utm.edu/n/nihilism.htm

Rorty, Richard. 1998. *Contingency, Irony, and Solidarity,* Cambridge University Press, Cambridge.

Schiereck, L.A. 1996. *Max Stirner's Egoism and Nihilism: A Thesis Presented to the Faculty of San Diego State University.*

Vattimo, G. 1991. *The End of Modernity: Nihilism and Hermeneutics in Postmodern Culture,* Johns Hopkins University Press: Baltimore.

Wikipedia. 2006. "Nihilism" http://en.wikipedia.org/wiki/Nihilism (Accessed: April 12, 2005).

8. My Own Private Apocalypse—Shinji Ikari in Hideaki Anno's *Neon Genesis Evangelion* as Schreberian Paranoid Superhero—*Paul M. Malone*

Bibliography:
Adams, Michael Vannoy. 2004. *The Fantasy Principle: Psychoanalysis of the Imagination*. Hove/New York: Brunner-Routledge.
Anno, Hideaki. 1998. What were we trying to make here? Transl. Unknown. In *Neon Genesis Evangelion: Special collector's edition*, Vol. 1, San Francisco, Viz Communications.
Bregman, Lucy. 1977. Religion and madness: Schreber's Memoirs as personal myth. *Journal of Religion and Health*, (16, 2): 119-135.
Bromberg, Waller. 1959. *The Mind of Man: A History of Psychotherapy and Psychoanalysis*, New York: Harper Colophon.
Dinnage, Rosemary. 2002. Introduction to *Memoirs of My Nervous Illness*, by Daniel Paul Schreber. New York: New York Review of Books.
Drazen, Patrick. 2002. *Anime Explosion! The What? Why? & Wow! Of Japanese Animation*, Berkeley: Stone Bridge Press.
Edwards, A. 1978. Schreber's Delusional Transference: A Disorder of the Self. *Journal of Analytical Psychology*, 23(3):242-47.
Eng, Lawrence. 1997. In The Eyes of Hideaki Anno, Writer and Director of *Evangelion*. http://www.evaotaku.com/omake/anno.html (Accessed July 15, 2003)
Freud, Sigmund. 1958. Psycho-analytic notes on the autobiographical account of a case of paranoia (dementia Paranoides). Ed. & Transl. James Strachey. In *The Standard Edition of the Complete Pyschological Works of Sigmund Freud*, Vol. 12. London: Hogarth Press/Institute of Psychoanalysis.
Fujie, Kazuhisa and Martin Foster. 2004. *Neon Genesis Evangelion: The Unofficial Guide*, Tokyo: Cocoro.
Hendershot, Cyndy. 1999. *Paranoia, The Bomb and 1950s Science Fiction Films*, Bowling Green: Bowling Green State University Popular Press.
Jung, C. G. 1974. Neue Bahnen der Psychologie. *Zwei Schriften uber Analytische Psychologie*, Gesammelte Werke 7. Olten/Freiburg im Breisgau: Walter.
_____. 1966. New Paths in Psychology. *Two Essays on Analytical Psychology*, Transl. R.F.C. Hull, Collected Works 7, Brollingen Series XX, Princeton: Princeton University Press.
_____. 1968. On Psychological Understanding. *The Psychogenesis of Mental Disease*, Transl. R.F.C. Hull, Collected Works 3, Brollingen Series XX, Princeton: Princeton University Press.
Keegan, Eduardo. 2003. Flechsig and Freud: Late 19th Century Neurology and the Emergence of Psychoanalysis. *History of Psychology*, 6(1): 52-69.
Kirsch, Thomas B. 2000. *The Jungians: A Comparative and Historical Perspective*, London/Philadelphia: Routledge.
Lucas, Janet. 2005. Reading the Memoirs: Schreber and "False" Representation. http://www.yorku.ca/jlucas.Schreber_False_Representation. (Accessed March 24, 2005).
_____. 2003. The Semiotics of Schreber's Memoirs: Sign, Sinthome and Play. *The Symptom*. 4. http://www.lacan.com/semofmemf.htm (Accessed March 24,

2005).

Kotani, Mari. 1997. *Seibo Evangerion: A New Millennialist Perspective on the Daughters of Eve*, Tokyo: Magazine House.

Miller, Glenn, H. 2001. Memoirs of My Nervous Illness. Review. *American Journal of Psychiatry*, 158(11):1943-4.

Napier, Susan J. 2005. *Anime From Akira to Howl's Moving Castle: Experiencing Contemporary Japanese Animation*, Rev Ed. London: Palgrave Macmillan.

_____. 2002. When Machines Stop: Fantasy, Reality and Terminal Identity in *Neon Genesis Evangelion* and *Serial Experiments Lain*, *Science Fiction Studies*, 29: 418-35.

Roberts, Mark S. 1996. Wired: Schreber As Machine, Technophobe, and Virtualist, *The Drama Review*, 40(3):31-46.

Sadamoto, Yoshiyuki. 1998. My Thoughts At The Moment, Transl. William Flanagan. *Neon Genesis Evangelion: Special Collector's Edition*, Vol.2, San Francisco: Viz Communications.

Santner, Eric L. 1997. *My Own Private Germany: Daniel Paul Schreber's Secred History of Modernity*, Princeton: Princeton University Press.

Sass, Louis A. 1992. *Madness and Modernism: Insanity in the Light of Modern Art, Literature and Thought*, New York: Basic Books.

Schatzman, Morton. 1973. *Soul Murder: Persecution in the Family*. New York: Random House.

Schreber, Daniel Paul. 2000. *Memoirs of My Nervous Illness*, Transl. Ida Macalpine and Richard A. Hunter, New York: New York Review of Books.

White, Robert B. 1961. The Mother Conflict in Schreber's Psychosis. *International Journal of Psycho-Analysis*, 42:55-73.

9. Shamans vs (Super)heroes — *Lucy Wright*

Bibliography:

Bogoras, Waldemar. [1904] 2001. Doomed to Inspiration. *Shamans Through Time: 500 Years on the Path to Knowledge*, (Eds. Jeremy Narby & Francis Huxley). London: Thames & Hudson: 53-57.

Bukatman, Scott. 2003. The Boys in the Hoods: A Song of the Urban Superhero. *Matters of Gravity: Special Effects and Supermen in the 20th Century*. North Carolina: Duke University Press: 184-224.

Burkett, Walter. 1979. *Structure and History in Greek Mythology and Ritual*. Berkeley: University of California Press.

Clottes, J & Lewis-Williams, D. 1996. *The Shamans of Pre-History: Trance and Magic in the Painted Caves*. New York: Harry N. Abrams, Inc.

Eliade, M. 1964. *Shamanism: Archaic Techniques of Ecstasy*. London: Arkana.

Elwin, Verrier. 2001. [1955]. The Shamanin Performs a Public Service with Grace and Energy. *Shamans Through Time: 500 Years on the Path to Knowledge*, (Eds. Jeremy Narby and Francis Huxley) London: Thames & Hudson:115-118.

Gresseth, Gerald K. 1975. The Gilgamesh Epic and Homer. *The Classical Journal*. 70(4). (Apr-May):1-18.

Grim, J. 1983. *The Shaman: Patterns of Siberian and Ojibway Healing*, Norman, Oklahoma: University of Oklahoma Press.

Levi-Strauss, Claude. 1966. *The Savage Mind*. Chicago: University of Chicago Press.

Narby, J. and Huxley, F. 2001. *Shamans Through Time: 500 Years on the Path to Knowledge*. London: Thames & Hudson.

Reynolds, Richard. 1993. *Superheroes: A Modern Mythology*. London: B. T. Batsford Ltd.

Richardson, Niall. 2004. The Gospel According to Spider-Man. *The Journal of Popular Culture*, 37(4): 694-703.

Ripinsky-Naxon, M. 1993. *The Nature of Shamanism: Substance and Function of a Religious Metaphor*, Albany: State University of New York Press.

Stutley, M. 2003. *Shamanism: An Introduction*. London/New York: Routledge.

Tylor, E. 1871. *Primitive Culture*. London: John Murray.

Wright, R. M. 1992. Guardians of the Cosmos: Baniwa Shamans and Prophets, Part II. *History of Religions*. 32(2): 126-145.

10. Dreaming Superman: Exploring the Action of the Superhero(ine) in Dreams, Myth, and Culture—*Jamie Egolf*

Bibliography:

Azzarello, Brian, Jim Lee, and Scott Williams. 2004. *Superman*. December (210) New York: DC Comics.

Baiyul, Oksana. 2004. Interview with Oksana Baiyul. *Biography; Arts & Entertainment* channel. Aired Dec. 20.

Campbell, Joseph. 1973. *The Hero With a Thousand Faces*. Princeton: Princeton University Press.

Cohn, Norman Rufus Colin. 1975. *Europe's Inner Demons*. New York: Basic Books.

Dooley, Dennis and Gary Engle, Eds. 1987. *Superman at Fifty: The Persistence of a Legend*. New York: MacMillan.

Grun, Bernard. 1991. *Timetables of History*. New York: Simon and Shuster: 512-516.

Higgins, Carolyn. 1987. *Nietzsche's Zarathustra*. Philadelphia: Temple University Press.

Jurgens, Dan, Jerry Ordway, Louise Simonson, and Roger Stern. 1993. *The Death of Superman*. New York: DC Comics.

Jung, Carl. 1988. *Nietzsche's Zarathustra: Notes of the Seminar Given in 1934-1939 by C.G. Jung*. James Jarrett, Ed. Vols 1 & 2. Princeton: Princeton University Press.

_____. 1976. *The Collected Works of C.G. Jung*. William McGuire, Ed. Vols 5 & 6. Princeton: Princeton University Press.

Kamm, Robert. 1998. *The Superman Syndrome*. San Luis Obispo: 1st Books-Library.

Kemerling, Garth. 2005. Nietzsche. http://philosophy pages.com (Accessed March 7, 2005).

Pasco, Martin. 2004. *The Superman Story*. New York: TOR Books. Originally published by DC Comics in 1979.

Stern, Roger. 1993. *The Death and Life of Superman: A Novel*. New York: Bantam Books.

Von Eschenbach, Wolfram. 1991. *Parzival.* Andre Lefevre, Ed. NewYork: Continuum Books.

11. The Superhero Versus the Troubled Teen: Parenting Connor, and the Fragility of Family in Angel — *Gwyn Symonds*

Notes:

1 Transcriptions for quotation purposes have been sourced from *The Buffy Dialogue Database* (Spah 2006).

2 One exception is the Marvel Comics' Fantastic Four, who share a bond forged by the traumatic accident that gave them their superpowers. With two sibling members, two joined by marriage and the fourth the child of a broken home and needing a place to belong, the Fantastic Four are an exception that proves the genre rule (Ryall and Tipton 2005).

3 *Angel,* as a spin-off from Joss Whedon's *Buffy The Vampire Slayer,* brought his back-story with him. He was the vampire Angelus until a gypsy curse gave him a soul, causing him to develop a brooding sense of guilt over his evil past. The second part of the curse, that he could lose his soul if he found perfect happiness, is the source of the instability that is at the heart of his superheroic conversion to fighting evil.

4 There are also Oedipal overtones to this relationship because Cordelia plays a mother substitute role with the infant Connor.

5 Angel's friends are caustically aware of the moral questionability of some of his acts: "He locked twenty lawyers into a room with a couple of psychotic vampires. I'd say his mind is changed enough" (Redefinition, 2.11). Gunn's remark emphasizes that Angel's moral instability is not confined to the danger of his reverting to his evil alter ego Angelus.

6 Lillian S. Robinson, in common with many other feminist readings of the superhero genre, has argued that it is the female superhero who offers a unique "challenge to the masculinist world of superhero adventures" (Robinson 2004, 7). However, Connor's storyline, despite being that of a masculine protagonist, is equally a vehicle for mounting the same kind of challenge. Even when he is on the road to reconciliation with his father towards the end of the series, he is still seeking to find his own version of how to make a difference: "If I'm gonna do this, you gotta let me do it my way...Now I just gotta figure out what my way is" (Origin, 5:18).

7 Angel wants something similar from Connor to the acceptance Peter Parker gets from the crowd on the bus when his mask was ripped off in the film *Spiderman II.* Commenting on a child's line to Spiderman: "It's OK. We won't tell anybody", Gerard Jones correctly notes: "His secret is safe, not because it's really secret but because he can trust the world to handle it"(*Sydney Morning Herald,* December 13, 2004, 15).

8 In an article on the Welsh poet Dylan Thomas (*The Australian,* November 1-2, 2003, R22), John Borthwick quotes Dylan's description of his own attitude as a teenager as "the strutting and raven-locked self-dramatisation of what seemed incurable adolescence". It is a description that fits Connor's oppositional obnoxiousness exactly.

9 In a discussion with a High Priest of Jasmine's in Peace Out, Angel says he is fighting to save his world from Jasmine but the Priest contradicts him, saying he is really fighting for his son and the effort is pointless, so why bother. Angel replies: "I can see you never had kids" (Peace Out, 4:21).

10 The show's concept of the overwhelming power of parental love is deepened by its portrayal of Holtz's genuine, if warped, love for Connor. Holtz's vow that "I will take good care of him, as though he were my own son" (Sleep Tight, 3:16) is not without truth. As a parent, Holtz also has some part of the moral high ground compared to Angel: "I kept your son alive. You murdered mine" (Benediction, 3:21).

Bibliography:
 Clover, Carol J. 2000. Her Body, Himself: Gender in the Slasher Film. *Screening Violence.* S. Prince ed. New Brunswick, NJ: Rutgers University Press: 125-174.
 Klock, Geoff. 2002. *How to Read Superhero Comics and Why.* New York; London: Continuum.
 Lorrah, Jean. 2004. A World Without Love: the Failure of the Family in *Angel. Five Seasons of Angel.* Glenn Yeffeth ed. Texas: Benbella Books: 57-63.
 Maltby, Richard. 2003. *Hollywood Cinema.* 2nd ed. Malden, MA.: Blackwell Publishing.
 Reynolds, Richard. 1992. *Superheroes: A Modern Mythology.* London: B.T. Batsford Ltd.
 Robinson, Lillian S. 2004. *Wonder Women: Feminisms and Superheroes.* New York; London: Routledge.
 Ryall, Chris, and Scott Tipton. 2005. The Fantastic Four as a Family: The Strongest Bond of All. *Superheroes and Philosophy: Truth, Justice and the Socratic Way,* Tom Morris and Matt Morris, eds. Chicago and La Salle, Illin.: Open Court: 118-129.
 Schrader, Paul. 2003. Notes on Film Noir. *Film Genre Reader III.* Barry Keith Grant ed. Austin: University of Texas: 229-242.
 Skoble, Aeon J. 2005. Superhero Revisionism in *Watchmen* and *The Dark Knight Returns. Superheroes and Philosophy: Truth, Justice, and the Socratic Way,* Tom Morris and Matt Morris eds. Chicago and La Salle, Illin.: Open Court: 29-41.
 Sobchack, Vivian. 1987. Bringing It All Back Home: Family Economy and Generic Exchange. *American Horrors,* Gregory. A. Waller ed. Urbana and Chicago: University of Illinois Press: 175-195.
 Spah, Victoria. 2006. *The Buffy Dialogue Database 2006* (Accessed April 23, 2006). http://vrya.net/bdb/index.php.
 Wiater, Stanley. 1992. *Dark Visions.* New York: Avon Books.
 Wood, Robin. 1984. An Introduction to the American Horror Film. *Planks of Reason: Essays on the Horror Film,* Barry Keith Grant ed. Metuchen, NJ: London: The Scarecrow Press: 164-200.

12. Gibson's *The Passion*: The Superheroic Body of Jesus—*Peter Horsfield*

Notes:
 1 Of particular note is the work *The Dolorous Passion of Our Lord Jesus Christ,*

a record of the mystical visions of Anne Catherine Emmerich, an Augustine nun who lived in Westphalia around the late 18th early 19th centuries. This was a significant influence on Gibson's own spirituality and the source of much of the imagined violence in the film (Webb 2004).

Bibliography:

Asad, Talal. 2003. *Formations of the Secular: Christianity, Islam, Modernity.* Stanford: Stanford University Press.

Ash, Jennifer. 1990. The Discursive Construction of Christ's Body in the Later Middle Ages: Resistance and Autonomy. *Feminine/masculine and Representation,* T. Threadgold and A. Cranny-Francis eds. Sydney: Allen and Unwin.

Beard, J. 2004. Book Review: The Left Behind Series. http://www.rapidnet.com/~jbeard/bdm/BookReviews/left.htm (accessed February 25, 2005).

Boyer, Peter. 2003. The Jesus War: Mel Gibson's Obsession. *The New Yorker,* September 15. http://www.freerublic.com/focus/f-chat/980753/posts. (accessed January 25, 2005)

Cooper, Thomas. 2004. Of Anti-Semitism, Romans de Sade, and Celluloid Christianity: The Cases For and Against Gibson's *Passion.* Paper Presented at the 4th International Conference on Media, Religion and Culture, in Louisville, Kentucky.

Denby, David. 2004. Nailed: Mel Gibson's "The Passion of the Christ". *The New Yorker,* March 1, http://www.newyorker.com/critics/cinema/?040301crci_cinema (accessed January 25, 2005).

Franklin, Garth. 2004. Review of *The Passion. Dark Horizons*: http://www.dark-horizons.com/reviews/passion.php (accessed February 2, 2005).

Goa, David J. 2004. *The Passion,* Classical Art and Re-presentation. *Jesus and Mel Gibson's The Passion of the Christ: The Film, the Gospels, and the Claims of History.* K. E. Corley and R. L. Webb eds. London: Continuum.

Goodacre, Mark. 2004. The Power of *The Passion*: Reacting and Overreacting to Gibson's Artistic Vision. *Jesus and Mel Gibson's The Passion of the Christ: The Film, the Gospels and the Claims of History.* K. E. Corley and R. Webb eds. London: Continuum.

Gordon, Mary. 2004. For One Catholic, 'Passion' Skews the Meaning of the Crucifixion. *New York Times,* February 28, B7.

Hunter, James. 1991. *Culture Wars: The Struggle to Define America.* New York: Basic Books.

Jeffords, Susan. 1994. *Hard Bodies: Hollywood Masculinity in the Reagan Era.* New Brunswick: Rutgers University Press.

Lundby, Knut. 1997. The Web of Collective Representations. *Rethinking Media, Religion and Culture.* S. Hoover and K. Lundby eds. Thousand Oaks: Sage.

Maresco, Peter. 2004. Mel Gibson's *The Passion of the Christ:* Market segmentation, Mass Marketing and Promotion, and the Internet. *Journal of Religion and Popular Culture* VIII (Fall): http://www.usask.ca/relst/jrpc/art8-melgibsonmarketing-print.html (accessed February 25, 2005).

Mathieson, Craig. 2004. Bloody Awful. *The Bulletin,* September 7, 67.

Noonan, Peggy. 2002. Face to Face with Mel Gibson. *Reader's Digest,* October, http://www.readersdigest.co.uk/magazine/melg.htm. (accessed January 25, 2005)

Prothero, Stephen. 2004. The Personal Jesus. *New York Times Magazine*, February 29, 26-30.

Rothstein, Edward. 2004. Two Men, Two Different 'Passions'. *New York Times*, February 28, 9.

Sine, Tom. 1995. *Cease Fire: Searching for Sanity in America's Culture Wars*. Grand Rapids: William B. Eerdmans.

Steinfels, Peter. 2004. In the End, Does 'The Passion of the Christ' point to Christian Truths, or Obscure Them? *New York Times*, February 28, A.13.

Tasker, Yvonne. 1993. *Spectacular Bodies: Gender, Genre and the Action Cinema*. London: Routledge.

Wall, James. 2003. The Passion of the Christ. *Media Development* XLX (4):52-54.

Webb, Robert. 2004. The Passion and the influence of Emmerich's The Dolorous Passion of our Lord Jesus Christ. *Jesus and Mel Gibson's The Passion of the Christ: The Film, the Gospels and the Claims of History*. Edited by K. E. Corley and R. L. Webb. London: Continuum.

13. "Perception is Reality": The Rise and Fall of Professional Wrestlers — *Wendy Haslem*

Notes:

1 *Smackdown*, Aired on Fox 8, Foxtel Australia, Saturday December 3, 2005.

2 Superheroes also become wrestlers–before adopting the role of superhero, Peter Parker showed off his skills in a cage match for fast cash.

3 See Gabrielle Murray's essay in this anthology for further discussion of Mexican wrestling. Ecologisa Universal also fought outside the ring as an environmental activist.

4 Another wrestler who made his reputation for taking an inordinate amount of physical punishment is Mikey Whipwreck, an ECW wrestler.

Bibliography:

Artaud, Antonin. 1958. *The Theatre and Its Double*, trans. by Mary Caroline Richards, New York, Grove Press.

Bakhtin, Mikhail. 1984. *Rabelais and His World*, trans. by Hélène Iswolsky, Bloomington, Indiana University Press.

Barthes, Roland. 1972 [1957]. *Mythologies*, London, Paladin.

Baudrillard, Jean. 1988. The Work of Art in the Electronic Age (1988), *Block*, 14:3-14.

Douglas, Mary. 1978. *Purity and Danger: An Analysis of Concepts of Pollution and Taboo*, London, Routledge.

Foley, Mick. 2001. *Foley Is Good: And the Real World is Faker Than Wrestling*, New York, Collins Willow.

Jenkins III, Henry. 2005 [1997]. "Never Trust a Snake": WWF Wrestling as Masculine Melodrama. *Steel Chair to the Head: The Pleasure and Pain of Professional Wrestling*, Nicholas Sammond (ed.), Durham, Duke University Press:33-66.

Kline, Chris. 1997. Defender of Justice Superbarrio Roams Mexico City. *CNN Interactive*, July 19. http://www.cnn.com/WORLD/9707/19/mexico.superhero/ (ac-

cessed May 1, 2006).

Levi, Heather. 2005. The Mask of the Luchador: Wrestling, Politics, and Identity in Mexico. *Steel Chair to the Head: The Pleasure and Pain of Professional Wrestling,* Nicholas Sammond (ed.), Durham, Duke University Press:96-131.

Mazer, Sharon. 1990. The Doggie Doggie World of Professional Wrestling. *The Drama Review,* 34 (4) (T128), Winter: 96-122.

_____. 2005. "Real Wrestling"/"Real" Life, *Steel Chair to the Head: The Pleasure and Pain of Professional Wrestling,* Nicholas Sammond (ed.), Durham, Duke University Press:67-87.

Oates, Joyce Carol. 1987. *On Boxing,* London, Bloomsbury.

Rock, The. 2000. *The Rock Says...: The Most Electrifying Man in Sports-Entertainment,* (with Joe Layden), New York, Collins Willow.

Sammond, Nicholas. 2005. Introduction: A Brief and Unnecessary Defence of Professional Wrestling. *Steel Chair to the Head: The Pleasure and Pain of Professional Wrestling,* Nicholas Sammond (ed.), Durham, Duke University Press:1-21.

Westerfelhaus, Robert and Brookey, Robert Alan. 2004. At the Unlikely Confluence of Conservative Religion and Popular Culture: Fight Club as Heteronormative Ritual, *Text and Performance Quarterly,* 24 (3):302-326.

**14. 'No Apologies, No Regrets': Making the Margins Heroic on *Queer as Folk* —
Joanna Di Mattia**

Notes:

1 *Queer as Folk* premiered on American television December 3, 2000, on cable network, Showtime.

2 Various configurations of Dynamic Duos permeate *Queer as Folk,* the most repeated twosomes being Brian and Michael, and Brian and Justin. Both Michael and Justin are positioned as Brian's Boy Wonders – they are physically smaller men next to Brian who dominates the screen whenever he is in a scene. In addition, Michael's boyfriends, David Cameron and Ben Bruckner, are bigger, more muscular men, who replicate both a father figure and his desire for a superheroic protector as his lover.

3 The comic contained full-color cover-art by Jerry Ordway and panels by Joe Phillips, an openly gay artist who has worked for DC Comics. The story, based on events in *Queer as Folk,* was written by the show's executive producers, Ron Cowen and Daniel Lipman.

4 Other issues of *Rage* are created throughout the series, and in season four Michael and Justin are approached by a Hollywood producer who wants to compromise their vision and turn the comic into a live-action feature.

5 The full comic can be viewed in at the Showtime website by Showtime subscribers. Images from the comic book sourced at http://www.angelfire.com/home/qaf/rage/rage (accessed April 20, 2005).

Bibliography:

Brooker, Will. 2000. *Batman Unmasked: Analysing a Cultural Icon.* London and New York: Continuum.

Fingeroth, D. 2004. *Superman on the Couch: What Superheroes Really Tell Us*

About Ourselves and Our Society. New York: Continuum.

 Gerzon, M. 1982. *A Choice of Heroes: The Changing Face of American Manhood.* Boston: Houghton Mifflin.

 Goldstein, R. 2002. *The Attack Queers: Liberal Society and the Gay Right.* London and New York: Verso.

 _____. 2001. Learning from *Queer as Folk. Village Voice,* January 23: 61.

 Kilday, G. 2001. Is it good for gays? *The Advocate,* June 19: 66-73.

 Millman, J. 2000. The gayest story ever told. *Salon.com,* Online November 29. http://www.archive.salon.com/e...ill/2000/11/29/queer_as_folk/print.html (accessed October 29, 2002).

 Modleski, T.1991. *Feminism Without Women: Culture and Criticism in a 'Postfeminist' Age.* New York and London: Routledge.

 Newitz, A. 2003. The super queers. *AlterNet* Online July 9, 2003. http://www.alternet.org/print.html?StoryID=16368 (accessed July 14, 2003).

 Pearson, Roberta A. and William Uricchio, eds. 1991. *The Many Lives of the Batman: Critical Approaches to a Superhero and His Media.* New York: Routledge.

 Reynolds, R. 1992. *Superheroes: A Modern Mythology.* London: BT Batsford.

 Vilanch, B. 2001. Queer as who? *The Advocate* April 10: 47.

 Walters, S. 2001. *All the Rage: The Story of Gay Visibility in America.* Chicago and London: University of Chicago Press.

 Warner, M. 2000. *The Trouble With Normal: Sex, Politics and the Ethics of Queer Life.* Cambridge, MA: Harvard University Press.

15. Gods Amongst Us / Gods Within: The Black Metal Aesthetic—

Aleks Michalewicz

Notes:

1 Rayor (trans.). 1991. 21. In the writing of this paper, I am greatly indebted to David Collard, Christian McCrea, Ramon Lobato, Miriam Riverlea, Estelle Strazdins and Sonya Wurster, as well as Wendy Haslem and Angela Ndalianis for their comments. Also, a disclaimer: as with all genres of music, there are as many, if not more, perspectives and interpretations as there are fans. I offer here but one such perspective.

2 Andrew Denton's *Enough Rope,* screened on the ABC, April 11, 2005.

3 http://www.anus.com/metal/about/blackmetal.html, (accessed 03/04/05). Despite its name, www.anus.com contains carefully written and informative sites regarding the history and artistic development of the many metal genres. The only exception to this is a somewhat dubious account regarding the progression of popular music. For example: "The consequences of this hoax [American popular music as a marketing hoax] have been a persistent blaming of white Americans for "stealing" a black form of music that never existed, and in return, a condescension toward traditional forms of music of all races that became identified with, and scorned as, a black form of music."

4 A very modest number of books have been published on various metal subcultures, many of which adopt a narrow sociological perspective that does little to

capture the spirit inherent in participation and often focuse on the falsely perceived 'social disenfranchisement' of fans. For example, "[metal] appears most common-ly, but not exclusively, to white, working class teenage males, living in suburbs and small towns, who don't plan to pursue a college education and who usually have diminished job opportunities" (Victor 1993, 162). Or from Deena Weinstein's *Heavy Metal: The Music and its Culture*: "Metal fits into the 'prole' leaning of popular cul-ture today...Despite the virtuosity of metal musicians, the genre, like other 'prole' entertainment, is free of subtlety and understatement" (2000, 294). Natalie Purcell's *Death Metal Music: The Passion and Politics of a Subculture* is much more positive, stating that "[i]t is a friendly community immeasurably different from the stereo-typical vision of a depressed, antisocial and aggressive collection of youth" (2003, 38). Robert Walser's 1993 *Running with the Devil: Power, Gender, and Madness in Heavy Metal Music* remains a seminal academic work on the subject. Books written by fans often have an agenda to push and fail to adequately interrogate metal as a cultural and artistic phenomenon. Moynihan and Soderlind's work on BM, *Lords of Chaos: The Bloody Rise of the Satanic Metal Underground*, is marred through bias and selective representation of events. Much more comprehensive is Gavin Baddeley's *Lucifer Rising: Sin, Devil Worship & Rock'n'Roll*. As a self-proclaimed Reverend in Anton La Vey's Church of Satan, Baddeley openly states in his Introduction that "[n]obody launches themselves into territory like this without some kind of axe to grind" (1999, 9).

5 The term 'Black Metal' originates from Venom's 1982 album of precisely that name.

6 Other Australian bands include Gospel of the Horns, Hobb's Angel of Death, Abominator, Resistica and The Ninth Path, amongst others.

7 It should, however, be noted that metal, including BM, has enjoyed a much higher success rate on the charts in Scandinavian countries.

8 Hellhammer, the drummer from Mayhem claims Euronymous "climbed in there and and found him [Dead] with half of his head blown away. So he [Eu-ronymous] went out and drove to the nearest store to buy a camera to take some pictures of him, and then he called the police... I was the one who took them to be developed. They were in color, real sharp photos. Dead was sitting half up, with the shotgun on his knee. His brain had fallen out and was lying on the bed." Moynihan and Soderlind 2003, 49-50.

9 Grishnackh, is after all, a follower of Sauron in Tolkien's work.

10 In 1997, a tribute album entitled *Hellas Salutes The Vikings* was released by Greek Metal magazine *Metal Invader*. This featured ten Greek bands' interpreta-tions of Bathory songs.

11 Track titles as follows: In Eternal Sleep, Summer of the Diabolical Holo-caust, The Dance of Eternal Shadows, Unholy Black Metal, To Walk the Infernal Fields, Under a Funeral Moon, Inn I De Dype Skogers Fabn, Crossing the Triangle of Flames.

12 Track titles: The Call of the Wintermoon, Unholy Forces of Evil, Cryptic Winterstorms, Blacker Than Darkness, A Perfect Vision of the Rising Northland.

13 Danow 1995. 120: "Both magical realism and grotesque realism are born not only from the ancient tale, legend, and myth but also from the darker aspect of folk "wisdom" that includes superstition and false belief."

14 *Written in Waters*. Misanthropy. 1995.
15 *The Shadowthrone*. Moonfog. 1994.
16 Candlelight. 1995.
17 Lotman also writes that "[a] text behaves like a partner in dialogue: it reorders itself (as far as its supply of structural indeterminacy allows) in the image of the readership" 1990, 80.
18 *Heaven Shall Burn …When We Are Gathered*. Osmose. 1997.
19 For example, "I have been old since the birth of time. Time buried me in earth centuries ago. I tasted blood. Buried by time and dust." Mayhem, 'Buried by Time and Dust' from *De Mysteriis Dom Sathanas*, 1994.
20 For example, "Honour, commended no longer as virtue. Yet, shalt be extolled at light's demise. By the fallen one I shall arise." Emperor, 'The Loss and Curse of Reverence' from *Anthems to the Welkin at Dusk*, 1997.

Bibliography:
Baddeley, Gavin. 1999. *Lucifer Rising: Sin, Devil Worship & Rock'n'roll*, London: Plexus.

Bakhtin, M. M. 1984. *Rabelais and his World* (trans. Helene Iswolsky), Bloomington and Indianapolis: Indiana University Press.

Bauman, Richard. 2001. Verbal Art as Performance. In *Linguistic Anthropology: A Reader*, edited by Alessandro Duranti, Oxford: Blackwell Publishers Ltd., 165-188.

Berrong, Richard M. 1986. *Rabelais and Bakhtin: Popular Culture in* Gargantua and Pantagruel. Lincoln and London: University of Nebraska Press.

Booker, Keith M. 1991. *Techniques of Subversion in Modern Literature: Transgression, Abjection and the Carnivalesque*, Gainesville: University of Florida Press.

Danow, David K. 1995. *The Spirit of Carnival: Magic Realism and the Grotesque*, Lexington, Kentucky: The University Press of Kentucky.

Fingeroth, Danny. 2004. *Superman on the Couch: What Superheroes Really Tell Us about Ourselves and Our Society*, New York and London: Continuum.

Fiske, John. 1987. Carnival and Style. In *Television Culture*, London and New York: Methuen, 240-264.

Lotman, Yuri M. 1990. *Universe of the Mind: A Semiotic Theory of Culture* (trans. Ann Shukman). London and New York: I.B. Tauris & Co. Ltd.

Moore, Andy. 2004. No War for Heavy Metal! In *Vice Magazine* (Australian Edition), Vol. 1 No. 8. Richmond, VIC: Slow Right Down, 56-7.

Moynihan, Michael and Didrik Soderlind. 1998 (revised edition 2003) *Lords of Chaos: The Bloody Rise of the Satanic Metal Underground*, Los Angeles, CA: Feral House.

Purcell, Natalie J. 2003. *Death Metal Music: The Passion and Politics of a Subculture*. Jefferson, North Carolina and London: McFarland.

Rayor, Diane J. (trans.). 1991. *Sappho's Lyre: Archaic Lyric and Women Poets of Ancient Greece*, Berkeley: University of California Press.

Russo, Mary. 1986. Female Grotesques: Carnival and Theory. In *Feminist Studies/Critical Studies*, edited by Teresa de Lauretis, Bloomington: Indiana University Press, 213-229.

Vernant, Jean-Pierre. 1991. Death in the Eyes. In *Mortals and Immortals*, Princ-

eton: Princeton University Press, 134-8.

Victor, Jeffrey S. 1993. *Satanic Panic: The Creation of a Contemporary Legend*, Peru, Illinois: Open Court.

Walser, Robert. 1993. *Running with the Devil: Power, Gender, and Madness in Heavy Metal Music*. Middletown, CT: Wesleyan University Press.

Weinstein, Deena. 1991 (revised 2000). *Heavy Metal: The Music and its Culture*. Da Capo Press.

Internet:

American Underground Nihilist Society, 'Black Metal'. http://www.anus.com/metal/about/black_metal/, accessed April 3, 2005.

Television:

Andrew Denton's *Enough Rope*. Australian Broadcasting Corporation, screened 11/04/05.

Music:

Burzum. *Det Som Engang Var*. Misanthropy. 1992.

Darkthrone. *Under a Funeral Moon*. Peaceville. 1993.

_____. *Transylvanian Hunger*. Peaceville. 1994.

Emperor. *In the Nightside Eclipse*. Century Media. 1995.

_____. *Anthems to the Welkin at Dusk*. Century Media. 1997.

Immortal. *Diabolical Fullmoon Mysticism*. Osmose. 1992.

Immortal. *Pure Holocaust*. Osmose. 1994.

Marduk. *Heaven Shall Burn … When We Are Gathered*. Osmose. 1997.

Mayhem. *De Mysteriis Dom Sathanas*. Deathlike Silence. 1994.

_____. *Grand Declaration of War*. Season of Mist/Necropolis. 2000.

Satyricon. *Dark Medieval Times*. Moonfog. 1993.

_____. *The Shadowthrone*. Moonfog. 1994.

_____. *The Forest is My Throne*. Moonfog. 1995.

Ulver. *Nattens Madrigal: The Madrigal of the Night – The Night Hymns to the Wolf in Man*. Century Media. 1997.

_____. *Themes From William Blake's* The Marriage of Heaven and Hell. Jester. 1999.

Ved Buens Ende. *Written in Waters*. Misanthropy. 1995.

Venom. *Black Metal*. Neat Records. 1982.

16. Harry Potter and Oedipus: Heroes in Search of their Identities — *Babette Pütz*

Notes:

1 I would like to thank Angela Ndalianis, Chris Mackie and John Davidson for their very useful comments on earlier drafts of this essay.

2 Rowling studied French and Classics: Fact Monster Database. 2006. Pearson Education, Inc. http://www.factmonster.com/spot/harrycreator2.html (accessed April 27, 2006).

3 The myth is also dealt with in Sophocles' *Oedipus at Colonus* and *Antigone*.

Furthermore, it features in Aeschylus' tetralogy which includes the almost entirely lost plays *Laius*, *Oedipus*, *Sphinx* (a satyr play), and the extant tragedy *Seven Against Thebes*. It is also briefly mentioned in Greek epic: *Iliad* 4. 365-400, 23.676-82, *Odyssey* 11.271-80, the *Oedipodia* and *Thebais* (of which little is known). For a brief overview over these sources see Brown, A.L. 2003, Oedipus. in *The Oxford Classical Dictionary*. ed. S. Hornblower and A. Spawforth. 3rd revised edition. Oxford: Oxford University Press. 1061-2. The myth also appears in representations in art. References to *O.R.* are given as lines from the Oxford edition, those to the *Harry Potter* books as volume-number (rather than titles, in Roman numerals) followed by page number.

4 For an overview see Harris and Platzner 2004, 304.

5 Blondell 2002, 98-9 who provides many references.

6 De Rosa 2003, 163-83 mentions some reversals of usual hero patterns: Harry is in her opinion safer at Hogwarts than he is in his childhood life, where he has to suffer physical trials in form of abuse. It is true, that Harry does not suffer abuse at Hogwarts, but he now faces deathly perils which he was safe from at the Dursleys', so that I cannot really agree with De Rosa.

7 Note that even Harry's position as Quidditch player is seeker. It is also important here that both heroes (will) return to their birth places (*H.P.* VI 606).

8 Waters & Mithrandir 2002, 9 bring up the question whether the scars in the *Harry Potter* books function not only as means of recognition, but also as signs of courage. There is no evidence for this so far: baby Harry survived the attack in which he received his scar through the protection of his mother's sacrifice and presumably his special magical powers rather than his own bravery and we do not know how Dumbledore got his scar (even though one would like to think that it was during his defeat of the dark wizard Grindelwald in 1945, as mentioned on his Chocolate Frog card (I 77) - but this cannot be proven). Dumbledore's scar appears to allude to Odysseus' famous scar over his knee which is used for his recognition, just like Harry's (*Odyssey* 19.392-4, 449-51). There is a further thematic overlap between *Harry Potter* and the *Odyssey*: Telemachus does not know his father and sets out to find his identity, just as Harry and Oedipus leave their homes. On the connection of travelling and intellectual inquiry in antiquity see Blondell 2002, 99.

9 *O.R.* 711-4 and 1176 mention the prophecy, but not when exactly it is given.

10 *O.R.* 718, 1034, 1171-4, *H.P.* I 14-5.

11 The fact that Laius is on a journey to consult the oracle when he is killed emphasizes the importance of prophecies. Sophocles does not reveal what Laius' question is, but in other versions of the myth he inquires whether Oedipus has really died: cf. Blondell 2002, 26 n. 15.

12 Oedipus questions this oracle after Polybus' death, but at the end of the play says that now he will trust Apollo (1446). Furthermore, Creon who is the one who brings the oracle regarding Laius' murderer suggests that Oedipus himself go to the oracle to see whether he gave a true report (603-4), and Tiresias makes a prediction about Oedipus' near future as blind beggar (454-60).

13 Sirius' death is actually connected with Voldemort's attempt to retrieve the oracle made before Harry's birth.

14 It is used to produce the Elixir of Life which makes the drinker immortal. Cf. also Voldemort's name which in French means "flight from death": e.g. Waters

& Mithrandir 2002, 17.

15 See Segal 1988, 128 on Oedipus' loneliness.

16 Harry also goes on alone at the end of his adventures in books I, II, and IV and realises that he cannot have a love relationship in book VI, but this is heroic loneliness because of his special status.

17 Harry's bravery is repeatedly pointed out and is the reason why he is in Gryffindor house (cf. IV 626-7). Book III deals with Harry successfully fighting his fears in the form of the dementors.

18 The more the heroes mature the more proactive they become. Oedipus consults the oracle first in reaction to a taunt and makes the decision not to return to Corinth in reaction to the prophecy. However, as a king in *O.R.* he is very proactive, already having sent to the oracle before it is suggested to him and actively inquiring about the murder (69-72). In book I Harry is mostly reactive. It has been argued that he only reacts and all trouble finds him (Manlove 2003, 191). However, over time he becomes more proactive, finally even flying to London and entering the Ministry of Magic at night in book V. In connection with their proactiveness, both characters display a great deal of self-reliance and perseverance, Oedipus in his inquiries (1065, 1076-7), and Harry when he feels that others are not doing enough, e.g. to save Ginny in book II. See also Dodds 1983, 187 on Oedipus' great "inner strength". They also show a remarkable adaptability to changing circumstances, Oedipus when he leaves Thebes as a beggar and Harry who is afraid whether he will fit in at Hogwarts and then does very well. Cf. also Knox 1971, 190.

19 The theme of knowing and ignorance is underlined by imagery of seeing, blindness, darkness, and light in *O.R.* (e.g. 412-4, 419, 454-5). Cf. Reinhart 1979, 106-110 on the topic of light and darkness in *O.R.* In *Harry Potter*, in contrast, dark and light are used for atmospheric reasons, as can be seen particularly well when contrasting the 2001 film with the 2002 film which has a darker colour scheme, fitting its darker atmosphere. The image of blindness is hinted at in the mention of the blinding green light of Voldemort's curse on Harry.

20 Cf. Dodds 1983, 178-81 for a discussion of the question of Oedipus' tragic flaws. See also e.g. Winnington-Ingram 1980, 202-3 on this problem.

21 Transl. Hard 1997, 106 of Apollodorus 3.53.13-4. The wording of the riddle is not given in *O.R.* It is pointed out at 440 that Oedipus is naturally good at solving riddles. Vernant 1983, 194-5 analyses ways in which the play as a whole is composed like a riddle. Harris and Platzner 2004, 638 give a clever interpretation of the riddle which goes beyond the figure of Oedipus and the play: "humans are by nature a riddle – a mystery even to themselves."

22 This passage seems to be left out in the movie for cinematographic reasons: after the task involving the dragon more monsters in the labyrinth scene would not be as effective as the maze itself being threateningly alive

23 Cf. Schroeter in: Cook 1963, 122-33 for a Freudian analysis of the play regarding Oedipus' father figures. He views Oedipus' attacks on his "symbolic fathers" as his *hamartia* (127). However, Oedipus suffers for different reasons (see above).

24 This is a change in the film from the book where Harry's happy thought during his practice lesson with Professor Lupin is the moment when he found out that he was a wizard and would leave the Dursleys (III 179).

25 Blondell 2002, 105 n. 1 mentions two explanations: (a) that the mutilated

state of the child would deter potential rescuers, which obviously did not work in Oedipus' case and is thus unconvincing, (b) to prevent the ghost of the child from taking revenge.

26 However, one can argue that the Dursleys are lowly in a moral sense: cf. Grimes 2002, 107.

27 His effort to protect Oedipus is underlined by the fact that he moved away after delivering the baby, apparently so as to be unavailable to answer questions (758-62).

28 Antigone, although younger, protects Oedipus in exile. Furthermore, he is protected by the non-relative Theseus in *O.C.*

29 *O.R.* 300-4, 326-7; *H.P.* I 156-7, 214-8. Harry is protected by several other wizards, often without knowing it, e.g. by members of the order of the Phoenix (V, VI), Mrs. Figg, and (unsuccessfully) Mundungus (V 24, 48-57).

30 Colbert 2003, 81; Pharr 2002, 60.

31 In contrast, in book IV 554 Harry faces Voldemort all alone, having been transported miles away from the headmaster by a portkey, which gives him independence and confidence in his own magic abilities.

32 Cf. Bushnell 1988, 75. See Vernant 1983, 191 on the duality of Oedipus.

33 Bushnell 1988, 72 (following Knox) convincingly draws a connection between Oedipus' theory of Tiresias' and Creon's conspiracy and his trying to appear to be the city's new prophet. He even speaks in an oracle-like way at 216-8.

34 Cf. *H.P.* VI 477 about Voldemort being a tyrant in fear of those he oppresses.

35 He may or may not have misjudged Professor Snape. In books I to V it looks as if, although Snape loathes Harry and treats him most unfairly, Harry still can learn from him not to judge people at first impression. Cf. also Pharr 2002, 59. I do not count Harry's teachers Professors Snape and McGonagall as real parental figures, even though he learns much from both of them, as he does not have too much contact with them beyond a student-teacher relationship. The only exceptions are the few disastrous weeks during which Snape gives Harry Occlumency lessons (V), Harry witnessing Snape murdering Dumbledore (VI), and the brief instances in which Professor McGonagall gives Harry supportive career advice and warns him about Professor Umbridge (V).

36 Cf. e.g. *O.R.* 337-44, 404-7, 523-4, 673-5; *H.P.* I 26, V 273, V 726-7.

37 Laius drives Oedipus from the road by force and hits him on the head after Oedipus has struck one of his men; Oedipus kills all but one of them (802-13).

38 Harry even once mistakes himself for his father at III 297-8. In the same book we learn that James and Harry produce the same patronus, a stag. James however turns out to not be all good when Harry sees him as a bullying teenager in Snape's memory (V 568-72).

39 The topic of blood connections in *Harry Potter* is important and complex. After Voldemort re-gains a body through Harry's blood at the end of book IV, he can physically touch the boy, which he was not able to do before (I 213, IV 566), yet Harry's protection through Petunia is still intact (V 737, VI 157-8).

40 There are some exceptions in Harry's case: he sees his parents in the mirror of Erised (I) and his parents' ghosts help him escape Voldemort (IV). Furthermore, Molly Weasely takes the place of his mother when she comes to watch Harry for the last task of the Triwizard Tournament (IV 535).

41 Cf. also Grimes 2002, 107-21. Zipes 2001, 175, when arguing that the books lose appeal through their "conventional" nature, fails to understand how the fact that patterns of myth are followed can actually add to the enjoyment of the books, especially for grown up readers, as Grimes 2002, 106-122 explains. Cf. also Bice 2003, 35 for a very vague comparison of the first Harry Potter book with themes from Celtic myth.

42 Knox 1988, 18.

43 Van Nortwick 1998, 71-2, 165. Cf. also Pucci 1992, 167.

Bibliography:

Aeschylus. 1953. *Septem Quae Supersunt Tragoediae*. ed. G. Murray. Oxford: Clarendon Press (reprint with corrections).

Apollodorus. 1965. *Mythographi Graeci*. vol. 1. ed. R. Wagner. Stuttgart: Teubner.

Bice, D. 2003. From Merlin to Muggles: The Magic of Harry Potter. The First Book. in: D. Bice, ed. *Elsewhere. Selected Essays from the "20ᵗʰ Century Fantasy Literature: From Beatrix to Harry" International Conference*. Lanham, MD: University Press of America, 29-36.

Blondell, R. 2002. *Sophocles' King Oidipous*. intr., transl., and essay. Newburyport, MA: Focus Classical Library.

Bushnell, R.W. 1988. *Prophesying Tragedy. Sign and Voice in Sophocles' Theban Plays*. Ithaca, NY: Cornell University Press.

Colbert, D. 2003 [2001]. *Magical Worlds of Harry Potter*. London: Puffin/Penguin.

Cook, A., ed. 1963. *Oedipus Rex. A Mirror for Greek Drama*. Belmont, CA: Wadsforth Publishing.

De Rosa, D. 2003. Wizardly Challenges to and Affirmations of the Initiation Paradigm in *Harry Potter*. in E. Heilman, ed. *Harry Potter's World. Multidisciplinary Critical Perspectives*. New York and London: RoutledgeFalmer, 163-86.

Dodds, E.R. 1983. On Misunderstanding the Oedipus Rex. in E. Segal, ed. *Oxford Readings in Greek Tragedy*, Oxford: Oxford University Press, 177-88.

Grimes, M.K. 2002. Harry Potter. Fairy Tale Prince, Real Boy, and Archetypal Hero. in L.A. Whited, ed. *The Ivory Tower and Harry Potter. Perspectives on a Literary Phenomenon*. Columbia and London: University of Missouri Press, 89-122.

Hard, R., transl. 1997. *Apollodorus. The Library of Greek Mythology*. Oxford: Oxford University Press.

Harris, S.L. and G. Platzner. 2004. *Classical Mythology. Images and Insights*. 4th ed. New York: McGraw-Hill.

Homer. 1920. *Iliad*. ed. T.W. Allen, Oxford: Clarendon Press. 3rd ed.

_____. 1919 & 1920. *Odyssey*. ed. T.W. Allen. Oxford: Clarendon Press. 2nd ed.

Knox, B. 1988. Sophocles' Oedipus. in H. Bloom, ed. *Sophocles' Oedipus Rex*. New York and Philadelphia: Chelsea House Publishers, 5-22.

_____. 1971. *Oedipus at Thebes. Sophocles' Tragic Hero and His Time*. New York: W.W. Norton.

Manlove, C. 2003. *From Alice to Harry Potter. Children's Fantasy in England*. Christchurch, NZ: Cybereditions.

Pharr, M. 2002. In Medias Res. Harry Potter as Hero-in-Progress. in L.A. Whited, ed. *The Ivory Tower and Harry Potter. Perspectives on a Literary Phenomenon*. Co-

lumbia and London: University of Missouri Press, 53-66.

Pucci, P. 1992. *Oedipus and the Fabrication of the Father. Oedipus Tyrannus in Modern Criticism and Philosophy*. Baltimore: Johns Hopkins University Press.

Reinhart, K. 1979. *Sophocles*, Oxford: Blackwell.

Rowling, J.K. 1997. *Harry Potter and the Philosopher's Stone*. London: Bloomsbury. (= I)

_____. 1998. *Harry Potter and the Chamber of Secrets*. London: Bloomsbury. (= II)

_____. 1999. *Harry Potter and the Prisoner of Azkaban*. London: Bloomsbury. (= III)

_____. 2000. *Harry Potter and the Goblet of Fire*. London: Bloomsbury. (= IV)

_____. 2003. *Harry Potter and the Order of the Phoenix*. London: Bloomsbury. (= V)

_____. 2005. *Harry Potter and the Half-Blood Prince*. London: Bloomsbury. (= VI)

Segal, C. 1988. The Music of the Sphinx: The Problem of Language in Oedipus Tyrannus. in H. Bloom, ed. *Sophocles' Oedipus Rex*, New York and Philadelphia: Chelsea House Publishers, 127-42.

Sophocles. 1990. *Sophoclis Fabulae*, ed. H. Lloyd-Jones and N.G. Wilson. Oxford: Clarendon Press.

Van Nortwick, T. 1998. *Oedipus. The Meaning of a Masculine Life*. Norman: University of Oklahoma Press.

Vernant, J. P. 1983. Ambiguity and Reversal: On the Enigmatic Structure of Oedipus Rex. in E. Segal, ed. *Oxford Readings in Greek Tragedy*. Oxford: Oxford University Press, 189-209.

Waters, G. and A. Mithrandir. 2002. *Ultimate Unofficial Guide to the Mysteries of Harry Potter*. Niles, IL: Wizarding World Press.

Winnington-Ingram, R.P. 1980. *Sophocles. An Interpretation*. Cambridge: Cambridge University Press.

Zipes, J. 2001. *Sticks and Stones. The Troublesome Success of Children's Literature from Slovenly Peter to Harry Potter*. New York and London: Routledge.

Filmography:

Harry Potter and the Sorcerer's Stone, dir. Columbus, C., Warner Bros., 2001.

Harry Potter and the Chamber of Secrets, dir. Columbus, C., Warner Bros., 2002.

Harry Potter and the Prisoner of Azkaban, dir. Cuarón, A., Warner Bros., 2004.

Harry Potter and the Goblet of Fire, dir. Newell, M., Warner Bros., 2005.

17. Hercules Psychotherapist—*Ruby Blondell*

Notes:

1 For a longer version of this paper (which includes discussion of the Amazons in *Xena: Warrior Princess*) see Blondell 2005. I am grateful for research assistance to Larry Bliquez, Yurie Hong Easton, Mary-Kay Gamel, Sandra Joshel, Ivar Kvistad, Walter Penrose, Clare Pitkethly, Douglas Roach, Jennifer Stuller, and Ryan Wilkerson.

2 For the mythic details see Gantz 1993, ch. 13. For a historical survey of the many faces of Herakles see Galinsky 1972.

3 The executive producers were Sam Raimi, Robert Tapert, and Christian Williams. I shall use "Herakles" to refer to the Greek mythic hero, "Hercules" for the hero of *HLJ*.

4 Gans' description of lower-middle-class culture and its audience (1999, 110-15) fits the implied audience of *HLJ* remarkably well, despite the passage of time (it was first published in 1974). Some aspects of Gans' lower-class culture (Gans 1999, 115-19) are a good fit as well.

5 In order of first broadcast: *Hercules and the Amazon Women, Hercules and the Lost Kingdom, Hercules and the Circle of Fire, Hercules and the Underworld, Hercules and the Maze of the Minotaur.* The five telemovies are closely interconnected and indistinguishable in style. They were conceived as a package and presented as such via the opening credits, which draw upon clips from the movies as a set. Generically, they therefore fall somewhere between the made-for-TV movie and the dramatic series. The weekly series had its debut in January 1995 and ran for six seasons.

6 Weisbrot 1998, 58, 160, 174, 192, 220, 230.

7 Iolaus (Michael Hurst), Hercules' "buddy," has been promoted from a minor (and sometimes homoerotic) role in Greek myth. The self-restraint of Sorbo's Hercules makes him a direct descendant of the fifth-century BCE sophist Prodicus' influential Herakles, who chooses virtue over the pleasures of food, drink and sex (Xenophon, *Mem.* 2.1.21-34).

8 See van Hise 1998, 53. In *Minotaur* Iolaus declares, "Herc and I both decided, that when we married and had kids, we would become the fathers *we* had never had." In a later episode, Hercules rejects a beautiful woman because "I just don't want to go through life leaving a string of fatherless children behind" (*As Darkness Falls*).

9 Notable exceptions include one night stands with both Nemesis, his "first love" (*The Enforcer*) and Xena (*Unchained Heart*), both of whom leave him against his will the next morning. He also "falls in love" with Rheanna in *Heedless Hearts*, but does not sleep with her.

10 Quotations from *HLJ* are transcribed from the telemovies and episodes.

11 Though the belt is a *zoster* (war-belt) in the early tradition, it is later eroticized as a "girdle" (see Tyrrell 1984, 90-91; Gantz 1993, 397-8; Dowden 1997, 100; Blok 1995, 424-30).

12 For a comprehensive survey see von Bothmer 1957.

13 For fuller discussion of the Greek Amazons see Tyrrell 1984; Blok 1995; Hardwick 1990; Pembroke 1967; Dowden 1997; duBois 1982.

14 This happened long enough ago that the adult Amazons are no longer personally aquainted with the men of the village (though there also seem to have been some more recent recruits).

15 The least "attractive" and oldest-looking of the Amazon warriors has her useful femininity guaranteed in a different way: by the production of a son, to whom she hankers to return (along with his father).

16 Greek Amazons worship not Hera but Artemis/Cybele and Ares (Tyrrell 1984, 86-7; Dowden 1997, 126-7).

17 Cf. Faludi 1991, 35-6, 338-46; for "infection" see p. 342.

18 A drunken Herakles offers a didactic discourse on the meaning of mortal life at Euripides, *Alcestis* 779-802. For later examples see Galinsky 1972, esp. 193-4.

19 See Faludi 1991, passim (esp. x-xii, 70-71, 89, 93, 113, 183-4, 199, 338, 341-2, 449-52). This trend has, if anything, increased since the publication of her book.

20 Contrast the casual promiscuity of the Greek Amazons (cf. Tyrrell 1984, 24, 53-5).

21 A 1988 prediction of the "resurgence of the traditional family" includes the comment, "Romance and courtship will be back in favor, so sales of cut flowers are sure to rise" (Jib Fowles apud Faludi 1991, 18; cf. also 196).

22 On the functioning of ideology, particularly in television see Fiske 1987, ch. 3; 1992; White 1992. On the mythic functions of television see Fiske and Hartley 1978, 41-7, 85-100; Fiske 1987, 131-5.

Bibliography:
Blok, Josine. 1995. *The Early Amazons*. Leiden: Brill.
Blondell, Ruby. 2005. How to Kill an Amazon. *Helios* 32: 73-103.
Dowden, Ken. 1997. The Amazons: Development and Function. *Rheinisches Museum für Papyrologie* 140: 97-128.
duBois, Page. 1982. *Centaurs and Amazons: Women and the Pre-History of the Great Chain of Being*. Ann Arbor: University of Michigan Press.
Faludi, Susan. 1991. *Backlash: The Undeclared War Against American Women*. New York: Crown Publishers.
Fiske, John. 1987. *Television Culture*. New York: Routledge.
_____. 1992. British cultural studies and television. In *Channels of Discourse, Reassembled*, edited by Robert C. Allen. Second Edition. Chapel Hill: University of North Carolina Press, 284-326.
Fiske, John and John Hartley, eds. 1978. *Reading Television*. London: Methuen.
Galinsky, Karl. 1972. *The Herakles Theme: The Adaptations of the Hero in Literature from Homer to the Twentieth Century*. Oxford: Blackwell.
Gans, Herbert J. 1999. *Popular Culture and High Culture: An Analysis and Evaluation of Taste*. Revised and Updated Edition. New York: Basic Books.
Gantz, Timothy. 1993. *Early Greek Myth: A Guide to Literary and Artistic Sources*. Baltimore: Johns Hopkins University Press.
Hardwick, Lorna. 1990. Ancient Amazons: Heroes, outsiders or women? *Greece and Rome* 37: 14-36.
Pembroke, Simon. 1967. Women in Charge: The function of alternatives in early Greek tradition and the ancient idea of matriarchy. *Journal of the Warburg and Courtauld Institutes* 30: 1-35.
Tyrrell, Wm. Blake. 1984. *Amazons: A study in Athenian mythmaking*. Baltimore: Johns Hopkins University Press.
van Hise, John. 1998. *Hercules and Xena: The unofficial companion*. Los Angeles: Renaissance Books.
von Bothmer, D. 1957. *Amazons in Greek Art*. Oxford: Clarendon Press.
Weisbrot, Robert. 1998. *Hercules: The Legendary Journeys: The Official Companion*. New York: Doubleday.
White, Mimi. 1992. Ideological analysis and television. In *Channels of Discourse, Reassembled*, edited by Robert C. Allen. Second Edition. Chapel Hill: University of North Carolina Press, 161-202.

18. Someone to Watch Over Me: the Guardian Angel as Superhero in Seicento Rome—*Lisa Beaven*

Notes:

1 Under pressure from the Protestant Reformation, the Council of Trent was called to examine Catholic doctrine and reform the Catholic church. Its principal motivation was to counter the progress of the Reformation.

2 This theme seems to have been prompted in part by the popularity of St Bonaventura's Life of St Francis. See Askew, 1969, 280-306. For a study of the reception of sacred paintings and how people interacted with them see Jones, 1999, 28-86.

3 Caravaggio, *The Ecstacy of St Francis,* c. 1594-5, oil on canvas, 92 x 127.8 cm, The Wadsworth Atheneum, Hartford, The Ella Gallup Sumner and Mary Catlin Sumner Collection Fund, inv. no. 1943.222.

4 Bailey, 2003, 68. The earliest source for the seven archangels is the Book of Enoch. They are named as Uriel, Raphael, Raguel, Michael, Saraqael, Gabriel and Remiel.

5 Raffaello Sanzio (with the contribution of Giulio Romano?), *St Michael and Satan,* 1518, oil transferred from wood to canvas, 268 x 160 cm, Musée du Louvre, Paris.

6 Guido Reni, *The Archangel St Michael,* c. 1636, silk, 293 x 202 cm, S. Maria della Concezione, Rome.

7 Lo Bianco, 1997, 372. Lo Bianco notes that while Pascoli reported that Cortona gave the two paintings to the Pope as a gift, nonetheless in July 1656 payments exist to Cortona for two paintings, almost certainly these two.

8 For the purposes of this essay I am using the English translation of the *Book of Tobit* by Frank Zimmerman; (Zimmerman, 1958, 73).

9 The pseudonym adopted by Raphael, Azariah ben Hananyah means 'God-helps, son of God-favors' and therefore is a device to alert the reader to Raphael's real status (Zimmerman, 1958, 75, n. 13).

10 Matthias Stomer, *Tobias and the Angel,* oil on canvas, 111 x 125 cm, Museum Bredius, The Hague, Inv. nr. 202-1946.

11 Rembrandt van Rijn, *The Archangel leaving the family of Tobias,* 1637, oil on wood, 66 x 52 cm, Musée du Louvre, Paris.

12 Gianantonio Guardi, *The Angel appears to Tobias,* c. 1750, oil on canvas, Chiesa dell'Angelo Raffaele, Venice.

Bibliography:

Albertino da Catanzaro, Francesco. 1613. *Trattato dell'Angelo Custode,* Rome: per Guglielmo Faccioti, 1613.

Askew, Pamela. 1969. The angelic Consolation of St Francis of Assisi in post-tridentine Italian painting. *Journal of the Warburg and Courtauld Institutes,* 32: 280-306.

Bailey, Gauvin Alexander. 2003. *Between Renaissance and Baroque: Jesuit Art in Rome, 1565-1610,* Toronto: University of Toronto Press.

Bukatman, Scott. 2003. *Matters of Gravity: Special Effects and Supermen in the 20th Century,* Durham and London: Duke University Press.

Capps, Walter. 1990. *The New Religious Right: Piety, Patriotism, and Politics*, Columbia: University of South Carolina Press.

Charles, R. H. 1913.*The Apocrypha and Pseudepigrapha of the Old Testament*, Oxford: The Clarendon Press.

Gonzaga, Luigi. 1792. *Meditazione Sopra gli Angeli Santi*, Rome: nella Stamperia Salomoni (no page numbers).

Jones, Pamela. 1999. The Power of Images: Paintings and viewers in Caravaggio's Italy. *Saints and Sinners: Caravaggio and the Baroque Image*, ed. F. Mormando, ex. cat., McMullen Museum of Art, Chicago. University of Chicago Press: 28-86.

Lawrence, John Shelton and Robert Jewett. 1977.*The American Monomyth*, Garden City, New York: Anchor Press/Doubleday.

Lo Bianco, Anna. 1997. Catalogue entry 56, in *Pietro da Cortona 1597-1669*, Milan: Electra.

Maroni Lumbroso, Matizia and Antonio Martini. 1963. *Le Confraternite Romane nelle loro chiese*, Rome: Fondazione Marco Besso.

McGuiness, Frederick.1995. *Right Thinking and Sacred Oratory in Counter-Reformation Rome*, Princeton: Princeton University Press.

Reynolds, Richard, *Superheroes: A Modern Mythology*, Jackson: University of Mississippi Press, 1994.

Schiavo, Armando. *Palazzo Altieri*, n.d., Rome: Associazione Bancaria Italiana.

Zimmerman, Frank. 1958. *The Book of Tobit*, New York: Harper and Brothers.

19. Smack-Head Hasan: Why Are All Turkic Superheroes Intemperate, Treacherous, or Stupid? — *Claire Norton*

Notes:

1 By Turkic myths and literature I am referring not only to those written in the Turkic languages of Turkish, Azeri, Uzbeki, Kazakh and various Turkmen languages, but also the related versions of these epics prevalent in non-Turkic speaking Central Asian populations including the Tajiks, Kurds, Armenians and Central Asian Arabs.

2 *Gazavatnames* are generally relatively accurate Ottoman narratives of specific military campaigns which can contain more or less imaginative or rhetorical sections. Levend, 1956 is the definitive work on Ottoman *gazavatnames*.

3 Schaefer 1991, 117 uses the term 'vocality' coined originally by Zumthor 1987 to describe works which utilise the oral-aural medium of performance regardless of their manner of transmission or whether they were originally oral or written compositions.

4 One episode in the Köroğlu cycle narrates the adventures of his adopted son Ayvaz when he goes to steal game from the park of a pasha. Likewise Alaman Bet, one of Manas' compatriots is the hero of a number of independent adventures. See Chadwick and Zhirmunsky 1969, 58 and 80.

5 A detailed discussion of the *Manas, Joloi, Köroğlu, Dede Korkut* and *Er Töshtük* epic cycles mentioned in this paper can be found in Chadwick and Zhirmunsky 1969 and Başgöz 1978. For the *Köroğlu* epic cycle see Eberhard 1980 and for the

Dede Korkut cycle see Lewis 1974.

6 See also Chadwick and Zhirmunsky 1969, 85 for the important role that horses play in these narratives.

7 The name Köroğlu can variously be read as 'son of a blind man' or 'son of the grave'.

8 These two different types of manuscript production, and reception can also be seen in a European medieval manuscript context: Machan, 1991.

9 For more detailed descriptions of these alternative models of text production see: Machan 1991 and Dagenais 1991 and 1994.

10 There is evidence that some of the manuscripts in the corpus were inscribed and received within a more fixed discourse. I discuss this in greater depth in Norton 2005.

11 *Menakibnames* are narratives detailing the semi-legendary exploits or heroic deeds of heroes framed as warrior-saints. They are therefore often perceived as having a pronounced fictional aspect although this is not always the case. *Kesikbaş* (severed-head) narratives were very popular in the Balkans and Anatolia in the medieval and early modern period in both Muslim and Christian communities. They generally describe the miraculous exploits of either a headless body or a lone severed head as it overcomes numerous obstacles and endeavours to obtain revenge or justice. For a detailed analysis of the genre see, Ocak 1983, 1989 and 1992.

12 The abilities and skills of *menakibname* warrior saints are described in Ocak 1992, 70-95.

13 The corpus of manuscripts describing the 1601 siege of Nagykanizsa are generally considered to be of the *gazavatname* genre – despite the rubrication of certain of the manuscripts as either history or story.

14 A version of the event can be found in the work of Ottoman historian, Ibrahim Peçevi 1866-7, 355. Peçevi writes it in rhymed couplets with the Muslim cleric as the narrator and gives it the title, *ve min kerâmâti'l-guzât*.

15 This event is found in all of the extant manuscripts.

16 Interpretative naming is essentially covert interpretation through naming by attaching a noun to a particular character or object and thereby labelling it. It thus conveys particular expectations or imbues the recipient with predictable qualities for particular interpretative communities or audiences. See Jaworski and Coupland 1999, 11 and Tannen 1993, 49.

17 He is renamed as Tiru in three manuscripts: Paris: Bibliothèque Nationale Nr.525 (undated), Istanbul: Millet Kütüphanesi A.E.Tar.188 (1810), and Budapest: Magyar Tudományos Akademia Konyvtara O.216 (1716). He is described as abstemious and ascetic in a 'sequel' to his adventures at Nagykanizsa which is included together with the first narrative in four manuscripts: Budapest: Magyar Tudományos Akademia Konyvtara O.216 (1716), Paris: Bibliothèque Nationale Sup.Turc.170 (1760), Vienna: National-bibliothek H.O.71d (1754), Manisa: İl Halk Kütüphanesi No.5070 (1757).

Bibliography:

Başgöz, I. 1978. "The Epic Tradition among Turkic Peoples" in F. Oinas, ed. *Heroic Epic and Sages: An Introduction to the World's Great Folk Epics.* Bloomington: Indiana University Press.

Baysun, C. 1950. *Tiryaki Hasan Paşa ve Kanije Savaşı.* Istanbul: Milli Eğitim

Bakanlığı Köy Kitaplığı no.15, Milli Eğitim Basımevi.

Chadwick, N. and V. Zhirmunsky. 1969. *Oral Epics of Central Asia*. Cambridge: Cambridge University Press.

Chodzko, A. 1842. *Specimens of Popular Persian Poetry*. London: n.p.

Dagenais, J. 1991. "That Bothersome Residue: Toward a Theory of the Physical Text," in A.N. Doane and C. Braun Pasternack, eds. *Vox Intexta: Orality and Textuality in the Middle Ages*. Madison: University of Wisconsin Press: 246-259.

_____. 1994. *The Ethics of Reading in Manuscript Culture: Glossing the Libro de Buen Amor*. Princeton: Princeton University Press.

Dumézil, G. 1969. *The Destiny of the Warrior* trans. A. Hiltebeitel. Chicago: University of Chicago Press.

_____. 1992. *The Stakes of the Warrior*. University of California Press.

Eberhard, W. 1980. *Minstrel Tales from Southeastern Turkey*. New York: Arno Press.

Ersever, H. Z. 1986. *Kanije Savunması ve Tiryaki Hasan Paşa*. Ankara: Türk Asker Büyükleri ve Türk Zaferleri Seri no.12, Genelkurmay Askeri Tarih ve Stratejik Etüt Baskanlığı Yayınları Gnkur. Basımevi.

Ibrahim Peçevi, 1866-7 (1283 H.). *Tarih-i Peçevi* [The History of Peçevi]. Istanbul: n.p.

Jaworski, A. and N. Coupland. 1999. "Introduction: Perspectives on Discourse Analysis," in A. Jaworski and N. Coupland eds. *The Discourse Reader*. London and New York: Routledge, 1-44.

Katib Çelebi, 1869-70 (1286 H.). *Fezleke-i Katib Çelebi* vols 1-2. Istanbul: Ceride-i Havadis Matbaası.

Levend, A.S. 1956. *Gazavat-nameler ve Mihaloğlu Ali Bey'in Gazavat-namesi* Ankara: Türk Tarih Kurumu Yayınlarından / XI. Seri, No. 8, Türk Tarih Kurumu Basımevi.

Lewis, G. (trans.) 1974. *The Book of Dede Korkut*. London: Penguin Books.

Machan, T.W. 1991. "Editing, Orality, and Late Middle English Texts" in A.N. Doane and C. Braun Pasternack, eds. *Vox Intexta: Orality and Textuality in the Middle Ages*. Madison: University of Wisconsin Press: 229-245.

Naima, 1864-6 (1281-3 H.). *Ravat al-husayn fi khulāsat-i akhbar al-khāfikayn*. Istanbul: Matbaa-i Âmire. Also commonly known as the *Tarih-i Naima*.

Norton, C. 2005. Plural Pasts: The Role of Function and Audience in the Creation of Meaning in Ottoman and Modern Turkish Accounts of the Sieges of Nagykanizsa. Ph.D. diss., University of Birmingham.

_____. 2005(b). "The Lutheran is the Turks' Luck": Imagining Religious Identity, Alliance and Conflict on the Habsburg-Ottoman Marches in an Account of the Sieges of Nagykanizsa 1600 and 1601" in M. Kurz, M. Scheutz, K. Vocelka and T. Winkelbauer eds *Das Osmanische Reich und die Habsburgermonarchie in der Neuzeit. Akten des internationalen Kongresses zum 150-jährigen Bestehen des Instituts für Österreichische Geschichtsforschung, Wien, 22.-25. September 2004* MIÖG Erg. Bd. 49, Wien: Mitteilungen des Instituts für Österreichische Geschichtsforschung.

Ocak, A. Y. 1983 *Bektaşî Menâkıbnâmelerinde İslam Öncesi İnanç Motifleri*. İstanbul: Enderun Kitabevi.

_____. 1989. *Türk Folklorunda Kesik Baş*. Ankara: Türk Kültürünü Araştırma Enstitüsü.

_____. 1992. *Kültür Tarihi Kaynağı Olarak Menâkıbnâmeler (Metodolojik Bir*

Yaklaşım). Ankara: Türk Tarih Kurumu Basımevi.

Schaefer, U. 1991. "Hearing from Books: The Rise of Fictionality in Old English Poetry," in A.N. Doane and C. Braun Pasternack, eds. *Vox Intexta: Orality and Textuality in the Middle Ages*. Madison: University of Wisconsin Press: 117-136.

Stitt J. M. 1998. "Ambiguity in the Battle of Þórr and Hrungnir" in F. Sautman, D. Conchado, and G. Di Scipio eds. *Telling Tales: Medieval Narratives and the Folk Tradition*. Basingstoke: Macmillan: 121-136.

Tannen, D. 1983. "What's in a Frame? Surface Evidence for Underlying Expectations," in D. Tannen, ed. *Framing in Discourse*. Oxford: Oxford University Press: 14-56.

Zumthor, P. 1987 *La Lettre et la Voix: De la "littérature" medieval*. Paris: Seuil.

Manuscripts:
London: British Library, O.R.12961
Paris: Bibliothèque Nationale, Nr.525
Paris: Bibliothèque Nationale Sup.Turc.170
Istanbul: Millet Kütüphanesi, A.E.Tar.188
Budapest: Magyar Tudományos Akademia Konyvtara, O.216
Vienna: National-bibliothek, H.O.71d
Manisa: İl Halk Kütüphanesi, No.5070

20. Conqueror of Flood, Wielder of Fire: Noah, the Hebrew Superhero— *Estelle Strazdins*

Notes:

1 All translations are my own unless otherwise stated. Translations of *1 Enoch* are made from the Greek text of Black (1970). Translations of the *Genesis Apocryphon* are made from the Aramaic text of Fitzmyer (1971). Translations of Genesis are made from the Hebrew text of Elliger and Rudolf (1990). This article derives in part from my undergraduate Honours thesis. It has been improved greatly by the criticisms and suggestions of Associate Professors Chris Mackie and Angela Ndalianis, and my supervisor Dr. Rhiannon Evans. I also wish to thank Aleks Michalewicz, Miriam Riverlea and Sonya Wurster for their helpful comments.

2 *1 Enoch*, *Jubilees*, and the *Genesis Apocryphon* form part of the inter-testamental corpus of Jewish writings. *1 Enoch* is an apocalypse, and *Jubilees* and *Genesis Apocryphon* are paraphrases of sections of the Pentateuch. My focus is on *1 Enoch* 6-16 and 106-107, *Jubilees* 4:1-10:17, and *Genesis Apocryphon* ii-xii. Each text contains a similar Flood narrative, and both *Jubilees* and *Genesis Apocryphon* are dependent on *1 Enoch* to some extent. Although *1 Enoch* is preserved in Aramaic fragments and a complete Ethiopic text, I will focus primarily on the Greek text compiled by Black (1970). For textual transmission see Black (1985 and 1970), Isaac (1983), Knibb (1978), and Nickelsburg (2001). *Jubilees* has a similar textual history (see VanderKam 1989b, ix-xvi). The Aramaic *Genesis Apocryphon*, discovered in Qumran Cave 1 in 1947, retells the story of *Genesis*. The patriarchs, however, are the focus of the work, often telling their stories in the first person, with free elaboration on the biblical texts (Fitzmyer 1971, 6-9; Bernstein 1999, 206).

3 On the traits of the 'traditional' hero see Raglan (1934, 212-231) and Rank (2004, 47-92). See Eco (1972, 15) for the function of the hero of myth.

4 For more details on the superhero's traits, see Reynolds (1992, 12-25).

5 See VanderKam (1992, 226-31) for a discussion of Noah's ambiguous status.

6 On the traits of the supervillain and his relationship to the superhero see Reynolds (1992, 16-17, 24-5, 66-8) and Harney (1993, 194-5).

7 Translated by Wintermute (1985).

8 In addition, the *Septuagint*, the third-century BCE Greek translation of the Old Testament, translates *gibborim* as 'giants' (Milik 1976, 166).

9 See Strazdins for a discussion of the Nephilim as an amplification of humanity in possession of divine fire and for a similar discussion of the word *nephilim* (Strazdins 2005, 293, 296 n. 24-5).

10 On the importance of the spilling of blood in this myth, see VanderKam (1999, 166) and Dimant (1978, 327-29).

11 This holds true even for the *Jubilees* version, in which the angels come to earth on a mission from God. They are charged with judgement and righteousness, not the divulging of divine wisdom or the intermingling of gods and men.

12 For a detailed discussion of the effect of divine fire on humanity in this myth, in comparison with Hesiod's Prometheus myth, see Strazdins (2005).

13 *Genesis Apocryphon* ii-v also describes Lamech's reaction to his son. See too 4QMESS AR, which is an Aramaic fragment that describes a special child in similar terms to Noah in both *1 Enoch* and *Genesis Apocryphon* (see García Martínez 1992, 1-44).

14 Spoken twice by Uncle Ben and quoted once by Peter Parker/Spiderman.

15 Translated by VanderKam (1989a). Additionally, *Jubilees* 5:5 states: 'But Noah alone found favour in the sight of the Lord'. Translated by Wintermute (1985).

16 See Clarke (1971, 273-4) for the opposing view that Noah's righteousness is only potential until he performs the first post-diluvian sacrifice.

17 In the bible, Noah's righteousness depends on his obedience to God throughout the Flood narrative. Thus, Genesis denies any subjectivity to Noah, does not provide a physical description of him, nor lets him speak for himself, which essentially denies him a heroic nature.

18 See Reynolds (1992, 81), for the 'reconciliation of opposites' as a 'stock-in-trade of the ideological subtext of many superhero comics'.

19 See Strazdins for the application of these oppositions to humanity before and after the gift of divine fire (Strazdins 2005, 288-93).

20 *Genesis* 6:9: '...with God did Noah walk'. *Genesis* 5:24: 'And Enoch walked with God, and he was not because God took him'. This use of 'walk' is not a metaphorical expression of righteousness, but is 'walk' in its literal sense (VanderKam 1980, 13).

21 Translated by VanderKam (1989a).

22 See Grabbe for an alternative derivation (Grabbe 1988, 156).

23 A close relationship between Noah (or at least his fate) and Enoch is stressed in *1 Enoch* 106-07 and *Genesis Apocryphon* ii-v, (VanderKam 1992, 221). Moreover, the language that describes their respective 'walks' with God uses the same words in reverse order.

24 Translated by Wintermute (1985). Cf. *Genesis Apocryphon* x:15.

25 The Old Babylonian *Atrahasis* epic is inscribed on clay tablets in Akkadian which can be dated to around 1700 BCE (Lambert and Millard 1969, 23, 32). This is the oldest Flood narrative extant and its hero Atrahasis is granted immortality after the waters disperse.

26 Translated by Lambert and Millard (1969).

27 Translated by VanderKam (1989a)

28 'And the Lord smelled the sweet aroma, and he made a covenant with him so that there might not be floodwaters which would destroy the earth' (*Jubilees* 6:4). Translated by Wintermute (1985). *Genesis* 8:21 reports the same sentiment: 'And God smelled the soothing odour and God said in his heart: I will never again curse the earth on account of mankind, since the inclination of the heart of man is evil from its youth; and I will never again strike down all living-things, as I have done'.

29 Translated by Wintermute (1985).

30 That Noah was taught medicine in order to counteract the Nephilim is explicitly stated at *Jubilees* 10:7-14.

31 Translated by Wintermute (1985).

Bibliography:

Bernstein, Moshe J. 1999. Noah and the Flood at Qumran. In *The Provo International Conference on the Dead Sea Scrolls: Technological Innovations, New Texts, and Reformulated Issues*, edited by Donald W. Parry and Eugene Ulrich, 199-231. Leiden: Brill.

Black, Matthew, ed. 1970. *Apocalypsis Henochi Graece*. Leiden: Brill.

Black, Matthew and James C. VanderKam, eds. 1985. *The Book of Enoch or 1 Enoch: A New English Edition with Commentary and Textual Notes by Matthew Black in Consultation with James C. VanderKam*. Leiden: Brill.

Clarke, W. Malcolm. 1971. The Righteousness of Noah. *Vetus Testamentum* 21 (3): 261-80.

Dimant, Devorah. 1998. Noah in Early Jewish Literature. In *Biblical Figures Outside the Bible*, edited by Michael E. Stone and T. A. Bergen, 123-50. Harrisburg: Trinity Press International.

_____. 1978. 1 Enoch 6-11: A Methodological Perspective. In *The Society of Biblical Literature Seminar Papers*, edited by Paul J. Achtemeier, 323-39. Missoula: Scholars Press.

Eco, Umberto. 1972. The Myth of Superman. *Diacritics* 2 (1): 14-22.

Elliger, Karl and Wilhelm Rudolph, eds. 1990. *Biblia Hebraica Stuttgartensia*. Stuttgart: Deutsche Bibelgesellschaft.

Fitzmyer, Joseph A., ed. 1971. *Genesis Apocryphon of Qumran Cave One: A Commentary*. Rome: Biblical Institute Press.

García Martínez, Florentino. 1992. *Qumran and Apocalyptic: Studies on the Aramaic Texts from Qumran*. Leiden: Brill.

Grabbe, Lester L. 1988. *Etymology in Early Jewish Interpretation: The Hebrew Names in Philo*. Atlanta: Scholars Press.

Harland, Peter J. 1996. *The Value of Human Life: A Study of the Story of the Flood (Genesis 6-9)*. Leiden: Brill.

Harney, Michael. 1993. Mythogenesis of the Modern Super Hero. In *Modern*

Myths, edited by David Bevan, 189-210. Amsterdam: Rodopi B.V.

Isaac, E., ed. and trans. 1983. 1 (Ethiopic Apocalypse of) Enoch. In *The Old Testament Pseudepigrapha Volume One: Apocalyptic Literature and Testaments*, edited by James H. Charlesworth, 5-90. Garden City, N.Y.: Doubleday.

Klein, Ernest. 1987. *A Comprehensive Etymological Dictionary of the Hebrew Language for Readers of English*. New York: Macmillan.

Knibb, Michael A., ed. and trans. 1978. *Ethiopic Book of Enoch: A New Edition in Light of the Dead Sea Fragments Volume 2: Introduction, Translation and Commentary*. Oxford: Clarendon Press.

Lambert, Wilfred G. and Alan R. Millard, eds. 1969. *Atra-Hasis: The Babylonian Story of the Flood*. Oxford: Clarendon Press.

Milik, Jozef T. with Matthew Black, eds. 1976 *The Books of Enoch: Aramaic Fragments of Qumran Cave Four*. Oxford: Clarendon Press.

Murray, Robert. 1984. The Origin of Aramaic '*ir*, Angel. *Orientalia* 53: 303-17.

Nickelsburg, George W. E. 2001. *1 Enoch 1: A Commentary on the Book of 1 Enoch, Chapters 1-36; 81-108*. Minneapolis: Fortress Press.

_____. 1998. Patriarchs Who Worry About Their Wives. In *Biblical Perspectives: Early Use and Interpretation of the Bible in Light of the Dead Sea Scrolls: Proceedings of the First International Symposium of the Orion Centre for the Study of the Dead Sea Scrolls and Associated Literature, 12-14 May 1996*, edited by Michael E. Stone and Esther. G. Chazon, 137-58. Leiden: Brill.

Raglan, Lord. 1934. The Hero of Tradition. *Folklore* 45 (3): 212-31.

Rank, Otto. 2004. *The Myth of the Birth of the Hero: Expanded and Updated Edition*, translated by Gregory C. Richter and E. James Leiberman, with an introductory essay by Robert A. Segal. Baltimore: Johns Hopkins University Press.

Reeves, John C. 1993. Utanapishtim in the Book of Giants? *Journal of Biblical Literature* 112: 110-115.

Reynolds, Richard. 1992. *Superheroes: A Modern Mythology*. Jackson: University Press of Mississippi.

Richardson, Mervyn E. J., ed. 1994. *Hebrew and Aramaic Lexicon of the Old Testament Volume 1, The New Koehler-Baumgartner in English*. Leiden: Brill.

Strazdins, Estelle. 2005. Transforming Fire: The Effect of Technology on Humanity in Hesiod's Prometheus Myth and the Watcher Myth of *1 Enoch*. *Comparative Critical Studies* 2 (2): 285-96.

VanderKam, James C. 1999. The Angel Story in the Book of Jubilees. In *Pseudepigraphic Perspectives: The Apocrypha and Pseudepigrapha in Light of the Dead Sea Scrolls: Proceedings of the International Symposium of the Orion Centre for the Study of the Dead Sea Scrolls and Associated Literature, 12-14 January, 1997*, edited by Esther G. Chazon and Michael E. Stone, 151-70. Leiden: Brill.

_____. 1992. The Birth of Noah. In *Intertestamental Essays in Honour of Jozef Tadeusz Milik*, edited by Zdzislaw J. Kapera, 213-31. Krakow: Enigma Press.

_____. ed. 1989a. *Book of Jubilees: Translated*. Louvain: E. Peeters.

_____. ed. 1989b. *The Book of Jubilees: A Critical Text*. Louvain: E. Peeters.

_____. 1980. The Righteousness of Noah. In *Ideal Figures in Ancient Judaism: Profiles and Paradigms*, edited by John J. Collins and George W. E. Nickelsburg, 13-32. Chico: Scholars Press.

Wintermute, O. S., ed., 1985. *Jubilees*: A New Translation and Introduction. In

The Old Testament Pseudepigrapha Volume Two: Expansions of the 'Old Testament' and Legends, Wisdom and Philosophical Literature, Prayers, Psalms, and Odes, Fragments of Lost Judeo-Hellenistic Works, edited by James H. Charlesworth, 35-142. Garden City, N.Y.: Doubleday.

21. RIPPED OFF! Cross-Media Convergence and 'The Hulk'—*Gareth Schott & Andrew Burn*

Bibliography:
Aumont, J. 1997. *The Image*. London: British Film Institute.
Bana, E. 2003. Eric Bana Talks Hulk. http://www.comicbookmovie.com/news/articles/401.asp.
Bittanti, M. 2002. The Technoludic Film: Images of Videogames in Films (1973-2001), *Gamasutra*, http://www.gamasutra.com/education/theses/20020501/bittanti_01.shtml
Bolter, J. D. & R. Grusin. 1999. *Remediation: Understanding New Media*, Cambridge, MA: The MIT Press.
Burn, A. & G. Schott. 2004. Heavy Hero or Digital Dummy: Multimodal player-avatar relations in Final Fantasy 7. *Visual Communication* 3(2): 213-234.
Castell, M. 2001. *The Internet Galaxy: Reflections of the Internet, Business and Society*. Oxford: Oxford University Press.
Cubitt, S. 2005. Are We Not Men? *X-Men, X-2* and GM apologetics. *Eco Media*. Amsterdam: Rodopi.
Debruge, P. 2003. *Review: The Hulk*, http://www.premiere.com/article.asp?section_id=2&article_id=1068
De Gaetano, R. 1996. *Il cinema Secondo Gilles Deleuze*. Rome: Bulzoni.
Deleuze, G. & C. Parnet. 2002. *Dialogues II*. New York: Columbia University Press.
Holleran, S. 2003. *The Introspective Hulk*, http://www.boxofficemojo.com/reviews/?id=60&p=.htm
King, G. & T. Krzywinska, eds. 2002. *ScreenPlay: Cinema/ Videogames/ Interfaces*. London: Wallflower Press
Kress, G. & T. van Leeuwen. 2000. *Multimodal Discourses: The Modes and Media of Contemporary Communication*. London: Arnold.
Lemke, J. 2002. Travels in Hypermodality. *Visual Communication* 1(3): 299-325.
Ong, W. 2002. *Orality and Literacy: The Technologizing of the Word*. London: Routledge
Poster, M. 1995. *The Second Media Age*, Cambridge: Blackwell Publishers.
Press Release 2003. Vivendi Universal Announced The Incredible Hulk, http://www.nintendospin.com/news/gamecube/692/vivendi-universal-announced-the-incredible-hulk.htmlaq
van Leeuwen, T. 1999. *Speech, Music, Sound*. London: St. Martin's Press.

22. Transforming Superheroics Through Female Music Style—*Kim Toffoletti*

Notes:

1 Lyrics from the song 'Rich', as performed live at the Fillmore, March 16 2004. See DVD recording *Tell Me What Rockers to Swallow*. Prod. and Dir. Lance Bangs, Modular, 2004.

2 The contributions which make up the edited collection *The Madonna Connection* (1993) are indicative of the breadth and prevalence of scholarship examining the intersections between postmodern culture, identity politics and gendered subjectivity in relation to Madonna's image and performance.

3 My own experience of Peaches' concerts, as well as observations of the crowd and informal discussions with Peaches fans concur with Sawyer's experience of humour and laughter as responses to her gender play.

4 The website Denim and Leather: The Home of '80s Heavy Metal and Hard Rock! offers the following description of glam metal:

> Glam Metal is basically the Heavy Metal variation of Glam Rock. Glam Rock started in England in the early seventies as a reaction to the more "serious" and introverted music of the time. Noteworthy artists included T.Rex, David Bowie and Slade. In short, Glam Rockers played quite "simple" music and performed in more or less gaudy outfits and makeup. While Glam Metal can not be said to have stemmed directly from the Glam Rock of the seventies, it was certainly influenced by it, not least regarding the clothing and heavy use of makeup. Also, Glam Metal had its stronghold in the USA as opposed to England. The reason for this was perhaps that the Glam Metal bands were musically generally more pop oriented than most other Metal acts, and the popier, more mainstream side of Heavy Metal was always more popular in the USA. It's hard to pinpoint which bands were really Glam Metal acts, but Poison, Twisted Sister and Glam pioneers Hanoi Rocks are a few examples. Also, there was the occasional band (such as Sweet) that played bona fide, old school Glam Rock in the seventies but started flirting with Heavy Metal in the eighties. http://www.sundin.net/denim/thesaurus.shtml (accessed 1April, 2005).

5 A related analysis is offered by Susan Hopkins in her consideration of shifting configurations of femininity in 2000's film revival of the 1970s series *Charlie's Angels*. See pp. 130-138 of *Girl Heroes: The New Force in Popular Culture*.

Bibliography:

Auslander, P. 2004. I wanna be your man: Suzi Quatro's musical androgyny. *Popular Music* 23(1):1-16.

Brown, Jeffrey A. 2004. Gender, sexuality and toughness: the bad girls of action film and comic books. In *Action Chicks: New Images of Tough Women in Popular Culture*, ed. S.A. Inness, 47-74. New York: Palgrave Macmillan.

Bukatman, Scott. 1994. X-Bodies (the torment of the mutant superhero). In *Uncontrollable Bodies: Testimonies of Identity and Culture*, eds. R. Sappington and T. Stallings, 93-129. Seattle: Bay Press.

Cartledge, Frank. 1999. Distress to impress?: Local punk fashion and commodity exchange. In *Punk Rock: So What?*, ed. R. Sabin, 143-153. New York and

London: Routledge.

Chicks on Speed. n.d. Chicks on Speed official website. http://www.chickson-speed.com/tv.html (accessed 13 April, 2005).

Connell, R.W. 1995. *Masculinities*. Cambridge and Oxford: Polity.

Denski, Stan and David Sholle. 1992. Metal men and glamour boys: Gender performance in heavy metal. In *Men, Masculinity, and the Media*, ed. S. Craig, 41-60. Newbury Park, London, New Delhi: Sage.

Fingeroth, Danny. 2004. *Superman on the Couch*. New York and London: Continuum.

Fiske, John. 1989. *Reading the Popular*. Boston: Unwin Hyman.

Frith, Simon and Angela McRobbie. 1990. Rock and sexuality. In *On Record: Rock, Pop and the Written Word*, eds. S. Frith and A. Goodwin, 371-389. London: Routledge.

Gottleib Joanne and Gayle Wald. 1994. Smells like teen spirit: Riot grrrls, revolution and women in independent rock. In *Microphone Fiends*, eds. A. Ross and T. Rose, 250-274. New York and London: Routledge.

Greer, Germaine. 1999. *The Whole Woman*. London: Doubleday.

Hebdige, Dick. 1979. *Subculture: The Meaning of Style*. London and New York: Methuen.

Hopkins, Susan. 2002. *Girl Heroes: The New Force in Popular Culture*. Annandale, NSW: Pluto.

Inness, Sherrie A. 1999. *Tough Girls: Women Warriors and Tough Women in Popular Culture*. Philadelphia: University of Pennsylvania Press.

_____. ed. 2004. *Action Chicks: New Images of Tough Women in Popular Culture*. New York: Palgrave Macmillan.

Jameson, Frederic. 1983. Postmodernism and consumer society. In *The Anti-aesthetic: Essays in Postmodern Culture*, ed. H. Foster, 111-125. Seattle: Bay Press.

Jirousek, C.A. 1996. Superstars, superheroes and the male body image: The visual implications of football uniforms. *Journal of American Culture* 19(2): 1-11.

Kaplan, E.A. 1987. *Rocking Around the Clock: Music Television, Postmodernism, and Consumer Culture*. New York: Routledge.

Krenske, L. and J. McKay. 2000. 'Hard and Heavy': Gender and power in a heavy metal music subculture. *Gender, Place and Culture* 7(3): 287-304.

McDonnell, Evelyn. 1999. Re: Creation. In *Stars Don't Stand Still in the Sky: Music and Myth*, eds. K. Kelly and E. Mc Donnell, 73-77. London: Routledge.

Mc Robbie, Angela. 1994. Second-hand dresses and the role of the ragmarket. In *Postmodernism and Popular Culture*, ed. A. Mc Robbie, 135-154. London and New York: Routledge.

Middleton, Peter. 1992. Boys will be men: Boys' superhero comics. In *The Inward Gaze: Masculinity and Subjectivity in Modern Culture*, ed. P. Middleton, 17-42. London and New York: Routledge.

Mötley Crüe. 2001. *The Dirt*. New York: Regan Books/Harper Collins.

Mulvey, Laura. 1989. Visual pleasure and narrative cinema. In *Visual and Other Pleasures*, ed. L.Mulvey, 14-26. London: Macmillan.

Nourse, Pat. 2004. Strange fruit. *Black and White* 70:30.

Poniewozik, James. 2002. Superhero nation: The new, sensitive incarnation of the webbed wonder reminds us how America likes its superheroes. *Time* 159: 77.

Reynolds, Simon and Joy Press. 1995. *The Sex Revolts: Gender, Rebellion and Rock 'n' Roll*. Cambridge: Harvard University Press.

Sawyer, Terry. 2004. Peaches, 23 April 2004: Emo's – Austin, Texas. *Pop Matters*. http://www.popmatters.com/music/concerts/p/peaches-040423.shtml (accessed 6 April, 2005).

Schippers, Mimi. 2003. Rocking the gender order. In *Catching a Wave: Reclaiming Feminism for the 21ˢᵗ Century*, eds. R. Dicker and A. Piepmeier, 279-293. Boston: Northeastern University Press.

Schwichtenberg, Cathy, ed. 1993. *The Madonna Connection*. NSW: Allen and Unwin.

Springer, K. 2002. Third wave black feminism. *Signs: Journal of Women and Culture in Society* 27(4):1059-1082.

Stein, Arlene. 1999. Rock against romance: Gender, rock 'n' roll, and resistance. In *Stars Don't Stand Still in the Sky: Music and Myth*, eds. K. Kelly and E. Mc Donnell, 215-227. London: Routledge.

Straw, Will. 1990. Characterizing rock music culture: the case of heavy metal. In *On Record: Rock, Pop and the Written Word*, eds. S. Frith and A. Goodwin, 97-110. London: Routledge.

Taylor, Paul. 1988. The impresario of do-it-yourself. In *Impresario: Malcolm McLaren and the British New Wave*, ed. P. Taylor, 11-30. New York: New Museum of Contemporary Art.

Toffoletti, Kim. 2003/4. Chicks on spandex. *Black and White Mode* 4:16.

Whiteley, Sheila. 1998. Repressive representations: patriarchy and femininities in rock music of the counterculture. In *Mapping the Beat: Popular Music and Contemporary Theory*, eds. T. Swiss, J. Sloop and A. Herman, 153-170. Oxford: Blackwell.

Discography:

Chicks on Speed. 2003. *99Cents*. Chicks on Speed Records/EMI.

Peaches. 2000. *The teaches of peaches*. XL Recordings.

Peaches. 2003. *Fatherfucker*. XL Recordings.

2 many dj's. 2002. *As heard on radio soulwax Pt.2*. PIAS Recordings.

23. Check The Use-By Date: Shelving an Icon as Superheroes Become Super-brands in Advertising to the Junior Generation — *Holly Stokes*

Notes:

1 This gender-bias reference to the hero will be used throughout this paper in favour of traditional references to his title as presented in the work of Propp (1968), Campbell (1956) and Carlyle (1935), and further in consideration of the gender of the two key protagonists – Coco Pop Monkey and Paddle Pop Lion – being investigated. The hero's feminine equivalent will be referred to as a 'female hero' or 'girl hero.'

2 This organisation is not religious based nor associated with a school or education sector.

3 This research and methodology was approved by the Divisional Human Research Ethics Committee under the Division of Education, Arts and Social Sciences at the University of South Australia on September 23, 2003.

4 The design of the focus group followed the recommendations out lined by Hansen, Cottle, Negrine & Newbold 1998: 257-278.

5 *Spider-Man* (Columbia Pictures 2002), *Spider-Man 2* (Columbia Pictures 2004), *The Hulk* (Universal Pictures 2003), *Monsters, Inc.* (Pixar 2001), *Shrek* (Dreamworks 2001), *Harry Potter* (Warner Bros. 2003).

6 Key discussion points raised within these publications focus on a victim-centred cosmology in defining the consumer. Advertising is blamed for social ills and the homogenisation of society through the mass production and consumption of goods and images. Such publications arrive from the Frankfurt school of thought with concerns for the domination of capitalism and its effect towards minor social and cultural groups.

7 An example would include Clemenger BBDO's *VISA Lara Croft* campaign (2003)., PepsiCo, Inc. *Britney Spears for Pepsi* (2001).

8 The Wish Chip game is played with Homebrand Corn Chips. A chip which curls back on itself is called a Wish Chip. To make a wish, the child holds the chip between the index and middle finger (touching the chip with one's thumb voids their chance of a wish). Here the game seems to differ, either the wish is granted upon smashing the chip against one's forehead and eating the remains from the palm of the hand, or the chip must be chewed and swallowed in no more than three bites. This game has been played as early as the 1990s, however its origins are unclear.

Bibliography:

Avery, Gillian. 1965. *Nineteenth Century Children: Heroes and Heroines in English Children's Stories*. London: Hodder and Stoughton.

Barthes, Roland. 2000. *Mythologies*. London: Vintage Random House.

Baudrillard, Jean. 1996. *The System of Objects*. New York: Verso.

Bourdieu, Pierre. 1989. *Distinction: A Social Critique of the Judgement of Taste*. London: Routledge.

Burns, Norman T. and Reagan, Christopher. 1975. *Concepts of the Hero in the Middle Ages and Renaissance*. New York: State University of New York Press.

Byrne, Mark. 2001. *Myths of Manhood: The Hero in Jungian Literature*. Sydney: RLA Press.

Campbell, Joseph. 1956. *The Hero With a Thousand Faces*. New York: Meridian Books.

Carlyle, Thomas. 1935. *On Heroes, Hero-worship and the Heroic in History*. London: Oxford University Press.

Elley, Derek. 1984. *The Epic Film: Myth and History*. London, Boston: Routledge & Kegan Paul.

Freud, Sigmund. 2003. *The Uncanny*. London: Penguin Classics.

Garbarino, James. 1989. *What Children Can Tell Us: Eliciting, Interpreting and Evaluating Information From Children*. San Francisco: Jossey-Bass Publishers.

Gilbert, Keith. 1998. Chapter four: The body, young children and popular culture. *Gender in Early Childhood*. New York: Routledge.

Greig, Anne and Taylor, Jayne. 1999. *Doing Research with Children*. London: SAGE.

Hansen, Anders, Cottle, Simon, Negrine, Ralph and Newbold, Chris. 1998.

Mass Communication Research Methods. London: Macmillan Press.

Harris, Daniel. 2000. *Cute, Quaint, Hungry and Romantic: The Aesthetics of Consumerism*. USA: Da Capo Press.

Hourihan, Margery. 1997. *Deconstructing the Hero: Literary Theory and Children's Literature*. London: Routledge.

Jung, Carl. 1985. *Science of Mythology: Essays on the Myth of the Divine Child and the Mysteries of Eleusis*. London: Routledge.

Klein, Naomi. 2001. *No Logo*. Great Britain: Flamingo.

Latham, Rob. 2002. *Consuming Youth: Vampires, Cyborgs and the Culture of Consumption*. Chicago: University of Chicago Press.

Lindstrom, Martin. 2003. *Brand Child: Remarkable Insights into the Minds of Today's Global Kids and their Relationships with Brands*. London: Kogan Page Limited.

Pountain, Dick and Robins, David. 2000. Chapter nine: Cool rules. *Cool Rules: Anatomy of an Attitude*. London: Reaktion.

Propp, Vladimir. 1968. *Morphology of the Folktale*. Texas: University of Texas Press.

Tatham, Peter H. 1992. *The Making of Maleness: Men, women, and the Fight of Daedalus*, New York: New York University Press.

Traudt, Paul. 2005. Chapter six: Children and advertising. *Media, Audiences, Effects: An Introduction to the Study of Media Content and Audience Analysis*. USA: Pearson Education, Inc.

Williamson, Judith. 1978. *Decoding Advertisements: Ideology and Meaning in Advertising*. London: Marion Boyars Publishers Ltd.

Williamson, Judith. 1986. *Consuming Passions: The Dynamics of Popular Culture*. London: Marion Boyars Publishers Ltd.

24. I Outwit Your Outwit: HeroClix, Fans, and the Politics of the Collectible Superhero Tabletop Combat Game—*Michael G. Robinson*

Bibliography:

Fiske, John. 1992. The Cultural Economy of Fandom. In *The Adoring Audience*, ed. Lisa Lewis, 30-49. New York: Routledge.

Geertz, Clifford. 1973. *The Interpretation of Cultures*. New York: Basic Books.

Geertz, Clifford. 1983. *Local Knowledge*. New York: Basic Books.

HCRealms. 2006. http://www.hcrealms.com (accessed April 21, 2006).

Jenkins, Henry. 1992. *Textual Poachers*. Routledge, New York.

Popular Collections. 2006. http://www.popularcollections.com/index.html (accessed April 21, 2006).

Tulloch, John, and Henry Jenkins. 1995. *Science Fiction Audiences*. New York: Routledge.

Weisman, Jordan, et al. 2005. *DC HeroClix Icons: Quick-Start and Complete Rules*. WizKids.

WizKids. 2005. WizKids Announces Collectible Miniatures Game Featuring Characters from the Marvel Universe! http://www.wizkidsgames.com/documents/ pr/ 08_17_01MarvelAnn.pdf. (accessed March 2, 2005).

WizKids. 2006. Marvel HeroClix: How to Play. http://www.wizkidsgames.

com/HeroClix/marvel/howtoplay.asp (accessed April 23, 2006).

25. Girl Power: The Female Cyborg in Japanese Anime — *Craig Norris*

Notes:

1 Most participants in the field research I conducted between 1996 and 2001 were from a number of anime clubs I had been involved with. These clubs included AJAS (Adelaide Japanese Anime Society), AnimeUNSW (Anime University of New South Wales), SAS (Sydney Anime Society), SUanime (Sydney University anime), and the anime club I initiated JAUWS (Japanese Animation University of Western Sydney). The total number of fans who participated in my field research was 64; of this, 10 were in-depth interviews with club executives and established members of the fan community, 40 were questionnaire responses, and the remaining 14 participants were part of three small group discussions (ranging from four to six people). The in-depth interviews explored fan readings and texts derived from manga and anime forms that I used to investigate the spaces fans construct to explore issues of identity and culture. The three group interviews were with new members of anime clubs and explored the discovery of anime's 'difference'. The questionnaire responses covered a range of issues relating to the experience of manga and anime in Australia — beyond the Sydney focus of my interviews — and also informed the general direction of the group interviews through discussing the results of the questionnaire

2 *Seira fuku* is literally "sailor clothes," the term refers to a type of Japanese school uniform worn by many girls that resembles a Sailor outfit – such as that depicted in *Sailor Moon*.

Bibliography:

Appadurai, Arjun. 1996. *Modernity at Large: Cultural Dimensions of Globalization, Public Worlds;* v. 1. Minneapolis: University of Minnesota Press.

Clark, Scott. 1992. The Japanese Bath: Extraordinarily Ordinary. In *Re-made in Japan: Everyday Life and Consumer Taste in a Changing Society,* edited by J. Tobin. New Haven: Yale University Press.

Iwabuchi, Koichi. 1998. Marketing "Japan": Japanese Cultural Presence Under a Global Gaze. *Japanese Studies* 18 (2):165-180.

_____. 2002. *Recentering Globalization: Popular Culture and Japanese Transnationalism.* London: Duke University Press.

Jenkins, Henry. 1992. *Textual Poachers: Television Fans & Participatory Culture, Studies in Culture & Communication.* New York: Routledge.

Levi, Antonia. 1996. *Samurai From Outer Space: Understanding Japanese Animation.* Chicago: Open Court.

Morley, David, and Kevin Robins. 1995. Techno-Orientalism: Japan Panic. In *Spaces of Identity: Global Media, Electronic Landscapes, and Cultural Boundaries.* London; New York: Routledge.

Napier, Susan Jolliffe. 2001. *Anime From Akira to Princess Mononoke: Experiencing Contemporary Japanese Animation.* 1st ed. New York: Palgrave.

Newitz, Annalee. 1994. Anime Otaku: Japanese Animation Fans Outside Ja-

pan. *Bad Subjects: Political Education for Everday Life* (13):13-20.

_____. 1995. Magic Girls and Atomic Bomb Sperm: Japanese Animation in America. *Film Quarterly* 49 (1):2-15.

Schodt, Frederik L. 1983. *Manga! Manga!: The World of Japanese Comics.* Tokyo; New York: Kodansha International.

_____. 1996. *Dreamland Japan: Writings on Modern Manga.* Berkeley: Stone Bridge Press.

Ueno, Toshiya. 1999. Techno-Orientalism and Media-Tribalism: On Japanese Animation and Rave Culture. *Third Text* 47 (Summer): 95-106.

Index

Printed in the United Kingdom
by Lightning Source UK Ltd.
120161UK00001B/54